SEVEN WOMEN OF SATURN

SEVEN WOMEN

of

SATURN

The quarter life crisis of a lesbian romantic

FERN BEATTIE

Write Bloody UK • London, UK

Support Independent Presses

www.writebloodyuk.co.uk

"And from that dark night of the soul,

let me pull treasure through the filthy wounds of the past,

I emerge unscathed,

carrying gemstones on my tongue."

—*Unknown*

PROLOGUE

January 2018

THE SHOPPING LIST from that fateful afternoon is immortalised in my iPhone notes.

13:46

Medium cappuccino with one shot
Espresso
One small boy [sic] chocolate
One medium mocha
3 croissants
1 choc twist

Insignificant to the snooping eye, but a heart-breaking reminder for me. Final evidence of the life we shared; proof I was once privy to the intimate act of sharing dairy.

Twelve hours later and I'm clinging to this list, curled up on the sofa at my parents' house and watching Friends reruns in the middle of the night. I open and close the notes app on my phone to repeatedly stare at it, a desperate attempt to confirm that the relationship I'd just thrown away had really existed a mere day prior. Every so often a car passes by outside and lights the living room in brief flashes of red. My eyes flick back and forth from my phone to the TV like a metronome, searching for a clue to survive this pain. Focusing on our lunchtime coffee order because I can't text her anymore feels like pushing on a bruise, but watching TV is just as painful. I don't understand how Rachel still has makeup

on after her breakup from Ross; how she can interview for jobs and laugh with Monica like life is still an option.

Earlier that morning

"What are you thinking?" Grey asks with the disapproval I know so well. She takes a croissant from the bag I've brought back from Costa and shreds it delicately, waiting for me to talk.

"Nothing!" I reply with fake cheer, pulling my gaze away from the maple and cherry trees outside her kitchen window and over to where she sits across from me. I'd been admiring these trees on my walk, had forced myself to notice the fresh scent of the New Year still palpable in the January air. But I know she's not convinced by my response and I don't have the energy to care. A bigger part of me needs her to know I'm sulking.

"You have to get over this" she continues unsympathetically, twisting the lid off her hot chocolate. A searing rage slits my insides and I tense my stomach to stem it. I am *trying* to get over it.

"I'm not doing anything! I'm literally just staring out the window, thinking!" I force a laugh. I might be angry, but I'm scared of her anger more.

She leans back in her chair and fixes me with a sceptical look, her fingertips cradling the paper cup at arm's length.

"You are different with me, I feel it."

"How am I different? I just went to get you coffee!" My emotions towards Grey are so deep and complex that I have no control over them. As soon as she asks for an inch, it's hard not to let it all out. I know it's better to keep my mouth shut. Still, her eyes persist, so I attempt to justify myself.

"I'm fine, Grey. What have I done wrong? I kissed you goodbye before I left and thought lovely things about us the whole time I was out. It's just that sometimes I remember what you did, and my mind wanders."

"Bah"—she dismisses me as she reaches for her tobacco tin.

"I'm trying to rationalise things, to make peace with them. But you insist on interrupting and antagonising me! I'm not pestering you. These are my thoughts. And if I'm constantly in your home then I should be allowed time to think them."

She pinches the brown flakes out of the shiny yellow packet. "But we are never gonna move past this if you keep thinking about it."

"I can't help it! You wouldn't be able to either, if the roles were reversed. How dare you try to rush me through this to make you comfortable?! You should be bending over backwards to make sure I'm okay!"

Grey and I had broken up on New Year's Eve and were trying to work things out. That night wasn't the first time I'd threatened to end it; the difference is, it *was* the first time she'd called my bluff and forced me to face the consequences of our separation, if only for a few weeks. But Big Ben chimed and eventually we did the same, our forgiveness heralding another year in which to get it right. Although it's nearly February now, and I'm increasingly unsure that we can.

"No, Fern. You didn't have to come back to me." Grey performs origami on the Rizla, and the tender way her fingers move stirs something inside me that makes me want to weep for what was. "I can see now that you will always punish me. And I won't allow it." She plugs the cigarette with a filter, gives it a shove in between her lips and leans back - a femme Al Pacino.

I push the unwelcome mix of lust and rage down as I swallow.

"Allow what? All I was doing was staring out of the window! Why does that bother you so much? Let me be!"

For the hundredth time, I've had enough. She controls my actions, my words, and now my thoughts? My relaxing Sunday walk feels like hours ago. I give up.

"For fuck's sake, I need to get out of here."

My chair squeaks on the linoleum as I push myself back from the table to escape the prison of fake domestic bliss I've created in my head. Both of my Gemini twins are wide awake and duelling.

"If you leave again, don't think of coming back," she mutters calmly but not without threat. "I've already told you, I don't accept that. Don't do it. If you leave you can't come back. Trust me."

I will replay these words over and over for the next year and a half, torturing myself about how I could have responded differently. I don't heed her words as a warning; never believe they'll be the final fork in our road. We've fallen out so many times but always snap right back to each other. If ever things are final, I'm sure it will be on my terms.

Grey hates being walked out on. It's a specific boundary she made me aware of when we first got together, but right now I'm not bothered. The red mist is smudged so thick across my vision that I charge away from her as if to walk through it, hoping it will disperse the more distance I put between us. With every passing day, the fluctuations in my mood become more frequent and aggressive. Turning left into her bedroom, I find the Santa sack I'd bought to contain her Christmas presents hanging on a hook behind the door. Reaching in like a child at a lucky dip, my fingers find the battery of the egg-shaped sex toy I'd gifted her. Am I really going to be this petty? There's no time to think about it. I'll combust if I don't start screaming, don't let out all the bitterness and resentment that's slowly corroding my dignity.

I grapple with it furiously, brandishing the egg in Grey's face like a literal sex weapon. It slips out of my hand and I stumble clumsily, reaching out to catch it like an embarrassing parent at their child's sport's day race. I don't dare look at her, knowing she'll smirk at what's turning out to be quite the performance.

"I'm taking this with me," I spit, "so that this time when you sleep with someone after I'm gone, you can't use the Christmas present I got you."

A low blow and I know it. But I'm no longer in my body, I'm astral like a sleep-paralysis demon, looking down on the pathetic scene we've painted in Grey's bleak North London flat. I know how ridiculous I must look from her vantage point as she finally

abandons her drink and gets up from the table—fag hanging from her upper lip—to plonk herself on her bed in front of me. The whites of her eyes grow wider, like I'm a small budget telenovela she can't tear her eyes from because the graphics are so lame. Then she snaps. Without raising her voice. Which is always worse.

"Get out. The woman of my life wouldn't talk to me like this."

The woman of my life. One of those French sayings of hers that used to make me swoon, but now sounds trite, corny, and—if I'm being honest with myself? —devastating in its implication of loss.

"The woman of my life wouldn't treat me the way you have!" I scream back. My body is heaving. Even from the doorway I feel like I'm towering over her as she stares up at me nonplussed, head bolstered by two greying cushions.

Silence. And then.

"Well let me know when you find her."

At this coup de grâce, I storm out of the flat and slam the front door, my heart in two at the prospect of a future in which I might inform her of a new partner. The indifference on her face is what hurts the most; my charade of abandonment has lost its novelty. Where once my default ammunition of leaving was a gun to the head, it's now little more than a papercut on Grey's pinky, yet I can't stop myself repeating the drama, to try and get her to feel some regret.

Pausing for breath on the landing— the way I have so many times before—I feel the red mist evaporate. My emotions do a headstand. I've left her again. A brief feeling of triumph, before I'm longing once more for what I've lost.

July 2018
Six months later

It's the hottest summer in England since 1976 and I haven't shut my bedroom window since I moved in with Sara a week ago. I can hear the clamour of artists setting up for soundcheck at Wireless Festival in Finsbury Park opposite our house, and England are in

the semi-finals of the World Cup for the first time in twenty-six years, creating an atmosphere of hope in my home city that's in direct opposition to my internal environment. There's no problem at all with my surroundings. The issue is the heavy brick of dread in my chest. Because no matter which environment you take yourself to, you always take yourself with you. And it's my perspective that needs to change.

I reach for my phone and press play on an audiobook by Eckhart Tolle with a casual urgency that can only be afforded on weekends. Plugging my ears with spiritual affirmations as soon as I open my eyes is the only way I can be sure I won't drown in despair before I've had the chance to get out of bed. I roll onto my side, sink my cheek into the pale blue of my pillow and revel in the luxury of a horizontal anxiety. It's Sunday and I have no plans.

"Life is a series of nows. The future never arrives," comes the sound of Tolle's hypnotic drawl.

It's July 23ʳᵈ, the day after Grey's birthday. I've jumped another hurdle: the last day of the age that tied her to me has passed. A new beginning. Something in today's energy feels good, and I can almost grasp it. Almost. Which is more than can be said for the past half year, most of which I've spent bed-bound and clinically depressed.

"You are the creator of your own reality", says Eckhart. I know this already, which is what makes my current situation all the more frustrating. After years of painstakingly building a stable launchpad for myself, I'd decided to smash all of my plates on the floor without warning like a guest at a Greek dinner party. Girlfriend. Career. Home. All gone.

COME BACK! I want to scream. *I DIDN'T KNOW WHAT I WAS DOING!*

Was it courage, or self-sabotage?

Sunlight pours through the window and onto my face like golden syrup onto porridge, as if I'm a collection of disparate flakes on my way to re-congealing with its help. It's likely I'd have made all these life-changing decisions eventually—our relation-

ship was toxic and I wanted to move out of my family home and start a creative career—but was now really the right time? In hindsight, it seems ridiculous that in the middle of a breakup, I'd pulled anchor on the only other points of the triangle that nailed my reality into place. What kind of person takes a giant leap into the unknown and leaves their whole life behind when what they need more than anything during heartbreak is familiarity to stabilise them? Why does a man one day wake up and abandon the wife and kids he dotes on, except to satisfy a midlife niggling within him? And is doing so ever worth it? The idea of regret is abhorrent. Regret is what I feel.

If I'd stayed put while I recovered from what I hadn't realised was a mental health crisis, I would have been back at work by now. Heartbroken still, but nothing a few bottles of red and the usual sarcastic digs from my work friends wouldn't fix in time. *If you feel this bad about a breakup*, my monkey-brain reasoned, *you may as well make ALL areas of your life impossible and tackle everything at once!*

Of course, making my life harder wasn't the intention. The method to my madness was to turn my greatest pain into my greatest revamp in order to regain balance. The usual self-improvements of dyeing my hair or going on a health kick wouldn't cut it this time; I'd done all those before with lesser loves. But I thought this girl was *It*, so once I'd thrown her away, the self-saboteur in me decided to chuck everything else in the bin, too. Clearly my life wasn't working for me. May as well start everything from scratch!

Devastated that I'd spontaneously decided to abandon my work family, who greeted me every day with a sardonic quip about my outfit [1] and immediately sweetened it with an offer to grab me a mocha from our local coffee shop, I'd moved in with

1. "Morning, Krusty the Clown. Or is it The Fresh Prince of Bel Air?"—my friend Megan asked wryly from behind her computer screen one morning as I entered the office in a green denim jacket, floral culottes and brown brogues.

Sara so I could maintain some semblance of normality. She was my office partner and living with her meant I could remain part of her everyday routine, get the gossip in the evening and kid myself that I still worked there, that nothing had changed. But I could barely make ends meet back when I was employed and living with my parents. How on Earth will I make rent now?

The initial adrenaline of my recent choices has long faded, leaving me to realise I've bitten off more than I can chew. I keep thinking of Marcella, the detective from the BBC drama who suffers from violent dissociative blackouts. It's been half a year and I can barely remember making my life-changing decisions from inside Dante's ninth circle of Hell. I can, however, imagine how awful it must have been for poor Marcella, blacking out and then coming round to realise she may have killed whoever or whatever she loved, when every morning I wake up and catch my breath, in a new home, with no girlfriend, no job, no money, an extremely steep hill to climb and absolutely none of the comfort that blanketed me throughout my early twenties, thinking: how the hell did I get here?

I keep Tolle's speech playing and rearrange myself so that I'm cross-legged on the duvet, typing into my laptop's Google search bar:

My life fell apart at 27.

I'm hoping this will be a sort of password, an open sesame that will grant me access to a group of people who have found themselves in a similar situation. My yearning for an astrological or spiritual explanation isn't too off base. Clicking on the first link, I notice—as it turns from navy to purple like a bruise already beginning to heal—a reference to the infamous 27 Club. Although I was twenty-six when I left Grey, I am now twenty-seven and after six months of emotional and mental illness, desperate for things to get better. And there I find what I am looking for: The Saturn Return. I am by no means an astrologer; I'm just looking for something to blame. I learn the following:

Saturn is the teacher planet. It takes roughly 29.5 years to circle

the Earth and has a wide, sweeping orbit, meaning its energies can be felt well into our 30s, often starting around age 27. The consequences of these energies are stern, showing no mercy if we've not learned the first quarter of our life's textbook by heart. By the time Saturn comes back to check how our lives have been going since it witnessed our birth—like a snooty invigilator roaming the exam hall to come peering over our shoulder when we least expect it—it better not catch us flunking, or cheating in the School of Life. Saturn has the authority to disqualify us, or if we're more fortunate, simply make us re-sit by forcing us to revisit past lessons we've failed to learn. Only this time, they may be harder to recognise, and come with harsher repercussions. This cycle of education will repeat until we finally learn what we've previously failed to, and graduate onto a healthier path that will bring us greater joy.

Judging by the way I'm coping, Saturn's clearly marked me as bottom of the bloody class, I think, shifting in my seat slightly, but fully engaged.

Saturn is strict on authenticity. It wants you to be yourself without exception. In order to do this, it shines a light on your fears, boundaries and limitations—anything holding you back from living up to your full potential. If you want to hazard a guess at what Saturn might have in store for its return to your natal chart, let your mind wander to the place it fears to tread. There may be something you avoid thinking about. Not spoken to your mother for two years because of an argument that hurt your ego, and pride is preventing you from reconciling? Saturn will see to that. Feeling sluggish every day because you can't kick your unhealthy diet and nicotine addiction? It will be Saturn who forces you to rectify if you haven't already made a start. If we do not heed Saturn's Return and have not been putting into practice the lessons life has been trying to teach us so far, it will make us question everything we thought we knew about ourselves. Upend our lives, yank us by the bootstraps and in my case, try to strangle me with them in the process.

Reading this for the first time does not shock me, in fact it's what I hoped for - a reason. But I'd be lying if I said I wasn't a little surprised. Clearly I've been living a blinkered existence. I had considered my life happy and purposeful, believing I was slowly making my way towards a dream future, like a tortoise racing no one but herself. And then whoosh. Saturn, the hare.

I don't want to end up in the 27 club and, although my lack of musical ability will likely render me safe from membership, there have been some close calls this past year through no one's fault but my own, through suicidal ideation. Plus, death isn't the only outcome of a difficult Saturn Return (thankfully, or thanklessly? I'm still at the stage in my recovery where I'm not entirely sure what's better). If we double down on our bad decisions during this period, we can stay stuck on our current path until the next Saturn Return in our late fifties/early sixties. Considering all the decisions I've made in the past that have amassed into my current agony, I conclude there are three areas of my life I need to work on: my love life, my career and my inconsistent financial independence. It's time to grow up.

Along with the dose of Vitamin D from today's sunshine, admitting this to myself makes me feel better about my decisions already. Maybe my pain is necessary, because the risks I've taken have led me so far out of my comfort zone that perhaps I've jumped in the right direction, but my nervous system just hasn't caught up yet. Maybe I've been driven by something deep and omniscient in my subconscious, startling myself awake for the first time in years.

For our lives to have meaning both for ourselves and the greater good, Saturn must do the work we've so far been unable to. It will reward us if we've stayed alert and learned our lessons. So if you are one of those individuals whose transition is seamless and you reach your thirties with no existential hiccups, then congratulations, you've had your head screwed on rather than repeating old patterns until the increasing implications force you to make a sharp U-turn. You may in fact find that your dreams come

true during this age, as your first Saturnian cycle completes and prepares you for the second. If you're like me, you'll be shunted into the second phase abruptly, the rug pulled from under your feet. Saturn doesn't want to punish us; it is just a tough lover.

Being able to place the responsibility of my nervous breakdown onto something universal and external—just so I can breathe for a moment, *please*—feels good.

A childlike lover of aesthetics, I can't complete my research on Saturn until I've found out more about its colours. The NASA Hubble Space Telescope provides images of Saturn in many rainbow tones. Its seven rings offer a fresco of my favourite pastel combinations. Learning that Saturn is clearly the prettiest planet—a haloed rainbow globe—I feel a childish sense of satisfaction this should be the one to educate me. With some quick maths, I calculate that there have been seven women in my life who have taught me valuable lessons. Lessons that, had I learned them, would probably permit me to be drinking cider in a pub garden with my friends right now while watching the football match, or listening to J Cole live from the comfort of our garden, rather than researching the galaxy alone in bed on the hottest day of the year while popping propranolol. I can relate each colour of Saturn's rings to the synaesthesia I've experienced with past lovers, where I associated each of them with the colour that most suited their personality and the shade of our respective relationships. It appears that Saturn came down to Earth as different women—like Zeus as a swan to Leda—to seduce me; the female embodiments of my seven Saturnian lessons. To shake me awake. Grey is the one who finally succeeded. It's up to me what to do next.

So with eyes closed, I listen to Tolle talk. He's slowly reminding me that I used to be happy. All I need is the receipt of one thought that will confirm the choices I've made were the right ones and hopefully rid me of regret. I don't just want to be told that things will be okay. I can't justify abandoning everything for

plain old vanilla. My future has to be magnificent or this will all have been for nothing.

"Whichever decision you make, is the right one. Own it and align with it."

Well, I have no choice. I've made my decisions. The canary tint of Summer is pressing on my eyelids.

So what next? I know I'm supposed to write. I have a visceral desire to immortalise the contents of my heart in red, buttery words. A more recent dream of mine has been to train as a hot yoga teacher, to fully explore and share the physical, emotional and spiritual benefits the practice has given me during my depression. I've signed up to a teacher training course which starts next month, primarily as a way of tricking myself out of bed, but ideally to also make my dreams a reality and forge a new career path for myself that I'm actually passionate about. But something is still missing, some synapses in my brain circuitry haven't yet reconnected, keeping me melded to my bed.

Writing has helped me before, but in the absence of motivation to write a novel or finish the screenplay I've been working on, if I can just get my story out of my body—give it form and somehow make sense of it—that will be something. It will be therapeutic to organise those black and white blocks of ecstasy and despair into a kind of inky Tetris, figure out my outstanding lessons by laying them out on paper, and learn them along the way. I will revisit specific experiences in my life which stand out to me as integral checkpoints for who I have become and why I have failed to succeed. At the centre of them all will be my relationship - as a lesbian - with women. I will attempt to untangle myself from my seven women of Saturn.

Why have I always been attracted to women who look like they will use my heart for pizza dough?

Why am I addicted to the chase of making emotionally unavailable women love me?

Why do I so often leave in a cloud of red or blue rage, before I myself am left?

Why do I seem to find it so much harder to recover from romantic rejection than my peers?

Why have I convinced myself I want second best?

If the story of my life and how I got here resonates with others, if it helps just one person to see that there is always an exit route from situational depression, then that will be the cherry on the cake. To crystallise what's held in these four chambers of my chest has always been a bucket list priority of mine anyway. So, there. Something to get started on.

This was the "A-ha" moment I had been waiting for, on the morning of 23RD July 2018. Writing this book, simply getting the words out onto the pages, was going to save my life. And it did.

PART

ONE

CHAPTER

1

O N THE 16TH June 1991 at 9.16pm, I am born three weeks premature at Hampstead's Royal Free Hospital, wearing rose-tinted glasses. According to the lady who draws my birth chart the next day, the time and date of my birth is no accident. All the digits are either one or nine, if you turn the sixes upside down, which apparently has something to do with beginnings and endings. Surely it can be argued that all the digits are either one or six if you turn the nines upside down. But true to the former, the first quarter of my life will reveal itself to be a succession of promising starts and disappointing finishes, particularly where romance is concerned.

My mum is twenty when I arrive into the world, my dad ten years her senior. They both work 9-5, mum as an accounts payable supervisor for a telecommunications company, dad as an in-house painter for a Central London hotel. Mum pulled many teenage stunts to make my dad hers, including but not limited to: holding an alarm clock out of her window when he lived next door with his then-girlfriend to disturb their Saturday lie-in (encouraged by her giggling best friend, my future Godmother), and throwing a vodka coke over him down the local. Something obviously worked because I was born, but unfortunately they part ways—as young lovers often do—when I am three years old. They remain on good terms and my dad is a consistent source of support and unconditional love. He takes me out each weekend and often comes over in the evenings once my mum has given me a bath, to tuck me into bed.

To soften the effects of the breakup, mum and I temporarily move out of our council house in Cricklewood, on Clitterhouse Road (a near literal signpost to my future sexual preference) and in with the family of her friend from work, located in the much swankier Totteridge & Whetstone. They have a son my age named Frankie and living with him makes every day feel like my birthday. As an adult, opening this distant doorway in my memory brings with it a welcoming rush of warmth, because Frankie's house is golden-tinged thanks to his parents' dimmer switch—a type of light I've never seen before—lending a fireside cosiness to our evenings. Our new home has an incessant familial hubbub and never-ending colours emanating from children's television, the remote of which Frankie and I have full control over. Anything is possible living here; it is the first physical location aside from my mum's chest that I associate with abundant comfort. Sunsets cast honey-coloured shadows on the foam alphabet playmat we sit on each evening while watching *Disney Singalong*, waiting for dinner to be served. My world is encased in a snow globe of safety and security in this house—the five of us preserved in a perfect freeze-frame where everything is magic and every moment is playtime. What more does a four-year-old want than to live with her buddy and their matching pink and blue Care Bears?

But after some time, mum naturally decides to date other men and as an attractive blonde in her early twenties, has multiple successes of varying lengths. Around the sixth month mark of her relationship with a redheaded man, we pack up my gilded life at Frankie's to move in with him. My memories of this living situation are hazier but involve a lot more grey and less gilt. A *Bump the Elephant* VHS keeps me company on a loop in an unfamiliar and toy-sparse sitting room, in addition to a bleak children's show with dark green and beige animals (where have the happy-ever-after colours gone?). There are no photos on the walls nor any vibrancy about the place at all. Mum spends a lot of time asking me if I've woken up on the wrong side of the bed, which I

think is stupid, because the other side is pushed against the wall, so I don't have much choice. The Redhead resents me. He has a toddler of his own who stayed with his ex, and he doesn't like the fact that he has me to contend with instead. *This* toddler wants to climb into bed with her mum all the time; an unwelcome slice of light cutting through the blackness of their bedroom each night as the door opens to reveal a four-year-old girl with large, brown eyes and a head of huge, blonde curls, standing there like something from a horror film. The Redhead's romanticised notion of leaving his family for a single mother is destroyed in one fell swoop. "A demon child", he calls me. He doesn't want to share my mother. Neither do I. But she was mine first, so there's no competition. The relationship doesn't last long.

So, here we are, four moves later, back at Clitterhouse Road without my dad, who has now moved out. We don't have much by way of material possessions, but I am spoiled with love. I don't know the meaning of the word "no," as, although we aren't wealthy *at all* (we don't own a dining table so we eat sitting on my playmat on the living room floor), most of what I ask for is attention, which mum gives in abundance. I am happy simply to be with her. But despite her outpourings of devotion and all the fun I had at Frankie's, my body registers the upheaval and instability of our moves in a way my mind cannot yet comprehend.

I wake up and blink a few times, eyes adjusting to the darkness. Realising I'm in mum's bedroom and not my own, I snap them open, startled by a flash of fluorescent yellow-green. I learned the word 'fluorescent' in school recently and despite feeling sore *everywhere*, am proud of myself for remembering it. The colours are coming from the high-vis boiler suits of two strangers standing to the right of my bed. I can't move or speak, so I scan the bed-

room without turning my head until I spot the strawberry blonde of my mum's hair in my periphery, recognising her palpable fear in a way only the child of a single mother is conditioned to. She sounds panicked, uttering incoherent concerns to the paramedics, so I roll onto my side to shield myself from her fear. The loud voices and bright colours make me wince. I'm lying in a giant wet patch—my own sweat—and mum is at once over me, wiping clammy strands of hair from my forehead before stripping me topless and scooping me into her arms. I nestle my face against her chest and close my eyes. The words are becoming clearer, although I don't understand what they mean: something about a *fever*, falling in and out of *consciousness*. *Mono*, they suspect, *exacerbated* by *stress*. All I want to do is go back to sleep, but mum keeps tapping my face to stop me. I am *not out of the woods yet* and *in danger of having a fit*, they say. I'm carried outside and taken in an ambulance, back to the hospital where I was born.

I can't stop crying for Best Bear. My paternal grandad gave him to me the day I was born and we are inseparable. When dad finds out I have to stay at the hospital overnight, he collects Best Bear from Clitterhouse Road and walks all the way to the Royal Free to bring him to me with a bottle of Robinsons' orange juice and a bunch of bananas. This hospital stay provides the first catalyst of worry that my parents will maintain throughout my life. They fumble through the highs and lows of parenthood admirably, like I'm their favourite toy, despite the fact they're no longer a couple and essentially still kids themselves. I already feel the purity of their love deeply—an imprint—I carry it with me everywhere, want to drown in the treacle of it. This is the first time I notice their separation because I can't remember another night we've spent this long together, just the three of us. I feel safe here, knowing I'm not only being taken care of by doctors and nurses, but because for once my mum and dad are in the same place because of me. And so I sleep intermittently that night, not wanting to miss a second of it, mum stroking my clammy forehead with her thumb. The following morning, she takes me to the hospital

crèche where I sit at a table laden with felt tip pens and set to work colouring in a giant clown's face while she visits with my doctors. I am just about to finish, filling the clown's perfectly round cheek with a juicy red and losing myself in the crimson circus, when she returns to tell me I've been discharged (glandular fever flare-up confirmed—triggered by anxiety). Before I have the chance to finish up, I'm led by the hand, out of the crèche with my drawing abandoned, pen lid decapitated from its blood red nib and left to bleed out on the table. The entire cab ride home I plead to go back so I can finish it. I beg and I beg and I cry and I cry, and for months I fail to let up, asking mum when we can go back *just* so I can finish colouring in the clown's cheek, *please*?

Of course, we never return. If only I'd concentrated more, coloured a little faster, maybe I could have completed our family picture and drawn us back together.

MUM IS BEHIND the wheel of a learner car, her ladylike fingers shaking over the gearstick. From the back seat, I watch the strange man beside her write something in his little pad. I hope whatever he writes is nice; it's only her first-time driving. I look down at the drawing in the notepad on my own lap. With my favourite pen, I scrawl a huge pink heart around my doodle of her bright yellow hair.

Mum has rented a big plastic bed in our spare room that will give her a suntan. She lies on it wearing a tiny pair of string goggles that look like they would fit Best Bear. "You okay Papa Smurf?" she asks before closes the lid, and I smile *yes* with all my milkteeth. I sit in the corner of the room until she's finished, under the bright blue light that spills through the gap in the machine. My Great Nana Dinner says I shouldn't come in here because it will make me need glasses when I'm older. But I don't want to be anywhere without mum.

Mum works late sometimes. Her own mum, my Nana Jenny, picks me up from school with a bag of penny sweets from Eddie's sweet

shop most days, but every Tuesday, mum's friends do it instead and take me back to their house. They are sisters, and I love it there because the younger one is nineteen and lets me watch her do her make up in her pink bedroom. Today I told them I needed a new dummy and they bought me one. It was a lie. I've never tried one before, and I'm four so I'm too old for them now. But all the cute kids in my class have them, and the adults give them more attention.

Mum doesn't feel very well. She has a headache because she's been doing washing all day and I was naughty earlier, but I'm scared it's a "brain-haemorrhage", because she's always worried about those. I don't know what "brain-haemorrhage" means but I know you can die from them because she keeps telling me so. She lies on the sofa for a nap and I wedge all the teddies from my bedroom underneath her blanket, her chin, her armpits. I know this will make her feel better because it always works when she does it for me. "Thank you, Papa" she says, stroking her thumb on my fore-arm. I hand her my second favourite toy to cuddle: two monkeys clinging to each other with magnetised paws.

Mum is crying in the kitchen because she thinks she doesn't have any friends. I know this isn't true because the ones who are sisters looked after me yesterday and bought me a dummy. Mum used to go to a place called "Ashton's" at night-time when my dad still lived with us. I thought Ashton was a man, and cried because I wanted to meet him, but she said it's just the name of a club. She says you lose your friends when you have a baby. I feel bad but I

still know it isn't true. I think she's really crying because she's done too much washing, and I haven't stopped talking.

Mum and I are on our way back from doing the Big Shop at Safeway. I'm not very good at carrying the bags because they are heavy and the handles make red grooves on the insides of my fingers, but I help her because she is so tired, and there's no one else to do it. "What are you thinking, Dolly Daydream?" she asks me in her tinkling voice, always one step ahead of me. "Mummy?" I respond, a beat later. "If you died in the street, I would simply NEVER climb off you."

Mum and I are watching *AI: Artificial Intelligence*. I am lying on top of her and our cheeks are smushed together. The little boy, David, makes a wish on the Blue Fairy for one more day with his mum and I hold mine tighter. Mine would never sell me to a robot the way David's did. When David wakes up the next morning a miracle has happened: his mum is in bed next to him, lit up by the sun. My face is wet but mum doesn't move from my tears. *Yes* I think, as they drip down her neck. *David is right. This is the One True Wish. The only one that matters.*

Mum and I are at a pub called The Production Village, eating lunch with my Godmother and the friends who are sisters. I take the straw of the disgusting Um Bongo out of my mouth and do

a big grin, shout "SEE MUMMY! YOU DO HAVE FRIENDS" across the table. I don't understand why everyone goes quiet. My Godmother laughs a little bit, pulls me onto her lap and changes the subject.

When we get home, mum slaps me on the bum, hard.
"Don't you EVER embarrass me like that again."

I am obsessed with women. Always have been. I believe this stems from the bond I have with my mother.

I am convinced women are the reason I was put on this Earth; that they are the meaning of life itself. No matter how much soul-searching I do, how deep I delve into my psyche or my childhood to resolve any trauma or my feelings on the subject, I simply don't see a purpose for me on this planet if it doesn't involve having a woman to revolve around. I doubt this will change. When I focus on a woman with love, she becomes a mirror to the best of me, and I am better myself. If she chooses to love me back—perfect! Although that's when things become tricky, because two people in love can just as easily become a mirror to the worst in each other.

Of course I do not mean that I fancy my mother (although as a four-year-old I do once beg her to French kiss me, but that's only because I don't know what French kissing is. She looks at me, appalled, probably wondering what the hell she has birthed), but even in the labour ward, I am reluctant to leave her body. God knows why I am premature (my Gemini twins duelling again, perhaps) but each time she crowns, I suck myself back inside her stomach - already regretting the decision to leave my sanguine bed - until the midwife forces me to face the world with three injections to the skull. As a teenager and even a young adult living

at home, I am overcome with melancholy bordering on guilt on occasions when I leave the house or stray far from my mum for too long. The rain amplifies these feelings, pouring into me an urge to rush home out of the wet and into the safety of her shadow. I will move out of home several times between the ages of eighteen and twenty-three, but always return under the guise of "saving money". I still crave the metaphorical umbilical cord. The strength of this connection is a beautiful thing. It does, however, give me an Achilles' heel: seeing women as a soft place to fall; the human embodiment of the security I felt in the womb. This can be a problem for lovers, as often it is not what they've signed up for.

There is nothing sordid about the conclusion that my early relationship with my mother has shaped my sexuality, in fact it has its own famous Freudian theory, the Oedipus/Electra Complex: that you become romantically attached to the parent of the opposite sex during the phallic stages of development (ages 3-6). This can be compounded if a child experiences trauma during this age, like I did with my parents' breakup, The Redhead, and my visit to the hospital.

At the time, I don't feel that any of these experiences are traumatic because being with my mum makes everything seem perfect and I have my rose tints firmly on. Later, I come to understand that certain decisions I make in adulthood are linked to these defining moments. With an absence of research on what the Oedipus and Electra complexes mean for non-hetero individuals, I will be left wondering if these complexes are typically misplaced in single parent homes. My mother is my everything. She speaks to me as a friend and an equal as soon as I learn to talk, I guess to have a sounding board— which is why I know scary words like "brain-haemorrhage". It must be lonely, raising a little girl when your toes are still grazing the tips of your own childhood. I am my mum's interactive diary, meaning I'm exposed to a lot of information that is inappropriate for a young child. I worry a lot, am highly strung, existentially anxious and will exhibit a bizarre dis-

play of obsessive compulsive disorder during later childhood that lasts well into my young adult years. Not being able to finish that blasted clown likely didn't help.

And yet, the part of the Oedipus/Electra Complex about displaying hostility towards the other parent because you see them as your competition, doesn't apply to me. As my parents are already separated, I don't have to vie for their time; I feel such love from both that I want for nothing. As an only child with two single parents, perhaps I have room to display both Oedipean and Electran qualities. I am quite spoiled, after all.

Each Sunday without fail my mum takes me to mass at St. Agnes' church, a routine she has adopted since I was born because I changed her life to such a degree that she ought to thank someone for it, and who better than God? After the service, we cross the road to the Trades Hall working man's club where my dad takes over duty of me. Most of the Cricklewood residents spend their Sabbath at the Trades Hall, including my Nana Jenny, who is partial to a brandy. Mum doesn't want to spend our only child free afternoon in a smoky club, but I am five now, so I'm allowed. My dad's mates have an English charm and old-school chivalry about them; rough diamonds with kind, twinkly eyes whose penchant for drinking doesn't get in the way of how they safeguard all women in their company. Dad always stops after his third Carlsberg. Sundays are our Father-Daughter day; my favourite of the week.

My face lights up when I see his pristine Reebok Classics and signature Fred Perry polo emerge from the door of the club. "Daddy!" I yell, running into his outstretched, tattooed arms. He scoops me up with a kiss ("Alright darlin'?") and I can smell the comforting scent of his aftershave as his whiskers scratch my cheek. I trace the tattoo on his neck with my finger.

"Eagle", he says. My dad is a man of few words, but that's okay because I can look at the drawings on his arms in silence for ages. They're like a comic book: Popeye on his bicep, a naked lady holding a banner reading "Death Before Dishonour", a heart

with the name "Mandy" (an ex-girlfriend) blacked out, a little green cartoon frog, the Grim Reaper wielding a scythe with the words "Who's Next?" above it. The Grim Reaper doesn't scare me, because he's painted on the man who'll protect me from anything. Years later, dad will add the final illustration to his skin: my name, written on his wrist in italics.

We say goodbye to my mum and head inside to begin our Sunday routine. Carlsberg for dad, a glass bottle of Coca Cola and packet of Bacon Fries for me. An Irish band are setting up around a large laminate dance floor and the place is heaving. My dad's friends are waiting in our regular nook in the back corner of the club with their wives, soaking beer coasters in Fosters until they are wet enough to fall apart in my curious fingers when I'll inevitably make a house of cards with them later. Nana Jenny is rouged up in her glad rags, sitting with her new boyfriend who is two decades her junior—and even weirder—one of my dad's mates. I run over to give her a cuddle and as I do, bony knees in her bonier lap, I lean over the table to take a discreet sip of orange Bacardi Breezer that belongs to the lady sitting next to her. The woman squints her eyes and nods her blonde crimped hair in assent the way she always does.

The band open their set with a rendition of *I Useta Lover* by The Saw Doctors and the older ladies gingerly get to their kitten-heeled feet, stockinged legs ready to twirl with their spider-veined husbands. The lady who runs the club opens a ruby red tin with a small silver key and walks up to her pedestal on stage. My dad gives me a fiver to buy some bingo tickets from her. "Ang on a minute, love!" Nana Jenny calls out before I scamper off. She places three pound-coins in my palm for her own tickets, with a couple of Juicy Fruit strips for my troubles. I love playing bingo. I've won so many times—even scored a Full House once—the winnings of which bought me a new bike. I spent the rest of that afternoon smoking candy cigarettes from Eddie's sweet shop to capitalise on evolving into a wealthy adult with her own vehicle.

Today, I won't win because I won't even play. When I get

back to the table with the paper slips bunched in my fist, I am distracted by the most handsome of dad's friends. His name is Gareth and he has a silver eyebrow ring with a tiny pink ball on it that I long to spin round like a bead on an abacus. Gareth looks like a cross between Phil & Grant Mitchell from *Eastenders* (which I watch with mum every weeknight) but much more handsome. My dad's friends all have bald heads, and these Sundays have developed in me a penchant for any Cockney geezer with a pastel-coloured Hackett shirt and a skull I can admire my reflection in.

"Alright mush?" Gareth says to me.

"I'm gonna marry you when I'm older!" I shout across a cover of *Take Me Home, Country Roads*, the music removing my already lacking inhibitions.

Gareth laughs, embarrassed. "Oi, Bob!" He says, "Come and get your daughter! Did you 'ear that?"

"I even have the dress! I'll show you!"

I am referring to my Christening dress.

Gareth doesn't quite know what to say to this, but luckily he doesn't need to, because the voice of the lady who runs the club is booming over the tannoy.

"All the twos, twenty two!"

"Quack quack", the room shouts back.

I may have an anomalous crush on Gareth, but what I truly crave is the attention of girls. This is different. I do not actively seek girls out the way I do my collection of "husbands" at school (which I rotate with every term), yet certain girls fall onto my path during something as inconsequential as assembly or Girl's Brigade and I find myself suddenly obsessed with them for no logical reason, like I've been smacked around the face with a kiss from the Angel

Gabriel, come to tell me I have been chosen to feel Love with a capital L in a way no mortal has before. I acknowledge that some of these girls I have feelings for are not what you would call conventionally "pretty" but it doesn't matter, something deep and visceral in my gut wants to be close to them anyway. With boys, the bond between us is irrelevant (as it should be when you are SINGLE DIGITS); it's all about their looks, popularity, and the façade of having a "boyfriend". But something about girls' energy genuinely enraptures me. I almost pee myself with excitement just to be standing in the same half of the netball court as them.

I'll always remember the musk of the green jacket Teresa wears as she spins me around in the playground. The highlight of my day is when Caley waits for me on the yellow line dividing the junior and infant playgrounds at lunch time. Layla is an Irish teenager with a beautiful, freckled face who I met down the Trades Hall and she becomes the main reason I love the Eric Clapton song. Siobhan is younger than me—rare considering my love for authority (which at this stage is judged only by whether someone has been visited by the tooth fairy). Zoe has yellow teeth and I write a poem about them for homework. Mum says this is rude, but I do it anyway. Nothing is embarrassing about the person you are blinkered by, and anyway, my rose-tints add a yellow tinge to white. Vicky lives in Nana Jenny's block of flats and is seven years older than me. She is thirteen when she first tells me I belong in a mental home, which of course makes me fall for her. Vicky has somehow procured a batch of newborn kittens which she keeps nestled beneath her clothes, meaning at any given time several baby fluffs will take it in turns to pop through the neck hole of her jumper to say hello. What's not to love? Nana Jenny will later say she had her suspicions that I liked girls ever since I came home from school one day, brandishing a card I'd made Vicky at lunch time when all Vicky did was tease me.

Lindsay is my "Big One" of primary school. Blonde notwithstanding (I prefer brunettes), she is just my type with her narrow, villainous glare and one hell of an attitude. She bullies me, which

is the way to my heart and means I sit in my bedroom making perfume for her all weekend. Surprisingly, Lindsay gracefully accepts this masochistic love potion. But once its effects wear off, the bullying starts again. Mum tells her off her at the school gates one day when I am particularly "distressed." She threatens to go to the headmistress if it doesn't stop. But I have a higher tolerance for distress than I thought. When she stops I miss the attention and antagonise her to bully me again.

My love for women in authority means my idolatry of teachers is on another level. I colour my hand in red felt-tip so that Breda, the nursery nurse, will think it is bleeding and give me more attention than the other kids (I'm noting a trend with red felt-tip and my childhood neuroses). My Year Four teacher, Miss Kelly, and I buy each other presents which leads me to believe we are in some kind of secret relationship. I fancy Miss Woolaghan too—she doesn't teach me, but I still write her a Christmas card: *You are my favourite, but don't tell Miss Doogan.* She comes into my class with the card and announces to my teacher, "I have a secret admirer in your class!" So much for confidentiality. I am mortified and don't speak to her ever again (i.e. she gets married and moves to Cumbria. I'd never spoken to her anyway, come to think of it).

As a treat, mum takes me to Camden Market instead of Wembley Market whenever I need a new school bag, and my stomach churns like a candyfloss machine as she leads me down the winding paths of street vendors and tarot tents. The scent of incense emanating from each stall does something to me; I imagine their owners to be voyagers, pirates and vagabonds —the illusion of romantic fantasy, selling their trinkets containing medieval secrets and exotic spells. A young woman with sharp eyes once winks at me as she offers me a sample of Bang Bang chicken. I feel a sharp pang of desire in my stomach at her offering and burst into tears. I want her to smother me, steal me away behind the folds of those mysterious hessian curtains and protect me from the underworld beyond them. This is a place of colour, magic, and danger. I know without a doubt there is nothing sexier in the world.

But of all these women, a particular vision stands out. It is a rare hot summer and I am in the backseat of a car pulling into the drive of my Godmother's house. On the side of the road stands a brunette in a red dress, suspended in the Tyndall effect of the sun, dust particles dancing around her like a galaxy. She is petite with quick, cunning eyes and porcelain skin, and looks like the personification of *Smooth* by Santana featuring Rob Thomas, a song I've heard repeatedly on the radio that makes me think of Spain, salsa, and obsessive love. This is the first glimpse of a woman I truly either want to be, or to have.

CHAPTER
3

"Fernie, I need to have a word with you."

Mum has taken me to The Production Village with her friends again. I am outside by the pond; feeding the ducks.

"Why mummy?" I turn to her, bag of crusts hanging loose in my fist.

"I'll tell you when we get home."

"But why? I want to know now!"

"I either tell you now and we have to go home, or you can wait until later."

This annoys me. *Why warn me now, then? Why don't YOU wait until we get home?*

But children aren't known for their patience, so I decide I want to skip the rest of the afternoon and leave the pub immediately to get the gossip on myself. This is the green light for mum to forget her initial plan and have her word with me then and there, right when one of the ducks is trying to chew my fist off.

"Is there anything you want to tell me, Fern?"

"No mummy?" I pull my fingers out of its squawking beak, terrified.

"A policeman told Nana Jenny he saw you putting sweets from Eddie's shop in your pockets. Do you have any idea what I'm talking about?" She smooths a hair behind my ear to soften the blow. I shake my head.

Deny, deny, deny. I know exactly what she is talking about but I am not ready for my life to be over. I am a criminal. I want absolutely everybody in the world to like me. The realisation that

these two things are at odds with each other makes me cry. She apologises to her friends and takes me home.

That night, tucking me into bed, I am softly reassured.

"You know, if there's anything you want to tell me, you can."

I met her with resolute silence. She is halfway down the stairs when I murmur timidly.

"Mummy?"

She crosses the landing back to my room and I lift my mattress without saying a word to reveal a treasure trove of stolen goods balanced on the bed frame underneath. She stifles a laugh, unsure whether this is appropriate, or if she should cry instead. Staring back at her are several dozen Fry's chocolate bars - melted and sweaty in their sealed packets; an assortment of children's books; multipacks of Cherry Drops; Daniel's Lypsyl (Daniel is my husband); pocketed from his school drawer, vows broken; my friend Sophie's unicorn necklace which I'd taken from her bedroom (sorry, Sophie, if you read this).

Years later, mum will tell me that the thing she found most remarkable was how none of the confectionery had been opened; I'd been too nervous to consume my contraband. This makes sense where Daniel and Sophie are concerned—clearly I can't parade around school with their belongings on my person—but all the chocolates have gone to waste, ageing like tiny minty corpses. What's the point?

Control, perhaps. What I do know is I can still smell the Lypsyl, Cherry Drops taste of guilt and even now, the song *Don't Speak* by No Doubt, which had been released around the time of my misdemeanour and was constantly playing on the radio, makes my stomach flip with anxiety. A kind of secret, dirty pleasure, and not just because it's such a sultry song.

To put the fear of God in me for thieving, the next morning mum takes me to St. Agnes' Church. I am frogmarched around the side of the building after Mass and thrust outside the front door of the cobbled vicarage where Father Maher, my favourite school priest,

lives. I gulp as I knock on the door, sorry for myself because I am wearing my Sunday Best which makes me feel vulnerable, like the misunderstood princess in a Disney film. Father Maher opens the door, ushers me in with a paternal smile and the cloud that has been building in my chest fills to the top, ready to burst. I can't bear how nice everyone is being to me when I don't deserve it. At the same time, I am devastated that in about ten seconds, once my sins have been confessed to God's spokesperson, no one will ever be this nice to me again.

I enter a small bleak room, the sole purpose of which seems to be to advertise how alone Father Maher is. It looks like an office, sitting room and kitchen all in one. Everything is singular, either neatly positioned or folded away. A lone chair by a small wooden desk with one plate in front of it. One mug, one fork, one knife, one spoon. A pyramid of sunlight pours through the only window in the room and I stand in it for a last-minute miracle, hoping it is sent by Jesus to save me. I can smell the Frankincense on Father's Maher's cassock.

Mum has already told him why we are there, it seems, as his big, kind face begins a rehearsed but empathetic speech... *"It is important to love thy neighbour, be a good Catholic citizen, do not take what doesn't belong to you..."* I'm trying to listen but am distracted by how underwhelming this home is for a messenger of God. I look around for any sign of golden trumpet, a blessed scroll... even a biscuit. But I feel better as soon as he stops speaking, even though I'm too worried to look at my mum for reassurance in case either of them change their mind about this gentle approach. I don't want the bubble to burst when I so desperately appreciate that Father Maher has treated me like the kid I am: confused, upset, and not to be tried as an adult.

But that's it. Within ten minutes, I am back out in the Sunday sun, my dignity intact, relieved that I can now enjoy the rest of the afternoon getting pissed on Coke in the Trades Hall across the road with my dad. I can see the beautiful Layla kicking some

stones around the car park while her brother's football rolls out into the road. I notice another twinge in my stomach.

But mum isn't done there. No Trades Hall for me today. Our next stop: Hendon Police Station.

How committed she is. We don't own a car. To spend a day on spontaneous bus rides so that your child doesn't succumb to a life of stealing, no matter how petty, is conscientious parenting. Of course, there is no need. I already feel like I've been judged by St. Peter at Heaven's gates and have *just* made it in by the skin of my teeth or an admin error. The news that my punishment isn't over makes me feel like I am falling down the escalators into Hell like Tom in my favourite *Tom & Jerry*'s episode: *Heavenly Puss*.

It's a hot day, and I walk for what feels like my whole life in the blazing sun, pleading with her not to do this to me. When we arrive at the police station, I'm asked to take a seat on another plastic chair in the waiting room. It's completely empty, and just as boring as Father Maher's house. Being a criminal is nowhere near as exciting as I expected. Mum heads to the glass partition to speak to a receptionist and when she goes off, a young officer is presented to us through a side door. His eyebrows see-saw when he sees me.

"But she's just a child?"

"I know", my mum says, trying not to second guess herself. "But if she carries on this way, she'll be an adult, and the conse-quences entirely different."

His eyebrows see-saw the other way as he considers this for a second, then decides his first conclusion was right: it's a waste of police time. Mum must be as relieved as I am because she looks like she is about to cry again. The officer mutters a sentence or two about being a good girl before disappearing behind a door to deal with something more important. This is finally enough crime and punishment for the both of us, because mum sits down next to me and smooths my hair once more. "I'll let you off this time, because I can tell you're sorry" she tells my tear-streaked chops, as if what the policeman had really wanted to do was feed me only

bread and water for the rest of my life. But I don't feel betrayed nor bitter, just grateful the ordeal is over.

Witnessing crime in both the council estate we live in at the time, and the ones she'd grown up in as a child, means my mum wants to nip any adherence to the stereotype of a single mother's child in the bud. Her own father was stabbed to death for petty theft outside The World's End in Camden when she was just five years old. Of course, the police hadn't really seen anything on CCTV. Nana Jenny was just confused as to why she kept finding random sweets in my pockets when she was the only person who took me to Eddie's on weekdays.

She needn't have worried. I will never steal so much as an ice pop again.

I am reformed for life.

CHAPTER
4

A ND SO, I become religious. I read the Bible. I start altar service, trailing behind Father Maher every Sunday in my robe, patiently awaiting the day my belt will be upgraded from the colour of sawdust to gold. My goal is to be the one who rings the bell after he announces "Let the Lord be with you" and the congregation responds "and also with you."

While I'm busy sprouting wings in an attempt to live up to my middle name (Angel), my OCD grows horns. It starts with a repetitive hand washing habit. I've been a clean freak since I was a baby; spreading my fingers wide and holding my palms away from the mess I inevitably made in my highchair each meal time. It's a natural progression.

As I get a little older, I start pinching my nose every few minutes, attempting to flatten what I am convinced are my huge nostrils. I develop a stress rash around the left side of my nose. When I eventually grow out of this habit I will be convinced it was all in my head, but looking back at photos of me aged ten, my nose is actually quite big—probably swollen from all the squeezing - a self-fulfilling prophecy.

I catastrophise constantly, dread any further instability and the prospect of losing my parents. By placing this responsibility onto external rituals, I can convince myself I am securing my family's eternal life as long as I touch every doorframe I walk through three times. My doom mentality is such that I once spend a sleepless night staring at the ceiling, convinced the S Club Juniors will hate me if they find out I've formed a dance troupe of my friends

and that we give fully choreographed performances of their hits during school assemblies because, instead of taking it as a compliment, they might think I am plagiarising them and trying to steal their fame.

Ever since I can remember, I've struggled to live in the present. I've also always been aware of it. It's an odd thing for a child to acknowledge. By six years old, I'd say around eighty percent of my life is experienced solely in my head. Whether this is an escape from my rocky early upbringing or just my broad imagination, I'm in a near permanent state of dissociation, seeing my life as something that will begin at some intangible point in the future and ignorant to the fact it's already happening. I believe my life will start, for example, on the first day of Year Three, once my mum has bought me the right denim jacket and electric blue blow-up backpack for school. When we go to Brent Cross to buy the bag and find it's sold out, I have an internal meltdown, knowing I'll now have to wait until the following September to "really be me". Instead, I spend the following year with part of my brain cordoned off and defunct, living only in my daydreams, a liminal doorway, prepping for the following school year when I can evolve into my final form. And so it continues, year in, year out, whenever the slightest thing doesn't go to plan. As a result, I am rarely prepared for my lessons and develop a reputation as a clumsy and scatty child. My teacher moves me to a desk facing the wall by myself for the last two terms, because I chat too much and distract my classmates. This would *never h*ave happened if I had the blow-up bag.

Whenever mum takes me on a trip during the school holidays, I waste my own experience by fantasising about how I will show my future children the same sights when I'm older, planning what they'll be wearing right down to their matching socks. I have no idea that the kids in my class meet up over the summer break, so every September I arrive back to school like a butterfly who has just spent a month and a half perfecting itself in its cocoon, ready to parade the brand-new version of myself about the place and

assuming no one else has seen each other either. I play only with those on my council estate who attend the neighbouring schools and otherwise am happy to stay home with my mum, taking thirty books out from the library at a time and stacking them on the arm of the sofa, barely moving until I've read them all. I prefer the life in my head and the written word much more to what I'm living. I feel I look too geeky and am not quite worthy of anything beautiful. This forms the base for the fantasist I become.

My alone time is my one stabilising force; it allows me to recalibrate and figure out how I feel about reality in comparison to my inner world. I become reliant on being alone, reassessing every social interaction I've had in order to work out how I feel about it, rewriting it in my head until it resembles the story I'd like best for the script of my life, where I am the coolest, the most beautiful, the best loved. The rest of the time, I'm barely grounded and rarely digest my own experiences as they are happening, rather I witness them from afar, box them up and muse over them at a later date in the comfort of my bedroom. You could see that as a waste of life, and I agree it would have been if it had continued into late adulthood. But I no longer see it that way, as this time spent exploring my imagination, honed my imagination and my love of reading and writing.

Whenever I notice myself dividing too much, I vow to stop. Young as I am, I'm self-centred enough to be self-aware. This is how I become fixated with clean, new beginnings. Birthdays, Back to School and New Year are my fixed, golden points in the calendar. I have a preoccupation with looking the part before I feel worthy enough to be present, so anything I buy with my pocket money or that is gifted to me is put away and stored until the next divine checkpoint arrives, and it is then that I can take it out and use it, start my life again, like a PlayStation game in which I'm given just three lives per year. Each time I begin a new level, I act as if I've just been born, convinced that every minor decision going forward will be of utmost importance to the outcome of my life trajectory (how thoroughly I brush my teeth, how I enunci-

ate each word), at the same time disregarding all the decisions I've made in the past like they are no longer consequential. January 1st, the start of September term and June 16TH therefore become my only anchors to the real world, the days I can sink my teeth into reality and move on without regressing back into my day-dreams. When each of these dates arrive, I come fully into alignment for a brief time, am joyful and at utter peace with myself. What I need, of course, is mindfulness. To squeeze every day for what it's worth. Not to discount a good day simply because my hair is frizzy and I don't like my nostrils. It will take until I'm twenty-one for me to grasp this.

MY MUM DESERVES a break. She is twenty-six now and has been saving—with the diligence of Scrooge at Christmas—for a holiday to visit my Godmother who moved to Melbourne three years ago. I've seen accounts in her ledger detailing budgets and every penny of expenditure from the years '94—'96, next to which I have tastefully graffitied my own contributions in pink felt tip pen:

TAX: 50P, RENT: 89P, Bill: €81, INNIT MAN WICKED.
(If only.)

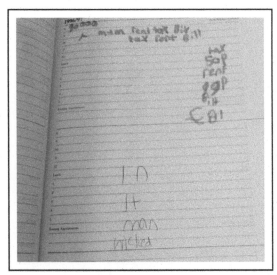

It appears I invented the euro.

We are on Bondi Beach when I first meet Pete. I don't remember how he got there—this apparition in red swim shorts—just that he was suddenly part of our group, running towards us with his shaved head and tanned, muscular physique like a character from *Baywatch*. I am smitten from the start. He's about my dad's age, much more handsome than Gareth, with teeth brighter than the halo of sun directly behind him. I spend much of the day on my back, knees bent and toes massaging the sand, holding a *Goosebumps* book directly over my face with my arms extended so I can read it without blinding myself. It also serves as a shield to gawp at him privately. A few feet away, my mum, Godmother and her husband are sitting on three patterned beach towels laid together like a giant Aladdin's carpet. Every so often I turn my head left to try and catch Pete's eye, but they are all too busy laughing to notice me. On the third attempt I get lucky and Pete tilts his head in my direction, sticking his tongue out at me with a wink. I giggle, place the book down like a tent on the sand and shield my eyes with my arm because I'm suddenly shy.

"Do you want to make a sandcastle, Fernie?" mum asks, shifting her seat and turning her legs towards me. I don't. But I do want to be nearer to Pete.

Pete helps me scoop the sand into the pink plastic bucket. I use my spade which is shaped like a starfish, he uses his hands. I don't look at him because his Hollywood smile is too much.

"Here, Fern, look at this" he whispers with his empathetic Australian twang, picking up a sandy black nugget with two fingers. "It's dog poo."

"EWWW!" I squeal, but I'm laughing.

"Watch this", he says.

He pushes himself up onto his feet and monkey crawls around behind my mum to where her flip flops are, placing it in the socket where her big toe should go. She doesn't notice, and he places a finger from his other hand over his lips to silence me. *I like this man*, I think, placing my own finger over my lips to show him I am loyal to him. That we now share a secret.

When we are packing up to head back to the car, I ask mum:

"Who's that man, mummy?"

"He's your Godmother's friend", she says. "He went travelling around the world with his brother, but now he lives in Australia too."

"Why do you act like you know him?"

"I do a little bit. He's originally from Clitterhouse."

This blows my tiny mind, meeting someone from our road on the other side of the world. He seems far too exotic for Cricklewood.

She stops in her tracks and wrinkles her nose.

"WHAT THE HELL IS THIS IN MY SHOE?" She yells. But she is laughing, too.

The next morning, we're sitting in the early morning sunshine of my Godmother's garden. I'm on Pete's lap, playfully pinching his neck for attention. He stayed over last night and is trying to enjoy his morning cup of tea. I'm making this as difficult as possible for him but to his credit, he humours me.

"Go on!" he encourages over the steam rising from his mug. "You can pinch harder than that!"

So I do.

"Is that the best you can do?" he goads.

Not wanting to fall short of his expectations, I give the skin of Pete's neck the full strength of my vice-like fingernails while laughing at our fun game. Having never been shouted at by my dad, nor any other man for that matter, what comes next scars me deeply.

"DON'T YOU EVER DO THAT AGAIN!"

I fall from his lap as this suddenly *alien* man yells and jumps up from his chair. There is a volleyball lodged in my chest; I can neither swallow nor look up at him. All I feel is alarm and embar-

rassment. How can he build my trust like that, only to betray me? Why is it okay for him to tell me to do something, then have a go at me for doing exactly that? I run inside and lock myself in the bathroom where I am safe to sob my heart out on the floor, and bellow for my mum to call my dad because I miss him.

I decide that to get this man back, I will simply hold a grudge for the rest of my life. I'd looked up to him like a superhero, thought he was beautiful and wanted him to love me—I'd even offered to smooth suncream across his broad, olive back that morning!—and he had squashed my spirit.

We have plans to go out for dinner that night, so for the rest of the day I refuse to acknowledge him; plan to meet him with a stony gaze the next attempt he makes to smile at me, which—considering how often he flashes those gnashers—is a guarantee. As predicted, he doesn't apologise (I guess, by a frustrating standard, I am the one who should apologise to him), but at the games arcade that evening he grins at me so genuinely from across the ice hockey table that my scowl melts and I can't help but return it. I'm immediately pissed off with my lack of resolve.

Mum cries the entire flight back home to England. I've been so wrapped up in my little crush and subsequent heartache that I hadn't realised that her and Pete had fallen in love. He'd only intended to visit for the weekend but ended up staying the entire three weeks of our trip, not—as I would have liked to believe—because of me, but for her. I cling to her arm through turbulence and twilight for twenty-three hours, hoping I can remind her I am the one she loves, that she doesn't need to cry because it's not me she has left behind. Through sobs she tells me she can barely wait until they are reunited.

This is sooner than I think, because within six months he has

cut his world travels short and is flying back home to live with us. I didn't realise my desire to hold a grudge for the rest of my life would actually be possible.

CHAPTER
6

I DEMAND MY entire class make Welcome Home cards for Pete on the day of his arrival in England.

Water now under the bridge, I'm almost as excited as my mum to have this novel man back in my house: to show off to him, take him on a tour of All My Things, to have a brand-new audience member for the most interesting show of all: My Life.

Our time in London picks up where it left off in Melbourne. We playfight often, something I know to prepare for as soon as he shouts, "LET'S GET READY TO RUMBLE!" from the kitchen, and I have three seconds to remove my glasses so that they don't get smashed or blind me in the scuffle. I feel none of the feelings of being left out that I had with The Redhead, as Pete actively involves me.

He throws us Christmas in the middle of Summer à la Down Under as soon as he arrives, with presents including a fridge, a microwave and other household items barely disguised in cheap, loose wrapping paper and decorated with tinsel so we can celebrate finally adding some decent furniture and appliances to our house (a project started by my dad's delivery of a low, wooden coffee table, left neatly in the middle of our living room as a surprise on our return from Australia. What a blessing, to have not one, but two good men in my life). Pete includes bubble wands and confetti streamers from the Pound Shop for me so that I can join in the fun.

He lets me ride on the back of his motorbike which I think is the *coolest thing in the world*, and as I grip the fabric round his

waist, leaning left and right each time he turns the corner like I'm in the games arcade, I'm interrupted by the muffled shout through his visor.

"You steer me like your dad!"

You know my dad? I think. And not only that, *He's been on the back of your motorbike?*

The following Sunday, down at the Trades Hall, I mention Pete's comment to my dad, gauging his reaction by the way he looks at me over his pint. My dad has heard my mum is dating Pete and isn't overjoyed about it. He tells me they were at opposite ends of the same friendship group as teens; not close enough to be best mates but friendly enough to have been on multiple group holidays and motorbike rides across foreign terrain.

"Remember who your dad is," he says softly with a short laugh, and a subtle nudge of the elbow.

"What do you mean, daddy?" I ask, and he picks up a Bacon Fry from the packet torn open between us.

"Nuffink", the word comes out muffled as he chews. "Just remember yeah?" He gives another short laugh. His eyes are twinkling, I can feel how much he loves me from what he's not saying, but I don't really understand. I just know I don't want to let him down.

It was the smallest exchange, objectively inconsequential, but this is where the shift occurs and I step into the second moral quandary of my life so far (the first being Holy poverty vs. a life of chocolatey crime). This one conversation is where all my loyalties suddenly fall accordingly into their chequerboard squares. My dad is my dad. My mum is mine, full stop. Pete—who once shouted at me for no good reason—I can now clearly see, is a usurper in my home, and despite looking and acting a bit like Joey from *Friends*, is not to be trusted. He is "other." I go home that night and everything changes. I refuse to speak to him, other than to answer "yes" or "no" or give the occasional grunt of acknowledgement. Playfighting is no longer on the cards.

Our relationship remains at a standstill for at least two years.

In retrospect it surprises me that such a casual comment from my dad would trigger such an extreme reaction within me, when I am absolutely appalling at holding grudges over petty things, despite my best efforts, particularly if the person in question keeps showing me they have a good heart. But I love my dad too much to disappoint him. My relationship with Pete improves when I reach adulthood but it takes years before we reach a place where we can talk together without a stifled, civil politeness - like he's my school teacher, a neighbour, or a family friend at a wedding - despite the fact we share a home. When I come home that day in my new suit of armour, he no longer knows how to act around me nor how to show affection in our easy playful way, because I block him at every turn. Deep down, I still know he is the kindest and greatest of all potential stepdads because he consistently shows it in his actions. He quizzes me every week on various trivia, geographical cities and currencies, and gives me pocket money if I get them all right in a "Moment of Truth" style game. Mum gets me a tutor to advance my learning when he notices my ability to retain information and express myself both verbally and on the page. The glasses I mentioned taking off during our playfights were thanks to him, because when my poor sight started to concern him, mum booked me into the opticians and I was diagnosed short-sighted. He teaches me to swim and ride a bike (I feel terribly guilty towards my dad about this). I'm a skinny child who has problems eating, but he is the only one who can bribe me to finish my spaghetti bolognaise with a fiver. He builds a bed out of MDF and bubble wrap for my Lovable Puppies. I appreciate all of this, but never tell him with more than a brief and embarrassed "thanks," not wanting to expose my vulnerability.

My mum is talented at drawing and once worked as a freelance muralist before reverting to a stable 9-5. Trying to find ways to keep her passion alive, she volunteers to teach a one-off art lesson at my school and surprisingly enjoys the teaching side of it so much that Pete encourages her to apply for a teaching course at university. He buys our council house and extends it, selling it

on until we can afford to upgrade to a two bed in Colindale. Suddenly, my life is a lot more comfortable. But I barely notice, because he's always in the way, blocking the view.

During my phase of trying to hate the man, my friend Sophie (still none-the-wiser to the whereabouts of her missing necklace) comes to mine for a school-night sleepover.

"Pete's got a Samurai Sword", I tell her that evening, leading her up to the bedroom they share while mum cooks dinner and Pete's in the garden shed, seeing to his motorbike. I watch her face to see whether she thinks this is cool, or scary. I don't know which I'd prefer. "Wow", she says, ambivalently. I don't know how to take this, and my blood boils a bit. If she thinks it's cool I want to prove her wrong. If she thinks it's scary, I'll want to defend him. So I just get on my knees and lift up the frilly peach valance of their bed to reveal the black eaves underneath. I can see rubies and emeralds glittering within the mound of Pete's freshly laundered pants where he keeps the sword like forgotten treasure. It gives me butterflies to know that Pete is the owner of this weapon—the same way the ladies in Camden Market did when I was a child—and I remember briefly his broad olive back. Resentment kicks in. I will never again let him make me feel the way I felt about him in Australia. I found the sword when I'd been rooting through his belongings looking for condoms and other things that would prove he was evil. The weapon confirmed this for me. But Sophie just thinks it's "wicked".

The next morning, while we're getting ready for school, Sophie bursts into my bedroom, shrill, nearly tripping over the inflatable pink armchair that takes up two thirds of my room, gasping, "Fern, look!"

Behind her is my mother, in a long satin nightdress, her strawberry blonde hair tumbling over her shoulders, face still lined and puffy from her pillow. She is shuffling from foot to foot in an excited half dance, and in her hand is a bridal catalogue. Another thing stolen from me. Sophie finds out, before I do, that my mum is getting married. To Pete. *My* Pete, who I saw first as he roamed

the sands of Melbourne's Brighton beach, is marrying *my* mum. *Mine*. The woman I love more than any other woman on the planet, whose heart I have heard beating from the inside of her body. From this moment, my childish crushes on men code blue and die. From this moment, I will try my hardest to prove that women can love *me* more than the men in their lives.

NOT ONE TO do things by halves, Pete arranges to marry my
mother—who deserves every lovely thing a man can offer
her—on a private beach in Florida which will double as a holiday
to Disney World for me. How selfish of him. There is a home
video of him waking me up on the morning of our flight (the wall-
paper next to my bed visibly peeled away from the wall by my con-
stantly anxious fingertips), singing "Don't stop, get out of bed, get
dressed and wash your head!" to the tune of S Club 7's *Don't Stop*.

"Get dressed and wash my head?" I retort, opening one eye.
"You are the most dumbest man I've ever seen."

"Thanks," he laughs awkwardly, turning the camera off.

Despite trying to humiliate him the moment I wake up, I'm
smiling. I can't help but like the man. He's lovely. But isn't being
lovely *my job*?

I enjoy the wedding day as much as any eight-year-old eating
cake on the beach can, but I still make it difficult for the both of
them. Beforehand, mum takes me to get my hair done in a profes-
sional salon for the first time. I hate wearing my hair up because I
think it makes me look too posh and British, and therefore ugly,
but I allow her this small mercy on her day. We are picked up by
limousine to the tune of *Bright Side of the Road* by Van Morri-
son. In the official wedding video (Pete's camcorder again), I can
be seen rolling my eyes while sucking a radioactive green lollipop
and burying my face in yet another *Goosebumps* book at the back
of the limo, convinced that anything R. L. Stein has to say is far
more interesting than being a bridesmaid on a beach in Orlando.

Most of the day involves me sulking while mum tucks her finger under my chin and lifts my face to the Florida sky, peppering it with kisses, laughing off my moods, refusing to acknowledge I'm always two seconds away from ruining her special day. Nana Jenny is the only other guest invited to the elopement and together we take a ferry to a private island. I find it difficult to walk in my repurposed Holy Communion dress and kid's heels, but the sand blisters my feet whenever I take them off, so I rotate irritably between barefoot and shod. When the priest holds his hands out to the heavens as he announces "You may now kiss the bride", I stand a little to the left, scowling at the sand. This moment, of course, becomes one of their official wedding photos (small victories). On the way back to the mainland, my mum has had enough of my sulking and leaves me in the charge of the photographer, Ginger, a young blonde lady who does her best to placate me by telling me my dad is still my dad (how vocal must I have been about my discontent?) and distracts me by teaching me the difference between "chips" and "crisps" down under.

I'm a pain in the balls. But thankfully there is someone else with us that day, cradled tightly beneath my mothers' wedding dress, about to sprout and make me a nicer person.

CHAPTER
8

I'VE WANTED A baby sister *forever*. When the pregnancy is announced, Nana Jenny and I are two years into an unspoken commitment of watching *Annie* each time she looks after me and I have cast Molly, the youngest orphan, as my dream sibling. The runt of the orphanage's litter with large chocolate pools for eyes, dark shaggy hair and a thick fringe, Molly is the perfect candidate. I envy Annie being the one Molly calls upon in the night when she wakes from a recurring nightmare about her parents abandoning her, struggling in her trussed-up bedsheets with a severe case of the sweats. *I know all about being abandoned by parents*, I think with irrational resentment, and would know just how to comfort her. It's as if the universe heard my request, because baby Taylor is born in the spring of the new Millennium, with a shock of black hair and puppy fat that reduces her eyes to slits.

We take Taylor home that same day and, crossing the threshold, I hang her tiny, star-flecked coat on the downstairs banister, white and soft as powder, declaring, "She's officially part of the family!" My stint as the baby of the house is over, and I'm okay with it.

How can I not be? With her half-moon eyes, petal plump lips and the rosacea that develops on her edible cheeks during the teething stage, I'm finally willing to share my glory with this *obviously* worthy creature. She is the cutest thing I've ever laid eyes on. I settle into sisterhood like a duck to water and calm down; no longer needing to fight for attention because not only do I understand why she should have all of it, but I give her the entirety of

my own. My solitary pursuits of reading from dawn till dusk fall by the wayside as I swap them for days spent trying to make my new little sister laugh; placing my jumper next to her while she sleeps so she can get used to my scent and repeating my name into her ear so it will be the first word she learns. It doesn't work. I try *Fernie* instead. The F is too hard for a pup with no teeth to pronounce. So, I drop the F, try *Ernie*. Taylor eventually settles on *Eddie*, and I am given a new name to compliment my new personality.

A few months after Taylor is born, my dad takes me on holiday to Spain with his new girlfriend and her children. I meet my future stepsiblings for the first time at Luton airport; a fifteen-year-old sister and a little brother, not yet two. I am stunned by the girl. She is cute as a button with a perfectly symmetrical face, freckles and a brunette Croydon facelift ponytail. Strikingly thin, she wears so many jewelled clown pendants around her neck (the 24 carat gold ones you'd find in the Argos catalogue back in the nineties) that I'm surprised she can stand up straight. I stare in awe as she walks into my life via the airport WHSmiths - almost dropping the copy of Mizz I've picked up— and the ruby gems of the clown's eyes in her necklace glare back at me with the threat of blood I will go on to look for in every woman. The purple/yellow/purple/yellow/purple of her nail polish confirm my hypothesis: she is the coolest person I've ever met. Naturally, I stay by my dad's side and barely speak to her, considering myself majorly nerdy by comparison with my mousey, frizzy hair and glasses. Next to her mini tennis dress, my navy bootcut jeans, GAP fleece and Nike Cortezs are humiliating.

She has brought her friend along for the trip and, through them, I learn first-hand about rudegirls. I long to be one myself, with their resting bitch faces, do-not-cross-me attitudes and interest in garage, reggae, and R&B. I realise this is a whole genre I have always fancied around my estate and just never known the name for. I like that they wear tracksuits with huge hoop earrings.

"*The bigger the hoop, the bigger the hoe,*" they laugh with self-

deprecation on the shuttle bus to our gate. I do not say a word. Nor do I care when I hear our flight is delayed, as I'm in celebrity company. The three of us stroll around Duty Free for an hour and, having been assigned to them, I am permitted to become cool by proxy, like a fan who has won a competition to go shopping with her favourite girl band. My shiny new sister buys me my first cassette tape: *Angel* by Shaggy, to go with the Walkman my future stepmum buys me to placate me throughout the delay. I listen to it on repeat while the rest of our troop naps and lounges on the airport benches, closing my eyes to feign sleep while transmorphing the freckled beauty that is my new big sister into my own angel. "Closer than my peeps you are to me," I sing along in agreement—this qualification justified, seeing as I've now known her for a grand total of an hour and a half.

I pick my bikini bottoms out of the cleft of my butt cheeks and a bulk of wet sand plonks itself in the bowl of the toilet. I've spent all day in the complex swimming pool with a new friend but the remnants of our beach day are still itching my backside. As I open the toilet door to wash my hands, my new big sister is standing by the sinks in a two-piece bikini. Embarrassed that she heard the sand in the toilet, I try to hide the fact I'm blushing as I turn on the tap and cool my wrists under the cold water.

"You been for a number two since you been here?" she asks, teenage and blunt.

"Ha." I laugh, nervously. This is my go-to response that the friends of my holiday romance, Chad, mock me for, when I repeatedly offer it up as my answer to "Do you want to kiss him?" in the giant sandpit they use as a football pitch.

"Have you?" She repeats. "Mum told me to ask you."

"No!" I object, like that's the only obvious answer. I dry my hands and exit quickly to end the conversation.

Alas, this turns it into a full-blown discussion about my gut health over the dinner table that night because my stepmum is worried the flight has dehydrated me and interfered with my digestion. *Please don't embarrass me and blow my chances of my new sister letting me hang out with her*, my intestines scream, humiliation the only thing irritating them. They get a battering anyway, as the girls spend the next ten days drinking blue WKDs and offering me secret sips through a straw. The rest of their time is spent saying things like "buff" and "butters" and flirting with boys. They are both successful in this respect; my stepsister so much so that she ends up in a long-term relationship with the guy she meets on this very holiday, with my step-niece and nephew to show for it. I understand her power over these boys, as she has me under a spell myself.

When I return to England, I graffiti my stepsister's phone number on a few tables at the Trades Hall. My dad has "a word" with me for vandalism and invasion of privacy. Shame is becoming an increasingly familiar feeling. Not that *I* think I'm weird—in my opinion it is perfectly normal to love such majestic, knife-edge girls so intensely. I deem it a charitable act for me to make her phone number public, so that everyone can text her to find out for themselves.

CHAPTER
9

Thanks to my mum, my stepdad, and the gold star sticker books my Nana Dinner's makes me complete when she looks after me, my tutoring pays off. I pass the entrance exam for St. Michael's Catholic Grammar School in North Finchley, where I absolutely do not want to go, and am invited for an interview with the headmistress. Most of my friends have applied for La Sainte Union in Camden, which my mum has put down as my fourth choice, after Henrietta Barnett and Copthall, and before St. James'. I'm desperate to follow suit and join my primary school friends at LSU, but despite myself, I wait empty-handed in the foyer of St. Michael's next to a prim-looking goody two shoes holding a folder chockablock with certificates. I dislike when teacher's pets use academia to gain clout as opposed to my method of schoolboy charm and charisma, but am interrupted from my reverie of disgust by the echo of a voice calling my name down a long walkway which I will come to know as the Forbidden Corridor. I enter with my mum, to be told that out of the 96 girls they can accept that year, I came 36th in the test results. My mum cries with pride, knowing this is the pivotal moment in which I will be given a better chance at life than her, Nana Jenny, and Nana Dinner combined. I run out of the building and hide behind a parked car. Nana Jenny eventually coaxes me out from under the bonnet by promising me a congratulations gift (which, now I come to think of it, I never received).

If my relationship with my mother had me leaning towards a life-

time of loving women, attending an all-girls' school is the nail in my rainbow coffin. I start my first day looking like a grape Jolly Rancher in the violet uniform that has us dubbed "The Purple Virgins" throughout North London. Our school rules are ridiculous. Aside from the Catholic typicals of not being allowed to wear our skirts above our knees, we are given measurements for the diameter of our ear studs. In my first week, I hear through the grapevine that horizontal stripes are forbidden on the clothes of sixth-formers and teachers alike because apparently this symbolises homosexuality. So, there I am, oblivious to my gayness and drowning in a blazer two sizes too big for me because our uniform is from Harrods and therefore expensive, so it's in our parents' best interests to buy a size that will last us the entire five years of secondary education. My naturally curly hair is brushed into a ponytail (big mistake, I have not yet discovered hair straighteners or the process of scrunching with mousse, meaning it is always frizzy) and the frames of my glasses make Harry Potter look like Regina George.

I am number two in the alphabetical register and an Italian girl named Jess is number one. Jess is a cool kid—this is obvious immediately—she has three older siblings who all watch Nickelodeon and listen to Usher, two things I know nothing about. Jess asks me what my hobbies are and I answer "reading and writing stories," thinking every Grammar School student would be expecting this answer; when in fact I'd just broken the first rule of how to be cool in 2002. She'll tell me years later that her first impression of me was "Oh great, I'm stuck next to a geek"—but martyr that she is, Jess gives me a chance and we become close friends. Throughout our time at this indigo institution, our friendship group steadily expands to include numbers 3, 5, 6, 7, 8, 12, 14, 18, 20, 21 & 22 in the register. By final year, we have labelled ourselves loosely as "The Twelve" (because by this point, number 4 has left).

Number 4 is a wild card. Before being removed from the

school in Year 11, she is, at best, antagonising but wet-yourself hilarious. At worst, she is a bully. She gets off on scaring me with the alleged statistics on gays, jeering to our friendship group, "Apparently one out of four people turn out to be gay. It's definitely going to be Fern." Whether this is said to my face masked as a harmless joke, or bitched behind my back, depends on whether I'm in her good or bad books that week. I have no idea of the truth in that statistic but *Oh my God*, I think. *What if it is me?* My friends seem to have accepted my fate before I'd even considered it. This keeps me up at night, cartwheeling round my mind as the article I've cut out from Sugar magazine about "knowing the signs of being attracted to the same sex" lies folded on my bedside table, the print faded from the amount of times I've opened and closed it to convince myself I am gay, then straight, then gay again; a nightmare carousel of terror and despair.

The reason number 4 thinks *I* am the lesbian in our group is obvious to everyone but me. I am obsessed with a girl in the year above me—and having been proud of my sisterly obsessions in primary school because I am oblivious to what they really mean—do nothing to hide it.

It starts when the girl pushes a man aside one afternoon as he tries to get on the bus before my friends and I. We stand aside, gawping like a shoal of mauve fish as she gives him a dressing down for being a full-grown man shoving a pack of kids. She is only thirteen herself, but extremely tall for her age and the man retreats silently, successfully embarrassed by this young adolescent. The girl then ushers us onto the bus without a smile nor a backwards glance before sitting down with her mates at the back of the top deck. The way she came to our rescue then ignored us gives her authority in my eyes and makes me swoon. With my liking for aloof types, I quickly become obsessed. Each moment intended for learning is instead spent assessing the girl's whereabouts, ensuring we are conveniently in the same place at the same time so I can get my fix of a hug, or in most cases, just a "Hey!" If I don't obtain this interaction I'll be on a comedown, unable to

concentrate until the next time I catch sight of her in the corridor. I'm attracted to those who are hard to please because I like the idea of winning them over, like I felt I had to with my stepdad and the way I failed to with The Redhead. The moment someone makes me feel special and gives me a brief window into the possibility that they will treat me better than the average person in their life, I become hooked on making that possibility a reality. And so I become a complete addict. She is my first thought in the morning and my last thought at night, and being in the throes of puberty, this is my first real, all-consuming infatuation. I even cry at the prospect of not being loved by her in return while gazing out of my bedroom window listening to *Another Day* from Lemar's *Dedicated* album. "I don't wanna live another day without you by my side, I don't wanna run any more, running out of places to hide..." It's such a hilarious picture, you could almost forget I hadn't lived a day with her by my side in the first place.

The turning point in my realisation of what this obsession really means hits me one lunchtime like a brick in the face. The girl stops in the doorway of my classroom to seek out someone who isn't me, her hands on each side of the door frame and her Amazonian height filling the space. My eyes have barely registered her when my heart jumps so hard I feel like I've been whacked in the chest.

Why has my body reacted this way before my mind has even identified who was standing there?

This is the first time I recognise the role the human heart physically plays in attraction; where I acknowledge it as a separate animal from my mind and notice I have no control over whom my body chemically responds to. That afternoon, I bunk off PE to sit in the medical room in silence, staring at my lap and faking physical illness, though I'm definitely emotionally disturbed. I feel like my life has halted. *Why did my heart do that? Judas!* And then *Maybe I AM gay?* The school nurse calls my mum and she arrives to take me home early. In the shower that evening, I bawl my eyes out until water and tears are indistinguishable. Mum hears me

sobbing in the bathroom, still wrapped in a towel because I am too dejected to dry myself. She knocks. I unlock the door and my mouth, can hold it in no longer.

"I think I'm a lesbian!"

Sitting on the side of the bath and pulling me into her arms, without needing further context, she calmly asks me:

"Have you had sexual thoughts about girls? Or do you just want to cuddle them?"

I think about it for a moment between sobs. As I'm only fourteen, I truly only want to be around them, to love them; have them love me back.

"Just cuddle them," I decide quietly, not without relief.

My answer manages to convince us both that this is just a phase. I get back in the closet and stay there for another four years.

A year after the phase with this girl starts, it fades overnight as quick as it arrived. I grow tired of stoking the fire alone. But in the following years at St. Michael's, I develop two meaningful infatuations within the same month, both of which have lasting impacts on my life.

Black —The First Woman

"MY NAME IS Miss White, and I am NOT a lesbian psycho bitch!"

I am fourteen and getting changed for PE. Inches below the heaving throng of lilac shirts held above the torsos of my classmates undressing from their uniforms, comes a yell from the tiny stranger who strides into our changing room and slams her register down on the bench.

This introduction is naturally recycled around the school for weeks afterwards. Miss White is our new PE teacher and she is determined to put a stop to the lesbian stereotype early on. For the first time in the history of St. Michael's physical education, our teacher is not only admitting that homosexuality exists by denouncing her involvement with it, but she is actually going to make us exercise. We are asked to bring in our own deodorant wipes, which she will sign as acknowledgement of receipt, because "teenagers stink." We can't be bothered. This rule stinks.

Miss White is twenty-seven years old with a strong physique, banana boat smile and huge, eager eyes that are always sparkling; willing you to become the best version of yourself (when they aren't glaring at you furiously because you've forgotten your wipes). She has a smattering of freckles when the sun hits right, and is very pretty—pretty to my heart, too—which is to say she looks familiar. My classmates kick their shoes under the bench and bustle into the hall at Miss White's command. I follow.

"I recognise you," she says with a sideways glance as I squeeze past her in the corridor. We accidentally nudge shoulders and I can't help but notice that she smells *incredible*, like a particular strain of Nag Champa mixed with washing powder. Lightyears away, two universal filaments spark awake and frazzle at their tips, inch closer, fuse. A porthole closes.

That's odd. I think. *Me too.* Something about her feels homely, and safe.

"I recognise you too, actually!" I respond, not necessarily meaning her face, but that there is something in her energy I feel positively familiar with.

She reels off a list of places we could have crossed paths, but ultimately we draw a blank.

"Perhaps it was in another life!" she concludes, satisfied.

I beam, and pile into the hall with the rest of my classmates.

Miss White is a breath of fresh air to the PE department. All we've had before her is a conveyor belt of substitutes, for some reason all Australian. She introduces dance to the curriculum, which is exciting—for me at least—because I've recently taken up ballet again for the first time since I was a toddler and have rediscovered my passion for dance. But other than a general liking for her after our instant recognition of each other, I don't give her much thought. I do get embarrassed when she catches me in concentration mode, though.

"Well done!" she encourages during our Fosse class when I stop in the middle of a choreography to *All That Jazz* because I've forgotten the moves; plastic cane and glittery paper hat looking ridiculously out of place on my awkward, teenage frame. I look up and see Black, a popular girl from the year above, walking past the open doors to the school hall. I shrivel, not only from Miss

White's attention, but knowing Black has seen me in this embarrassing costume. She is the ONLY girl at school that I don't like. Not only does she carry natural intimidation by proxy of being in the year above, but she wears a permanent screwface that keeps me from going anywhere near her. Considering our school is quite small, this is something that at times I have to actively avoid.

The next day at lunchtime my class and I are back in the school hall, practicing a different routine for our dance show at The Arts Depot—the first of what Miss White hopes to make an annual tradition. We've been left to our own devices and most of the class are marking the moves half-heartedly, making the most of this rare opportunity to gossip unchaperoned. But then Miss White storms in, yelling, at least eight miniature buns on her head like Björk.

"ER, LADIES!" Her cheeky features are furrowed, Little My woken from her winter hibernation.

"WHAT do you think you're doing?! I am TRUSTING you to practice alone, show me some RESPECT and stop behaving like children!"

For all her warmth, she does not suffer fools and her face blooms pink with anger. She switches off the music with a harsh jab of the thumb and marches straight over to me, parting the lycra-clad class like the red sea. I wait for my punishment, even though I've been rehearsing diligently the whole time. As a chatterbox, I am used to being punished as the ringleader even when it isn't me.

But what comes next isn't a reprimand. She lowers her voice as she walks towards me, keys swinging lightly by her side.

"Hi!" She says, her smile melting the former expression from her face as if a storm has just blown the last thirty seconds away and she's forgotten all about it.

"Can I ask you a favour? How do you feel about stepping in on a dance performed by the year above? Someone has dropped out and they need a replacement. You up for it?"

She signals roughly in the direction of a group of Year Eleven

girls filing into the adjacent changing rooms, getting ready for their turn at rehearsal. She points to one girl in particular. "*She'll* teach you the choreography."

I crane my neck to see who she's pointing at. *For God's sake.* It's Black. I hesitate. If I agree to this I'm going to have to talk directly to the girl I don't like and address her by her name—a name which holds too much social power for the likes of me to utter it. Not wanting to let Miss White down (judging by our first interaction, I presume I've signed a soul contract with her in another life and probably owe her one), I nod. When the Year 11s file into the hall from the changing rooms, I approach Black with faux confidence. She is bent down tying her jazz shoes, long black curls shielding her face, her mates crowded around her. I launch straight in.

"Hey! Apparently I'm part of your dance now... I'm filling in for someone?" I look down at her, buoyed by the brief superiority I feel while she's below me on the floor. I don't want to give her the chance to reject me. "Miss White has asked if you will teach me the choreography."

Black looks up and processes my question, blinks a little and nods.

"Heyyyyy." She says, as though actually responding to me is an afterthought.

Then she smiles. "Oh, okay!"

I'm relieved to find she's alright. Quite friendly, actually. When the bell signals the end of lunch time, Black tells me I've picked up the choreography quickly and that she finds me cute. The next day, I pass her in the teacher's carpark between lessons and she screeches "Love you!" then blows me a kiss.[2]

She *loves* me? I deduce that actually, she's indirectly letting me and everyone in earshot know that I am now hers; from this moment on she has dominion over me, which may one day extend to my entire group of friends of even year group, depending on how close we become and how much gossip I deign to tell her. Popularity and insight is currency at our age. Regardless, I'm

ecstatic. When a girl gives off the impression of hating the general public yet shows a particular interest in me, I become hooked. Black's austerity melts and a switch has flipped. From this moment on, I scrabble for her iridescent attention, relishing that someone so exclusive told me she loves me after one day.

Black soon takes the place of the girl who stood up for my friends and I on the bus. Only this time, it's reciprocated—albeit for a different reason: Black sees me like a little sister. She visits me on morning breaks and at lunch times when she's bored, barging into my form room and sitting on the lip of my wooden desk, dedicated to her new role as my overprotective sibling and demanding to know everything about my life. In return she tells me all about the boys she fancies, the teachers she hates, the students she "can't stand." With a 75% / 25% effort on my part admittedly, we grow thick as thieves. Black is happy to go along with the friendship I generate and laps up all the attention I give her. I go out of my way to do thoughtful things for her, like sticking a lit candle in a radioactive blue jellybean muffin and waiting outside her form room to surprise her on her birthday. She reciprocates the bond by looking out for me at school.

Our nights are spent chatting on MSN where I learn the ins and outs of each kiss and tiff with her latest love interest. Having the same inclination towards oversharing as me, she copies and pastes entire online conversations between her and whichever boy she is seeing at the time, for me to dissect and give my opinion on the following day. Not only do I become entirely up to date with everything going on in her personal life (eventually to a degree more than her closest group of friends, as I have all the time in

2. Years later Black says she found me cute straight away, in a young, scruffy way and was surprised I was more likeable than she first assumed. "Who is this confident BRUV", she confessed to me later down the line of our friendship, "who stands on the back of her loafers, always has one jumper sleeve hanging off her shoulder and is so confident jamming with the older girls? That's what I used to think about you."

the world for it) but I learn what makes her tick in a romantic relationship, how to win her over and what pisses her off. As an undercover third wheel, I am training on the job for loving her better than anyone else. Black is straight and I know not to over-step any boundaries—not that I want to anyway. I'm not sexually active, haven't had my first kiss and am still unsure about sexuality. All I know is I want to be the person she loves most in the world, and in return love *her* more than anyone else—in whatever capac-ity.

I can't pinpoint exactly what it is about Black that I like, aside from the fact she has thawed around me. Like the rest of the girls around whom I've been a satellite, there's just something ineffa-ble about her. I have no idea how we are friends, aside from the fact I won't have it any other way, and Black is easy-going enough to make it happen. We are total opposites moving in completely different social circles, yet before I've even explored her personal-ity I am already committed to having this girl play a starring role in my life. It's like I'm chomping at the bit to sign a contract I haven't read. Many express confusion at our new unlikely pairing, as Black doesn't let just anyone in her group. I start to bunk my free periods in favour of spending time with her and her mates, eventually becoming a solid member of their friendship group too.

She soon takes the final spot on my Myspace Top 8, which is digital currency for millennial friendships. Our friendship is solid enough that I can include her without being mocked by her main friendship group, but I keep her eighth so that my own friends don't think I'm prioritising a whimsical crush over them (they're still trying to convince me I'm a lesbian). I also don't want to move her any higher in case *she'll* think I'm a lesbian too. I needn't have worried, because in no time at all she's also made me number eight on hers. Bolstered by the reciprocity, I immediately move her to first place, where she truly belongs. I'm quite anxious for people to notice this, but no one does except Black herself.

"LOVE YOUUUUUUUUUU!" she screeches again the

next morning, pulling me into a bear hug in the school car park. This is the best reaction I could have hoped for. I am proud of her shining gold medal on my page, my blue tick before blue ticks were invented. I don't mind in the least that I remain in eighth position on hers. My joy is in her reaction, that she should know how important she is to me. But inside, I'm still a little insecure that she's privately interpreted this move as *gay*.

The next Saturday, my friends and I are at Anna (Number 21)'s house for a sleepover. We are sprawled across sofas and floorboards in her TV room in various states of disarray, heads on each other's laps and legs draped across each other's torsos, tangled up in shared adolescence while watching *Eternal Sunshine of the Spotless Mind*. I am preoccupied with my phone because I've heard of a HTML code you can use to view someone's MySpace Top 8 if they have hidden it. You see, only days after I made Black number one, she hid the visibility of her own Top 8. This could have been for aesthetic reasons—MySpace profiles were an extension of ourselves and we would spend hours making them as pretty and minimalistic as possible — but I'm paranoid she thinks I'm a lesbian and is retrospectively freaked out that I've made her my number one. What if she's removed me and wants to spare my feelings?

I enter the code into Black's MySpace URL, oblivious to the girls' chatter and the arguments of Clementine and Joel from *Eternal Sunshine* ricocheting round the room. I press enter and hold my breath, hoping against hope that I'm still included. As the pixels load, my eyes hover patiently upon the blank spot underneath position 8. The profile picture appears and it isn't mine any more. A lump catches in my throat. Anna and the girls have fallen silent as if holding their collective breath for me, but really their eyes are fixed on Joel spotting Clementine for the first time on their train back from Montauk. He stares at her as she pours a shot of liquor into her coffee, promptly writing into his diary as he narrates aloud:

Why do I fall in love with every woman who shows me the least bit of attention?

Meanwhile, adrenaline has paralysed me. My eyes snake backwards through the positions to find myself, upgraded perhaps?

7, 6, 5, 4....None of them are me.

Surely she can't have removed me completely? I wasn't expecting her to be *that* ashamed? My mind flashes through every interaction we've ever had as though I'm hurtling towards the light via a tunnel on my deathbed-

...3, 2...

She talks to me all the time! She can't be that much of an actress to fake all the "love yous", surely?

And then *bam*. There I am. Number 1.

I'm validated; our friendship is genuine. She didn't put me there to flatter me, because her grid isn't visible to anyone but herself. My throat prickles with gratitude and my eyes fill a little with tears. I wipe them away quickly with my sleeve to avoid any questions, because Anna is already eyeing me sideways for not paying attention to the film. Any tiny, fractured thoughts I'd quietened throughout my friendship with Black at once dissipate and any tension I didn't know I was carrying slides off my shoulders like the weight of a century. The purity of love I feel for Black is overwhelming now I know it's mutual, so strong that I rest my phone—that glorious brick of good news—on my chest, close my eyes, drunk on teenage emotion.

I fall asleep from the exhaustion of the saga. When I wake forty minutes later, it's to a pale plum sky, the yawns and stretches of the girls, and Joel in love with Clementine.

I could die right now, Clem. I'm just... happy. I've never felt that before. I'm just exactly where I want to be.

The piano keys of *Everybody's Gotta Learn Sometime* by Beck tinkle softly round the room as the closing credits roll, delicately stirring me from a second sleep, piercing my body until happiness rises out of me like a kind of condensation. There are two seconds of blissful mindlessness before I fully wake, where I know I'm the

happiest I've ever been but am unable to remember why. Then it hits me: *Black loves me just as much as I love her.* It's the first time since I was a child that reality has been kinder to me than my sleep. This is a peace I've felt since but never before. I imagine it's the same feeling as when you die and go to heaven or wake up in the morning next to the person you love. Both *Eternal Sunshine* and its soundtrack fuse themselves with my memory of this moment, as I decide—despite having fallen asleep before the end—that this is now my favourite film, and I want Beck to be played at my funeral, to mark the only other time I will feel such unadulterated joy again, once the DMT floods my brain and my eyes close to this world forever.

After this night, the proof is in the pudding. Black and I are best friends. She confirms it to my face like there was never any question, because unlike for me, there is no ulterior motive for her to doubt it.

CHAPTER
11

M Y GCSE ENGLISH class are reading *Captain Corelli's Mandolin*. One of the characters, Carlos Guercio, is a closeted gay man in the Italian army. It is in Miss Theodore's English room, on chapter 4, (erotically named "L'Omossesuale") that I am first confronted with my own feelings regarding the purity of love I feel for the same sex—or at this point in time—Black specifically. My love for her has compounded since its reciprocity was confirmed, as if I'd taken ten MDMA pills at once and been in a constant state of coming up ever since. Not that I knew what that felt like.

Carlos joins the army after reading Plato's *Symposium*, a book in which esteemed Greek philosophers debate the definition of love. The argument of the aristocrat Phaedrus is that love makes you strong: a hero, willing to die rather than betray your lover, to kill rather than embarrass yourself by appearing cowardly in front of them. Carlos knows that through the laws of probability he will find a man to love in the trenches and that this will make him an exceptional soldier, giving his life the purpose it lacks in a homophobic world. The ancient Greeks saw the relationship between men as the highest form of love, and notwithstanding the misogynistic reasoning for this (that men were the better sex—I later found out while studying Sappho during my Classics degree that they did not view lesbians in the same light), I was touched by the sentiment of what I read from the viewpoint of this Italian soldier, living and fighting through the Second World War.

He refers to Dante's Inferno, as he says, *'According to Dante,*

my like is confined to the third ring of the Seventh Circle of Nether Hell. I am mentioned almost nowhere, but where I find myself, I find myself condemned. And how remarkable it is, you doctors and priests, that Dante pitied us when God did not. Dante said "It makes me heartsick only to think of them." '

He goes on to expain,

'*I joined the army because the men are young and beautiful, I admit it. And also because I got the idea from Plato. I am probably the only soldier in history who has taken up arms because of a philosopher. You see, I had been searching for a vocation in which my affliction could be of use. In short, I read The Symposium, and found Aristophanes explaining that there were three sexes: the men and women who loved each other, the men who loved men, and the women who loved women. It was a revelation to conceive that I was of a different sex; it was an idea that made some sense. I knew that in the army there would be those that I could love, albeit never touch. I would find someone to love, and I would be ennobled by this love. I would not desert him in battle, he would make me an inspired hero, I would have someone to impress, someone whose admiration would give me that which I cannot give myself, esteem and honour. I would dare to die for him, and if I died I would know that I was dross which some inscrutable alchemy had transmuted into gold.*'

Granted I have no army to fight in, but Carlos' words resonate with me. I smile down at my copy and notice the clock ticking, the soothing sound of fountain pens scratching exercise books. I've been so afraid of the judgement and condemnation of my schoolmates, my family, society as a whole—of the unknown life that lay ahead of me if I turn out to be gay—that I've blocked out any sneaking suspicion of its possibility since the first girl did that thing with my heart in the doorframe. There were stronger negative connotations surrounding gay people back in 2005; I knew nothing practical about the queer lifestyle aside from tabloid details of celebrities who were deemed eccentric. I had very few realistic success stories or positive role models to hold for hope. What did I have in common with Elton John, or Lily Savage? But

I was comforted, like Carlos, by the idea that I was of a different sex entirely—women who loved women—and that there was simply more mystery surrounding this kind of existence. The way Carlos describes his feelings for Francisco, the straight soldier he does end up falling in love with in the barracks as he predicted, hits the nail on the head for how I feel about Black. It doesn't matter if the love is never physical. The treasure is in the bond, in how having a person to love reminds you of the meaning of life and makes you want to be a better person. Black is my singular, opalescent pearl, and I realise in my twice weekly English lessons that she is all the embellishment I need. Accepting this allows me to strip back my idea of what's important and what isn't. As a perfectionist, I want to give Black perfection in turn. She reinforces and justifies the three golden checkpoints I gave myself as a child, gives me a brand new reason to be pure, clean and perfect—but this time, daily. I start to polish each facet of my life, paying attention to how I nourish my body, study for my lessons, dance during Miss White's classes, interact with my loved ones. I spend more time on my appearance. Even my handwriting improves. I have to step up to be the person who loves Black the most, so that no one can give her more than I can. Everything I do needs to be to the best of my ability. In the words of Walt Whitman, "Dismiss whatever insults your own soul, and your very flesh shall be a great poem."

So this is my second revelation. That the reason I have Black on a pedestal is because I'm in love with her. It's obvious to everyone else, but I'd been distracted with the more pressing issue of finding out whether our friendship was requited. Being first in her MySpace Top 8 frees me up to face the truth: that on this occasion my infatuation has stepped it up a notch. There is a lot to be said for the reciprocity of a bond allowing its roots to grow deeper (even if this reciprocity is not of the same ilk). The moment I accept this in its entirety, I'm on an early evening walk to ASDA for some snacks after school. Absentmindedly watching the sky as I walk, thinking of Carlos Guercio, thinking about my *best friend*

(saying it still hasn't got old), I notice the sunset, how the clouds overhead are the colour of Barratts' Fruit Salad sweets—pinks and oranges spread above the retail park like raspberry and pineapple candy floss. A grin syrups its way across my chin at this beautiful view across an acrid landscape, a quiet signal of acceptance to me from above. That I will be okay. I am allowed to love Black. It is clear as silence. And I am not scared. I am dross which some inscrutable alchemy has transmuted into gold.

CHAPTER
12

Miss White —The Second Woman

ARRIVING HOME FROM ASDA, I see my mum pull up in the driveway, having just come back from my parents' evening. I run to catch up with her so I don't have to knock on our front door to be let in. I'm not trusted with my own key just yet.

"Your PE teacher... she LOVES you," she says, twisting her key in the door.

"Why?" I ask, following her inside. Miss White hasn't been around long enough to know me yet. I rack my brain for forgotten conversations we might have had. Nothing stands out.

"She said you remind her of herself when she was young," mum responds. "She sees potential in you. You're one of her favourite students."

I scrunch my forehead. We've not had any one-to-ones or exams yet, nor anything to warrant me being a favourite. But not one to say no to the approval of a pretty and feisty authority figure, I feel myself grow smug. *I'll take it.*

Throughout the following weeks, I keep my eyes open for clues of Miss White's favouritism. Does she pay more attention to me in class? Not really. Some heartening eye contact maybe, a supportive smile here and there. But perhaps this is because I am the only one offering her frequent grins, a subtle *thank you* for what I've heard. My hunt for hints that she *loves* me—as my mum so emphatically put it—begin to take over my PE and dance lessons until in no time at all my entire school day is consumed with my

two new infatuations: Black and Miss White. I bloom in quiet confidence as I skip around the school with a spring in my step, allowing my cheeky demeanour to blossom, "knowing" I am the "favourite" of them both. My cup of morning coffee is seeing her navy Vauxhall parked in the second bay of our school carpark. The first thing I do when I arrive at school each morning is check for it. She only works part-time, so if it's there—impressively shiny and large with its bonnet like the edge of a Kit Kat Chunky—this means I'm in for a good day. I even sign up for Rounders. I've never played before but am willing to do everything I can to impress her, because one afternoon the proof I have been searching for arrives. A handwritten note in our form register, addressed to *me*.

Fern, round up 14 students to play in the rounders tournament next week. Thanks! Miss White x

I have been chosen. *Why me?* Despite no previous accolades, I am the one she trusts to collate a winning team. I imagine she sees through me, knowing she can count on me because I'll want to please her. This just makes me happier. My attention has been accepted kindly, rather than interpreted as something to shy away from (the first girl and my stepsister were not as forthcoming, remaining rather indifferent to my existence). I have no interest in obeying this personalised instruction other than to secure Miss White's favour. What lazy teenager can be bothered to find more than a dozen students to play a game she doesn't know the rules of? It's an effort to even get any of us into our PE kits before class. But I feel such pride in the note, I could have pinned it to my bedroom wall as a certificate. Instead, I fold it up and keep it in my memory box.

I rally the team, myself included, and on the day of the tournament Miss White gives me her lucky bat and tells me to make her proud. As everything she says to me is Gospel, I try my best to do just that. We come second in the whole of Barnet, not bad for a makeshift squad who have never played before. I come home that night and bounce on the trampoline in my back garden a total of

one hundred times as a celebration, not totally unrelated to the childhood OCD that has come creeping slowly back since the private realisation of my sexuality. I continue with this after school fitness regime every day for the next few weeks, using Miss White as motivation for my new athletic prowess before I inevitably slip out of mindfulness again.

You like me, I think, *so I'm going to give you my attention,* and I make more effort to chat to her. We develop a strong student-teacher bond. I do my best not to give too much away about my growing adoration for her, rather to let her know I respect and admire her as a "fellow woman". I want to forge a legitimate and mutual friendship with her and as such, understand that any form of fangirling or being over the top (not my style, makes me cringe) is not the way forward.[3] So whenever she gives us a tiny insight into her personal life either by mentioning what she's up to on the weekend or referencing her boyfriend in passing, I give her "advice" on the snippets she divulges (how naive to think I have anything to contribute), listen to her talk about her more beautiful and smarter, younger sister ("no one could be better than you", I assure her, leaking childish devotion despite myself) and only occasionally throw in the schoolboy charm indicative of my age. "You know you're my favourite!" I chuck in as a throwaway comment at lunchtime before telling her I have homework to catch up on and walking away. I am attempting to play hard to get, to "woo" her, without being old enough to realise that's what I am doing. I want her to know she was right to call me a favourite, to plant the seeds of staying close to her long after I stop being her student.

Miss White is young and cool enough to have a student following and gets on well with those of us in my friendship group who have chosen to take Dance for GCSE. She is professional but personable, a blend of governess and best mate that is perfect for a

3. Have you ever seen a musical heartthrob marry the fan who cries and faints in front of him? Exactly.

group of teenagers, garnered from an understanding that she will get the best out of us academically if she relates to us as a friend. A unique bond between an adolescent and an appropriate adult that facilitates the latter's development and validates our emotions is necessary during puberty, as it reminds us we are worth something when we are not quite children, not quite adults, and get buffeted around in the limbo of it all. Miss White respects this. For some of us she shows it through relaxed chats and anecdotes, humour and support. For me, it is through all of the above in addition to the bear hugs I learn she is fond of, which—being an affectionate and tactile person myself—is music to my ears. Sometimes we envelop each other in muscle busting squeezes as we pass each other in the corridor. "I saw you GROPING Miss White at lunch" a girl in my year laughs. I roll my eyes at this crass comment and don't let it bother me. It's not like that. We're real friends. My mum said she *loves* me.

I am naughty at school in the harmless sense: forgotten books, scruffy uniform, in detention every Wednesday for talking. I frustrate some teachers, and some like me more for it, as I suppose it breaks up their day.

Whenever I come into Miss White's lessons upset because I've been told off, I make it obvious in a quiet way. I'm less chatty, my smiles are smaller, tiny suggestions of feeling sorry for myself. It's her affection I crave most, her alone who can make me feel better because her authority offsets the others'. The slightest change in behaviour from me is enough to prompt her attention. She has a sixth-sense towards my emotions and seems to know instinctively that I'm only upset because I've been misunderstood. She offers big-sisterly affection towards my hormonal mood swings in a way that is attentive and personal. Instead of brushing me off as pout-

ing or moping, she panders to me just enough—gives me a quick cuddle, asks me what's wrong and cracks a joke, which is exactly the Holy Trinity I crave. Then she reminds me of my potential in a way that makes me want to man up and do her proud, somehow dissolving my silent tantrum in an instant by indulging it. Whether this natural gift is because she knows how *she* would have liked to be treated at my age—because I remind her of herself—or because she cares enough to learn me personally, I'm not sure. It's subtle as a nod, but as I'm looking out for every little thing she does, I notice how much she genuinely cares about us. Miss White's emotional intelligence towards teenage girls is not lost on me, and the more mature part of my moody, adolescent brain appreciates it. She teaches me that the way to gain respect is to act like an adult but doesn't deny me my childish whims in order to push me to that place prematurely. I don't want to let myself down nor make her think less of me by acting like a child, so it works. I become better behaved.

Miss White soon develops my love for dance to the extent I decide I want to be a dancer when I grow up. My friends and I come into school forty minutes early on Thursdays for Chance 2 Dance rehearsal, stay late after school and often sacrifice our lunch breaks. I relish the trippy, lyrical contemporary performances she choreographs for us, assembling our twenty-strong troupe into swarms of different shapes and colours for each local performance, cladding us in colourblock costumes of red, white and black, our heads covered in space buns just like hers. We dance to tracks by Portishead and Leftfield; an army of beetles storming the stage, flooded with lights to match our outfits. She introduces me to two of my favourite soundtracks through her artistic direction: *American Beauty* and *Requiem For a Dream*. For performances limited to the school hall, she tones it down a little to stay on the good side of the older teachers, who remember her from when she was a pupil at the school herself and who she says still treat her like a child at times. There is Destiny's Child's *Killing Time* and James Blunt's *No Bravery* for Jesus' crucifixion dance at

the Easter Mass. We learn both Matthew Bourne and Mats Ek's interpretations of *Swan Lake* as well as Christopher Bruce's *Ghost Dances*, the latter of which cracks my taste in music wide open. She takes us to Sadler's Wells to see *Edward Scissorhands* and Rambert's production of *Swan Lake*. When I get a part as a ballerina in the West End production of *Thriller Live* at the Dominion Theatre, she is first up dancing in the aisle that opening night next to my family with a drink in hand. Miss White mentors me through my journey towards dance college, giving me information on all the places I can apply, including LCDS at The Place, where she herself was a student.

The night of Chance 2 Dance finally arrives. We are backstage at the Arts Depot in North Finchley preparing for our big performance. The corridors and dressing rooms are wide and stark, the spotlights around our dressing table mirrors highlighting the sheen of sweat collecting on our foreheads as the countdown to "curtains up" approaches. I sneak out of our dressing room to run up and down the echoing hallways and expend some of my restless, pre-show energy, and can hear the audience filing into the auditorium: hushed whispers, clinking glasses, rustling sweet packets. Opening the door to the foyer a touch, I spot my mum and stepdad ordering a drink at the bar. A lover of camaraderie, I am buzzing. A night where my family will watch me, Black and the rest of our friends perform a dance by my favourite teacher—what more could I ask for? I go back to the changing room with my stomach chasseing wildly and sit in front of the mirror for hair and make-up, deep in thought. I can see Miss White across the room behind me, styling Anna's hair. As I watch in silence, taking in the commotion, Anna catches my eye in the reflection and shouts across the din.

"You okay Fern?"

Before I have time to respond, Miss White does the honours without looking at me, focused on wrapping the black hair tie around one of Anna's auburn buns. "She's fine, she just goes quiet

when she's nervous. Give her time by herself for a few minutes and she'll be back to normal."

I glow with this mundane revelation about myself, feeling intimately seen by such a casual observation; that she studies me enough to notice a quirk of mine I wasn't aware of, the same the way I do with her. Such a small, inconsequential sentence means everything to a teenager who adores her teacher. It is an act of love. No grand gesture, nothing to write home about, just showing me she sees me and listens to body language; which is—as she always reminds us—exactly what she's trying to teach us through dance. This validates the love I feel for her. I will spend the rest of my teenage years and my twenties seeking out others who pay this kind of attention.

The show is a success. Back home, I brush my teeth meticulously, polishing each one individually before passing out drunk on adrenaline. Tonight has cemented itself as a new golden date in my calendar, despite not being my birthday nor the New Year. I know for sure that I want to be a dancer—the thrill of performing with and in front of your loved ones is like nothing else. I need to do everything perfectly from now on to express my gratitude towards God, to justify my worthiness for the wonderful evening I've had.

Two months later, when we are told we are to have a substitute teacher for a while because Miss White has had a car accident, we are concerned for only a moment. She has a self-proclaimed reputation for being clumsy ever since she told us she slipped on a non-slip mat. Rumour has it she's sustained minor injuries (primarily whiplash) so eventually we find amusement in the story, another to add to the canon, despite the fact she was not the one who caused the accident, rather her car was hit. Of course, I miss

seeing her parked on the property every day. I buy her a *Me To You* bear (probably the most common gift from adolescents between the years 2002—2005) covered in bandages. She keeps it permanently on her Kit Kat Chunky dashboard on her return, at which point she tells us she has some news for us: incapable of teaching physical dance for the remainder of the year, we will instead focus on theory. I don't mind sitting at a desk and writing because it means I get to watch her for a full hour and a half. She tells us that if she stands on the right-hand side of the classroom we will engage our "right brain," trained to take in facts which will help us with our exams, rather than our "left brain" which engages our emotions. But she's forgetful as well as clutz, and often stands on the left. *No wonder I love her*, I tell myself. *It's science.*

Since the return of my OCD, its twin, Catholic Guilt, has reared its anxious head again, with the most recent manifestation being prayer. I pray for Miss White often, for reasons I can't explain.

"What you doing, Fernie?" Mum asks me one evening as she spots me kneeling by my bed in the shaft of light coming from my bedroom door.

"Praying for Miss White," I reply curtly, annoyed to be interrupted. Disruptions mean my prayers lose their power and I have to start from the beginning. Mum doesn't respond. She tries not to make me feel weird about my OCD. I guess because I own it. Too much energy is spent on the behaviours themselves to have any left over to justify them.

Despite my prayers—though I knew not what they were for exactly—Miss White hands in her resignation in the last term of our penultimate year of school. She breaks the news to the rest of the class while I'm in the toilet—correctly pre-empting I'll take it especially hard—and when I come back to a silent audience of shocked peers, asks to speak to me privately. I stand barefoot and tear-stained in the school grounds, devastated, as she wraps her arms around me and cries too, promising we'll stay in touch, that she'll remain my mentor and friend. This woman has single-hand-

edly changed the athletic creativity of our student body. Where once we would make up all manner of excuses to not change into our PE kits, she has managed to give our twice weekly exercise a makeover. Now she is leaving just before our GCSEs and we are essentially orphaned. There is no other dance teacher in the school, so we'll be back to recruiting substitutes to get us through finals. She holds a small picnic on the grass in place of our last lesson on the final day of summer term. There are cartwheels, fairy cakes and memories shared before heading into end of term Mass.

I sing louder than usual that day, tuning into the hymns' lyrics and really trying to *mean* them as I soak up the sun streaming through the technicolour stained-glass windows of our school hall; the kinetic energy of hundreds of teenagers growing up together under one roof. It's bittersweet, knowing that this is the last time we'll all be here together with our beloved teacher. I zone out during the homily, reflecting on the teeming private emotions and inner worlds that must be held in all the evolving hearts in this room. All the friendships, the crushes, the secret and not-so-secret loves. It's a beautiful realisation, especially with the promise of six weeks of summer ahead and the sound of *Our God Reigns* on our rusty school organ.

As our precious school priest Father John ends the services with his famous parting refrain "And remember... don't beat up you little brother," we give a weak, courtesy chuckle before filing out of the hall. Glancing over at my dear teacher as the remnants of Year 10 follow us out of the hall like dust particles into a month of freedom, I feel an immense gratitude rise up in me, and as always, I thank God for it.

True to her word, Miss White keeps in touch, as long as we start to call her by her Christian name, *Nadine.* Jess and I help her

coach a primary school netball team for a bit, and she stays on emails throughout our GCSEs. I injure my shoulder the day of the final practical exam which is *typical*, because not only am I one of just two girls in our class who want a career in dance (the other being Nina, Number 20), but I never managed to so much as scratch myself during my Year 8 phase of hanging off the shower rails in the changing rooms trying to break my leg for attention. Incapable of performing, I have to take the exam via a recording one month later, receiving an A instead of the A* I covet (travesty) and am convinced this mess wouldn't have happened if she was still here.

We keep in touch less frequently as I grow into a young adult and she takes on another group of kids to mother through puberty, but whenever I miss her, I look at my favourite of all the posts she left on my Facebook wall, back in 2008:

XXXXXXXXXX

This row of *x*s—sans conversation—serves as a happy reminder that despite both of us being too busy to stop and chat, there *was* time for a silly little string of kisses to let me know she still thought of her all-time, one of a kind, favourite ever student.[4]

4. Just kidding. Kind of.

CHAPTER
13

A YEAR LATER, I have my first kiss with Nina's ex-boyfriend, a boy named Josh who asked me to prom. I'm not out yet, and my logic was that if I was going to kiss any boy, I wanted it to be him because he was good-looking, funny and popular with the girls. Nina gives me her blessing. Josh is engaging and in touch enough with his feminine side for me to entertain the idea of fancying him. I struggle to understand boys, they have minds running on completely separate tracks to women, but every so often I meet one I'm able to truly relax around, as it seems their company is not contrived nor centered around pulling girls. Ironically, it's these guys I'm more inclined to be attracted to. They are comfortable enough in their own skin to be themselves, which lends itself to a subtle magnetism. Josh was recently cast in a BBC Drama with Nicholas Hoult of zeitgeist *Skins* fame, which gives him further leverage in my eyes. Plus, his name is *Josh* for God's sake. That's a hot name. My first kiss with him suits my Movie Protagonist Syndrome just fine. I am sixteen when it happens, satisfied that for a whole month I am "sweet sixteen and never been kissed," desperately applying film tropes to my life to allay any prior feelings of dejection.

I haven't escaped the adolescent desire for boys to want me. I succeed in chatting to a few teenybopper dreamboats on MSN long enough to be asked on a date, but soon enough they realise I'm "frigid" and are introduced to my friends who wear much cooler clothes than me and are more likely to "do stuff" with them

because they're actually straight. The boys always end up choosing them instead.

Up until sixth form I am the only girl in my friendship group who doesn't wear make-up to school, has only just started wearing contact lenses, and has a half-hearted commitment to straightening her hair (very important in the early millennium). This inconsistency means I can look cute in my MSN avatar when I've made the effort, but like a ragamuffin child in the cold light of day. Plus, I have an unusually good-looking group of friends. I understand this, and often pre-empt the consequences, but my ego still feels the burn. I spend many a night sitting alone at the computer chair in my dining room, streaming Foreigner's *I Wanna Know What Love Is* on Limewire and logging in and out of MSN trying to get guys to notice my online presence, eventually logging off after another fruitless night of attempting to acquire a boyfriend. By now I've experienced feelings for two girls who confirmed in black and white that I am gay. But I am lonely because I have no one to share these feelings with, while meanwhile my friends seem to flit between willing boys without much effort.

I want a boyfriend badly as a distraction from the fact my secret affliction for girls has now flourished into full blown lust. I am confident about my feelings for Black, but still don't know how I feel about being a lesbian in general, as a lifestyle choice. Then halfway through Year 11 a miracle happens: it becomes cool for girls to kiss girls.

I do not recognise this miracle at the time and am unimpressed. Where previously my friends had unconsciously been compliant in the societal construct of internalised homophobia, they are now up for salivating into their closest friends' mouths after a few Smirnoff Ices, whether to get attention from the boys they really want to kiss, to experiment, or simply for a laugh. My disgust has less to do with the girl-on-girl action and more to do with the fact I hate how carelessly they are giving away something I place so much sanctity around. I feel such a strong pull towards the girls I like; harbour fantasies of kissing them for

so long and experience such intense chemistry, it seems bleak to know my peers are dumping their lips on any girl rather than waiting until they find someone to revolve their entire life around. Have they not felt the same depth of instant and natural emotion that I have? Surely they wouldn't be doing this if so. Kisses, like anything, are less special when diluted or overused, and if you don't feel the metallic penny of longing in the gut then what's the point?

I have my second kiss not long after—my first with a girl. My friendship with Black is as secure as ever, but I've grown to know her so intimately as a best friend that in addition to my preoccupation with the first girl I kiss, my love for her merges into a new kind. I don't fall out of love as such, the energy simply alters. Our bond is now doused in an alchemical liquid, cooler but more powerful, transforming our relationship into something thicker and familial. I no longer fancy her, but in a way, I'm still in love with her because her ignorance to my feelings means she was never forced to break my heart and so there is no clear ending. I have none of the typical feelings of falling out of love that are standard at that painful age: no bitterness, resentment nor disenchantment. Little do I know how rare this is: to remain close to someone you have loved as an idol, love interest, friend and now—a sister. That's four layers of a bond to break before you could crack my allegiance to her.

CHAPTER
14

G CSEs ARE OVER. For AS Levels, I take English Literature, Classical Civilisation, Latin, Psychology and Performing Arts so I can continue my studies in dance and drama. Our sixth form college comprises girls from my school, boys from the neighbouring Catholic boys' school, and a few new students who took their GCSEs someplace else, so I'm able to enjoy mixed gender classes for the first time since primary school. Performing Arts takes place in the boys' building because they've just had a new block built for this purpose. Before and after class, a minibus shepherds us to and from our original schools.

Vangelis and I gravitate towards each other on the first day of our A Level Performing Arts class. Partly, I think, because a few years beforehand, we'd both turned up to our respective schools on Bank Holiday Monday and to distract from our mutual embarrassment, he launched straight into a story at the bus stop about how he'd jacked off a stranger in a Soho nightclub the prior weekend. We'd met only briefly years before, at Alex (number 6)'s fourteenth birthday party, where I have a vague memory of him saying something hilarious while sucking drily on a blue ring pop. Forgetting we had the day off school is the first of our many similarities. We are both Geminis, entirely similar in thought, humour and moral compass. Where we differ is that Vangelis has no filter between the darker parts of his mind and his mouth, vicariously freeing me from my Catholic Guilt when he says things I wouldn't dare to admit or tells me exactly what I'm thinking (he always gets it right). That boy knows me better than anyone. He

can predict what I'm going to say and has an impressive knack for seeing through my defences. He gauges very early on in our friendship that I am on the same wavelength as him; someone he can pour every effervescent thought into like ink on a diary, knowing I'll understand exactly what he means, and if not, at least I'll entertain him. His naive nonchalance lends itself to a child-like curiosity which is hysterical in its lack of inhibition. He has zero academic interest. Instead, he wants to be a singer, so spends most of Year 12 locking me in the music room utilities cupboard and singing Celine Dion *at* me, practicing for his future X Factor auditions amongst an audience of mops and paper towels while I play the role of Simon Cowell.

His humour is a cross between Charity Shop Sue and Jill from *Nighty Night*. I'm always laughing until I can't breathe when I'm with him and I once walk into a lamppost on the way to class because I'm too busy watching him speak. Mr. Sell, our drama teacher, notices this about me. We are both called into the staff room during second term.

"Guys, I'm going to have to separate you. And if this continues, I'll have to consider kicking you off the course."

"Yes Sir", we bleat in unison, chins down, trying not to catch each other's eyes.

"Vangelis, stop making her laugh. And Fern, stop being dis-tracted. You spend your entire time in lessons just staring at Van-gelis, waiting for his next joke."

I try to keep a straight face. Thankfully, Mr. Sell finds it amus-ing too, and after laying down the law pats us both on the shoul-der. "Get back into class and smash your exam."

"Remember that A we talked about", Vangelis winks to Mr. Sell on the way out, pulling a fiver out of his trouser pocket with a flourish and placing it in the palm of our bemused teacher's hand.

"I'm not taking it down until you admit it!" Vangelis exclaims gleefully after school that evening, dangling my trainer above the bus stop shelter and threatening to drop it on the roof.

"I'm not! Give it back!" I'm exasperated. At 5'6"—not particularly little for my age—6 foot Vangelis is the only friend who makes me feel physically small. I like this. Usually.

"You so are! Admit it! You're gay!"

I plead with him.

"I'm not gay! I fancy Bishoy! Give me back my shoe!" (Bishoy is the first good looking boy in our year that I can think of.)

"Oh PISS OFF!" He laughs. "I can see right through you! You're the girl version of me!"

As far as I'm concerned, Black remains oblivious to my sexuality. I still follow the crowd. I've managed to convince my friends, for the most part, that my love for women is a different animal: sisterly and fanatic, yes, but just part of my personality. That I still fancy boys. The only person who sees straight through this is Vangelis.

His arm will get sore eventually, I think, after five minutes of him glaring down at me like a Disney villain, eyebrow raised sardonically with a sarcastic Jafar-like smirk on his mouth. I look at him warily, calculating whether I feel safe enough to confide in him. I decide against it. It isn't his reaction I'm concerned about, rather his big mouth. I know he's been through the ringer himself; being obviously gay in an all-boys' school can be no easy feat. But by this point he is very much comfortable in himself, unashamedly putting *The Worst Witch* on the class projector whenever we have a free period, indifferent to what the straight boys might think. I jump up and grab his wrist, managing to free my pink and purple Dunk from his grip. He looks over the moon with himself for getting me worked up. I try not to let my foot touch the wet ground, clinging to his arm as I wedge it back inside.

But the damage is done. I've thought about it for too long now—suspended in the fear of being forced to confess or hopping

home—that the admission is halfway up my throat like an Adam's Apple, a sphere of original sin. I'm unable to swallow it. Can I tell him?

I take a deep breath and close my eyes.

"Okay, fine! I like girls!"

"I knew it! His eyes glint, victorious. "You're the only test I've ever revised for."

PART

TWO

CHAPTER
15

VANGELIS PROVES HIMSELF to be a worthy safe place for my secret. But once my A Levels are over, my sense of security wavers once more. I am thrust into the real world to fend for myself.

I'm accepted into university but defer my place until the following September so I can take a gap year to audition for dance colleges. If unsuccessful, I'll reluctantly submit to further academia but in the meantime, I've taken a job as a receptionist at a prestigious dance studio in Central London in the hopes of surrounding myself with all the right people and giving myself the best chance of success. One of the perks is unlimited free dance classes, so I'm able to train after each shift. Despite offering every style of dance, Royal Academy ballet dancers flood the building during the day and watching them practice through the glass window behind our reception desk confirms I do not want to take my ballet classes any further, not now that Miss White has introduced me to lyrical contemporary. Ballet is far too rigid by comparison. The studio is a hot spot for celebrities, another source of endless inspiration throughout the dance college application process and a constant reminder of where I want to be.

The job does not disappoint; a highlight being signing Madonna's daughter, Lourdes, up for a private lesson in my first month. I've acknowledged that my golden checkpoints have run out; I have no more lives left now that my childhood is over and I have to begin living the "real life" I've been preparing for all these years. I must be perfect immediately. I wander around Selfridges

Food Hall on my lunch breaks from the dance studio, imagining all the wonderful things I'll buy when I'm rich, successful and 'allowed' to indulge: pear salad, quails eggs (probably not) and chocolate brownie squares dusted with real gold. I remind myself to tell Miss White where I'm working—she'll be proud.

I last saw Miss White two years ago on my way home from sixth form when I popped into Waitrose. She was loading her shopping into her car, but I had a stain on my dress, so I didn't say hello because I didn't feel worthy—I didn't want her to think I was untidy or unattractive. I've only spoken to her twice since: once when I asked her for a dance college reference during the summer and we caught up on the phone for an hour, and the previous week when she texted me for the first time, out of the blue.

Hey! I have some news to tell you. Fancy meeting for a coffee?

Her message took me by surprise. I wondered what she wanted to tell me—she was getting married? Pregnant? We'd made a vague arrangement to meet but hadn't set a date yet. On the tube home from work that afternoon, remembering our abandoned plans and reminiscing on my school days, I find myself overcome with the urge to text her that I love her. I've never said those three words to her before but am feeling particularly carefree, which in my case often leads to brazenness. I take my phone out of my pocket, type "I love you! X" and press send. The clock symbol promptly appears next to the buffering message. I'm confident she'll receive my text positively when it delivers because I'm secure enough in the strength of our bond. I rarely shy away from affection and am generous with the L word when I mean it. Everyone who knows me expects this from me. I'm certain Nadine will too.

When I tap out of the Underground at Colindale and reception is restored to my phone, it's already ringing. I wedge my phone between my ear and shoulder as I slide my Oyster Card back into its wallet.

"Hello?" I answer.

"Hi, who is this?" a quiet voice responds. It sounds just like Nadine's, but distant and far away. *Is she crying?*

"It's Fern, who is this?!"

"It's Kim, Nadine's sister. Nadine's in hospital."

"What?"

There are muffled sobs.

"I thought that if somebody was texting that they loved her, they deserved to know. Who are you?"

"Thank you. I'm one of her old students. Is she okay?"

Kim is the sister Nadine talked about with affectionate envy. She tells me Nadine is on life support following a routine operation. She's reacted negatively to a blood thinner called Heparin and has less than twenty-four hours to show signs of improvement before the decision will be made to turn off life support. Not knowing what to say, I quietly thank her for telling me and hang up. White noise swarms my ears. It's rush hour, dozens of people are rushing past me and jostling each other. A man knocks the strap of my bag off my shoulder. This would normally frustrate me, but I barely react as I catch it with the crook of my elbow and stare straight ahead, unblinking. This was the first time I'd ever text Nadine, aside from replying to her request to meet for coffee. I can't believe the timing: the one moment I have the urge to write down what I feel about her, this is the response I am met with. I think back to the first time we met.

"I recognise you,"

"That's odd, me too."

Are we tied together by a red thread? Did I *know*, on some, psychic level, that she needed energetic love in that moment, the way a twin feels a phantom pang? I cling to this thought as I walk home through the park that joins Colindale station to my street, the empty swings in the playground creaking in a new and lonely wind. The idea that we have been entangled for many lives, through time and space, that there might be some universal force behind all this, pushes me forward, guides my footsteps home. All will be well. It has to be.

On the twilight shift at work the following evening, I barely speak. Terror of what might happen has inflicted a mild paralysis over me. I've done nothing but refresh Facebook since I got home last night, not daring to text Nadine's phone for an update because I want to respect the privacy of those closest to her. It's quiet in the near-empty studio—students have begun heading out of London and back to their hometowns for Christmas—so I can get away with sitting at the reception computer stalking Facebook for updates under the pretence of checking company emails. I press the refresh button so often that I stop registering what I'm seeing, the harsh yellow of the studio lights and synthetic glare of the screen boring into my retinas, a trippy contrast to the coal dark December night outside. The process of *click* and *dissociate*, *click* and *dissociate* becomes a meditation. After a while of doing this, I'm startled to see a shift of pixels on the screen. Snapping back into the room, I register the short blur that has loaded at the top of Nadine's profile. Something new. I blink. The image clarifies.

RIP Nadine <3

I allow the words to lose focus again, raising my gaze above the monitor as my eyes cloud over once more. My body turns static, creating a force field to protect myself from whatever I can feel about to implode inside me. My mind empty, eyes two cold pennies, huge and numb beneath their sockets. After what feels like an hour but is probably only three minutes, I turn to my manager who is sitting silently at the computer beside me.

"My friend has just died."

My voice is barely louder than a whisper. I'm almost... *embarrassed* to admit this. I don't want to inconvenience her during what has been such an easy shift, nor do I know her well enough to burden her with my personal life. I'm even more embarrassed

to admit that the friend in question is my secondary school teacher.

She dramatically pushes her chair back from her desk with her hands.

"Oh my God! What? How? Are you ok?"

"I don't know. I just found out." I'm not in the mood to elaborate.

The rest is a blur. I am told to go upstairs to the wellness centre on the first floor and lie down. "Take all the time you need," she says. "You can leave early if you have to." As it's Sunday evening, the wellness studio is closed but unlocked and the lights are still on, so I enter one of the clinicians' rooms and lay down on a masseuse bed. Staring at the ceiling, the bulb of yet another light pierces through me—yellow, yellow, yellow, everything a disgusting chartreuse that once made this building I love feel festive and cosy, but now just makes me want to vomit. I let my eyes burn as they focus on the centre of the bulb, allowing the filament to bore through my pupils and into the back of my brain, convinced my attention to this nucleus is the only thing preventing my organs from falling out of my body. After half an hour I get to my feet, unsteady, and head downstairs to excuse myself. I need to go home. I love her. I *love* her.

Walking down Oxford Street towards Bond Street station, the stirrings of a new snow begin to fall around my shoulders. The sentimental visuals are not lost on me and I reproach myself for even thinking such thoughts. Why do I have to compare everything in life to a movie when really, if Nadine has died, it's actually a crock of shit? At the same time, how dare my surroundings be so beautiful in their poignancy when I've just heard news that's the total opposite?

Nadine loves snow. I'd forgotten this piece of trivia until now and feel a burst of gratitude that my love for her once led me to study her so hard that I can recall small things like this when I need them most. *Christmas Lights*—Coldplay's newest single—is playing from the window of Boots as I pass and the lyrics are cru-

elly apt; another coincidence that could be called serendipitous if the circumstances weren't so terrible. Before I know it, I'm walking down my street (I don't remember my tube journey home) and drawing a heart with my fingers in the snow that's caked on top of a parked car's windscreen, childishly writing her name inside.

Turning the key in my front door, I am immediately comforted by more yellow lights from the corridor (an ambience that continues to remind me of safety ever since living at Frankie's as a child) and drop to my knees. My mum at the sink, washing a singular mug, turns her head to see me fall. "Fernie? What's wrong?!" She rushes to my side and joins me on the ground, both of us kneeling on the laminate flooring, my face cradled in her hands.

"Nadine died" I whisper, leaning against the wall and bringing my forehead to my knees so she can't see my ugly, silent, heaving sobs. The contents of my bag are scattered around me from where I dropped it as I landed. I don't remember what happens next, but I do remember the comfort food mum prepares for me in solidarity: Birds Eye cod, chips and beans. How she sits beside me and holds my hand while I eat, chewing slowly as a toddler would. Odd, the things you remember in grief. Even when that grief is premature.

Because then the phone rings again. It's Kim.

"She hasn't passed away. I can't believe that was posted on Facebook. She just hasn't woken up yet. We're asking everyone to light a candle tomorrow at lunchtime. The decision of whether or not to turn the machines off will be made in the early afternoon." Her voice is curt, like she's trying not to cry or shout in case the grief is unplugged, left to roam free and never stops.

The fresh wave of hope that comes when I hang up is nothing short of a miracle. The plot twist you can only hope for in a film. It's David waking up next to his mother in *AI: Artificial Intelligence*, it's being jolted from a nightmare and realising you're safe, in your bed, in your old life, not the twisted version that exists

when you close your eyes. I spring to action, spurred on by the idea that Nadine might stay for the snow. Running up to my bedroom, I tip the contents of the bottom drawer in my dresser onto the bed. It's full of religious paraphernalia I've been gifted throughout the Catholic milestones in my life: two Bibles (one as a Christening present from my Godmother, one given on my first day at St. Michael's), a framed photo of Jesus from my Confirmation, a votive candle, a string of rosary beads.

For the rest of the night, I am on a deadline to summon her spirit back from the half-dead. Had anyone walked into my room they would have been confronted with what looks like something out of a horror film, but my family know to respect my privacy tonight. I look like a child giving a seance. It's Robin-Williams-in-*24-Hour-Photo* level weird. I take every picture of Nadine smiling from her Facebook page and copy and paste them into a Microsoft Word document, willing the universe to look at her smile on repeat, to remember her zest for life and give it back to her. I'm hoping her heart-warming grin can lift my energy enough to impact her, at least if we are connected the way I believe we are. Surely there's a reason I texted her when I did. Perhaps I needed to know she was in danger, so I could save her! For the first time since school, I read passages from the Bible aloud, pray to God, convince myself of His Goodness, summon all the Catholicism out of my young gay body. I stare so hard at my Nadine collage that eventually I fall asleep with pages of relevant scripture pressed against my heart, her cheeky face imprinted on the backs of my eyelids.

I wake to the sun streaming through my bedroom window, the same way it did in assembly back when she first left us. My bed sheets look like the aftermath of an exorcism, drenched in sweat and crumpled Gospel pages. The snow in my back garden is packed tight on the ground like fondant icing on a birthday cake; pathetic fallacy would indicate this is promising. I light my First Holy Communion candle. But it's too late. When I call the hospital they tell me she is gone.

I'd sat in silent prayer for her for years. She raised me in Faith.
I hang up the phone and then I throw away my Bible.

CHAPTER
16

THROUGHOUT THE WEEKS following Nadine's death I maintain the same level of manic productivity I had the night before she passed. It helps me to channel my love in a way that feels appropriate and useful. The collage of her smiles brings me comfort and I think it might do the same for her family, so I take all the photos to Snappy Snaps and spend a quarter of my monthly wages creating an A3 sized poster of them all, in a sleek black frame with her full name broadcast across the middle.

The bizarre level of chaotic perfectionism I inhabit intensifies in the days leading up to the funeral. I get a manicure, my hair done, even my first bikini wax. Like I said, grief is an odd thing. I want to present the best version of myself at the celebration of her life and to feel smooth as a pebble, to soften the sandpaper edges of my heart.

On the morning of the worst day of my life so far, I travel to the Church with some of The Twelve—those who had either taken dance for GCSE or enjoyed Nadine's PE lessons. We pile into Jess' car and I strap the collage into the middle seat. I'm nervous for the level of emotion I'm about to feel. Kim and I have been in touch over the past few weeks, usually at unearthly hours when it feels as if we are the only people in the world awake with matching, heaving chasms in our chests—although of course, mine could never compare to hers. I am touched that she has entertained me at all, let alone in the still of the night, considering we have never met and I am not part of the family. I know it's common for the bereaved to shut down and isolate, but

she has kept the channel of communication open and therefore my arteries, which keep threatening to squeeze shut out of spite towards the world. Kim told me she found emails in Nadine's inbox between us that proved, in her eyes, how much I meant to her sister. She said that learning about her from the viewpoint of a student—a side she never got to see—helps her feel closer to her.

The Church is rammed. There are no seats left, so my friends and I huddle at the back. I scan the rows and am touched to recognise more St. Michael's students and a couple of our old teachers. Despite having moved schools twice since being ours, it's clear from the turnout that Nadine made an impact wherever she went. A dirge starts to play from an organ and the room holds its collected breath. The temperature drops. I feel tears—an entire tsunami of them—prickle at the back of my eyes. Over the heads of the crowd, a wicker casket balances on the shoulders of pallbearers in smart black suits. They look like they're competing in the World's Strongest Man competition, faces crimson and screwed up, not—as it may seem—from the weight of the coffin, but from the burden of heartbreak.

Trailing behind them is Nadine. Except of course it isn't. It's Kim: small and regal, all in black, like a beautiful actress cast to play the young and sullen Queen Victoria. The sisters look so alike it physically hurts me. I would never know what Nadine wanted to tell me over coffee. I should have said hello to her in the Waitrose car park, not been bothered about a stupid stain. She was right—Kim is stunning. Smaller, darker, with the heart-shaped face and owl-eyes that also belonged to Nadine. As the casket grazes past us, one of The Twelve squeezes my arm—I'm not sure who—and mine in turn shoots out instinctively to touch Kim's. She startles and looks right at me.

What am I doing? It's another biological reaction, my body moving before my brain can remind me that she doesn't know who I am. Kim doesn't break eye contact, our gazes lock on each other for a moment until I see the cogs shift, her internal recognition that I am the person she has been texting at 3am. After a

second, she turns her head to the front once more and continues her green mile. I know from the way my arm shot out, instinctive comfort between strangers, that I already love her. Not in vain, not to make up for anything that could not be brought back by the loss of Nadine, but sincerely. Without realising it, she has been keeping my heart open since her sister's death.

After the service, the rest of The Twelve head home and my old art teacher offers me a ride to the crematorium. Travelling inside her car is like being in a parallel universe; this teacher put me in more detentions than any other, and now I'm her equal in grief. I'm surprised to learn she was close friends with Miss White. I hadn't known this, I never saw them together at school and they seemed total opposites. Miss White: extroverted, fiery, confident. My art teacher (whose first name I now learn is Caroline): introspective, reserved, quiet.

"I haven't seen you for years, but I knew you of all people would be here today. Nadine loved you, Fern," she says, her voice low and gentle.

There it is, finally, confirmation of what my mother told me five years ago.

"Really?!"

How did she know? Did they discuss it? The fifteen-year old in me wants to ask more, but her engine is switched off and we are at Nadine's final destination on this Earth.

The crematorium service is the hardest thing I've ever witnessed. First Kim, immobile in front of the hearse, staring at the back of the open boot like she could never be coaxed away. We stand and stare in silent pain at this brutally picturesque image, Kim like a doll on the front of a postcard no one would ever want to receive. At one point I think she might fall to her knees, climb inside next to her sister. I don't know how long we are kept there, watching her, watching Nadine. But not once have I been more present nor aware of my surroundings. My mind wanders to existential levels, considering transcendence and the futility of our time on this

planet. What is the point in living at all, now one of my defin-
itions is gone? Eventually Kim is guided away and we enter the
building in procession to *Kissing You.* As Des'ree cries in her gut-
ting alto-

Oh,

the aching

Kim buckles under the weight of grief. I feel sick. Yet I cherish
the exultant agony that is carried in abundance by hundreds of
people mourning here together. A final appropriate outlet for a
love I was too young to quite express.

I introduce myself to Nadine's mother, father, and cousin after the
service, hauling the huge photo frame across the carpark gravel
towards them.

"Mum, this is one of Nadine's old students" Kim says, gestur-
ing at me with an open palm.

"Lovely to meet you" her mum welcomes me with open arms.
I reach one arm behind her neck, the giant photo frame obstruct-
ing me from giving her a proper hug. When I pull back, I notice
the same twinkling eyes that belonged to Nadine, set in a friendly,
though heartbroken, face.

"Thank you so much for coming." Her father steps forward,
taking my free hand with both of his and clasping them as if
in prayer. Although I can see Nadine's eyes in her mother, it is
her father she most resembles. He is the male version of her. An
unlined, handsome face, head smooth as polished walnut. I show
them the photo frame.

"I made this for you. She was always smiling."

"Thank you, this is so kind" her mother takes the frame from
me with tears in her eyes as her father places his hand between my

shoulder blades in gratitude. Both parents are charming, visibly touched by my gift and seem to truly care who I am in relation to their daughter. I am astounded by their serenity and appreciation, how Nadine is a perfect hybrid of them both. How they can be so generous with their grace when they're going through what no parent should ever have to.

That night, scrolling through my emails, I find the reference Nadine wrote for my dance college application. I read it repeatedly until it has its own rhythm, like a hymn. A balm.

Fern was a wonderful student to work with and I enjoyed teaching her. I especially appreciated her contributions to my own choreography and her personal performance within my dances was emotionally gratifying. She is like a sponge that absorbs information at a phenomenal rate and as a result once interpretation has been understood the quality of movement then released is breathtaking. Her determined approach and mature disposition are attributes that any choreographer would value. As a pupil she has always been a pleasure to teach and one of the few students that has enabled my own passions to shine brighter. I have seen her perform on stage as a dancer through her educational years. I look forward to seeing her on stage as an adult dancer, fulfilling her potential and achieving her dreams.

Her words cause an ache, knowing that they came from another time, from a life that still had possibility. It's a beautiful testimonial, but I can no longer dance after that. I continue working as a receptionist at the studio to keep in the thick of it, to kid myself that my passion for a professional career in the industry will return, but I stop taking classes. It all feels pointless and heavy, like I have bricks under my feet. I attend one dance college audition and flunk it because I am not in my body at all. I cancel the rest and decide to fall back into my comfort zone, to go to university where I know I will thrive. I can always retreat to the safety of books, because they kept me safe back before I met Miss White.

I can't trust dance. I need to be somewhere I can live in my mind instead of my body.

CHAPTER
17

E very day feels like winter at Roehampton, the university I end up attending. Many of my school friends have chosen Bournemouth to be by the sea, but I pick my university for its dance offering. Aside from Middlesex—which is too close to my parents' house and would feel like standing still—Roehampton is the only university in London that specialises in dance and I want to stay in my home city so I can remain close to my mum. At least that's the story I tell myself. The truth is, I received conditionals from UCL, King's College London, and Royal Holloway (which I was particularly gearing towards because it looked like Hogwarts), but after receiving a BBC grade at A Level because I spent too much time prioritising my preoccupation with the same sex and aesthetic perfectionism over Roman Britain and *The Taming of the Shrew*, Roehampton—the 4TH on my list—is the only place that will have me. In my usual way of trying to tie things up in a pretty ribbon, I convince myself that my grades symbolise my destiny for a career at the BBC or that somehow, my university's speciality indicates I am still supposed to be a dancer, despite having no intentions of starting up again. I am there to read English Literature and Classical Civilisation.

In the throes of grief over Nadine's death, I am tackling tricky eating habits and obsessing over all the things that don't matter: my weight, social media, the decor of my student bedroom—anything to distract me from the pain in my body. The stunning grounds I live in—Victorian lecture halls set within fifty-four acres of lush land—are perfect for crisp walks to and from semi-

nars, which would have been medicine for my low mood were I able to enjoy them, if I were the 'ideal me' and not racked with neuroses. I'm unable to appreciate anything, my brain cloaked with an eiderdown of thick fog just like the lakes of my campus during the winter months. I've kept in touch with Kim and her parents, who were kind enough to invite me over to their house a few weeks after Kim and I ran (or rather, jogged for a bit and then walked) a 10k Race for Life in her honour. I got a tattoo of a heart on my wrist straight after, a reminder that I should always wear my heart on my sleeve and never shy away from sending an *I love you* text when I feel called to. My collage is mounted pride of place at the top of her parents' stairs. That they have welcomed me into their fold is the only peace I can find.

I make every excuse I can to return to my family home, because I'm struggling to look after myself alone. The pink mini fridge Nana Jenny bought me as moving-out gift (she came good this time) sits on the in-built study desk in my dorm and houses nothing but the leftover Indian takeaways I order daily. All the other food I eat is beige because I have no energy to cook, and my north facing prison cell means I barely see any daylight. I spend most of that first year freezing cold in bed, staring at the wall, crying and editing old essays I'd already submitted, rather than face the mountain of assignments not yet due, or lying under my duvet listening to the unlikely combination of Sarah McLachlan and Chicane (did I mention grief is weird?), waiting for my life to begin. Despite my best efforts—I've slipped out of being present and back into the familiar duvet of my mind. At home, at least I can count on childhood comforts, a homecooked meal, clean sheets, the happiness of my little sister and my mum's hugs.

"A letter has arrived for you", mum tells me on my next visit, handing me a posh, brown envelope. I notice my address is handwritten and this piques my curiosity, being accustomed only to paper bank statements and UCAS letters letting me know when to expect my next student loan instalment. I open it gingerly and find a long letter from Nadine's father, on three pages of lined

paper, thanking me once again for being there for the family during such a difficult time. The reciprocal gratitude is too much for me and causes me to break down again. I'd wanted to comfort them as it made me feel useful, not realising I also needed comfort in return. Receiving it from those who feel the pain of her loss most deeply is something I can't digest.

That night I dream of Nadine. I spot her through the square window of a classroom door, teaching a new bunch of kids. I am deeply sad. Not the word sad, overused by people to dress up a lesser emotion. I am Sad itself: soaked through to the bones with it, like some sort of Oliver Twist peering in at a family eating their Christmas dinner, longing for a blanket, a hot meal, a family. I watch her for ages, upset that she doesn't seem to care how I'm not amongst the throng. But then she spots me and approaches, flashing her laser beam smile as she gives me an ordinary instruction. She is always ready to teach me when I meet her in my sleep, as I often do. Always the same as when she was alive. All I can do is stare, search her face with my eyes to confirm she really is my Miss White, even though she doesn't see me anymore. She looks right at me, but no longer knows what's going on inside my confused young heart, the way she once could instinctively. All she can say is, "What's wrong?" with the characteristic affectionate roll of her eyes. "I'll come and get you, but you've got ages yet!".

When I wake up, I am hysterical. Mum comes rushing into my bedroom when she hears me wailing, perches on the end of my bed and strips my sweat-drenched sheets from me.

"What's wrong, Fern?!" She is panicked herself, no idea what has happened.

"It was so real!" I scream without context, still halfway between sleeping and awake. "Nadine just spoke to me in a dream, but it was real! It wasn't a dream mum! She said she'd come and get me, but I have ages." I collapse into her lap as she wipes my hair from my clammy face, the way she's done many times throughout my life. She holds me until I fall back to sleep.

When I wake again it is midday and I am calmer, a new dream

I can't recall having replaced the immediacy of the last. I roll to my side and unlock my phone, open Spotify, try to search for a song that will soothe me. At the top of the page is a sponsored advert for Florence & the Machine's new song *Only if For a Night*. I press play, lie back and close my eyes. The lyrics make me sit bolt upright. Nadine is surely speaking to me again. There's no way this can be a coincidence. The first verse:

> *I had a dream about my old school*
> *and she was there all pink and gold and glittering.*
> *I threw my arms around her legs, came to weeping.*
> *Then I heard your voice, as clear as day*
> *and you told me I should concentrate.*
> *It was oh so strange, and so surreal*
> *that a ghost should be so practical.*

I open Google as the chorus plays, to searching the lyrics so I can be sure I'm not going mad. Second verse:

> *And the grass was so green against my new clothes*
> *and I did cartwheels in your honour, dancing on tiptoes*
> *my own secret ceremonials before the service began*
> *in the graveyard, doing handstands.*

The first verse essentially describes my dream and the second illustrates the last day of Year 10, when we had her leaving lunch on the grounds of the school before Final Mass. The wailing refrain before the final chorus confirms this to me:

> *My darling, my dear, my darling—tell me what all this crying's*
> *about? Tell me what all this sighing's about?*

Baffled questions, echoing the confusion Nadine showed towards my sadness in the dream. I am hurt that her ghost doesn't understand my grief, but happy she has agreed to pick me up and

drop me to the other side when it's my time. *I wish I wrote this song*, I think. It's the only tangible thing that has effectively conveyed my grief, in the moving lyrics and haunting music. *Maybe I should write about her?*

It is only a fleeting thought.

A compulsory module for the first year of my English degree is Poetry. I'm not a fan, knowing only those dusty GCSE ghosts from the Norton Anthology: Carol Ann Duffy and Simon Armitage (forgive me, literary ancestors—I have since changed my ways and am a Duffy fan). In class the following week, our professor sets us an assignment to write a poem about an animal. I groan subtly as I pull out my pink notebook, suddenly understanding why my supervisor at the dance studio (the one I first told when Nadine died) jokes that I'm a member of the Mickey Mouse Club ever since I told her my required reading for the first semester was *Alice in Wonderland* & *Peter Pan*. This is not my thing at all.

That evening, I return to my measly box room with its breeze-block walls, lock the door and sit down to write about... what? I'm not an animal lover. The only poem I've written about an animal was in primary school when I compared my mum to a dove. I sit down at the uncomfortable wooden dining chair that comes with the room and slide it under the in-built desk taking up the entire wall beneath my window. I pick up a pen and stare blankly out of the window, motivation eluding me. The lyrics to *Only if For a Night* pop into my head again.

Instead of an animal, what tumbles out of my pen is lines and lines of Nadine. Unable to bring myself to correct my course, I give in to it. After ten minutes I'm in a trance, finding motivation only in focusing on the person whom my mind takes me to

on an hourly basis anyway. I practice my neatest handwriting so as not to do her a disservice. This adds minutes to the task but I soak it up, wanting to remove myself from reality entirely. Poring over each word takes me deeper within myself, and that's just the notetaking. Two hours go by. I spend another two piecing them together until I am satisfied. I've never studied poetry before this afternoon, have little understanding of technique. Yet by midnight it has loosened something in me, dislodged the lozenge of loss and yearning from my throat awhile. I have appeased something at the altar of my desk that night and released it—light as the wisps of condensation circling above the lake outside my window. Maybe I can get used to this poetry business.

"It sounds like the pure love you had for each other was so rare it could be bottled and flogged to the masses," my on-site bereavement counsellor responds after reading my poem.

I've agreed to take counselling to help with the grieving process, under the instruction of my professor. I sit opposite the strange, bespectacled man in a highbacked tweed armchair and say nothing in response, but manage a smile because I can't help but find such a notion beautiful, and that's something—a rare moment of sentimentality from a medical professional, assuring me my poem has worked. It had served its purpose: a stranger understands the bond Nadine and I had. I can see myself using this way of healing with other heartbreaks and in that moment, vow to myself that I will. True to my word, I write dozens more poems that year, alchemising hurt into stanzas and eventually compiling and publishing my first collection with Lapwing, an independent Irish press. Because it isn't just the death of Nadine that throws me out of whack and inspires me to write.

Mere months later, round the corner of my life, comes a girl. Of course.

I never go back to counselling.

CHAPTER
18

Purple—The Third Woman

P URPLE IS OLDER than me by just one year but has lived many lives by the time we meet. She is indirectly introduced to me through Nina, one of my friends at Bournemouth. They run in the same social circle on the club circuit; Purple is a door girl for several bars on the strip and Nina is out most nights, enjoying the full student experience. She thinks Purple will be just my type. By this point, my friends have all decided I'm a lesbian and I've finally accepted – I didn't even need to come out to them in the end.

My friends pride themselves on knowing my type because I've been vocal about it since the days of my 'sisterly' obsessions. In theory, they are generally right. Short. Brunette. A suggestion of evil in the eyes. Fangs or some quirk of the teeth are a bonus. A vague impression of taking no prisoners, be that in their attitude or an air of mystery around them. But in reality, it's rare I fancy the girls that my friends suggest to me as potential dates because the points above are not always necessary, not an exhaustive list and on the rare occasion they are met, the ratio must be just so. Not superficially, but chemically. The odds of this are the same as the sperm reaching the egg.

But on this occasion, Nina is right. She shows me pictures of Purple, who is dark-haired and petite, with dimples so deep it looks like an ice cream scoop has been set to work on her cheeks. Purple wears only black but her older photos hint that this hasn't

always been the case. The bright, garish colours of her outfits in previous years give the impression she lived a carefree life that has since been abandoned. As I flick through them, I feel a sense of loss over something I never had, like the bud of her naïve frivolity was nipped just moments before I heard news such a garden existed. I am curious immediately and want to gather as much of her as I can while there's still time. She oozes a sophisticated, *film-noir* type glamour; the kind a movie-star wife is gifted the moment she opens the door in her satin nightgown to find out she has inherited her husband's millions. I imagine there is a side to her that has recently been lost—a side I'll never get to see—and that it's with a regal resolution she now dresses in monochrome to quell the murky waves of sombreness beneath her surface. In my usual fashion, I want to save her, find out what has caused her to harden, to swap her lilacs and limes for charcoal and onyx. I make this hefty analysis while stalking her social media, which is what I mean when I say Nina shows me pictures. That she sends me a link to Purple's Facebook account.

I send her a friend request and forget all about it until she accepts the next day. With consensual access given, I immediately like a few of the photos I'd seen the day before, commenting on an old picture of her wearing a luminous pink cardigan with black hearts for buttons, telling her I have the same one. She'll know how deep I'm diving into her account from how long ago the upload was, but I don't care. I'm miserable and lack inhibition.

A message arrives in my inbox.

"Do I kno u?x"

I reply, "No...we've got mutual friends and I like your pics :)". Nothing wrong with a little flirtation from a cyber stranger, I think—I'm audacious enough to own it. She seems to appreciate this, confessing she has looked though some of mine too and especially likes the one of me holding cupcakes.

"Are they from that Angel Bakery where you can also buy red velvet?" she asks.

We continue the back and forth, asking each other the basics

like where we grew up and what we are studying until our first conversation draws to a natural end, sealed with a mutual kiss.

A week later she blocks me out of the blue and sends Nina an indignant Facebook message warning her not to give her social media profile out to people she doesn't know. Purple has figured out who our mutual friend is, and it turns out she doesn't know Nina that well at all. They've said hello on nights out but that's it. It's understandable she feels her privacy has been invaded, but given our friendly conversation, I find blocking me a little harsh. Still, I shrug it off as I know my approach can be deemed too forward by those who have yet to meet me.

First year of university comes and goes, I guess, although I forget how. Determined to get out of the gunmetal garrison of my own student accommodation with its wet slate, filter coffee and library lunches—where I feel like a character in *The Others* who can never leave and is eternally eating dinner alone by candlelight and then going to bed on a loop (isn't that the most depressing part of *all* movies based in a haunted house?) - I decide to move in with my sixth form friend Alicia and her three university coursemates for second year. The house is thirteen miles away from Roehampton, in Bow, where I know I'll have a better chance of being thrown into life headfirst. Youth is wasted on the young and all that, and I'm desperate to snap out of my malaise. Alicia is arguably the coolest of my friends, consistently up to date with fashion, make-up and everything to do with the zeitgeist. I have so little energy left that all I want to do is absorb some of what she has through osmosis. She has all the boys (and girls) after her and is out almost every night because she works in a bar in Mayfair. I know that living with Alicia will provide the immersive student experience I need and give me a glimpse of what I too can milk from my fading years of student freedom, if only I can believe I deserve it.

On the day I'm to be shown around my new area, I emerge bright-eyed from the steps of Mile End underground station to be greeted by Alicia on a Raleigh Chopper, dressed in a red panda

kigurumi. I'm satisfied already. This is exactly what I need, to be surrounded by the kind of levity belonging to students who wear onesies in public because they don't care what people think. These kids have no time to spare on things as heavy as the death of their beloved dance teacher many moons ago. Alicia gives me a backy through the sunny streets of Mile End to show off where we'll be living: on Purple Lane, just off Roman Road Market. The name of our street is not lost on me—another indicator to the trajectory of my life—and as she hitches the bike up to a wheelie to turn us onto our new road, I grab her waist and wonder if I'm living in a lesbian sequel to *The Truman Show*.

I move in for good on the night of our housewarming party. Turning up with the last of my suitcases when it's already in full swing, I am greeted by a kitchen of people I don't know and a proud announcement from Alicia that we've already been issued an ASBO by our neighbours. Wheeling my luggage through the kitchen, trying my best to avoid toes, I stop to say hello to two people from sixth form I haven't seen for years and struggle up the thin set of stairs. My room is the second smallest in the house, incredible luck considering I'm usually given the smallest because I don't complain. Fortunately, that one has already been allotted to one of my housemates in exchange for lower rent because it has no window. I'm content with my lot. Granted, there is a huge blood stain on my mattress (size suggesting more murder than menstruation) and a witchetty grub languouring in black goop in a coffee mug left by the previous tenant on one of my shelves. But as far as I'm concerned, I've been thrust in the middle of *This is England*, or another gritty British drama, and that's all I want. I head back downstairs after dropping off my stuff, help myself to a drink in my new kitchen, and in no time at all am kissing a stunning girl with pink hair and glitter on her face who looks like a mermaid. So far so good.

This home becomes my saving grace during second year, even though my daily commute is now three hours long because I have to travel from Mile End to Putney for lectures, with a detour to

Bond Street on the days I work at the dance studio. By contrast, my four housemates attend Queen Mary University which is just around the corner from our house. I don't resent this. My experience is still far better than the year before and as long as I can come home from my daily pilgrimage to Alicia in her master boudoir—her array of Mac lipsticks sprawled across her dresser—and listen to stories about her latest conquests while she gets ready for a night shift, I am content. I live vicariously through her and am welcomed into my favourite position as sidekick, a Kit to *Pretty Woman*'s Vivian, minus the prostitution. Alicia is equally the cat that got the cream, because this means she now has someone to read ancient Greek mythology to her on demand while giving her massages. As I sit straddled over her butt on my first weekend in Purple Lane, smoothing baby lotion into the Day of the Dead tattoo on the base of her spine with the *Penguin Book of Classical Myths* cracked open and held in position by my knee, our housemate Annika bursts through the door and cackles "Bloody hell, it's game over for you now Fern. She's got you under the thumb already. Took all of five minutes."

Despite having my own room, I spend most of my time in Alicia's at her request. She demands my company in a bratty way that makes me feel wanted. I buy a kigu for myself, as well as my own purple and pink Chopper from eBay which I ride back from the seller's house in Brick Lane.

"Look Fern, our bikes are kissing!" Alicia calls from the living room, as I park mine nose to nose with hers in the corridor. This abundance of platonic affection in our libertine squat lights a candle in my belly and it is in this way that I start to heal, through the powerful antidote of youthful chaos and collective oestrogen. I even start to study at QMUL on the days my commute is too daunting. Eventually my own coursemates wonder if I've dropped out altogether.

"She doesn't even go here!" Annika yells at me from across Queen Mary's library as I open my laptop to study. And by study, I mean log onto Facebook.

A friend request and a notification is waiting in my inbox.
"HELLO X"
Both from Purple. *Really?* What has prompted this all-caps turnaround? Mercury Retrograde? A New Moon? A change of heart, or simply boredom? Who knows, but I'm pleasantly surprised. Too embarrassed to reference the elephant in the inbox of my recent blocking.
"You good? x" I reply.
"I'm all good thank you. What have you been up to? Carnival? x"
And so I am forgiven. For what I don't know, but she forgives me all the same.

Each morning for the next year and a half, I wake up and fall asleep to a message from Purple. That first day, when she re-added me after my absolution, she jokingly suggested we move in together after our conversation naturally segued into a discussion about interior design and revealed we both had the same taste and ideas about what a home should look like. The easy intimacy was immediate. Within less than a month of speaking, we've clocked up over three thousand Facebook messages and have bonded over our shared interest in Tumblr, K Pop, and Afrikaans music group *Die Antwoord*. We set up a joint Tumblr account called the Doppleganger (sic) Archives, as that is what she has decided we are: twins, soulmates, whatever you want to call it. She picks up where I left off in that she is as immediately forward as I was in my initial message. There is an unspoken intrigue between us. I have no idea what has brought her back to me, but I roll with it. When I'm not sleeping in Alicia's bed, Purple and I fall asleep to David Attenborough documentaries on Skype—not my vibe, but the audio helps her sleep and I like being included in her bedtime routine. The sound of the ocean is soothing.

It is generally trickier to ascertain the nature of a relationship between two women than it is between two men. Broadly speaking, female friends tend to go deeper quickly, and—as I know too well from my school days—are not averse to kissing each other.

Purple tells me she even shared a bath with her best friend not too long ago. Existing in this limbo as a lesbian (me) and bi-curious girl (Purple) makes it difficult to pin down the exact moment our friendship toppled into something more. Perhaps it was more than a friendship from the beginning; at least I had ulterior intentions. Considering I slid into her DMs years before it was a 'thing', the fact we narrate every detail of our days to each other, and that she had already blocked and unblocked me (this usually doesn't happen until at least three months into an early millennial relationship), I think it's safe to say we start our cyber acquaintance knowing 'what the deal is'.

Purple opens up to me about her reason for wearing black (a natural progression since her grandfather died several years ago) and confides in me about her claustrophobia and paranoia (which alleviates my concern that the blocking was personal). We soon have our own songs, including the very unsubtle and corny *Insatiable* by Darren Hayes. It's obvious this isn't just a friendship. I look forward to coming 'home' to her every night after an evening shift, knowing she'll be waiting for me online with questions about my day and new films to watch via shared screen. But I'm so inexperienced, I'm unsure what to make of our bond, scared to approach the topic head on in case I break the spell. If I've got the wrong idea, I'm happy to keep it that way, as long as things stay the way they are. The confusion makes me fancy her more.

Four months into chatting, when our messages are well into the five figures, we agree to meet up. Purple is coming down to London for her friend's birthday at a nightclub Alicia regularly attends, and invites me along. I persuade Alicia and our friend Mercedes to join me. My hair is dyed dark red for the occasion and Alicia lends me her favourite vintage windbreaker for luck.

We're in the queue for the club when I first see her. Darting across the road in high-waisted black disco pants, a cream top and heels, is my Purple. As she calls my name and runs to me, my understanding that we are more than friends cements. We cling on to each other a little too long, too shy to look at each other just yet, letting our bodies communicate for the first time. She finally holds me apart by my shoulders and takes her first good look at me as I catch myself dizzied in her scent—an invisible cloud of Chanel—the first tangible evidence of her existence outside my laptop. I'm unable to hide my grin and she puts her hand over her mouth to staunch her own. There aren't butterflies so much as jellyfish lazily thwacking against the unrelenting waves of my stomach in a thick, slow tide. My fantasy has become a reality. All those months, all that longing, and here she is in front of me. Maybe with this one, this time, it will be different.

I introduce Purple to Alicia and Mercedes who are watching the whole scene with bemused astonishment ("this scenario of falling for someone you barely know is so typically *you*", they laugh when Purple is out of earshot) and she leads us to the front of the queue, holding me by my wrist. Her friends are already inside, so we descend the stairs. Her boyfriend offers to buy me a drink.

Yep, that's right. Purple has a boyfriend, and I know it. In my (weak) defence, we have never been inappropriate with each other beyond allusion and suggestion, and I don't yet know 'what this is'. This is my first rodeo and I want to find out what goes down in the arena. I accept the drink from her boyfriend with a pang of something like guilt which I quickly brush under the carpet before it threatens to ruin my night. I quickly justify my predicament in my head: Purple has feelings for me, I'm sure of it, and I'm still a fucking Virgin at age twenty. I, at least, deserve a Disaronno.

She introduces me to her friends, then I follow Alicia and Mercedes to the dancefloor. Purple abandons her group to join us. I choose to stay next to the speaker by the DJ booth so the bass in

my chest can drown out my pounding heart, but it only amplifies when she comes close to me; the mechanisms syncing, heightening my awareness that I am alive. Our bodies are *almost* touching and all I can smell is Chanel. Purple doesn't end up going back to her friends and stays with me for the remainder of the night. Less than an hour later the silhouette of her boyfriend disappears around the corner of my peripheral vision as she tells him she's not coming home. This is my Green Light. As soon she is back on the dancefloor and the coast is clear, I push her up against the wall and bite her lip. She hesitates briefly before kissing me back, a childish smack, brief tongues and then withdrawal.

"I don't do this!" she laughs, but kisses me again, harder this time. I don't say anything, but a grin cheats my composure as I pin her arms above her head.

The rest of the night passes in this way—an inebriated, blissful fuzz, that gorgeous dance of apprehension and certainty. When the lights come on to signal that the club is closing, we traipse up the sticky steps to the exit. A guy propositions me on the stairs. I ignore him.

"Oi, love!" he shouts after my retreating back.

"Excuse me, she's my *girlfriend*." Purple yaps back, batting him away before running up to join me. She can't see the grin on my face in the dark of the stairwell even though it's brighter than all the lights in the basement. We spend an hour kissing outside, in nooks between buildings and again at the bus stop waiting to go home. I'm not thinking about the fact that, instead of in my bed, she will be staying with her boyfriend tonight. Mercedes plays a respectful third wheel, engaging in small talk to remove any awkwardness while at the same time reminding us she's still there. Alicia is long gone.

The next morning, adrenaline still coursing through my system, I wake up with an ache that isn't just a hangover. I've seen her now, put a scent to her name and I know for sure I am attached.

She has a boyfriend.

What's worse is that I've met him now, so I can no longer

delude myself to his existence. My phone pings and I roll over to read Purple's message with one eye open, my head pounding.

"Come to Bournemouth tomorrow—I'll cook for you and we can watch Amelie? X"

This is everything I could have hoped for after waking up with The Fear. It's a Bloody Mary for my nervous system, a continuation of last night, proving that none of this was a dream. But where I should feel elation, there is only powerlessness. I'm in too deep and the video game is over, the bubble now burst. Already in full catastrophe mode, I can see our entire story spread out before me: I will be left heartbroken because Purple is not emotionally available. I've never been in this situation before, so as far as I'm concerned the power is all hers. It is at this moment that I make my first mistake in love and create a pattern, to be unfortunately repeated many times throughout my twenties. I erect a barrier to protect myself, wanting Purple to bang it down, but which only pushes her further away. I text back:

"I don't think that's a good idea"

No kiss, no further explanation. I can think of nothing better than watching Purple's favourite movie in her home while she makes dinner for us – roleplaying a real relationship for the first time - but I intend to take no further action until I have her all to myself. Of course, what I really want her to do is resist my refusal and assure me that now we've kissed, she will break up with her boyfriend and belong to me. I don't consider that my reply could be seen as just as much of a headfuck. To her, it may look like I got what I wanted from her and am now preparing to ghost. But what I've not yet said in our tens of thousands of messages, is that I've been falling hard for a long time, and as soon as anything were to happen, I would undoubtedly want more from it. I worry she is leading me on, deepening our connection when the possibili-

ties of what she will do with it are entirely in her hands. Half of me expects that now she has also put a scent to *my* name, she will realise she cannot live without me or our round the clock phone calls and must exit her straight relationship immediately. How am I to know that's not how this works? I've never even had sex.

I ignore the part of me that wants to tell Purple how I feel, even though doing so would maintain the direct approach and transparency that probably attracted her to me when I first sent her a friend request. I know that even if telling her how I feel doesn't get me the reaction I'm hoping for, at least I'll be put out of my misery sooner, but I'm too scared to taint our bond. I'd rather be aloof and have her come to me with intrigue, than tear down any illusion prematurely with what I'm terrified will be perceived as clinginess. Purple has inadvertently dragged me up from grief for the past few months, giving me something to look forward to every day instead of wandering the streets of East London like a ghost, thinking only of my dead teacher. I don't want this to end, whatever it is.

I knew we shouldn't have met. She'd once sent me a Tumblr image in the style of an aeroplane's health & safety manual, depicting two cartoon doppelgängers seeing each other for the first time: a glitch in the matrix, the murder that followed, one standing over the other with knife in hand, surrounded by a pool of blood. *Why you should never meet your doppelgänger,* was the caption below the illustration. We toyed with the idea of staying cyber friends in case we upended the chemistry, but all this did was serve as foreplay. Up until now it was easy to disregard the fact that I saw her more in that liminal space between sleeping and waking, or lit by the manufactured moonlight of her computer screen.

Why?x she texts back. (I know she's not stupid and that by refusing to show emotion, she is pressing me to divulge more) but I give her a vague answer and turn off my phone. I watch *Amelie* alone in my room that evening while listening to the *thud thud* of Alicia and her own girl sleeping together through the paper-thin

walls next door, separating us with a locked door for the first time since I moved in.

Purple and I become more distant and less intimate after that. We still chat every day, but unable to hide my frustration at the perceived injustice I've been subjected to—in that she's having her cake and eating it—I am prone to abrupt responses and sulking, which stains our connection. She knows me well enough by now to pick up on my resentment through mood alone but pretends it's not happening. Of course I am relieved that meeting me hasn't put her off, but I want things to change. I fight the urge to hammer *LEAVE HIM FOR ME* on my keyboard each time we speak.

On the contrary, she starts to mention her boyfriend more and more, and by a cruel twist of fate I discover that he lives on the road adjacent to mine despite the fact she lives in Bournemouth. What are the bloody odds. The night we met, we would have unknowingly slept a stone's throw away from each other. She doesn't hesitate to tell me when she travels from university to visit him, failing to stop by mine even when we've been texting all day. My housemates start to disapprove of her when they see the way I sob my heart out each time she heads back to uni without so much as a knock on our front door. I wonder if name-dropping her boyfriend is a provocation tactic of Purple's to coax me into confessing my love for her, or if she is doubling down on her position as someone's girlfriend in order to absolve herself. Is there regret about the night we met, or is she simply as conflicted as me? I'm too scared to find out, so I create an argument out of something small and tell her we have to stop speaking. Three months of radio silence follows and in her absence I grow cold (which may also have something to do with the fact we've run out of money for the electricity meter).

In the fourth month, I am warming myself with a hairdryer under my covers at 3am when my phone pings. I flood with adrenaline when I see her name on my screen for what feels like the first time in forever. All the scents and images and emotions I equate with the night we met wash over me at once.

I miss you x

My body instantly heats up. I smile to myself, roll over and close my eyes. The ball is back in my court. She knows what she has to do if she wants me to respond.

CHAPTER
19

DESPITE MYSELF, PURPLE takes my Virginity six months later.

I am celebrating Nina's birthday at a restaurant in Bournemouth when Purple texts a mutual friend for confirmation that I'm there. She's seen I've been checked-in on Facebook, but I still haven't responded to her text from half a year ago so this is the closest thing she's had to contact from me in all this time. I've carried her around like a pebble in my stomach and trying to hide my delight in her shameless interest is futile. The more cocktails I drink the less I succeed, until the protective barrier of our friend has fallen away and we are directly texting each other.

On the Jägerbombs in between messages, I have a flashback: crying to my mum about my self-inflicted separation from Purple back when it first happened. She had comforted me. "You like her, Fern. She likes you. You're twenty. *You're* single. It's not your problem that she's not. Be a bit selfish and do what you want to do for once." Deciding in this moment—with the help of the shots, no doubt—that being dishonourable with my mum's approval is better than being drunk and miserable with what I want right at my fingertips, I decide to forget about our disagreement and unlock the chastity belt of morality and resentment from around my waist. I allow the lust to build in my stomach when she messages to say she will be with me in half an hour. By midnight, the whole party, including Nina, are smashed and can-canning obnoxiously in the street, yelling, "Purple is gonna see Fern! Purple is gonna see Fern!"

All I remember from the rest of the night is standing straddled over her in Nina's guest bedroom, both of us in hysterics because I am wearing pink fleece heart-print pyjama bottoms. We laugh the whole way through my first time, then my hormones breathe a sigh of relief, unwind like a playground swing, and I promptly start my period.

Purple and I continue like this for over a year, sleeping with each other both in and outside of her relationships, which I am not proud of, do not recommend, and from a selfish point of view isn't for the faint of heart. It's a slippery slope. I rationalise my behaviour to the gods until I am the person I promised myself I'd never be. I continue to go quiet or moody whenever she mentions her boyfriends or when I feel I'm giving too much of myself away. Sometimes we sleep together when she's single and I'm renewed with pathetic hope. Just once, the hope is justified. After ending things with the first boyfriend of our clandestine era—the one who bought me a drink—she calls me at midnight during one of my all-nighters at Roehampton library and asks me, "Are you happy now? Because that's the main thing." I foolishly believe she has dumped him for me. But because I am still not bold enough to ask her to be mine and lack such self-esteem that I can't bring myself to believe she ever truly wants it, enough time passes for there to be another boyfriend. And another. She never asks me to be hers either, which confirms what I have always feared - it's never going to happen. Neither of us are proactive enough with our communication and I am too invested to call another ultimatum because I can't see it through. I am weak without her. Purple has already made me aware of her nihilistic outlook: she sees the finish line of all relationships before they begin. In my weaker

moments, I naively consider this a compliment. That she won't commit to this because she never wants it to stop.

Still, her university town remains a Mecca for me. I continue to visit her regularly—masochist that I am—and she creates cute itineraries for us involving dim sum and vintage tea shops. Her uptown rented apartment, with its high ceilings and huge sash windows, sprawls across one floor of a Victorian townhouse. She has a penchant for tacky, religious memorabilia, particularly any-thing to do with the Virgin Mary, and her room is full of knock offs—probably one for each of her sins- so that by turning her boudoir into a Church she can atone for cheating. I feel adult when visiting her home because she makes Japanese dishes from scratch while I still haven't taken my cooking expertise further than grilling a salmon in tin foil with a slice of lemon on top. She also makes us dumplings and I joke that they are the scooped-out insides of her cheeks. I get lost envisioning our fantasy life in that house together, by the sea, where even popping out to buy milk would be the most exciting adventure because I know we'll be coming back to the equivalent of an antique store; everything in her bedroom so pretty and Renaissance-inspired that it trans-forms us into characters from a Sofia Coppola film.

The fantasy never lasts long. I've developed a tedium towards the nervous pride that prevents me from broaching the subject of our illicit affair and eventually, each time we separate it gets eas-ier for me to cope with the idea of things ending, if only because my ability to cope with a repeat has weakened. The length of each time we are apart correlates with belief that this time we may have reached a full stop, rather than just another comma or ellipsis in our relationship. I tell myself I'll be okay with it. We never stop messaging, though. Always physically find our way back to each other.

A nightmare: Purple is a doll falling apart at the seams. A dress-maker tells me that in order for her to live, I have to love her back together. The pain of losing her in my sleep is bottomless, which wakes me up with the shocking epiphany that I love her enough to die. I have not yet gone so far as to admit this to myself while awake. Infatuated, yes, but not in love. My mum tells me love isn't love until it's reciprocated, and I have never felt secure enough about my position in Purple's life to call it that, even though I'm the person she spends most of her time talking to. Still, the night-mare upsets me so much that I sob when I wake. I resolve to make love to her on an entirely different level the following weekend so that I can show her how much she means to me. I vow to honour every inch of her without the fear of her falling apart on my lips like sugar the way she did in my nightmare.

Reality: It's as if this dream has wrung out the last drop of my exhausted passions—in the same way a dying person gets a sec-ond wind before they pass—because that weekend, the sex is the same as always, she doesn't put her arm around me afterwards, and I am so, so tired. The boring reminder that I only have a fifty-fifty chance of a morning cuddle doesn't cut it anymore. It's a human right—to be touched—and I know I deserve better but am still too shy to instigate affection after *eighteen months*. Post-coital tristesse is now default and always having to leave has finally chipped away at me enough to reach a wick of self-respect. We get dressed in silence before I order a cab to take me to Nina's, arrang-ing for it to drop Purple off to her boyfriend's on the way. My veins itch with apprehension because my mind is made up. The cab pulls into Nina's road when I tell her, hand in mine, that this will be the last time.

She says nothing at first, as if reaching inside herself to pull out everything unsaid over the last two years. Then finally, her usual, "Why?"

I roll my eyes discreetly. *Not another open question. I'm bored of doing all the explaining.* It's funny really, and sad, because I've

never been brave enough to explain much at all. But she answers her own question before I can respond.

"Okay, I get it." she responds to my invisible answer. "But. If you ask me to be your girlfriend in a few months, it might be different." This would have been music to my ears if it was any other day than this, the day my faith faltered and my body made my decision for me. This is the first time since our phone call in the library that her words have held even a scrap of promise. But the novelty of the push and pull has worn off. Staring straight ahead through the windscreen, I answer for the last time.

"I don't think so."

Opening the car door, I kiss her forehead and shut it on our story. It's all so weird and upsetting. We smile and wave goodbye as if it isn't happening. Perhaps she doesn't realise it is. I've pulled this stunt before; only I can feel the difference in the internal shift.

I spend the following months in a general malaise. Without her round-the-clock phone calls, all I have to think about during my walks home alone under the ink blue sky of Autumn, is my girls waiting for me in our cosy rented glow to remind me that she's bad for me. The smell of smoke from the stalls on Roman Road market reminds me of her, as does everything, because my whole life here—even down to the street name—is stained in her colour. I even miss the self-righteousness and indignant adrenaline that would course through me whenever she hurt my feelings; a mild but sweet Stockholm Syndrome. I feel the occasional shock of anger that she couldn't say she loved me, when I'd heard her casually shout those very words to our mutual friend after a drunken night out, even though that friend hadn't kissed the upside-down smile above her navel like I had.

And then slowly, I get over it.

We stay friends, because when you lose feelings for someone you were never officially in a relationship with, there isn't enough mutual emotional history for the friendship to stop without it coming across like one of you is bitter. I have too much ego for

that. Besides, our relationship was founded on having many things in common.

The week we ended, I read a word in the dictionary while looking up something for an assignment at the library. *Razbliuto*. A Russian word for the bittersweet feeling of no longer loving someone you once did. The word rhymed with her surname. That was closure, I think, finding the word to describe my feelings. Words have always been my way to heal. The resentment I had for Purple eventually fades. The fire burns out, like the faint scent of bonfire you can generally find in the East End.

CHAPTER
20

Red—The Fourth Woman

"THIS IS EITHER going to be the best day of your life, or the worst." are his parting words.

Vangelis and I are in the Eurostar departure lounge at St. Pancras International and I'm about to board for Paris with just six euros in my pocket. He announces his farewell with typical glee, because if this goes wrong, he'll have new material with which to mock me.

What's prompted my impulsive decision? A woman, naturally. But not just any woman.

"The One."

And she has no idea who I am.

It's my final year of university. This means one thing: dissertation. Or rather, that I sleep all day and stare at my computer screen through the night until my eyeballs resemble a pair of plasma globes. I've moved back home with my parents so that the social life I've now grown accustomed to can't distract me during final exams. It's during one of my witching hour laptop binges, laying horizontal in bed and watching hip-hop music videos on YouTube back-to-back, that I first see her. On the thumbnail at the top of the "Related Videos" list to the right, is who, at this time, I can only describe as the love of my life. This is an immediate, absolute comprehension; pure thought that comes fully formed before I have time to taste it and roll it round my mouth

like a gobstopper. I don't even have to click on the video to know. Yet still, I click.

She isn't merely my type. She is the prototype. Here is the result of the recipe God whipped up for me, made up of every detailed fantasy and fleeting whim that's skated through my mind since the day I was born. Each minute detail of all the women I've had a crush on throughout my life have been brought to the boil to create a reduction—no, a promotion—in the form of my perfect woman. I'm studying Ovid's *Metamorphoses* this semester; about a King called Pygmalion who is made into a sculptor and carves a statue of his dream female before bringing her to life. The sculpture turned woman is named Galatea. The name of my own Galatea, I learn, is Red. Red is the lady in the blood-coloured dress on the side of the road at sunset when I was a child. She is the woman who made me cry while attempting to sell me Bang Bang chicken in Camden market. The sad, drunk girl, teetering in her high heels and gold dress, who I wanted to save at a Halloween party when I was ten. Gwen Stefani posing for her mug shot in the *Let Me Blow Ya Mind* music video. Devon Aoki as Miho in *Sin City*, the claret spurting across her poker face as her victim bleeds out. She is Juntao from *Rush Hour* (sometimes my male crushes still find a way to sneak back in). She is everything.

No physical description can do her justice, so let me just say this. She is olive-skinned with dark, shoulder-length hair and a choppy fringe. In the video she wears a baseball cap backwards and (questionable) bright blue eyeshadow. There. The aesthetics of my heart's interior, realised for the first time.

My certainty reads as frivolous and I can already hear how it will sound to others. I hate being misunderstood so I'm pre-emptively frustrated that no one will understand how I can fall in love at first sight with an avatar, but to me it makes perfect sense. At an age where I'm on a quest to solidify a sense of identity, I feel I've suddenly found all the answers I need in this human on YouTube. The relief is immense; like my life's work is done and the living can begin. No more golden days in the calendar because now every

day is bullion. My understanding is omniscient: I *know* she was lined up for me long before the seventh day of creation. If anyone asks me who or what I believe in, all I must do is show them this video. No words needed. All attempts to express it in language will be hyperbolic and won't translate.

I try to, though, on a trip to visit Alicia in Spain (she lives in Madrid now, with a girlfriend and a dog).

"This is The One," I tell her, prefacing the story.

"Get a grip!" she laughs, rolling her eyes. "Such a *you*, Fern! Even if you do manage to meet her, what are the chances that something's actually going to happen?" I quickly learn the art of shutting up. But I'm fully aligned with this desire; there's not an atom of resistance in my body. This girl is the reason I've been born and there is nothing on Earth that will stop me from manifesting her into my life.

Red is a drummer from Canada. She's in a band and I've soon binged all their music videos. Google tells me they'll be touring Europe in a few months and performing in Paris on her birthday. My next student loan instalment isn't due for another month and although the show is free, a Eurostar return to Paris is £150. I can't afford it. Whereas in any other situation this would disappoint me, I don't feel disheartened at all. It's remarkable how the mere existence of this girl seems to cure me of all negative emotion. I continue attending my lectures with my earphones in, listening to her drumming as I copy down notes on Greek myth.

The night before Red's birthday, I'm on MSN despairing to my friend Josh, who has heard all about her (for his sins).

fuwarifern: I can't believe we'll be on the same continent on such a poignant day

even SNOW is forecast

how romantic

yet I'M NOT GOING

how can the universe line up such perfection and fail to invite me?

jgm: check your online banking

fuwarifern: what

why

omg

JOSH. £300??? Omg no you can't be serious

jgm: yes I can

you can pay me back when your loan comes through

go and get your girl.

fuwarifern: £300 though?! The tickets are only £150

jgm: the other half is for a hotel...

fuwarifern: wow

I hadn't even factored that in

I would have been happy to just wander the streets of Paris all night until the next day

It would add to the adventure lol

jgm: lol. You're nuts.

fuwarifern: I honestly cannot thank you enough. This is the best thing anyone has ever done for me.

jgm: <3

I lie to my mum and tell her I'll be staying at Vangelis' the following night, that there'll be no need to save me dinner.

The next morning, the most important of my life so far, I wake with the sun, my luggage already packed. The Eurostar will be leaving from St. Pancras International at 12pm sharp and the journey is only half an hour away from my house by tube. At 10am, I head to the off-licence for a pack of cigarettes.

"20 Marlboro Lights please."

The man behind the counter slides back the shutter to reveal his tobacco wall, picks the white and gold pack from the shelf and thwacks it down on the desk.

"What happened?!" He gestures incredulously towards my outfit. It's a pair of jeans, red lipstick, a black beanie and an oversized black t-shirt that says *I WOULD CUDDLE YOU SO HARD*.

"What do you mean?"

"You look nice!"

"Ha! I'm just dressed for once." Usually he sees me with no makeup, in a tracksuit. Sometimes, shamefully, in in my pyjamas.

He says nothing but punches the cost of the cigarettes into the card machine and hands it over to me. I slide the plastic into its slot and hover my fingertips over the buttons, waiting for my brain to guide my hand over the same four digits I punch in every day. But then something strange happens—or rather, doesn't. I freeze. I suddenly can't remember it. A jolt of panic. *How can this be happening? It's been the same number for the past year.*

"Two seconds" I laugh nervously, waiting for my synapses to wake up. Maybe they've been diverted towards today's mission, all other pathways temporarily unavailable. Fuck.

"Fuck! I can't remember it! Hang on." I hang my head back on the hinge of my neck and stare at the dirty ceiling, noticing a brown patch of liquid seeping through one of the gypsum tiles in real time as I tap my right foot impatiently. I try closing my eyes. Screwing my face up. Nothing.

"No worries dear, take your time." The man says.

"I don't have time, I'm going to Paris. Argh! Don't worry about it. Thanks boss."

I slide my card out of the machine and back into my wallet, bolting out of the shop. There's no way I can regulate the adrenaline of today without cigarettes, but what's worse is I need my PIN to retrieve my train tickets from the machine otherwise I'll be going nowhere fast. I rush back home to grab my luggage and call a cab to the Halifax in Camden, the branch of my bank that's nearest to St. Pancras.

Inside the building, the queue is long. Too long for a Tuesday morning. I wonder why this many people aren't at work while I queue for twenty minutes. Then a blessing happens, albeit a frustrating one. The moment I reach the cashier and open my mouth to ask her to reset my PIN, I bloody remember it. The four mischievous numbers land in my brain like they'd simply popped out to buy milk. I check my phone. The Eurostar leaves in ten minutes and I'm still two tube stops away. This completely unnecessary detour has made me miss my train.

Already charged up on superhuman hope, my vibration is still too high for negativity. Every cell in my body is conspiring to meet this girl tonight. The idea of bailing is unthinkable. I head to St. Pancras anyway and use the remaining £150 I was saving for the hotel to book the next train to Paris. I'll revert to my original plan of roaming the streets all night, maybe visit the Eiffel Tower at midnight, really add the cherry to the romance cake. The problem I refuse to acknowledge is that it's midday now and the next train to Paris isn't until 7pm, meaning I'll get to France at 9pm. The show begins at 8pm, so by the time I'm due to arrive at the venue, I'll have missed the gig. I don't have room to entertain this, so I convince myself I'll still bump into Red—maybe she'll stay late to sign autographs or to eat at a nearby restaurant. Inherent recognition of a soulmate cements a staunch belief your paths are supposed to cross. In the meantime, I will fill my time by sprinkling some truth on the lie I've told my mum. I text Vangelis to ask if he fancies hanging around King's Cross with me for the day. He obliges, so we kill seven hours eating cake at Carluccios, taking photos, and browsing the shops while discussing how extra I am.

I board the Eurostar at 7pm. Second time lucky. As I plug in my earphones and press play on my favourite drum solo of Red's—on a song called *Take Advantage*—the train pulls away and I settle into my seat with my head on the window. The music starts, bringing with it a tingling anticipation like I've never experienced. I close my eyes, ready to be taken to my girl. Instantly I fall asleep, drained.

When I wake, we're pulling into Gare du Nord. Outside the sky is pitch black, rain hashtagging the windows. I sit up, remove my beanie and massage my scalp with my fingertips to orient myself. My earlier optimism has vanished in my sleep. I'm no longer in my country, my parents have no idea where I am, I have only six euros to my name, and the gig is over anyway.

I dismount the train to the tannoy announcement of *"Bienvenue à Paris!"* Despite the darkness, the air feels bright and cool. Even though it's February, what I'm about to do fills me up with a Christmassy kind of hope. This chance with fate is what life is all about: it's the most alive I've ever felt, the wildest thing I've ever done. I refuse to surrender to any unhelpful thoughts. My brief dip in mood on the train shows me how consistently ecstatic I've been in comparison since I first saw Red on YouTube. I know the feeling I prefer and choose to stick with it. I will meet Red tonight. Mothers have lifted cars three times their body weight of a crushed child when they wouldn't have stood a chance had someone they loved not been underneath. I know what you can achieve when you want something this much. Still, obstacle number three is waiting on the platform to greet me.

I don't know where in Paris the show is.

Schoolboy error. I took for granted that once I was in the city, the universe would guide me the rest of the way with no effort on my part. I run over to a bunch of French boys standing by the entrance to the station, brazenly passing a spliff, backpacks at their feet.

"Excuse me, do you speak English?"

"Yes," they answer in a chorus of French accents.

"Do you know where Nouveau Casino is?"

"A casino? Oui," the one closest to me replies, pulling out his phone and typing "casino" into Google Maps to show me all the different places I can gamble tonight, as if this isn't already the biggest gamble of my life.

"No no, *Nouveau* Casino, a music venue," I correct him.

"Ah. I don't know it." He retypes the instruction on Google Maps.

"It's in Oberkampf. Fifteen minutes train."

"Fifteen minutes? I can't walk from here?"

I have *6 euros*.

"Nooo. Too far." He holds his spliff between pursed lips and points to the barriers at the other end of the forecourt. "Through there. Down the stairs."

"But I don't have any money."

"In Paris we don't bother to pay for trains! Just jump."

"Really?"

"Of course!"

Thanking them, I run as fast as I can to clear the barriers with a high-jump. Three stops later, I exit the station at Oberkampf and run up and down a lottery of wet, foreign streets on a whim with no WiFi or overseas data, aware my chances of meeting my love are depleting with every wasted minute. I'm counting on the universe to take me to the right place. As I race over puddles, my pulse pounding in my throat, I bargain aloud. "I will do ANYTHING if you let me meet Red tonight. Anything. The rest of my life can be up to you if you just let me meet her!" I yell to myself, a crazy English girl let loose in the city of love.

Out of breath, I stop to catch it with hands on bended knees.

"Excusez moi miss, are you okay?"

I look up to see a man hinged forward at the hips, head cocked towards me. I wonder how he can tell I'm English, but don't have enough air in my lungs to ask. Then I remember the slogan on my t-shirt. The man has a kind face.

"Nouveau Casino?" I splutter in response.

The man stands back to full height and chucks his head to the right, indicating that I follow him. I have no better option, so I do, wordless until my breath returns to its usual pace. We walk fast, a pair of Pacman munching our way through Paris to reach my little red ghost. After ten minutes of noticing how he stops at every crossroad and looks left and right as if flipping a coin before choosing a turn, I realise he knows no more than me and is becoming more of a hindrance than a help. Time is of the essence, there's none left for the type of British politeness that doesn't get anybody anywhere.

"Thank you, but please don't worry. I'll find it."

"You sure?"

"Honestly. Thank you."

I pause to get my non-existent bearings. The man bids me well and as he walks away, I see a sign. Literally. Directly behind the spot where his head was, slap-bang in the centre of my Field of vision, is an A3 landscape poster with her name in large, capitalised letters. Life halts for a half-breath. The head of this stranger—who I'm now sure was my guardian angel—had been blocking the inconspicuous entrance to the venue on the corner of the opposite street. He inadvertently led me to where I needed to be. I could KISS him, but he's already vanished.

Up ahead and around the corner, I hear a crowd of people chatting excitedly amongst themselves in French. Crossing the road, my heart rate dancing, I turn the bend. Illuminated beneath the brief lightning of flashing cameras, amidst a throng of fans, I see her.

School taught me that hearts are the size of a fist, still I'm struck by how little my own turns out to be. She is no taller than five foot. This is the only conclusion I reach as I make a beeline for the guy I recognise from her videos as the lead singer of their band and walk straight past her, too nervous to look directly into the sun. I can't believe how small she is.

"Hey!" I blurt out. "I came all the way from London but I missed my train, so I missed the show!"

"Hey!" He drapes an arm over my shoulder, pre-empting another photo request and getting into position. "What?! That's crazy! You can't come all this way for nothing! Why don't you come eat with us? It's Red's birthday." He throws an arm out and gestures towards the heart outside my body, like there's a chance in hell I don't know who she is.

So there I find myself, sitting for Red's very own birthday meal in the venue's restaurant. Thick red velvet curtains adorn a room laden with long, wooden dining tables on dirty maroon carpet, like a poor man's imitation of The Moulin Rouge. There are just seven of us - Red and I the only women - and I am seated at the head of the table. I say hello to her brightly as she takes her seat, and she returns the greeting and smiles politely, but I am so conscious she'll think I'm a groupie who is band-wagoning off the back of them—rather than her future wife—that I don't speak to her for the entire meal. I feel way more comfortable chatting to the lead singer, who asks me questions and seems genuinely grateful for my long trip to see them play. I make an excuse not to eat but order one glass of wine. Very French. I now have two euros left.

Candles are blown, the cake is cut, and as I watch Red close her eyes to make a wish, my own comes true. *How in sync we are already.* The lead singer asks if anyone wants to go outside for a smoke and Red and I step up to join him. This is my chance—it's been an hour, and although I'm conscious she doesn't know me, I also don't want her to think I'm here to sleep with her bandmate. I must talk to her now, or things will get weirder than they already are. As we're putting on our jackets, I hand her a birthday card as casually as I can, and after sliding it out of the envelope and reading the message inside, she lifts her eyelashes to take a proper look at me for the first time.

"Wait. This is you?" she asks, Canadian drawl driving me crazy. Even when she's surprised, it sounds lazy.

"Yeah," I fake nonchalance even though I know what I've written inside the card couldn't be less so. She recognises the message

as it's identical to one I'd posted on her public Facebook group a few months ago: *If I gave God the recipe for my ideal woman, the result would be you.* She'd liked it and commented with a heart. Our first interaction, the perfect one.

"No way!" She's animated now. "Give me a hug!" As I lift her off her feet, the lead singer interrupts. "Where are you staying tonight, English girl? What's your name?"

"Fern," I laugh." "I'm not sure yet—"

"You should stay with us!"

"Totally", says Red.

At the hotel - a small boutique number just off the high street - the boys head to their room to grab alcohol and tell Red to take me to hers, where they'll meet us in fifteen. I follow her through the corridors like a baby duckling, every human emotion rolled into a planet lodged in my throat, staring at the back of her ankles. I can barely speak and can tell she doesn't know much what to say to me, but her pretence that I haven't just declared my undying love for her via the medium of birthday card is charming.

"This hotel is so nice..." is all I can say as she unlocks the door. *In the next five seconds, I will be alone in her room with her.* My vision blurs at the thought.

"It's sweet. It's a shame you missed the show". She lets us in and dumps her bag on the wooden dresser. As she places her keys down on the bedside table, I notice how delicate her hands are, neat nails cut boyishly down to the tips of her fingers. I sit on the edge of the bed silently and watch as she takes her Jordans off, removes a spare toothbrush from her makeup bag and starts to clean the dirt from her trainers with it. This is just the right level of awkward considering we've barely met, and my company has already been thrust upon her. Overwhelmed with disbelief,

I am happy just to sit and watch her plod about, making herself at home. A home I am the first and only witness to so far. She is to me what Brad Pitt is to heterosexuals. She is to me what Beyonce is to straight girls. She is better than sleep, better than iced mochas, better than the first morning drag on a cigarette. I owe Josh my life for transferring me that money.

The group soon join us in her bedroom and the rest of the night passes in a dreamlike, marijuana and alcohol induced haze. Red is propped up on her pillows as the band drape themselves across her duvet and we chat junk for at least three hours. I spend the entire time sitting upright at the end of her bed, addressing her via the mirror in front of me so I don't burn to a crisp like Icarus. I'm so high and in such a state of shock that eventually I start to wonder if I'm dead, at which point I ask the lead singer if I can go to sleep in his room. I don't think I can cope with any more ecstasy and I need to unplug from reality *now* before I combust, so I forfeit the possibility of staying in Red's room for a chance to catch my breath alone.

The next day I return to London with not a penny to my name, but a pack of cigarettes I've managed to procure from a member of the band, my DSLR around my neck, Red's number in my phone and a grin of triumph. The walk home from St. Pancras is five miles (not quite The Pretenders, Vanessa Carlton or even The Proclaimers level of distance, but still) and I have to stop at Nana Jenny's flat on the way back so that she can lend me the remaining bus fare.

Vangelis is affectionately fuming.

Six months later

I wake beneath crisp white sheets, with Red in my arms, and wonder how anyone can think there are only nine clouds. We are back in Paris for her second tour of the year. Over the next four years and with 3,471 miles of Atlantic Ocean between us, we embark on a long-distance love affair. We visit five countries together, stay

in each other's family homes, spend birthdays, Easter, and New Years Eve with each other. Her brother invites me to his wedding in Morocco. Best of all, her best friends become mine and I visit them annually. I'm floored by how sublimely her inner beauty matches her looks, exactly how something deep inside me knew they would. Our relationship is intermittent but blissful, with no drama. Because, as we know from Purple, I can never allow a bubble to burst by asking "what we are,"—especially not the largest, most opalescent bubble yet. Plus, unconditional love isn't ownership. At least that's what I tell myself, of course. However, you can own your situation and show up.

Because if I hadn't forgotten my PIN, I wouldn't have missed my train.

If I hadn't missed my train, I wouldn't have been invited to her birthday meal as consolation.

If I'd used my hotel money for its intended purpose, I wouldn't have been asked to stay.

When life throws obstacles in your path, use them as ramps.

Because in the words of my mother: when you know, you know.

And even when people called me nuts, I knew.

CHAPTER
21

Pink– The Fifth Woman

Pink and I meet at the christening of a mutual friend's child a year before I discover Red exists. I'm drawn in by her eyes of blue zircon—how they twinkle, invite, question and seduce all at once in a disarming kaleidoscope before piercing right through me. We hit it off immediately. So immediately, in fact, that I ask her to kiss me in broad daylight in the smoking area of the Trades Hall, despite the fact we are surrounded by guests and she has just told me she's in a relationship. I've been here before, of course. It doesn't phase me now.

"I can't!" she laughs, with a playful gasp. It's the type of mock-refusal I am used to. She reaches into her bag and pulls out an eyeliner pencil. Taking my hand in hers, Pink turns it over and carefully writes her name and phone number on my palm. I grin. She plants a kiss on my right temple. I can smell her shampoo as her hair swings past my face and grazes my nose.

We reunite the next year—Red now in my life—at the baby shower of the same friend who is now expecting her second child. We've texted a couple of times since we first met but haven't kept in regular contact, so I'm pleasantly surprised when she messages me before the shower, suggesting we go halves on a joint present. We decide it will be fun to turn up together and fool the guests into thinking we've been an item ever since we met at the christening and are encouraged towards the reality of the idea by the fact that everyone believes it.

Months of casual and inconsistent dating follow. It's a long slog, finding out whether Pink has any real feelings for me; a pas de deux where I play the puppy-dog suitor to her Betty Boop, running behind her with my mouth wide open and my heart-shaped pupils popping out of their sockets on stalks. She shows her interest in the old-fashioned Hollywood way—through coyness and faux-resistance—always walking the tightrope between rejecting my kiss and succumbing to it. I am spurred on by her sporadic gushings of affection, often given to me as riddles via text message, sometimes even via the poetry she writes me. She gets offended when I mention my interest in other girls. I do this, of course, to test her feelings for me. I am jealous of her boyfriend. From what she has told me, he doesn't treat her very well. In fact, I don't think he treats her any way whatsoever, considering he's deployed in the army.

In the gap between Pink's choice to leave her boyfriend and her decision to be mine, I'm left to sweat. Thank God I enjoy a challenge because our courtship is a maze. I spend a lot of time at her house, which she shares with her older brother and younger sister. It's a high rise flat on an estate in Whitechapel, overlooking The Ten Bells, the pub where the infamous Jack the Ripper apparently selected his victims. I love English history and true crime—my dad took me to the London Dungeons several times as a child—so being with her in the heart of the city makes me feel I'm in the thick of something historical. Pink is Cockney, so I feel at home with her, and although her community has maintained the old-England feel of an Eastend market, we are also on the cusp of gentrified Shoreditch. It's the best of both worlds.

We are lying on the sofa in her living room one Saturday, trying to nap off a hangover from the previous night's drinking. I break free from her arms to sit on her balcony stoop and smoke, and can hear the market-sellers from Spitalfields yelling in an accent that feels like home. As I inhale my cigarette, I turn to look at Pink through one eye, to shield myself from both the light and the fumes. She stares at me wistfully.

"Can't we just elope?" she says, breaking the quiet with words that fill me up like the cup of tea I'm holding between my thighs, making the nicotine hit different. For once, someone wants me alone enough to sacrifice all other company.

It has been two weeks since Pink asked me to elope. I haven't heard from her since I left her home that morning. I'm annoyed that she can ask me to do something so meaningful with her—whether in jest or not—and then act as if I don't exist. She's been like this with me since the beginning; blowing hot and cold. I've persisted, because not only do I like the chase, but I can feel she is emotionally open in a way Purple was not. There is potential for us, no matter how exhausting it is to unlock it. The last time she went MIA on me for over a week, I decided the best way to cope with it was to tell her of my future intentions to marry Red. A bottle of Buckfast helped me make this decision in the early hours of a Saturday morning during a sexually tense argument in a mutual friend's bathroom about what we *were*. I believed it was in both our best interests for Pink to know about my feelings for Red, for two reasons. First, because I wanted to make her equally as jealous as I was about her boyfriend—just the right amount to remind her that two can play that game. I could see myself getting hurt by the time the conversation was over unless I got one up on her. Two, as an insurance policy for my truth. Red and I have now spent two romantic weekends in Paris with further plans to meet in the Summer. There is no pressure or label on us, but I've grown to consider my love for her a religion; one that will damn me if I deny it the way Judas denied Jesus. By letting Pink know of my intentions to end up with Red eventually, I am staying true, absolving myself from the guilt of loving another, while at the

same time making it look like I have game and am not so readily available. A hat trick of wins!

Pink and I switch back and forth weekly from lovers to friends and whenever we are in friendship-mode she gushes to me about her boyfriend. It's clear, then, that we *both* merely consider the other an option. If something is to happen between Pink and I, she won't be able to hold Red against me without hypocrisy. We'll both know full well what we're getting ourselves into.

This is how I level the playing field. But it still bugs the hell out of me that she's ignored me for two weeks.

But why pursue Pink when I have dreams of Red? Well, I don't think it easy or wise to close myself off yet, considering the Atlantic that separates us and the fact we've only met twice so far. Granted, we've admitted our feelings to each other and slept together, which to me is a miracle in itself—the fact her body responds to me like a bud turning its face to sunlight. But I know not to put my life on hold for a fantasy, regardless of how determined I am to make that fantasy real. I don't intend to blow my chances with Red by rushing the issue of commitment from another continent, and I have a lot of life to catch up on in the meantime considering I only lost my Virginity last year. I'm also aware of the mutability of young dreams. I really like Pink, and I haven't ruled out the fact I could end up wanting to marry her instead. Eventually. Maybe. At least that's what I tell myself, perhaps out of fear of Red's rejection. I'm keeping all bridges intact.

I've not yet learned the lesson Purple taught me: that it's better in the long run to confess your feelings for someone as soon as possible so both parties know where they stand. I've been conditioned to crave a challenging love, have grown to enjoy the uncertain phase Purple first gave me a taste of: the stolen glances, unspoken intimacy, the building of tension until I am ready to burst with one touch. I relish the slow dance between Red and I. Whilst I've tried to date out and proud lesbians, I just can't get into it, no easier than I can force myself to fancy a woman I log-

ically understand to be beautiful if there's no chemistry between us. I am not on the "gay scene" and any experience I've had with the lesbians who are has proved the antithesis of what allures me to women in the first place. Lesbians on dates are too forward, too familiar, too brash. Harsh, maybe, but I've been on enough dates to justify the stereotype. Lesbians make it clear they want to U-Haul you into their future after the second meet. I want to hold them by the shoulders and encourage them to *relaaax*. If there is no foreplay, nothing to unwrap layer by layer, I am bored before it's even begun, repulsed by anything gifted to me on a silver platter. The idea of two people turning up for a date *knowing* they are expected to fancy each other and eager for it to mean something is a repellent. I much prefer playing the satellite around whoever the universe pulls me towards from a neutral playing field, two magnets of the same pole, an inch away from each other but refusing to submit until there's nothing else for it. That's the only way I know the attraction is real. Organic lust. Aphrodisiac restraint. Suffice to say I hate dates. To the extent that if I met the love of my life on a date, I don't think I'd notice, purely because of the formality.

With no relationship experience at the grand age of twenty-two, the idea of getting married to my first partner seems ludicrous to me. I think it's perfectly acceptable and even *realistic* for me to let Pink know I intended to marry someone else. Doesn't everyone expect their first relationship to last about two years? I consider it morally right to keep Pink in the loop. At least that's what helps me sleep at night. I find my own honestly refreshing. Any jealousy on Pink's behalf will be the icing on the cake.

During these two weeks of radio silence, she posts a photo of herself on Instagram, posing with a bike by some mountains. Location tagged as Switzerland.

Who took it?

I text her as casually as I can to find out, still refusing to understand that being honest about my feelings is vital for mutual trust and will render me less vulnerable to resentment in the long run.

"I've just seen you're in Switzerland, nice! Who with? Hope you're having fun x"

No reply. When she does finally get back to me the next day, she avoids the question. So, I ask again, no filler this time, and she immediately calls me.

"Hey", she opens, sheepishly.

"Hi. You alright."

"Yep. How are you?" I can tell she's nervous to spit it out.

"I'm alright. Why are you ignoring my question?" It's impossible to keep the hurt to myself.

"Sooo... I didn't want to tell you because I didn't want you to get upset or the wrong idea, but someone took me to Switzerland."

"Who?" *Why the hell can't she just say it?!*

"His name is David."

IS IT JUST ME OR ARE THEY ALWAYS CALLED DAVID?

"Ok... who is he? Are you seeing each other?"

"Nooo it's not like that. He's lovely, just normal, you'd like him. We like the same music and he's recording an album out here so he asked if I wanted to come and I thought yeah, why not. He paid for it and it's not like my boyfriend can take me anywhere."

"Ok. I've gotta go".

I hang up.

I AM FUMING. I know when she's lying because she beats around the bush and acts awkward. As far as I was aware, I was the only person she'd been regularly seeing.

My phone buzzes.

I still really like you, Fern. x

My initial, raw reaction is that I want to punish her. It's not even that there's someone else. That's starting to become the typical situation for me. It's that I'm one of *multiple*. It's one thing to fall for someone else by mistake—a catalyst to end a relationship that's not working—*but dating multiple people while taken?* How dare she say she also likes me? Plus, she lied to me by omission. I might be the other person, but I refuse to be two of three, especially when the other two are men. Here I am—I delude myself—honest to a fault about Red even though it might squander my chances with Pink, and I can't get the truth from her until I push for it. I feel even less guilt for confessing my feelings about Red now, want to unleash a tirade over text and block her, to push her away so she'll regret ever getting on that plane.

Fortunately, Black's best friend senses are tingling and she calls me. I unleash my rant on her instead and she reasons with me, says I should simply tell Pink the truth: that I'm jealous.

Is she crazy? Can being open reward me? Turns out that if someone genuinely likes you, it can.

It doesn't happen in the most straightforward way, of course. We spend the last hour of 2013 together in her dad's empty apartment once I've finished my graveyard shift at the Irish pub I'm now working at. Hours are spent kissing on the sofa, toasting in the new year with cheap wine. We start to have sex, not for the first time, when she stops me suddenly.

"I don't think I can get used to this," she giggles. It's patronising, but not unkind.

I fall back, hips to my heels and say nothing. Instead, I turn my back to her and feign sleep, staring at the opposite wall.

"Awww, no, come here baby. I don't mean it like that. Not with you. Just sex with a girl. It's so different. Come and lie on me."

I do as she says, but my body has already shut down. She kisses me some more, but I'm immobile.

Why am I never wanted wholeheartedly?

This is the exact reason I can't bear to tell Red the full truth of my feelings for her. I can barely handle rejection from other girls.

Once Pink is asleep, I peel myself from her arms and look down at her petal plump lips slightly parted, the delicate sheen of sweat on her forehead, and decide I will not begin 2014 like this. It's already the early hours of New Year's Day, one of my Golden Dates. I won't start the year putting up with someone who cannot work out what they want from me, *again*.

I dress myself in the dark but then address the practicalities. It's 4am and I don't feel like getting the night bus for an hour in the cold. I check my phone to call an Uber and sit back down on the bed, unwittingly choosing the next fork in my road.

The next morning, I wake up in the same spot with my shoes on. *How* have I allowed myself to start my year by falling asleep next to someone who basically laughed at me during sex the night before? But Morpheus, god of dreams, cleanses the lesser emotions during sleep and my mood is lighter. Not one to say no to the affection I seek, we have sex again, she tells me it's different because it's *better,* and then she asks me to be her girlfriend.

Of course, I say yes. Last night is instantly forgotten. I am *wanted.* I'm filled with such gratitude that I immediately feel guilty about confessing my feelings for Red. We can't deny this awkward secret we now share which has undeniably formed a rocky road under the foundation of our relationship. Not only that, but she's still got a boyfriend in the army who doesn't know

it's over between them. Are we even legitimately together? I find out a week later through social media that Red now has a boyfriend now too. Everything's coming up roses.

It doesn't take a genius to figure out that any relationship which starts this way isn't likely to end well. But Pink and I, despite our beginnings, have a wonderful year together that I'll always remember fondly. I put my feelings for Red on hold even though they are still there, simmering low on the back hob. When she comes to Europe in summer, we meet only as friends. In the meantime, Pink and I become closer than ever, safe in the knowledge we belong to each other. We let our guards down and do everything together, looking out into the world with newborn eyes as this is a first for both of us—my first ever relationship and Pink's first relationship with a girl. We get matching blonde highlights and wear each other's clothes until we are mistaken for siblings. Weekends are spent at hers, mostly in bed with the windows open, smoking, having sex, and popping to Spitalfieds in our pyjamas for breakfast at midday. We are mutually loved and tenderly cared for.

When things are good.

CHAPTER
22

A FRIEND FROM an office job in accounts that I had during
the summer I finished my GCSEs has reached out to me on
Facebook, inviting me to her leaving lunch. I was sixteen when I
worked with her and still wrote my emails in pink font. She was
nineteen, wore heels and had already worked there three years.
She nicknamed me "Biscuit", took me with her to company drinks
on rooftop bars, and we got matching piercings in Camden dur-
ing our lunch break. I developed a crush on her, of course. Her
sophisticated blazers, the different parts of the city she had access
to, how she tapped her lanyard to the sensor—plastic hitting
plastic like her acrylic nails on the desk. She coloured my
experience of corporate offices with eroticism; the
professional silence in which I could inspect the
business-women, their obnoxious phone calls, inconspicuous
meetings behind closed doors, private jokes in another language. I
became a convert: for six short weeks, office life was the life for
me. Especially when I saw £1,000 in my online banking on
payday. I splurged in Urban Outfitters, went back to school,
finished my A Levels and forgot all about it.

When I meet her at our old office, now twenty-three years old,
I'm shocked to see everything is exactly the same. Time stands
still in the corporate world. The same warm receptionist
recognises me with a hug. The decor hasn't changed and the
players are still the same. Not so much as a seating re-jig. I have
lived a whole life since I worked here, graduated from university,
grown from a child to a young woman. How has no one moved
on from inside this time capsule? I've been looking for
full-time work since I

graduated, so when my old boss asks me if I'd like to cover one of her team members on their two-week annual leave, I agree. My nostalgia for the place is all positive, I'm welcomed and remembered like I belong. The office is easily commutable from Pink's house, I won't have to interview, and I already know what to expect. It's perfect.

But while things are looking up on the work front, neither Pink nor I are 100% secure in our relationship. Her ex is unaware of my existence and still believes they are together. The day of his discharge and reintegration back to the UK, she goes to meet him at the airport. Mainly because he expects her to be there, but also to break up with him in person. I, however, have quietly accepted that she will go back to him once they're reunited—after all, this is what experience has taught me. I brace myself to be upset but am still grateful for the four months she has committed to me wholeheartedly. It's more than anyone else has given me. I kiss her goodbye that morning and expect her never to return, so when she calls me that afternoon and asks me what I want for dinner, my heart overflows with appreciation. She's chosen me twice.

When you want a mutually loving relationship and are lucky enough to find one, surely there's nothing left to do but live happily ever after. But human nature is bizarre, and a reciprocal romantic love is not something I find easy to get used to. The honeymoon period lasts a month or so but after that, when there's nothing to resist or fight against, I don't know how to behave. The ride is so smooth that in time I start to look for speed bumps, things to be jealous of. So does Pink, whether in response or of her own accord, I'm not sure. I don't intend to mention Red again, but such things are not easily forgotten, so she likes to remind me in arguments, and once *I* even remind *her* out of spite, when I catch her writing a poem about the guy she went to Switzerland with on her iPhone notes. I find her passive aggressive, defensive and at times painfully insecure for no reason. I grow intolerant because I can see no reason for it. She is beautiful, has the world at her feet, and made *me* wait—why the chip on *her* shoulder?

Is it any surprise, considering she knew of my long-term plan to marry Red? I reflect on my part, and conclude that this is no excuse. I've only played her at her own game, holding the threat of someone else over our relationship to make her choose me. But it isn't just about us. She is grieving the recent loss of two of the people closest to her, and the length of time it's taken me to mention this shows you how little I factored that into our dynamic. As a friend, back when she went MIA periodically and I wasn't sure what we were to each other, it was punch in the gut to hear what she was going through and all I wanted to do was support her during this time. I held her, listened to her, comforted her, turned up at her house with a giant teddy on a day she was feeling particularly low. But in the realm of our relationship, I don't allow enough emotional space for it, and this is a catastrophic error on my part. I fail to see the correlation between grief and how she reacts around me, how it can impact intimacy and compound her fear of loss. Add on top of this the upheaval of suddenly introducing your family and friends to your girlfriend when you'd previously only dated men, and I can't even begin to imagine how difficult this time is for her. The depth of my love for Pink, although complicated, is deep indeed, and so her sadness is a pit in my own chest, but I am not fully equipped to be the pillar she needs as a partner. I am emotionally immature and do not have the capacity to love her the way she needs, but am too ignorant to realise this until it is too late. I'm still hung up on how long it took us to get together, rather than focusing on the fact she chose me eventually. I project all my hurts onto her and make her feel guilty for any duality of emotion she experiences; any time she speaks fondly of her ex or takes three hours to get ready because she feels like nothing looks right. I am impatient when her life has been turned upside down, hoarding any slight she shows towards me like jewels until they become a treasure chest of blame.

"Look! Look at all the ways you've hurt me!" I can use as a potential 'out' when things get too much. This is not something

I understand—it is on a much more subconscious level, but I've bent over backwards to please girls and for once I want someone else to take that role in my life. I expect to tell Pink all my flaws and expectations for *my future plans* (singular) and for her to just lie down and take them, then fit herself around them. Which to be fair (or rather, unfair) to her, she does.

Things finally come to a head at that fixed point in my calendar, 31st December, when I decide I can't bring this relationship with me into another new year because we've been arguing too much. We are built on too much insecurity and neither of us can trust that we won't hurt each other. The obsessive-compulsive part of my brain remembers we got together on the 1st January, and thinks it best to round this up to one total year and cut my losses. The realisation hits me on my commute to work the day before the Christmas holidays, when my bag splits on the escalators at Euston Station and I burst into tears. It is a pathetic symbol for how much I am carrying, and I know that breaking up with Pink is the relief I need. I am tired of fighting with her.

Then Pink sleeps with a stranger the night we break up and goes missing for three days. I am worried that this is my karma, that I've harmed her. The police get involved. She is found safe, but the shock of it all makes me second guess my decision.

Who is the manipulative one here? Both of us? Neither? We cry and beg and scream at each other and I swing like a pendulum between guilt one day and fury the next. Both extremes are laced with pity because I know she acted recklessly from a place of hurt and put herself in danger by doing so. We get back together for a while, but despite the responsibility I feel to fix things, my bruised ego prevents me and I end things again. I am a mess who doesn't know what she wants. It doesn't help that the guy she slept with turns out to be a model I see on billboards all over the city during the Christmas holidays. I hate myself for hurting her twice, because our co-dependency makes me miss her the moment I've done it. The realisation that I am half the reason we find ourselves in such a dismal situation and that I am not a two-dimensional

"good person" is a hard pill for me to swallow and the biggest wake up call of my life so far. Being a romantic, I'd had grand ideas for the kind of partner I could be. The truth is, I was innocent in theory, but then the practical began. Pink acted out of threefold grief after losing me, too. I don't give her room to mourn, then give her all the room at once.

The months following our separation, I am consumed by guilt. The only way to cope is to cut all ties. I remain conflicted between wanting to check up on her and needing time apart to process my feelings, so that even with distance she haunts me. It may have been a necessary breakup, but Bryan Ferry's back catalogue houses all our songs, and I can't resist the punishment of listening to *Slave to Love* on repeat during my morning commute to work. I almost crave the punishment of my stomach giving way, without fail, between 1:09 and 1:15 of the opening chords to the song, when the piano notes break like sunshine through the clouds of the introduction, my cue to sob my heart out for the rest of the journey.

Two weeks turn into six months and the hospitality company issue me with a permanent contract. I am a frequent wreck before 9am over Pink, so I decide once more to move out of home for a change of scenery and routine, to throw myself into another immersive experience of belonging to a group of hopeful youngens living together and getting up to mischief. I spend the first few weeks of living in that new place lying on the sofa worrying about Pink, but in short, that is how I find myself at the Fun House.

CHAPTER
23

Blue—The Sixth Woman

SOMETIMES A crush materialises with no explanation. Morpheus tinkers around with the cogs of my brain while I sleep, painting vivid images on the walls of my mind of people and things I'd never entertain when awake. I'll open my eyes to a new morning and notice someone I wouldn't have spared a second thought for yesterday, now lodged between my ears, cartwheeling round my head and taking up all the space. My dreams are jesters. When they get bored of my storyline, they throw a curveball into the night-time mix, their jingling hats sounding alarm bells in my memory. I'll wake up with a new crush or remembering how someone from seven years ago kissed.

But I don't remember dreaming about Blue.

Still, something in my subconscious leads me down the landing that morning, from my bedroom towards my housemate Dinah's room, where I know Blue slept the night before. I live in Hackney now, at the Fun House, named for its round-the-clock parties. Last night's theme was anti-Valentines. All three of my female housemates and I are single, so we'd celebrated by throwing what was essentially a Halloween party with the tacky addition of love heart paraphernalia from the pound shop. I still have grey face paint around my hairline and at the nape of my neck from the zombie make up I'd failed to wash off successfully before passing out.

I knock on Dinah's door, something I've only done a handful

of times before. You don't bother Dinah unless she asks you to. Why am I on this side of the house?

"Come innnn," croaks a voice that sounds like it hasn't been used since yesterday. A throat clears.

I open the door and sure enough, there's Blue lying next to Dinah in bed. Something small and unnamed inside my chest wakes up.

"Morning," I say, feeling like a Sim that has forgotten why it's entered a room. I wonder if they can see the green diamond above my head.

"Morning, mate," says Dinah.

"I think I'm still drunk," I mumble, just for something to say. I avoid Blue's eye contact but notice her crumpled face as it peeks out from under the bed covers and she squints up at me, smiling like a newborn who's just learned how. Her black hair clouds the pillow. She lets out a monosyllabic laugh. The unnamed thing beams.

"Anyone want a cuppa tea?" I ask.

"You're a cuppa tea," says Dinah. This is her favourite response to everything.

"No, you." That's another, and we've all adopted it.

"Oh, go on then, mate." Dinah started using the word mate in every sentence as a joke, but it's now become a solid part of her dialogue.

"Blue?" I ask.

"Yes please." When she smiles again, I become acutely aware of my hangover.

Closing the door behind me without finding out how the girls take their tea, I head down the beer-bottle lined stairs of our two-floor townhouse, grateful for an excuse to leave before I vomit on Dinah's carpet, as I digest the realisation I'd gone into her bedroom only because I wanted to see Blue.

Did something happen last night for my curiosity to be peaked?

Nothing comes to mind, although I was *very* drunk. Blue and I had at one point—through no choice of our own—found our-

selves alone in Dinah's room with a girl who unabashedly locked the door and treated us to an embarrassingly long rendition of Beyoncé's *Best Thing I Never Had* in an irritating vibrato. I'd sat on Dinah's bed feigning admiration, Blue on the floor at the other end of the room, smoking a roll up with her knees bent and her back against the radiator. We'd exchanged a few conspiratorial glances, knowing we couldn't leave the girl mid-serenade without appearing rude. We let her sing at us while we sat there, captive.

I've always been aware of Blue—in an objective sense—in that whenever she visits, I know which room of the house she's in at any given time. But that's only because we've never spoken, so I'm constantly calculating the distance between our first conversation and avoiding it. She intimidates me with her resting screwface and confident posture: chin tilted up, shoulders back, broad hands touching everything in a way that seems mocking, showing me she's familiar with my home and my housemates in a way I am still not. This persistent state of calculation whenever she's around is also because I'm embarrassed that Pink started an argument with her the first time we visited the Fun House. It was towards the end of our relationship, when I was considering moving in with the girls. The day after my step-grandad passed away, I needed something to cheer me up and Sade, my colleague at both the dance studio and more recently, a restaurant where I pick up the odd shift for extra money, told me she needed a new roommate. I liked the three girls she lived with; they always looked like they were having fun and from what Sade told me, had the entire catalogue of Mobo nominees chilling in their living room at any given moment.[5] I wanted to be one of them. Ever since moving in with Alicia during second year of university, I've been trying to

5. It turned out to be true—one weeknight, when we were wondering why our house was so empty, we turned on the TV to see Kanye West performing "All Day" at the 2015 Brit Awards, with a host of East London rappers (that he'd requested last minute and who spent nearly every other night on our sofa) on stage with him.

live vicariously through groups I admire by plunging myself in the centre of them. So when Sade invited me to a house party at theirs that weekend, I brought Pink along with me to see whether the girls would accept me as "ONE OF US! ONE OF US!"—something I'd hear them shout whenever I saw them out together.

The Fun House was everything I expected. Both floors were heaving by the time we arrived, and Pink loves meeting new people, so I soon lost her to a group of smokers in the garden as I searched for a seat in the kitchen with Sade and Dinah, the primary housemate—a musician recently signed to a major label and whose songs I'd heard on Radio One. Not long after I made myself a drink, I heard Pink's voice through the kitchen window, risen emphatically in pitch. I headed out the back door to find out why. She was arguing with a girl called Blue—someone, at this point, I only recognised from social media. I had no idea what the disagreement was about, but when I pulled Pink aside to calm her down, it turned out their petty disagreement ran much deeper in Pink's eyes. Pink thought Blue fancied me because apparently she had been staring at me. She was understandably irritated by this but in being so, got unnecessarily antagonistic in a discussion about music with Blue and her friends. Blue, unaware of her crime and confused by Pink's tone, called her out for being disrespectful. Her friends backed her up. Pink felt ambushed, Blue looked baffled, I was mortified, and no one knew how things had escalated so quickly.

Upstairs in the bathroom alone, I implored Pink to let it go because I wanted to make a good impression in front of my potential new housemates. I assured her there was no need to feel threatened by Blue. I didn't know her from Adam. I hadn't noticed her staring; in fact, the first time I knew of her existence was ironically when I was alerted to the raucous, so I was sure her suspicions were incorrect. That night ended in a row that involved Pink storming out of the house and me waiting with her at the bus stop for over an hour until she agreed to board with me as a

witness to her safety, rather than refusing until I left her alone the way she wanted.

Even now, I assume it was all a misunderstanding. If anything, since living here for the past two months and being in Blue's company considerably more, I'm certain she has no opinion of me at all. An old friend of Dinah's, Blue is one of the oldest Fun House frequenters. I've seen photos on Dinah's Facebook of them partying here way before I knew them. But now, Blue's daughter is nearly a teenager and about to start secondary school, so her visits are not as frequent. She is the only visitor who knows when it's the right time to leave and isn't sucked into our feral pit, glued to the sofa with alcohol, tobacco and regret for days on end. I'm always impressed by her ability to call it a night. The rest of East London falls under the spell cast over our fetid living room, with its fake trompe l'oiel wallpaper of floor to ceiling bookshelves; a giant framed wedding photo of its previous occupants hung above our fireplace like a creepy shrine to our tenancy ancestors.

There is always someone here of note—recently signed musicians, independent artists, writers, producers, stylists. We have an abundance of cigarettes and booze and can't resist an all-nighter. It's difficult to just *go*. Even I, one of the only two housemates with a corporate 9-5, find myself still sitting in my coat on the sofa in the living room at 10pm on weekdays, having been distracted from the path to my bedroom on the way home from work. It's so much fun you forget everything else. So in the grand scheme of things, Blue passes through my mind only as quick as the overground train that zooms past my bedroom window each morning, making sure I don't oversleep. My awareness of her is nothing more than self-preservation. She is too sophisticated, with—I expect—no time for bullshit or the irrelevant conversation I'll provide. My unconscious aim, I now realise, is an attempt to avoid her inevitable social rejection of me. Plus, embarrassment for my ex-girlfriend's behaviour.

But I'm not attracted to her, at least not consciously. In fact, at another of our parties, she'd innocently put her hand on my

knee to reach for a drink, and I moved instinctively like I'd been burned.

Why did I move? Nerves? Catholic Guilt because of my ex?

I second guess my past intentions as I enter the kitchen and switch the kettle on. Nu is standing by the grill, frying bacon. Nu is the fourth tenant I've replaced, but like I said, no one ever really leaves the Fun House. Nu's name is still on the tenancy, so I am essentially a squatter. The men behind the counter at the corner shop call me "New Nu", sometimes "Nu Squared". She's been here for three days this visit.

The kitchen is a tip; there are heart shaped sequins glued to the table with beer, fag butts floating in vodka drenched ashtrays. It's unusually sunny for February; Sade and our third housemate Caro are already in the garden outside, supine on giant filthy beanbags, groaning from the hangovers which have woken them earlier than they would have liked. Nu is chatting to a guy I don't know who's sitting at our kitchen table in his coat, beanie and trainers, no doubt ready to leave but unable to due to the spell cast by the wedded couple in the frame above our fireplace. Even though this is my home, I'm the newest member of the family, so waking up to strangers in random rooms is something I'm used to. The night after the Brits, I stepped over the singer Delilah, asleep on our stairs on my way to work.

"She looked banging last night," Nu is saying to the boy. He smirks. She turns her head towards me as I grab three mugs out of the cupboard. "Morning mate."

"'Ello mate. Who you talking about, Blue?"

Nu and Blue have casual history.

"Yeah," her eyes twinkle in her cheeky face. Everyone loves Nu, me included. I get so excited whenever I hear she's coming to stay that I turn into a kid who's had too many e-numbers, knowing I'll laugh my way through the entire weekend.

"I know. I think she's so hot," my mouth agrees with her.

I catch myself. *I don't really think that, do I?*

Truth is, I don't even remember what Blue looked like last night. But this small, unnamed thing inside my chest has reacted fast, staking my claim over Blue so Nu knows I want *in*. Another psychological reaction I have no control over. Nu and Blue have been 'off' for months, neither wanting more from the other than sex—at least not to my knowledge. So, I don't let my mouth take it back, my brain still half asleep.

Dinah and Blue traipse into the kitchen and I leave their teas on the counter, still avoiding eye contact as I squeeze past to take a bath. The smell of bacon makes me nauseous.

Baths are the one thing guaranteed to calm me down in any situation and it's not beyond me to run one at 3am in the middle of a house party, disappearing into a candlelit haven of bubbles for half an hour, ignoring the knocks of drunken strangers desperate to pee. I'm worried I'll collapse, so I climb in before the tub is full, lying on my left side so my right hip and shoulder jut out of the lukewarm pool. I don't care that this will ruin my hair; my heart is hammering, my eyeballs need washing in saline solution and my mouth is an open wound stuffed with cotton wool. I twist the cold tap anticlockwise and let the hot water rise in the hopes it will soothe and settle my blood.

It's just a hangover. Or was I spiked last night? I think I'm going to die.

My heart rate shows no sign of slowing despite my horizontal position, in fact it speeds up and my panic skyrockets. I start to type a text to the girls downstairs: *I think I need an ambulance* – but I don't have the energy to finish the sentence. My new crush, or whatever this is, isn't helping matters; the adrenaline increases my anxiety. I drop my phone over the side of the tub and let it clatter on the tiles as I close my eyes and surrender to the unnamed thing in my chest running riot.

I have to confront Blue head on, need to hold her in my eye-line before she leaves so I can work out if I simply indulged too much last night, or if Morpheus really has outdone himself this Valentine's Day by transplanting a usurper into my heart.

I survive the bath. We are on the couch eating pizza. Only half of my hair is wet. Blue is still here, sitting next to the boy in the beanie hat (who is also miraculously still here, in his coat and trainers) on the opposite sofa. Even though this makes me happy, I don't care enough about her presence to worry about how I look. That's a relief, at least. The crush can't be fully-fledged yet. I grab a Marlboro Light from the communal pack on the coffee table and swing my legs up onto it. This is where I'll station myself for the rest of Recovery Sunday.

Every Sunday after a party, we wordlessly agree to lie haphazardly across from each other on the sofas for the entire day. No one moves except for their turn in the obligatory relay race to the corner shop for Pomsticks, aloe water and more cigarettes. It's tradition. Naming the day is a formality that justifies the laziness. Blue hasn't stayed for a Recovery Sunday since I moved in. Perhaps she has a babysitter this time. Or maybe her daughter is with the dad.

I forgot there'd have to be a dad.

"Fern's going to Rome next week", a voice that sounds like Dinah's calls out from inside a pile of blankets between Blue and Beanie Boy's respective legs. Red is on her European tour and I've been staying at her hotel in London this past week. Before she left for Zurich, I gave her a necklace with two pinky fingers linking on the pendant, because we promised we'd make it official if we ever lived in the same country. In an extremely generous gesture, her tour manager has paid for me to fly to Rome with them on Tuesday for the Italian leg of the tour. My flatmates have started calling her "Hotel Girl."

"Tell them the story," Caro says, traipsing in from the garden with Sade, both looking worse for wear as I sit up and allow them to wedge themselves on either side of me. Nu follows close behind, a mug of tea cradled in her hands and a rollie behind her ear, visible beneath her elfin haircut. She settles down on the

carpet, crossing her dungareed legs. Caro and Nu love this story. Sade's heard it a million times. I oblige of course, because it's my favourite to tell, even though I'm pretty sure the only people who are interested are those who've already heard it. Blue listens with a frown as thin as a hairline fracture on her forehead. She'll probably think I'm out of my mind by the end of it, but if I worry about that I'll feel sick again.

When I'm finished being raconteur, the girls whoop like I've given them brand new information. Beanie Boy is surprisingly invested in the story; he leans forward, says, "raaahhh" and starts a slow clap. The story of how Red and I met always gets a good reception, especially from guys, two of whom have now paid out of their own pockets for our story to progress. It seems they admire my gumption, and this boosts my confidence in its happy ending. Accepting the applause of the room along with the demolition of my pizza has stabilised my mood. At least, my chest is behaving.

A copy of my poetry collection—the one I had published with an independent Irish press after Miss White died—lives on the coffee table as a makeshift tray for my housemates to roll their spliffs on. As I light up again and zone out, satisfied I've got a hold on my nervous system, I notice Blue gently pick it up so she can reach her phone which is lodged underneath it amongst all the other Recovery Sunday debris. She turns my book from cover to cover, retrieves the phone, but instead of putting it back down, opens it. I watch her, too tired to blink, awkwardly anticipating that she might read it but relishing the zen-like meditation this hangover has finally gifted me; a false confidence garnered from the fact I'm too tired to move a muscle or put energy into caring about anything in case it gives me a panic attack like the one I nearly had upstairs. Blue holds her thumb at the base to keep the pages apart. She furrows her brow, stays on the first page for a minute and then turns it. A pause, before she does it again. And again. *She's actually reading my work.*

A flutter of panic from the thing inside my chest interrupts my

peace - an intimidating stranger is now privy to my most intimate words. And not just any stranger, but one my body has decided I care about overnight. I remain still, afraid to interrupt such a curious image, but my nerves soften to appreciation as she continues to turn the pages, showing no signs of mockery, nor of stopping. Ash collects at the tip of the forgotten cigarette balanced gently between her thumb and forefinger and falls to the floor along with my senses and everything I thought I knew about myself: my certainty about my love life, my resoluteness towards Red. I stare at those hands. They are safe hands. Wide and precise, more like the hands of a boyfriend. I'm always the instigator in relationships and wouldn't mind being dominated for once. I thought she'd not be interested in anything I have to say and yet here she is, half cut and taking in my words.

Blue remembers her cigarette, and as she takes a deep drag without tearing her eyes from my poetry, I feel something like jealousy towards the smoke that curls out from between her lilac lips. I need to be close to her. A trance pulls me up onto my socked feet, walks me round the coffee table and over to where she sits. I sandwich myself between her and Beanie Boy, hair still damp and frizzy on one side. Blue leans back instinctively to meet me, her shoulder blades kissing the back of the sofa, and it's as if she's also received the steps to this dreamlike choreography, because she extends her arm without missing a beat and ropes it behind my neck, twirling her fingers around my damp curls, eyes still on my book.

It can't be real, this out-of-body duet. I must have inhaled some second-hand fumes from whatever Beanie Boy is smoking and now a benign demon is taking over our living room, manipulating the players, pushing Blue and I together. I'm confused by how safe I feel with her; yesterday someone I'd barely spoken to, today the only person who in this moment has the capacity to comfort me. The more she turns those damned pages and the deeper her fingertips massage my scalp, the more her presence wedges itself into my ribs to meet the unnamed thing in my chest.

I can't *believe* I don't care what I look like. I rest my head on her shoulder. She tilts hers in return, a gentle Jenga. I would happily spend every Recovery Sunday like this. What better way to cure a hangover than to spend it with someone who takes your standard version of The Fear, raises it by double and then makes it all go away just by wrapping her arm around you?

My phone buzzes and I look down at my lap to see a WhatsApp message from Sade: *What's going on 'ere 'ey?*

I glance at her on the sofa opposite. She's grinning. The change in her facial expression catches Blue's attention and she finally tears her eyes from my book to look down at the text on my phone. I feel my cheeks fill with blood as she reads it, but then she grins and laughs that monosyllabic laugh again. A good sign. She knows what she's doing.

"WHAT'S GOING ON 'ERE 'EY?" Dinah shouts. She's standing above me, reading the text. She repeats herself, and suddenly everyone has joined in (except Beanie Boy, that wouldn't suit him). I look at Nu, rudely awakened from my reverie by guilt, but she is also chanting, "WHAT'S GOING ON 'ERE 'EY?" while marching around the room and dancing to *Always Be My Baby* by Mariah Carey which is playing over the speakers. I'm not sure she understands the meaning behind the mantra.

"Wanna stay over?" Dinah asks Blue and Beanie boy as she stretches her arms up to the ceiling, midriff flashing mid-yawn. There's always room at the Fun House for family and strays alike. Sometimes, we push the two sofas together until they make a walled, square bed. The Recovery Sunday boat: respite for anyone who wants it.

"I hate staying over," Blue says. "I don't do sharing beds."

Course she doesn't, I think. That would be too much good news for one day.

Beanie Boy also declines. As he gets to his feet and prepares to leave, Nu heads to Sade's room to sleep and Blue unglues herself from my side to collect her belongings from upstairs. I say a gen-

eral goodnight to the room, still too shy to talk to her directly, and take myself off to bed.

I don't know what to make of all this. I didn't expect to feel warmth and excitement like it when the party itself was uneventful. At the height of my romance with Red, I didn't expect my head to turn for anyone else. I switch the light to my bedroom on, feeling soft and vulnerable, simultaneously small and huge with hope for a reason I can't place. I don't expect the lump under my duvet. For Blue to be in my bed.

CHAPTER
24

I'M NOT made for a job in accounts. I need people and words. I've been working here for a year now and although I love the corporate camaraderie, the novelty of the job itself is wearing off. I consistently turn up to work a mess thanks to spontaneous all-nighters at the Fun House, and my colleagues have nicknamed me 'Pyjamas', which I know is down to my ragamuffin appearance, although they say it's because of my recent penchant for floral cigarette trousers. My supervisor has his own nickname for me, '30 Percent', because he said that's all I give to the job. I appreciate that whenever I make a mistake, he tells me with a whisper before our boss finds out. But this is cold comfort; my filing has now piled high enough that I've had to resort to taking it home at the weekends to make a dent in it, spreading it out across my living room carpet and promptly bursting into tears. This, along with the fact I still don't know what the word 'accrual' means and fell asleep at my desk at 11pm during our last Month End, shows me I need to start thinking about an escape plan, the next step in my career.

My boss has a switch I know I'm close to flipping. We get on personally but she has reached her honey badger limit having me as a subordinate.

"Fern, you accidentally paid £50,000 to the sole trader of a small roofing company. It was supposed to go to the council."

I'm sitting across from her at a giant table in one of our minimalist meeting rooms that holds nothing but chairs, two bottles of still and sparkling water and a tissue box for all the inevitable

tears that are cried here by employees as immature as me. I'm
clutching an iced mocha and wearing an oversized faux fur coat
because I've just turned up half an hour late. I look down in
shame, my mouth open in an attempt at shock for my mistake,
but of course neither of us are shocked at all.

"You need to pay more attention. Where did we FIND you?!"

"I'm *so* sorry," I reply weakly. She breaks into deep, booming
laughter. Then she opens the door to usher me out and simply
says, "I'm keeping an eye on you, aye."

This is all the punishment I'll be getting, and I know it. Not
just because the roofer fortunately paid the money back
immedi-ately, but because I get away with more than most.
Working here when I was sixteen means everyone still sees me as
a child, which has its benefits, but I can't coast on
charm forever.

With Blue in my life, it's no surprise I can't concentrate on
work. We've been seeing each other for two months now; that's
eight weeks of feeling more alive than I've ever felt. Granted it's
also because I've stayed with Red during this period, and one day
with her is enough to glimpse immortality. But I've been with
Blue consistently since Red went back to Canada and it's the
com-bination of these two women—my ephemeral Heaven and
tangi-ble Earth—that keeps me suspended in a state of
Nirvana. I am social, sleep-deprived, satiated: all the things I've
longed to feel for years and see as evidence of a well-spent
youth. The night I found Blue in my bed, neither of us spoke.
We folded around each other like language was redundant
because neither of us could articulate what had happened
that day. I didn't understand how I'd turned the hardest nut
in the Fun House soft, especially on an ugly comedown and
after her lip service about solo sleeping.

We hadn't even exchanged numbers the next morning. I'd
left her in my bed with a kiss on her temple, wanting to develop
the snapshot of our perfect evening in the darkroom of my
memory rather than muddy it with my fingerprints by
instigating further contact. I didn't recognise this familiar tactic

of mine as a fear of rejection or intimacy. In fact I longed for intimacy. It was simply enough for me to dine on this memory until she messaged me on Instagram or we saw each other again. I knew it wouldn't be long until we did. At the Fun House, it never was.

Instead, I begin writing about her, drugged on reminiscence and overcome with a sleepy, painful paralysis that strips me of motivation for anything else.

The following Monday, I wake to the 8am train speeding by my window and resign myself to staying in bed. All I want to do today is lie down and dream about Blue. This woman I haven't yet kissed on the lips has rendered me useless. I know she'll be washed and dressed by now, getting her daughter ready for school with too many real responsibilities to think of me, but this does nothing for my motivation. I look around my room for an original excuse to call in[6] and notice that an incense stick has burned the edge of my mirror slightly. I text my boss that I won't be coming to work because my bedroom is on fire, then prepare for my daily Blue ruminations by putting on *Never Too Much* by Luther Vandross, which has been on a loop in my head since my decision to absent myself:

> *Hung up the phone, can't be too late, the boss is so demandin'*
> *Opened the door up and to my surprise there you were standin'*
>
> *Who needs to go to work to hustle for another dollar*
> *I'd rather be with you 'cause you make my heart scream and holler*

6. My last excuse was genius—I woke up late but realised by a stroke of luck that it was April Fool's Day, so I told my boss that my sister had turned my alarms off as a prank.

After I wash my face, brush my teeth and make myself a coffee, I fall back into bed and get cosy. Sitting cross-legged, I grab the notebook on my bedside table, crack the spine and spread its pages across my covers. Before I can even pick up my pen, I'm distracted by the doorbell. Assuming it will be Dinah's producer, who comes round most days to work on songs, I traipse back downstairs and open it to find Blue standing there, sunglasses combing her hair back into a ponytail and a leather jacket draped over her shoulders, her broad hands wielding a 2-pack of steak. Those *hands*. For a moment we're suspended in mutual shock, neither of us expecting to find each other on our respective sides of the door. Thank God I slept in basketball shorts and a t-shirt instead of my embarrassing matching pyjamas.

What the fuck? I was just listening to a song about this.

"Hi!" She says, stepping foot in the house and edging past me. "Aren't you supposed to be at work?"

"Yeah," I laugh. "I've pulled a sicky." *Because of you*, I want to say, to share this moment of serendipity with her.

"I've come round to cook for Dinah today." She follows me into the living room.

"I'm just in the middle of dying my hair!" Dinah calls from upstairs. "I'll be down in a minute."

I sit on the couch where I first fell under Blue's spell, watching her unpack ingredients from a carrier bag as I silently congratulate myself for staying home today. I *knew* I needn't have messaged her; letting things play out while I work on aligning my inner-being keeps proving to be my most effective manifestation technique. But I'm too nervous to make anything more than small talk.

"I've been thinking about you loads since that Sunday," Blue offers, tearing off the band-aid.

I laugh my nervous laugh, the one I used on my stepsister and my childhood boyfriend in Spain. "Ha." I can't believe she's being so bold this early on a Monday morning. She continues.

"I told my friend I want to fuck you."

No one I've been interested in has spoken to me so candidly before. Where her choice of language could be considered vulgar and would have turned me off if this scenario had been in *any* way different, I wince only because I find it hot. There is nothing tacky about her delivery, in fact she says it softly. It's not a chat up line, just a fact. This is a woman who knows who she wants and as I rightly predicted, has no time for bullshit.

I want a spliff. I'm allergic to weed but could really do with that nervous intake of breath, the butterflies before the burning lungs and that sedative sound of crackling paper. Instead, I grin, which is all the response I can manage, and lie back to elevate my legs above my heart. After putting her food in our fridge, she mirrors me on the opposite sofa, a recreation of that Recovery Sunday. I'm conscious Dinah is about to take her from me, so we lay quietly and a little awkwardly, savouring each other's company and pretending to watch TV. All I'm focusing on is our proximity to each other. The energy fizzing in our combined silence tells me it's mutual. When half an hour passes and Dinah still hasn't come downstairs, I realise I'm squandering our alone time, that there's no need to be scared of rejection because she's told me what she wants. So I walk over to her again, the way I did that first day, and lay in her open arms. She strokes my hair and I close my eyes against her neck, learning her scent. Dinah never comes down-stairs—perhaps she's seen us cuddling and wants to leave us to it—so I get Blue for the whole day. She doesn't seem to care that I've stolen her friend. At the Fun House, everything belongs to everyone.

After that, I am at Blue's almost every night. She lives in an opposite world to our East London cesspit; in West London, near Hammersmith, on the top floor of a regal block of flats with a

ladder that leads through an attic door to a roof overlooking the Thames. She's made the place her own, white-washing wooden floors to match the pristine walls. Everything is airy and sophisticated, with the exception of the lilac carousel horse that skewers her daughter's bedroom. Perfect.

Blue likes to prepare home cooked meals for us, and when her daughter asks to play PlayStation in her room before bed, we climb onto the roof with a bottle of Rosé until sunset. Everything about our romance is scented like adulthood, sincerity, and Comfort laundry detergent. I believe in it from the very beginning. She does not squander affection like Purple, nor project insecurities like Pink, rather we talk candidly to each other, finally kiss until our lips chap. I allow my face to be held and touched by the hands I'd ached for. Word gets out to The Fun House - not by me, for once - but because Blue told Dinah about us. The shame or secrecy I expect because I am used to it never comes. My housemates are excited by the news, but not surprised, which I can hardly believe. Nu gives me a hug, says she is happy for me because she sensed the chemistry between us and that they were over anyway. I end up spending more time at Blue's than Dinah does, and if Dinah finds this weird she never shows it. I, on the other hand, feel like I've been plucked from the back of the queue and placed straight in the VIP area through sheer luck.

Back home, the girls ask me if we've slept together yet. It is only when I answer "no" that I question why. After all, the entirety of our first conversation was a confession that she wanted just that. Chastity is not my usual practice, because although I can only sleep with someone if there's undeniable chemistry, if I've 'dated' someone more than three times it means I'm emotionally invested. I sack it off otherwise.

"The girls have asked me why we haven't had sex." I mention as we lay in front of an episode of *Mob Wives* one evening. I make sure to punctuate the end of this sentence with a laugh, a disclaimer that the statement isn't my own.

"Why haven't we?" I betray myself immediately.

"Just because we like each other, it doesn't mean we should have sex so soon. Anyone can have sex," she says, kissing the top of my head and pulling back to look at me.

She sounds annoyed. I don't ever want her to be annoyed with me. I shouldn't have asked the question. She continues.

"I thought I just wanted to have sex with you. When I read your poetry and heard your story about going after that girl in Paris, I fancied the fuck out of you. I could see you were someone who goes after what she wants, which is attractive to me. But the more time I spend with you, I'm surprised by how much I get on with you. You're the best company. I just want us to simmer and sink into this feeling because I like you more than sex, but I know your heart belongs to someone else. If we have sex, I'm screwed."

Blue's ability to be direct without shame doesn't cease to make me shy. I see my own vulnerability as weak, yet here is someone proving it can be the most attractive thing in the world.

She is right. I've screwed my chances with before we've had a chance to begin. I did it on purpose with Pink—using my feelings for Red to spite her—but with Blue, history is repeating itself through no fault of my own. Of course, I had no issue with telling the room my Paris story because I never imagined Blue and I would find ourselves in this situation with each other.

Everything between Red and I is just right. In three months she is due back for my birthday before we fly to Canada for her brother's wedding. For now, she is still unaware of my feelings and untethered to me - we are free to do our own thing. But our lack of substantial communication means our emotional history is shallow. Here, in front of me, is a genuine connection from a beautiful woman wanting to love me. And not judging me for loving another.

I nestle into her shoulder, touched by her candidness.

"It's no one's fault," she continues, responding to my inner monologue and twisting the watch on her wrist. "You didn't know me when you told me that story. But I can't unhear it. It makes things a little complicated. I know I can't stay away from

you, but I've held back sleeping with you until I can get my head around this. I haven't felt this way since my ex, and she ruined me. If I give you all of me, I'm not going to be okay at the end of it."

Neither am I. I think. *Neither am I and I'm certain, despite the fact you've yet to lay your hands on me the way I want.* I want to climb inside her, to denounce anything beyond this roof. But the certainty that Red was the love of my life the second I saw her brings with it a sense of responsibility. I owe it to myself not to get distracted. And yet.

"I have feelings for you," I say, knowing this will cause more pain in the long run. I only know to run towards love. Shutting it off from the source would be like cutting my own LVAD. But how can I feel this strength of infatuation for two women at once? "Don't let that story get in the way of us, please. I'm scared of what I'm feeling, but I don't want it to stop."

She sighs, but her arms are still around me and her grip hasn't loosened.

"You're a Gemini too, man. Like my ex. I swore I'd stay away from Geminis."

Inevitably, we do sleep together and her way of giving attention splits my heart wider than it already is. When I wake the morning after, in soft cotton sheets and a warm house that belongs on the cover of Ideal Home, I feel calm, adult, right. This life is so far removed from the cold and dirty student houses I've been surviving in for the past five years. She makes me an iced latte and I watch her smooth lotion onto her little girl's neck and knees, help her into her tights, tie her shoelaces. I imagine myself as part of the family. Witnessing Blue as a mother is a beautiful thing. Her daughter is a credit to her. Even when she's off school with a cold, we're watching educational shows or making paper maché volcanoes. The way Blue nourishes everything in her world tells me that this will be a healthy relationship.

When I leave her flat for work, I'm barely at the bottom of the stairs before I voice note Red.

"Hey! How are you? I've been seeing someone but it's really

weird because I keep thinking about you! Anyway how are you? Hope you're good!"

A pathetic attempt to sound casual. I can't stand my ability to shut out the world when inside Blue's home and then check in with my part-time lover the second I close the door. I justify my behaviour to soothe my self-loathing: if I didn't care about Blue so much, I wouldn't feel the need to touch base with Red in order to regulate my feelings. It's a compliment to Blue. After all, Red came first.

"Hey! Good to hear from you. I miss you! That's cool, hope you're having fun! And listen, don't hold back on anything on account of me, enjoy yourself, do your thing. Can't wait to see you this Summer. Mmmwah."

I've deduced from social media that she's broken up with her latest boyfriend, yet her tone, kind but non-committal, tells me there's someone new for her too. But it's my stomach that sinks this time, not my heart—now buoyant with Blue.

And so, I have permission to continue with my new love interest. The trouble is, Blue is scared to let us, so what was first smooth becomes stilted, and as our relationship deepens it becomes harder to untangle. Whenever we spend too long together, she reminds me that we shouldn't, yet will still invite me round the following night. This is for self-preservation, but she expresses her doubts so often and so directly whilst her actions are the total opposite, that it undermines the intention. I, the subject, am now also the therapist, absorbing conflicting emotions about myself that are presented to me without conclusion. I know it would be better for her to share with a third party and go cold turkey on me, but of course I don't want that. And so we build more intimacy and the cords pull tighter. I long for the day she agrees to follow our path wherever it leads. I want us to be together, to cross the bridge of Red in three months when I will be forced to. I am selfish. Blue has a daughter to think about.

Blue fell pregnant as a teenager and co-parents successfully with the father like my own parents did. I've seen him collect their

daughter for the weekend and I like him; he's a goofy, six-foot guy who hasn't grown out of his rudeboy stage, and because their relationship was child's play, there's no lingering jealously or harboured resentment between them. But I'd watch him—a visitor in his daughter's home—and think, *how did you do it? How did you leave Blue? And how do you still do it now, over and over, laughing and joking with us like it didn't rip your life apart, then walk right out of that door knowing you've left the treasure inside? How can you share a daughter and be content not to share a life?* Instead, it's me who has the honour of sitting on this sofa under a blanket with no make-up on, waving him off.

I lose count of the amount of times I travel home from Blue's house, deflated that she's called it quits again, only to receive the back-pedalling text: *I think I've made a mistake.* Our mutual compassion for each other's position makes our endings blurry, almost impossible to be endings at all. How can they be, when the feelings are still there?

I didn't think I'd ever decide enough was enough with our back and forth, but eventually my boundary is drawn, ironically when I am closer than ever to denouncing Red for the sake of this new relationship. Blue's freak-outs stop feeling like compliments and I begin to fear what's at stake for us.

"I wish she didn't exist," she whispers to me after a particularly difficult heart to heart, tears shining in her eyes as we lay like mannequins in bed after making love. *Red is me*, I think, fashioning anger out of thin air as a ludicrous attempt at martyrdom to avoid taking our relationship to the next level for the sake of Red. I'm scared to make the jump. *She's my Adam's rib. Blue can't hate her and claim to love me. Those things are mutually exclusive.* It's an arthouse hypothesis, even for me. An excuse. A weak attempt at trying to leave before I am left, or, perhaps, to avoid real intimacy, which will involve me truly being seen.

"STOP it, Blue!" I jump from the bed, startled by my own volume. "What do you want from me?! You say you can't accept my love for Red, but you keep changing your mind and bringing me

back here! You know my situation. If you can't accept it, what are we doing? It's wearing me down and getting harder each time!"

The hypocrisy, when I've refused to tear myself away from her for even a second.

"Get out." she says, final as a blade.

I'm confused by the turnaround in her blunt response. Only when I see the head of her daughter pop round the doorframe, does my mistake register.

"Get out." Blue says again, but in a whisper this time, tears shimmering like highlighter on her cheekbones. I know I've gone too far and there's nothing to do but leave. As I grab my jacket, she pulls a blanket over her head. I close the door on us, hearing her heavy sobs mingled with *That's Life* by SiR playing low over the speakers inside.

That evening I receive a text. "I've got a kid. I'm too grown for drama. I'm grateful for our time together, I'm always going to look back and think you were the one that got away. But this needs to end now. You can't shout in front of my kid."

Perhaps she is right not to trust me. I like to think we'd have been great for each other, but how can I know for sure? I am emotionally unstable, unable to choose between two women, incapable of recognising that I shouldn't yell in front of a child until I've already done it. Her daughter wasn't even on my radar; I am too caught up in romantic whimsy to deserve a woman so grown. But the care and mature communication Blue has given me has changed me as a person, even if the fruits of that growth haven't yet manifested on the outside. I don't feel shame about who I am anymore. She has taught me compassion and how to listen, by showing me that I too have the right to be heard, and to want what I want even if I have to deal with the consequences of my desires. *Especially* when. She has grown unconditional love from the velvet of her womb, yet still tried her damnedest for an inferior love like mine.

Unable to cope with heartbreak, as usual, I take a week off work and spend most of it crying in the bath listening to *Another*

Day by Jon Secada. I was right about not being okay when this ended. I dye my hair white, something Blue knew I wanted to do and was nervous about, "because I'm going to end up fancying you more." I appreciated that she wasn't too proud—was never too proud—to offer that compliment up even at the twilight of our relationship, knowing it would give me some power in the aftermath, and I cringe when the white turns to a rusty blonde after a few weeks and probably makes me easier to get over. I pretend I am fine when I see her out. She texts me to make sure I am, compassionate as ever, and I reply *Yeah! All good x*, too embarrassed to reveal otherwise.

After a night out with Caro, who tells me she thinks it's salvageable because she is close with Blue and can tell she "definitely still loves me", I am hopeful. I call Blue the next day from the sanctuary of another hot bath, and when she picks up I can hear the sizzle of a pan and people in the background. She has friends over, which makes me feel more alone than I already am.

"Blue, I need to speak to you." I steady my voice, try to make it conversational rather than desperate, knowing I have to keep it short as she has company. "It's been two months, and I still think about you every second of every day. I'll end things with Red. It's you I want to be with—"

"Look, Fern, I appreciate your call. But I can't. I did all my crying when you left, and since then I've built myself back up. I'm done now. I'm good."

"But where does all the love go?" My voice catches. "When two people end but still have feelings for each other, what does that mean? For the next person I see? Where will my feelings for you *go*? If I still feel like this in six months, do I just keep it to myself?"

The clinking of glasses and her daughter's laughter.

"....I don't know, babe. I think so."

"Okay."

" Look, I'll probably see you soon anyway. We're all good, okay?"

"Okay." I long for the conversation to continue but don't know what I can say to keep her on the phone.

"Bye, babe."

She hangs up, and I ugly cry.

For the next six months, the first two seconds after I wake up are the best part of my day. Before I remember.

I struggle to get my head around such a fruitless ending. If feelings don't fade after a breakup, why remain apart? And if feelings do fade, well—that makes even less sense, because how can any couple know the strength of their love unless they test it by separating? Are distance and time the *only* ingredients for moving on? Meaning you can *choose* who you love simply by who you stay with? The thought rocks my entire understanding of the heart.

The writing was on the wall for me to be in the same position as her daughter's father, foolish enough to walk away because of my self-imposed soul contract with Red. Of course, in time, I heal. I feel it as it is happening and because it goes against every-thing I believe in, I *hate* it. Until the healing is complete, of course, and then I don't hate it at all. In fact, I am grateful for the scar tissue, as without it—with the amount of times I've been cut and have emotionally self-harmed—imagine the mess. I thought closure would be the sound of shackles smacking concrete, but we do not celebrate what we no longer care for. Time erodes what we think is essential to our survival and cannot bring ourselves to face a new day without. Yet still, I can't fathom a new day without the idea of a future with Red. That's something to be proud of, at least? To cling to? There is grace in Blue refusing to let me give up on my dream of being with Red. She cares enough to know we both deserve to wait for what will truly make us happy. I don't know it yet, but Blue is the first to teach me how to be with some-one. She sows the seeds for the partner I want to become.

I remember she'd said those three little words once. Stumbled into bed drunk and mumbled them into the darkness when she thought I was asleep. I hadn't said it back and want to smack

myself now.

Because I might have learned it the hard way, but I now
know that the unnamed thing inside my chest was love.

CHAPTER
25

M Y PROCLIVITY FOR infatuation is too high. If I'm truly set on Red, I have to remove all obstacles to her, make reaching her my main aim. Running toward all the other potentials for love seems to bring me only pain in the long run.

But first, my job. It needs to go. In order to attract better, I've read that I must be grateful for what I have *now* instead of focusing on lack, so I resolve to make a list of ten things I like about each and every person in my office, whether I know them or not. My hope is that I'll ooze so much appreciation that a visa will fall onto my lap. Then I can get a job in Canada and be with Red. Simple.

I look over to the back corner of the office, where two women I only know by face are sitting. The first is a senior member of the company; I know this only because she struts across the office at full volume. I thought it was funny when she went behind the bar at last year's Christmas party and poured herself a drink. I found it sweet how she once wordlessly tucked in the label of my top as she passed me at the printer while I was scanning an invoice. Two things to be grateful for already. I open up a Word document and type out these two bullet points. The other woman isn't as easy to be grateful for. Her harsh tone confuses me; I often think she's shouting at colleagues until I hear them laugh in response. She's always in a hurry and never smiles at me. In fact, I leave the kitchen whenever she's the only person in there, afraid of getting caught up in a knife fight between her and the roast chicken she brings in for lunch. But she dresses well—freshly coiffed and pro-

fessional—and I admire that. I guess I also respect that she gives no fucks if she comes across as rude. Another two things to be grateful for, I guess.

It takes me a whole week to work my way round the office, but my mood rises considerably afterwards. A week later, I'm back to crying about my invoices in the stairwell, ready to hand in my notice, when the first of the two women walks past me and stops in her tracks.

"Are you ok, love?"

"Yeah. I just don't like my job anymore. I don't think I'm meant to work in finance!" As usual, I'm willing to tell my life story to a relative stranger.

"What are you interested in?"

"I dunno. I'm just so bad at maths. I'm better with people."

"Hmmm..." she leans her weight on one foot, the sole of the other suspended, its heel piercing the laminate floor. "I might have a role in my department coming up in a few weeks. Let me see what I can do."

I don't know what her department is, but she seems to think I'll take it regardless.

"What is it?"

"HR Coordinator."

I'm still none the wiser; I don't know what HR is but I thank her and for the next few weeks every time I pass her in the corridor I smile expectantly. Sometimes she simply smiles back, at others she says, "I haven't forgotten!" with a wink. I believe her, and this faith is the only thing keeping me here, numbing my brain with numbers. I begin to lose hope when two months have passed and I've heard nothing, until my boss tells me she's had a meeting with Claire, the Human Resources Director. So *that's* what HR stands for... Human Resources. They've decided a transfer might be right for me. I research what it is and am sold at the focus on "people".

The day of my interview, I sit across from both of the women I was first grateful for, forgetting they come as a pair and hoping

I haven't made the wrong choice. Ula, the second woman, looks me up and down and I can see her distaste of my septum piercing, my silver hair, my fiercely patterned trousers. They're probably offensive to her perfect nudes and neutrals. Claire tells us they've worked together for a decade and Ula will be the one to turn the lights off if ever the brand goes under. They're to our company what Pat Butcher & Dot Cotton are to Eastenders. Not in age – they're just OGs.

I get the job. There are just the three of us in the department. Ula and I report to Claire, but I have a dotted line to Ula for the day to day. I'm hesitant about this, knowing I'll no longer be able to avoid her. My first morning in the role, she gives me a to-do list as long as my arm and promptly tells me she's off on annual leave. I complete the list with all the diligence I can summon, seeking her approval, hoping I can prove her wrong about me as I know she sees me as nothing more than a scatty young girl. On her return, she's impressed with how I've got on, and I notice a hint of banter in our subsequent interactions. She plans to take her closest friend at work for a birthday drink and asks me to join them. I'm *in*. So, work ethic is the one thing of value to her. Work ethic alone is what I need to survive. My jig is up. Time to become an adult.

Ula is frantic, caffeinated, and when I get things wrong, quick to exasperation. She is not used to relinquishing control over her workload, micromanages without providing all the information, and if I ask where I am supposed to find something, sighs, "It's not saved anywhere, it's in my head!" I can hyperfocus for hours when I'm interested in something, and I am interested in HR, but I struggle to maintain her level of consistency and my brain doesn't work the same way as hers. It's tempting to regress to a teenager, to act as if she's a teacher who keeps putting me in detention. This place has been like a tertiary school to me, so whenever I've reached my honey badger limit, I call her out. To her credit she takes it well, gives it back, and dare I say she weirdly respects it – or at least, it amuses her.

One day we're inducting an employee and chatting amongst ourselves.

"Don't argue!" the new lady says, as we wait for her to fill in her private medical forms. She smiles kindly. "Kiss and make up!"

We frown at each other.

"We're not arguing!" Ula turns back to the lady, doing her best impression of someone chipper. "This is just how we communicate. We love each other!"

Realising we ought to stop before the easy irritability with which we communicate ruins her professional reputation, Ula and I learn to hold onto our frustration—not quite ready to give it up entirely—until it is safe for us to unleash. We use a meeting room on the mezzanine to communicate in the way that works best for us. Whenever it gets tense, which is at least three times a week, she points at the door, says, "Up here?" and we climb the spiral staircase so we can raise our voices without anyone hearing. The first time this happens, we stand across from each other afterwards, separated by the board room table, shaking and slightly red. Then she starts laughing. "Now let's hug it out!" she exclaims, arms wide open.

It's a weird dynamic, but it works.

Sometimes she makes me so angry I cry, her response to which is always, "man up!" but I once caught her checking the smoking area to see if I was okay afterwards, which warmed my heart. Where I can hold onto disagreements for days, she lets them go as soon as they happen. One Christmas Eve, I am emptying my inbox before a flight to Thailand with my family for the holidays when she tells me off for something I haven't done—something she has misunderstood. I find it so unnecessary for her to react like this on the eve of Jesus' birth, that I storm out without permission and end my year early. I call Claire to let her know and she allows it, but I spend my whole time abroad worried that I'll be handed my P45 when I return in the New Year. By that time, Ula can't even remember that we argued. I love the cat and mouse of

it, it keeps me on my toes and makes the job enjoyable. I'm eager to work hard even if only to spite her.

For the most part, life changes so gradually we barely notice. But I can pinpoint the exact moment the company pivots, when the players change and I become a true peer to the majority. It is a turn of direction that makes the following years some of the best of my life.

I am waiting for my morning toast to pop up, leaning against the kitchen counter with my eyes glazed over and attempting to delay my morning dose of Ula for as long as possible, when I hear a peal of young laughter. Looking up, I see a girl and boy my age. Within a few minutes there are six of us, all in our twenties, crowding the galley like student halls. I eye their clothes as I spread my butter, pleased with the fashion inspiration suddenly brought on by an explosion of ASOS in this tiny space. *When did this happen?* Despite the fact I draw up a third of the contracts, the company is large enough for new joiners to escape my notice for their first few days. But so many people in such a short space of time? There must be an influx of new recruits outside of my unit, which makes sense, because the business is growing rapidly. Sure enough, within the next three months, the entire makeup of head office has altered. Suddenly nearly everyone is young, and inexplicably, from this shiny new tribe, comes the blueprint of my life. An era I'll never shake.

Ula and I have gone through several agency administrators to help us with the transfer of our files from paper to digital, but our rotation of temps soon ends with the recruitment of Sara. She is my Spanish twin: same role, same star sign - we even get the same neck injury from straining to look at business that doesn't concern us. Where previously we used consultants, our department soon quadruples to include contracted recruitment, marketing and finance teams, with most of the new joiners in my age bracket. I am not sure what magic has been sprinkled over the back left hand corner of the office where we sit, but we fit together

straight away like the zig zag heart on a best friend necklace. I've never seen a team like it, individuals of all ages and from all disciplines getting on as well as we do. In the words of Lizi, our new accountant-cum-philosopher, "we move as one, like the ocean." I like them *all*, but as always, have my favourites. Sara, with her uncanny ability to cry the very moment a sad thought enters her head. You only have to mention something negative and a tear will already be halfway down the apple of her cheek (she can stop just as quickly, too. Should have been an actress). Sara thankfully becomes someone I can conspire with, and gives me a buffer from Ula—poor thing, now out of her depth with two emotional young girls on her plate. Lizi becomes Finance Director at age thirty which blows my mind, not least because—also a Gemini—she is scatty, talks the hind leg off a donkey, is late most mornings and makes me laugh which is unusual for an accountant. That she is this far along in her career at such a young age while still having a personality and rushing into the office like she's just woken up, inspires me. Then Megan comes along: Marketing Manager, discernibly posh with her double-barreled surname, catching my attention on her first day with her multicoloured tartan scarf from Oliver Bonas. She becomes my closest friend almost straight away, despite what she says—that I am aloof and hard to break, "like a Fabergé Egg." Her Marketing Assistant soon arrives, nicknamed MK because she is the owner of the longest name in the history of the world, containing not one but *two* double-barrels. MK pushes me off the spot as the baby of the company, but this is easy to forgive because she looks like that smiling emoji with the three lovehearts on its face. Duncan, another OG (he can be the Ian Beale of the company—replacing fish & chips with a number of European dishes) is our talented Development Chef. He spends most of his time downstairs in our brand-new food development kitchen. Duncan creates the menu for each of our concessions brands and makes frequent journeys to our floor in his chef whites with new concoctions for us to trial. Ula abuses her position in his team, pinching far more than her

permitted quota of the company fruit bowl and proudly declaring, "I'm going to ask Duncan to make me an apple pie today!" and then clomping downstairs to the kitchen before 9am. Last but absolutely not least, there is Leanne, our Regional Manager of the North, whom we don't see as often as we would like. Her red lego haircut, Liverpudlian accent and comedic delivery bring joy and hilarity on her rare visits to the office. Leanne's writing is exquisite, her language rich and articulation so deliberate she can make a disciplinary outcome letter read like erotica. We always make sure a night of drinking is scheduled when she visits. These are just a portion of the people who imprint on me, but to list them all would be fastidious to those who have not met them. We all sit on opposite sides of one long desk, disciples of each other at an eternal Last Supper of Duncan's dishes.

These people are going to make it so much harder to ever leave this place, I think, before the motivation to look for a new job disappears from my head and into the ephemera forever. With the exception of a few, most of my peers are in a similar enough position as me, so I suddenly feel that I'm right where I need to be. Our new team has a particularly impressive effect on Ula, who softens considerably, to everyone's disbelief. Where once she had been irritated by my generation—generally seeing us as distracted and trite—she is now the first one suggesting after-work drinks most nights and even books Megan, Lizi, and I for a spontaneous weekend away in Poland to meet her family *before* she has met Lizi in person (Megan and I give a positive character reference). The trip's success is such that it would be remarkable for lifelong friends, let alone a group of relative work strangers. The dynamics of respect and teamwork transfer from the office into our personal lives. We are a well-oiled machine, professionally and socially.

My need for two hours of alone time per one hour of socialising does not apply to this group of friends. I'm usually the last guy standing at any of our get-togethers, be that at a wedding or the opening of a company envelope. As an introverted extrovert who gets FOMO and plan-regret simultaneously, after-work drinks

don't feel like something I have to work myself up to, or energetically "get ready" for. There is no clockwatching or sense of anticipation that I have to be somewhere else. These people *are* the something else, and quickly rank amongst those I value most in my life, their company the only place I want to be. It is natural for us to say goodbye before midnight, catch the last tube and tumble into the office the next morning to do it all over again, arms laden with bacon sandwiches for everyone, knowing the hangover is collateral and the same restaurant we were in the night before will welcome us back for lunch. Even those of us who don't meet up in our personal time know each other's secrets, the inner workings of our tired brains, our most trivial daydreams. Alumni invite us to the leaving drinks of their *new* jobs. We tell each other things we wouldn't bother divulging to our closest friends, simply because we're always together. Work stress, political tensions, emotional labour, love triangles: a corporate Big Brother, drunk on love. The copious units of alcohol consumed help, of course.

During this time, I visit my friends in Canada for my 25th birthday. Red is in another relationship, and on the night of my birthday dinner she gets stoned and opts to stay home with her boyfriend to eat pizza. I overhear Nike, our closest mutual friend, whispering to her in the hallway.

"You know this is *Fern*'s birthday right. Fern's? YOUR Fern's. And you're not coming?!" The emphasis on my name highlights that Nike knows I am important to Red, which I appreciate; confirmation our bond is mutual to some degree, even if my fantasises are elevated. I act unaffected—after all, I am in Canada on my birthday, seeing Red most days anyway. But alone that night, high in my camp bed at Nike's house, my butt cheek still wet from the peach Alka-Seltzer I spilled over myself in the car ride home while drunk, I can't deny the shift I feel inside me. No Law of Attraction techniques can alter my gut instinct. Whether as lovers or friends, tonight has proved that Red and I don't mean the same to each other. I wouldn't miss the birthday of any crush, let alone Red's.

It's the first time I admit this to myself - a pearl of wisdom for my new age. Red makes it up to me the next day by taking me to a strip club and paying for me to get a private lap dance. Deep down I can't shake the feeling that holding out for her will be in vain.

Yet still, I never doubt that I will end up in Canada. I've completely surrendered to the hows and the whys and instead accept that it will happen when it's supposed to, as long as I remain grateful. In the meantime, I am happy. I am present day to day, enjoy my family and my friendships and continue to work hard for Ula - who I now adore - and who I am influenced by to such an extent that I start wearing thigh-high boots to work like she does, revert to my natural hair colour so that she won't shake her head with disappointment whenever she looks at me, and remove both my nose piercings (then put the nostril stud straight back in, because - "not that one! I like that one"). I've started to fancy people in the office, so I know I ought to bring myself to a new environment, a blank canvas with no nostalgia or temptation; somewhere that inspires me to switch the polarity on my moral compass and where tapping my lanyard won't whip me up into a frenzy of frivolity and hedonism like Pavlov's Dog. But I'm too tied up in my full life at this company to be proactive in moving forward. I don't want my halcyon days to end, plus they distract me from my epiphany that perhaps Red isn't the one for me. They distract me so well, in fact, that I eventually forget all about my 25TH birthday until eventually the idea of our chocolate box future twinkles at the back of my head once more. But it's hard to manifest something your intuition shakes its head at, so to take the pressure off, I make a list of all the qualities I'd want in a dream partner and ask myself for Red or *better*, instead of thinking only of her. The universe works fast without resistance, and the clock is ticking.

The day before I unwittingly broach my New Testament like a lamb stumbling blindly into the lion's den, I am on a train headed for Birmingham. Ula is on annual leave and requests that I take her place at the monthly HR Forum in Birmingham. I sit on an

Avanti West Coast train with a mocha in hand, staring out the window as London fades into the distance and the countryside rushes past me in flashes of green and yellow. *Caribbean Blue* by Enya is in my earphones, and as the opening chords fill my ears I am transported to the Atlantic Ocean instead, its blissful expanse of sea and sky: twin blue jewels gleaming above and below me. I feel hopeful for the future and contentment for where I am. My thoughts drift to a BBQ Megan hosted last Summer. It was Sara's first weekend out with us.

"I know I've only been here a month, but you guys are just the best, you know?" Lizi had said, squeezing my knee affectionately. "It's always the people. You can be on the highest salary, working for the best company in the world, but it doesn't mean anything if you don't love the people you work with. At least not for me. I'm so happy to have met you all."

I'd looked through Megan's double doors and into her living room where Duncan was deep in concentration, lovingly pouring his own cocktail concoctions into martini glasses for us all. MK and Megan were on FaceTime with their new boss, trying to convince her that the drinks would be perfect for their new menu by virtue of how drunk they'd got from sampling them. Lisa Aspinall (our Openings Manager – to be addressed only by her full name) was on the phone to her fiancée, telling her she had no choice but to stay with us in London for the night because she'd missed the last train (this was a lie - it was 7pm). I was full of (and covered in) the prosecco that had sprayed me in the face when I'd opened it earlier. No words could encapsulate the satisfaction that my friends—that life—brought me every day. Little did I know how soon it would come to an end.

Birmingham comes into view through my window, bringing me back to the present. I feel something simmering inside me, like a life-changing event is about to happen. Looking back, I do not bother wondering - if I'd have known what this life-changing thing was - whether I would embrace it or not. Of course, I would.

There are no alternate realities; we make every decision based on our life experience at that moment. And as Enya generates these visuals of oceans and voyage through my earphones, there is a tiny scarlet devil being hoisted into a catapult, ready for her own voyage to meet me within a matter of hours. If I was back there again – in 2016 – I would catch her over and over again, no matter how it burns the skin off my palms, turns my fingertips to soot, sears the very structure of my DNA. Because to be back there means to be who I was then, and we cast off all notions of consequence when what we think we desire is in front of us. Besides, as Prince Beslan says in Robert Jordan's *Wheel of Time*, "What's the fun in kissing a woman without the risk she'll decide to stick a knife in you?" Saturn's final disguise was all I'd ever wanted, and to convince my twenty-six year old self otherwise, would be foolish.

The Forum comes and goes, uneventfully. I learn a lot and contribute a bit. I head back to London for our colleague Conor's stag do that evening, where I get kicked out of McDonalds in Camden for drunkenly shovelling a stranger's fries into my gob. I fall asleep, satiated on salt and affinity for my work friends.

And then, on the very next morning, 15th September 2017, there she is.

PART
THREE

"At the midpoint of life's way, I reached what proved a crisis."
INFERNO, DANTE ALIGHIERI

(For me, it was the quarterpoint).

CHAPTER

26

Grey—The Seventh Woman

Recall the old adage: *there are three sides to every story.* The version I'm about to tell is mine only. Grey's is likely to be quite different. The truth will, as always, lay somewhere in between. I appreciate this bias, while recognising neither version is more honest than the other, each burdened by its own personal history; all the fear, desire, and muscle memory of previous hurts.

I've booked the day off work for a hair appointment and am on the tube, spaced out from my hangover and absent-mindedly eating a breakfast baguette from Pret. As my tube pulls into Hampstead station and slows to a stop, I look up to see a girl standing on the platform with her hood pulled over her head. She has long, dark hair, an unmistakable scowl, and does not look impressed to be awake.

She's hot, but angry, I think, as we catch eyes and she steps onto the next carriage. She chooses the seat nearest our adjoining door. I return to my breakfast and my thoughts wander elsewhere. A minute later, I look over again. She holds my gaze with her resting bitch face, a gem in her nostril glinting under the crude glare of the carriage lights.

I bet she's gay.

I am the public transport *Amelie* of compliments, peppering commuters with flattery. If I see someone I think is beautiful, or I like something they are wearing, I have a compulsion to tell them.

I want this girl to know I think she's hot, so I keep looking over for the opportunity. She stares intensely back at me. I wonder if it's obvious I'm interested, or if she's about to start a fight through the medium of mime. From the look on her face, I can imagine her eventually shouting, "What you looking at?" through the open window in the door separating us. This intimidates me. I like it.

While all this is happening, the Cherubim are finalising terms on a contract somewhere above us and a voice announces our next stop over the tannoy.

Belsize Park

The Seraphim take the paperwork from the Cherubim and hand it to the Power of Authorities. After scanning it with infernal eyes; fact-checking all the lessons we have failed to learn and the next level of education due to us, these two strangers crossing paths on public transport, the Dominions toss it to the archangels.

Chalk Farm

By this point the girl is slouched forward, man-spreading with her elbows on her knees and her head completely cocked in my direction.

Definitely a dyke.

Sensing a brewing hostility from her, I smile. Her frown immediately softens and she elongates her face with that stereotypically British smile, its down-turned smirk of acknowledgement. *We're on the same page.*

"You're hot," I mouth through the open window, pointing at her. An elderly man opposite me looks up from his newspaper.

The girl pulls an earphone out of her ear and scrunches her face in confusion. I find this funny, because even without her music in, she won't be able to hear me. Still, I repeat myself.

"You're *hot.*" I widen my eyes for emphasis.

"You are," she mouths back.

"Come here."
"*You* come here."

Camden Town (Charing Cross Branch).

With a nod, the archangels tuck the scroll of fate behind the ear of the smallest, naughtiest putto. It's his job to deliver it, spurred on by feathered wings, onto our banal Northern Line train this unremarkable September morning. It's decided. We are ready for each other.

I look down at my lap, coy. When our eyes next meet, the girl holds up two fingers, like a dealer trying to discreetly pass a baggy. I see a small, folded up piece of paper between them.

The next stop is Euston, and this girl—unaware she is about to alter my destiny irrevocably—stands to wait by the door. I could have stayed on without looking back and my life would have trundled on as ever, Saturn frustratingly whirring its gears at my lack of desire to change my life. Fortunately for Saturn, I realise the girl is either about to hand-deliver her note or depart from the tube and disappear forever, and I'm not about to take any chances. I rise from my seat to meet her. Separated only by metal and the thin veil between worlds very close to tearing, we approach our connecting window simultaneously. A portal between us, leading to the most fateful phase in my life so far. The wind whips our hair about our faces as we steady ourselves against the momentum of the moving train.

"You're confident!" I shout over the underground blizzard.

"What!?"

A French accent.

When the tube stops, we step onto the platform and she hands me a piece of paper. We have a brief conversation I don't remember a word of, and she's gone.

Wow, I think. I really fancy her. I never fancy lesbians.

Grinning to myself, I reboard and take my seat, opening the note between my fingers. It's a sheet torn from a waitress' notepad.

On the other side of the paper is a phone number and the prettiest name, written in red letters.

CHAPTER
27

I CAN hardly believe she's real. Grey is from the South of France with a voice of espresso, gravel, and sex. When she sends me a voice note later that day, my groin cramps with longing at its huskiness. The moment she walked away from me, I knew I wanted to sleep with her whether or not we saw each other again. The rarity of this buoys me with unexpected pride.

I imagine that when we meet up—which we undoubtedly will—I will kiss her passionately at hello and just surrender to the lust, because who knows if I'll ever experience such primal desire again, and what if it's fleeting? A pomegranate that needs to be split open and drained before it rots? I predict a heady encounter fuelled by the sensual confidence she's inspired in me through our subtle building of tension, first through the window on the track from Edgware to Kennington that day, and afterwards through our phone screens. I get the flu the day after we meet—perhaps my body warning me that what is to come will make me very, very, sick—but she's impatient and I don't want her to lose interest, so after declining her offer to have breakfast at the crack of dawn the next day, I agree to meet her the following Tuesday after her shift at a boujie bar in Central London, when the major symptoms have worn off and only a tickly throat remains. I hope that this preventative foreshadows a kiss, the way wearing ugly underwear will always get you laid.

When I see her again, waiting outside Camden Town station like a vision in a duffel coat with a spliff in-hand, I remember that Grey remains the cold, surveying girl I'd met on the tube

and become too shy to proceed how I'd fantasised. It would be the wrong move. Besides, she's on the phone. Simply processing her silhouette, gauging her physical presence once more, I know I won't be the one in control here.

She ends her phone conversation and steps forward, greeting me with a slow, guttural, "Bonjour" and the European double-kiss. Our cheeks touch on each side, a sacrament.

"Don't look at me." she says.

That her first words are an order disarms me. Abrupt. Author-atitve. *Hot.*

"Why?" I ask, a laugh hidden in my throat.

"You are Miss Universe 2000 and I... shouldn't have met you from work. Don't look at me like this." Her long, dark hair shields that beautiful face from public view like a pair of stage curtains. Fucking hell. Does she not own a mirror? Although perhaps it wasn't a compliment, seeing as 2000 was seventeen years ago.

We decide on a place I used to underage drink in and as we lean against the bar, she pulls out a wallet (*not* a purse—definitely a lesbian) and refuses to let me pay for our cocktails.

"Don't be ridiculous," she scoffs.

We sit outside in the chill midnight air and I drink her in with our Long Island iced teas while we talk, increasingly sat-isfied. Each time I look at her face I like it more; every time she speaks, my shoulders relax an inch lower. This is exactly the cosmic order I've placed and then some. She is mysterious and just... sexy, no other word for it—exactly like the French women you see in old arthouse movies, yet nothing like anyone I'd dated before. When she smiles there is a genuine, childlike elvishness that lights her eyes and leaves something behind—I don't know what—something invisible: the ghost of a shadow on the patch of skin between her cheeks and her ears, just below the temples. It is perhaps the only innocent thing about Grey's first impression. This, and her beautiful smile that reveals small, square teeth. I want to kiss their ceramic. The rest of her is unnerving in the best way. Our entire encounter is perfect: continuous teasing, genuine

interest laced with an affected nonchalance. I want her to teach me things I don't know, despite the fact she's four years my junior.

I realise very quickly that this woman does not suffer fools. It is in her quiet confidence, the cynical questioning, her flippant and laser-certain responses. I learn she came to London two years beforehand because there are not many jobs where she's from. She lives in a one-bedroom apartment close to me and despite her age and occupation as a bartender, is earning double what I am from tips thanks to the generosity of wealthy diners. Obviously she's not privy to my salary, but I feel inferior all the same and begin to question why I ever went to university, considering it's set me back four years in terms of earning my own money and I had a miserable time there anyway. Grey's girlfriend at the time followed her over to the UK, but after a fight that resulted in a dented wall, they'd ended not long after. She is close to her family and would like to move to Sicily for the weather.

Whenever there's a gap in conversation, it's a symptom of sexual tension as opposed to awkward silence. She's an expert at diffusing them regardless, with a narrowing of the eyes and what I come to realise is her favourite question: "And then?" to prompt our next topic. I find this question endearing but nerve wracking, as if it were rhetorical and the answer is "...I kill you." There are so many "And then?"s confettied throughout our evening that I point it out, and so we have our first private joke.

My attention is fractured by a small group huddled on the street next to our terrace. Standing up to join the commotion, we spot the milky jelly of a mouse foetus, shrivelled on the pavement between the punters' feet. The crowd are shouting about this poor creature with morbid curiosity, but Grey merely lifts her chin to get a better view and pulls a face of disgust.

"What the fuck?" I say to the boy who yelled first. He says nothing. It looks like a Haribo that's been recalled by the factory due to contamination.

The stillborn rodent puts us off staying for another cocktail, so we down our drinks and take a walk by Camden Lock. I stroll

with my hand sticking out a few inches; a subtle reminder to Grey that it's there should she want to hold it, yet already knowing she's not the kind of girl to engage in public displays of affection on a first date. She'd see it as handing over too much control. If I was in anyone else's company I'd be longing to get back to my bed. Instead, I'm charged. My sickness has vanished miraculously and there's no longer a pain in my throat. I want to kiss. We sit down on the peak of the lock and swing our legs over the side, watching the moonlight frisbee across the water. Conversation progresses naturally as she skins up for another spliff.

"I had a guest last night. For a few nights, actually." she mentions in passing but not without a smirk; tongue tentatively skating along the edge of her Rizla like she's licking a razorblade.

There it is. Too good to be true. She's a player.

I pretend to act unbothered and laugh. I mean, I'm not bothered—I barely know the girl—but it's hardly what you want to hear on the first date you've ever enjoyed. Also, why tell me?

"Nothing special," she goes on to say. "We met on holiday in Sicily. I sent her home this morning."

Hearing this gives me a solid excuse not to go home with Grey. I'm rarely spontaneous anymore, particularly not at 2am on a school night when I've only just recovered from the flu, but I find that moment where you have to reject an invitation (and I can tell it's coming) awkward, even more so because in this case I'm genuinely into her, so there's the added worry she'll misunderstand it as lack of interest. Just two hours ago, I practically wanted to greet this girl with sex, but the reality of our exceptional date has assured me we have time, and I'm not willing to be the next girl who jumps straight into her bed. So, once we've had our first kiss and our second and are walking back to Camden Town to catch the night bus home, I'm vindicated in my dissent when she suggests I stay over.

"I can't. I'm still ill, remember, and I have to be up for work tomorrow."

Grey's mouth presses against my neck and her hot breath rip-

ples through my body like liquor tiger balm or any miracle elixir for the common cold. *What illness?*

"Put that smile away," I say, kissing the tip of her nose.

"It's not miles away!" She objects, misunderstanding my English. Adorable.

It's obvious Grey isn't used to being refused. She truly believes she can convince me, but when we reach my stop and I stand up, never taking my eyes off that captivating face for a moment, she's still bartering to get me to stay. I dot her face with kisses to appease her before walking backwards down the aisle of the top deck of the bus, promising I'll stay with her as soon as I'm better.

When I'm home, I send her a text.

Me: I know you hate me for not staying with you. It's fine. And then...?

Grey: And then...?

Me: And then... I tell you I think you are even better than I remember on the train. Except for your preoccupation with Sicily... everything else was perfect.

Grey: I want to move to Sicily for myself, no one else. Anything else? And for the rest VA TE FAIRE FOUTRE! Putain.

My heart hammers in my chest as I Google Translate her response, unable to tell if she's angry or making a joke that's been lost in translation. Whatever the answer I want to appease her rather than call her out for swearing at me. *Why the hell is she swearing at me?*

Me: Why are you angry? Did you not have a good night?... I just meant it'd be bad for me if you lived there because I wouldn't get to see you.

She reassures me she is not angry, merely having a gin & tonic by herself, which is ultimately—she reminds me—my choice. This is followed by the lips emoji, which will come to be her signature for the kiss. Not the popular pucker that tilts to the left, but the neutral mouth, lips slightly parted with subtle, sharp pleasure. That small cerise character is my green light.

CHAPTER
28

O N MY WAY to work the next morning, I spot another dead mouse outside the station. Taking this as a sign (I'd never seen a dead mouse before and now two within twenty-four hours?!) I Google "dead mouse omen." There's little information on the symbolism of rodent cadavers, but a few hyperlinks later and I learn that a mouse—alive or dead—signifies not at all is as it seems. I must watch out for the details. As mice roam close to the ground, intricacies are all they see.

"I saw *another* dead mouse this morning" I tell her at lunchtime the next day (meet-ups come hard and fast with Grey—this is my first time dating a lesbian I'm actually interested in, after all). "Apparently, it's bad luck."

We sit straddling a park bench near King's Cross station, facing each other, the ingredients of her spliff laid out in the diamond made by our thighs. Watching her face as she rolls, at first I am expectant of an answer. But I become lost in the analysis of her strong, aquiline nose, those almond-shaped eyes. She shrugs her shoulders with a face to suggest she doesn't know what type of luck it brings, nor should either of us care, but at that moment two magpies fly out from behind a tree above her head.

"Look!" I say. "Two for joy! So, which is it?"

She smiles and gives me a kiss. "See. It's up to you. Are you going to be bad for me, or good for me?"

"Both, depending on the occasion."

"Good answer."

Grey lives in a tiny, one-bedroom flat on the first floor of a town-house that's been separated into two living spaces. The front door opens onto a box-landing with a bathroom to the left, bedroom to the right and kitchen straight ahead. When she invites me round for dinner the following week, I am greeted at the doorway by a hubbub of domestic activity from her flatmates and press forward nervously. She has pushed the dining table against the wall for extra space and tells me they are using it as a countertop to make gougères, a savoury French pastry. I'm struck by how relaxed Grey appears. She has made no extra effort with her appearance nor the tidiness of her home. This refreshing display of confidence impresses me, at the same time it gives me the impression she has girls over every day and I'm no one to clean or dress up for. I'd hesitated over my choice of outfit before I left the house, so this makes me self-conscious. With this morning's makeup and her long, wavy hair scruffily pulled up into a half-up bun, Grey is in no need of decoration anyway, gorgeous if only in a pair of tracksuit bottoms with a long black wife-beater, its large arm-holes draping down her sides to reveal midriff, a flash of bra and a large pin-up girl tattoo snaking down her waist. When you fall in love with someone, they're more edible in their natural form any-way; when they have just woken up, or you're spending a Sunday at home. Her ease gives me a glimpse into domesticity with her and I'm all the more enamoured.

"It is good to know you aren't a man!" comes an unfamiliar French accent from behind the kitchen door.

Adriana's giant smile leaps on me as I approach the centre of the room. She is Grey's best friend and flatmate, along with her girlfriend Cicci. They both followed her over from France a few months after Grey emigrated. Even with the inappropriate opener, I like Adriana instantly. Her round face looks to be on the verge of hysterical laughter even when neutral, and her glasses are round to match. Her equally wavy hair is also hastily tied up;

those that have escaped tickle her ears. She has eyes within which are already the makings of a mother. I can see what she would look like in twenty years just by watching her.

"What?" I say, baffled.

"Me and Grey were on the phone before she met you. I was laughing and saying you could be one of the many men who fancies her at work, pretending to be a woman to get in her pants. It would be the only way to succeed. Grey doesn't like cock." Just like Grey, Adriana's translation from French to English makes her sound oddly formal even when discussing something crass.

"Ignore her," Grey interjects from over her shoulder, scratching her forehead with a thumbnail and leaving behind a dusting of flour. "She is being ridiculous. Can you roll a spliff?"

"I haven't in years. Probably not anymore."

"Adri, teach her."

I help Adriana roll a joint while Grey hand-rolls fresh dough Adri has brought home from the restaurant she works in as a chef. Cicci is sweet and shy, speaks little English, but wears a permanent smile that reaches her ears. Adriana plays the clown, ordering me to say English words in French, making fun of me and asking a dozen questions. All three are younger than me by an average of five years but are so worldly and confident in their skin that I feel younger. I'm comfortable with them. The evening passes with delicious fried French food, bottles of Corona and many cigarettes, until the couple retire to the bed they share with Grey.

We're alone.

Lust rises palpably inside me as we size up the gulf of longing between us. But I cannot bring myself to sleep with her. I'm nervous; it will mean too much. I want every aspect of this to be prolonged and perfect. Plus, I want to ask her, where the hell will we do it? All three of them share a bed, for God's sake. In the bathroom? On the kitchen table?

That seemed to be Grey's plan. But after half an hour of kissing passionately against the floury countertop, I call an Uber to take me home.

Too much initial interest from a girl is a turnoff for me because I'm not used to fancying anyone who puts me on a pedestal when it's normally the other way round. But with Grey I'm flattered. Perhaps because her eagerness is balanced with indifference. I don't yet know where I stand beyond the physical chemistry. So when she texts me the next day and asks what I want to do that night, I say we can do whatever she prefers. She texts back, her English still learning to walk.

Grey: *I pretend you mine.*

Me: *?*

Grey: *I mean. I prefer you mine.*

Has someone hacked her phone? That does not seem like something she'd write so soon.

Grey is the personification of my favourite qualities: mischief, moodiness, mystery. There is something vital between us, as tangible as ink on paper, already written but at the same time impossible to put into words. My certainty of her relationship to my soul exists already; a little less epiphanous than when I first saw Red on YouTube, but this time the manifestation has been instant, fully reciprocal and based on action not words, which levels the scales and brings her up to joint first position. I want things to start moving now. Whatever the future holds for us, we will fulfil it. I know it isn't up to me. So when I hear my phone buzz later that afternoon, my head falls back in frustration like a bloody Pez dispenser. It's the first time I've had a negative reaction to what's usually my favourite dopamine trigger. *Red.* Seeing the emoji pair of ears that frame her name on my screen has always been one of my favourite things. But *not now.* I think. *Not now!*

"Hey! I heard you're seeing a new lady! I'm happy for you! Although I can't lie, I was a little disappointed when I found out."

I haven't heard from Red for months. Why the hell does she have to send this message today? Which one of our friends told her I am into someone? Is it because my resistance is low? Why did this not happen when I was uninvolved? I've witnessed this pattern many times over the years—innocent, but annoying all the same. Our friendship is constant, but in recent years she only initiates flirting when we are physically together, or when either of us are seeing someone else. It is as if she can feel my interest in another girl from across the ocean, the elastic band theory on a transatlantic level.

I've always tucked Red away in the best part of my mind, causing collateral damage in my romantic relationships. After Blue, I decided I would no longer put myself nor any other partner through the pain of being second best while I secretly pined for Red on some level. This is especially true now I have this imp of a gift in front of me. Grey is the game-changer, my life's pivot, and I already know it. I'd be insane to make the same mistake again.

I feel sick all day knowing what I'm about to do. When the clock strikes five, I rush home, prepared for the most important confession of my life. Ideally it wouldn't occur over voice note. I'd always imagined confessing my love for Red in person, during one of our European flings, perhaps. But urgency does not permit it; this is a choice I have to make while the adrenaline is potent, before I bottle it. The moment I open my front door, I sit in front of my bedroom mirror and pull my phone from my pocket, still in my coat and scarf. I need to watch myself send the voice note, so there's a witness to this Final Act, even if it's only my reflection.

Pressing record on WhatsApp, my heart hammering metallic in my throat, I tell Red everything. How I've always been in love with her and the effects this has had on my previous relationships.

I ask what she would do if I turned up on her doorstep that night and asked her to be with me. This is physically impossible considering the flight takes eleven hours, but if the hypothetical answer is anything other than *yes*, I tell her I have to close the door on the idea of us for good. We'll always be friends and I'll always have love for her, but I can't be hanging on by a single golden thread anymore. It's fucking up my life. By committing to this audio, I know I'm gambling my most precious insurance: the hope that my future with Red exists somewhere in the ether. But I remember an intention I set earlier in the year: to manifest a relationship with Red or something "better." What if Grey is the "better" I asked for? I recall the parable of the drowning man who rejects two boats and a helicopter because God will save him. When he dies, he challenges God, who tells him he *did* try to save him. He sent two boats and a helicopter!

Such a dramatic change in perception where Red is no longer the summit would wind me if Grey wasn't in my bloodstream already. But she'd said "I prefer you mine." If this means what I think it does, then I will not fuck it up. I've never been able to lie about Red. If Grey ever asks about her, like every lover of mine eventually does, I need to be able to tell her truthfully that it's in the past.

Dizzy, but knowing I've unburdened too much to back out now, I release my finger and rip the plaster off four years of my life. Staring at my reflection in the mirror, I find myself unchanged but there is instant relief, everything unsaid falling off me like a molten globe from Atlas' shoulders. I head straight out into the back garden and steady my hands by smoking two of my mum's cigarettes in a row. She knows everything. Her eyes widen when I play her the voice note.

"Are you sure about this, Fern?" she asks in disbelief.

It's too late either way. I know she's relieved I've met someone new, but truly didn't think she'd ever see the day I put a limit on Red. For the first time, her question makes me realise that I fear Red's answer. After waiting so long, could it be that I'm scared

she will say yes, she does want to be with me? My feelings have been wrapped in a trunk in my chest all these years with a note that reads, "Don't open until the future," the way I've dealt with everything important to me since I was a child. Fearing rejection, my mistake has been to think that what I didn't act upon couldn't hurt me. By never affording myself either the chance to be with Red or to get closure from her, I've sacrificed other meaningful relationships and wedged myself in a lose-lose situation. And now, if my dream comes true, there's more at stake. I'll have to pack up my life and move to Canada. Say goodbye to my family and friends. Leave my team. Stop things with Grey. It will be the start of the new life I've so desperately wanted since I was twenty-one. A literal dream come true. But a tiny part of me—so insignificant I cannot measure it—wants to be spared the upheaval now that I'm older. For years I would have jumped from any height for her without hesitation, but with age my roots have grown stronger. Still, I'm scared that the alternative will ruin me. I've based my entire life around Red. She's the person who has given it meaning. I always thought things would happen naturally with us. That, I guess, was the problem.

And so I sleep on it, leaving my phone on charge underneath my bed; expectant little brick that it is, carrier-pigeon for my future.

The next morning, I check my phone before work and see my message left on read. I keep it at home for the day, knowing I'll get no work done if I'm constantly checking my notifications. But I'm surprised how calm I feel after eight hours rest. My mind is made up. Today, despite four years of the same, Red's silence is different. And it's all the answer I need.

CHAPTER
29

CROSSING THE flyover towards her friend Raphael's apartment the next evening, Grey and I walk arm in arm underneath the black sky in unplanned matching outfits, when talk turns to our past relationships.

"Why did you break up with your only girlfriend?" She asks as we approach the tower block. I ring the buzzer and Grey settles on the curb to light a cigarette. I stay standing over her, one eye on the door for Raphael's arrival.

"He takes a while. He's on the top floor." She offers, noticing my distraction.

Truth is, I'm hesitant to answer the question. I'm not proud of my behaviour in my relationship with Pink: the outbursts of envy and selfishness, the parading about of Red. I'm embarrassed to reveal their consequences to Grey.

"We were young, jealous, and argued a lot." I summarise, waving my hand around vaguely. "We tried to get back together after our breakup, but she slept with someone the night we ended and I couldn't get past that."

Grey exhales, a cloud of smoke shielding the orb of her face. Spurred on by her quietness and the brief repose from those eyes, I continue.

"Surely if your body is open to sleeping with someone else so soon after a breakup, it means you'd have it in you to cheat?"

The cloud dissipates and her stare is back, drilling into me. She appears to be mulling over my philosophy. I have the urge to pour more words into the silence that exposes my vulnerability.

"When we slept together afterwards, I couldn't compartmentalise. I tried reasoning with myself, that we weren't together and all that, but I kept imagining his body on hers. *The same night.*"

The door opens.

"Bonjour, belles!" Raphael calls out, removing Grey's obligation to respond. He bends down to wedge the door open and as she chucks her cigarette on the floor and stamps it out with a twist of the foot, I instead receive her customary shrug—elongated jaw, lips an upside-down smile—all the suggestions of uncertainty or lack of care for the matter. I hope it's the former. With little context, I can forgive her for being unsure of the right answer.

Inside the foyer, Raphael hugs us both and presses the button for the lift. The doors open with a clang and as we enter, I make a mental note to bring the subject up with Grey another time. I want to know if she'll be averse to hurting me in the same way, or if she sees the night of a breakup as free game. These things matter. It's scary to think you'll never know how someone will respond to a fallout until it happens. You could spend your whole life married to someone, not knowing they'd lose the plot and murder you in your sleep if you ended it.

Raphael's apartment is impressive. A new build: all laminate flooring, walls and bright spotlights. The kitchen backs onto an open plan living space and glass double doors reveal a wide balcony overlooking a canal. "Wow." I compliment him as he takes my coat. "This place is amazing. From the view, you'd never think we're in London."

"Merci, merci!" Raphael's laugh rings clear as a bell as he kisses me on both cheeks. From inside his home, I can see his essence a little clearer. He has dark hair, piercing blue eyes and fresh, ruddy skin, like he'd been whipped about on the ski slopes just moments before coming down to get us.

Grey proudly introduces me to her friends as they arrive throughout the evening and I'm equally proud to be her guest. I spend most of the night translating the unspoken intimacies and nuances of a culture still unfamiliar to me. They all share some-

thing I don't: the experience of migrating to a new country at a young age, the hard work required to make a life in 'The Big Smoke'. Grey tells me they do this several times a week and their closeness reminds me of my work friends, although Grey's have much more stamina, travelling from their respective postcodes across the city to toast the burned-out working day with wine and good food, disregarding the need for a bubble bath and an early bedtime. We only have the tenacity to do the same when our restaurant of choice is a short journey from the office. Raph prepares a dinner of tartiflette while we take turns to help: a conveyor belt transforming chainsmokers to sous chefs and back again.

I step out onto the balcony to get my bearings after dinner. Grey joins me within minutes, snaking her arm around my waist and planting her lips on my cheek. I look up at the moon, full and textured like stracciatella ice cream. *What the hell are all these feelings?* I think, as her arm tightens around me. *She hypnotises me by doing nothing.*

"I am not like this." She lowers her voice to mask her words amid the chatter of two other girls on the balcony.

"Like what?" I inhale her neck; can't hide my smile.

"Like this. Taking you to my friends. Already I am different with you."

One of the guests interrupts Grey.

"Can I borrow your lighter?"

"Sure, it's not even ours," I say, tossing her the amber Bic.

Grey turns at this accidental joining of our pronouns, one elbow on the railing, a half-smile curling approval on her mouth. Within a second she is back facing the landscape again, smoke billowing from her grin, deep in thought.

I am hers by the end of the night. She asks me in Japanese using Google Translate, at my tongue-in-cheek request. The idea was to make it official in a language neither of us could understand, for neutrality, because sometimes we still struggle to interpret each

other. But it turns out I was correct about the intentions behind her earlier text.

"Watashi no mono ni natte," she smiles coyly, looking up at me as we sit facing each other at her kitchen table, adding "tu es à moi, de toute façon"—a correction.

And so it is. Grey is at once my girl, all five feet and six inches of her. I can't believe my luck. Grey, with her waist-length dark hair, chocolate-pool eyes and tattooed biceps. Perfect in her basketball jersey and shorts. *All mine.* She takes my thigh and with a biro sketches two figures with a small door between them.

"The girl on the train." she mumbles, dreamlike as she draws. "I realised I wanted more from us earlier last week, when you said 'our kitchen' talking about this room, even though you have only been here twice." She squeezes my leg, an invitation to remove my thigh as her masterpiece is now finished. "I liked the sound of it. And tonight, you said the lighter is 'not 'ours'''".

Is this really how simple it can be? Lust at first sight made official after two weeks - no chasing, no games? Neither of us had been searching for the other, I'd simply relaxed and the vortex had opened in the shape of a dirty, square window on public transport. I'd let go of my past and was rewarded. I've never agreed to be official with someone so quick. I've never slept with someone so quick. I've never even dated someone more than three times.

This sensitive version of Grey was alien to everyone but me. Her friends couldn't believe it, and I didn't think to question this.

"You fucking *kidding* me?" Adriana squeals and gawps at me when she hears the news. I smile in confirmation.

"NO, Baba!" She doubles down with disbelief (Adriana once overheard me call Grey "Baba," and passed it on so now everyone Grey knows calls me this. I'm never referred to as Fern). "You don't understand it, this is not like Grey! She *never* does it! I thought she was lying when she told me. And now, she is with the man!"

With a hug and a pucklike giggle, Adri verifies me. Grey leans

back in her kitchen chair, a smug smile languishing on her face, arm draped over the back of mine like a mafioso. She always got what she wanted. What did anyone expect?

When I arrive home the next evening, there is a message from Red waiting for me.

"Wow, this is a lot to take in. I'm going to have to think about it."

Another one directly underneath it. "I love you too."

I note how my heartbeat maintains its normal rhythm. What does this ambiguous reply mean? Was the "I love you" a response to my vital question? Or was it an afterthought of consolation, a platonic acknowledgement that she knew it would have taken some guts for me to confess? Either way, I couldn't ask for a better reply. By leaving me on read, Red has allowed me to make a different decision and break old patterns. After all, the mark of madness is doing the same thing repeatedly and expecting a different result. Forging a new path has definitely worked for me so far; I have a new girlfriend I'm head over heels with and its only day two since I made the decision. There is no point in me asking for clarification: "So you love me as a friend? Or love *love* me?!" No, that would further complicate matters. By leaving things as they are, nothing changes. If things don't work out with Grey, I can revert to my dreams of Red to nurse me through the breakup, because she's left me enough rope to hang myself with. I can take her words however I wish. There is nothing ground-breaking in her response, nor in her follow up voice note the next day saying she's not in the right headspace right now and would ruin our friendship if she agreed to make a go of it with me. This was probably her cowardly way of rejecting me, but I chose to see it as her earnest consideration of 'us', a 'not now, but never say never', and

this allows me an element of control, whether fictional or not. In all honesty, it doesn't matter now. I feel better for telling the truth and am totally high on Grey. Now, if she ever asks about Red, I can tell her it's over and mean it. I've done my bit. I jump straight into my new relationship with everything I have, for the first time ever, and the momentum only increases.

"I told you," Grey says as we share a glass of red wine in Raph's bath that weekend. He's away for a wedding and has let us stay there, affording us some privacy from Adri & Cicci so we can have our own bed for once. "I am not like this. I have been very bad."

The water laps softly over us, and I'm jealous of each minuscule rainbow bubble fizzing on her skin. I stay silent, willing her to talk more. Nana Jenny always told me that the less you speak in a confessional, the more information the sinner trusts you with.

"I was bad with women. I didn't treat them well. And there have been a LOT."

She emphasises the word *LOT* as if she's telling me off.

"That girl in Sicily... It was just sex but she wanted to be with me. I'd only known her for one week! But she wanted me to move with her to Italy... it was too much! She wanted so much crazy stuff: to come back with me to my home in France. NO WAY. To stay with me when she came to London. I didn't give a shit about this, so I said yes, because she said she was mostly coming to see friends. But she spent the whole *fucking* time at my house! Even when I was at work, Adri & Cicci had to look after her. I didn't mind it, but that morning when I saw you on the tube, I knew I had to send her home. You are different. With you I am different. So, I told her to leave that morning."

"So that's why you looked so moody when I first saw you." I laugh, reaching over the side of the bath for the wine bottle, pretending I'm not astounded by what I've just heard. I've never been on the positive end of a sudden decision between two people before.

Grey laughs.

"Probably. I haven't felt this way in years. You look like the woman of my life."

At these words, I unearth a hidden memory from my first year at university. My Spanish flatmate was in love with an American jock who lived in our halls and was crying on my shoulder after an argument they'd had. "Fern, he is the man of my life," she'd wailed, and I thought it was the most romantic thing I'd ever heard, the specificity far more poignant than the English 'love of my life'. I longed for someone to call me the woman of their life one day. Had I pinned it to my mind's vision board that night, and now it had come true?

As I top up Grey's wine and pray she can't see the involuntary wobble of my bottom lip, all the resentment and loneliness I'd pushed down inside my chest over the years threatens to burst. I think of fifteen-year-old me, listening to my friends talk about their boyfriends, wishing for my own love story. I think of all the times I'd cried myself to sleep at night, my mum opening my bedroom door to reassure me that my time would come, I just had to be patient. My skin was itching for love even then—*twelve years ago*. That I am now twenty-six, and fifteen-year-old me still had more than a decade to wait until she found what she was looking for, seems unbearable looking back. The tears I'm fighting are for the teenage version of me. But as the claret fills Grey's glass and I brave a look into this girl's eyes—her stupid face that always looks so affronted for no reason—I realise it has been so, so worth it.

"Where have you been all my life?" I say, bereft with appreciation.

"I had some business to sort." She smiles cheekily. "Sorry I took so long."

As intoxicating as she is, a deeper part of me questions why Grey's actions towards me are at odds with the story she tells me about herself. Both she and her friends have marketed her to me as unattainable and wary of commitment. With her looks and charisma, she can get anyone, so why settle for one person so quick? I've

known her for such a short time yet have been with her pretty much constantly, so I've had little time alone with my thoughts to wonder where we are headed. Before we made it official, I assumed she was simply this intense with every lover. No wonder the girl from Sicily was set on her; Grey probably baited the hook. And yet she'd been privately repulsed. Why, then, is she behaving as full-on as the girl from Sicily, towards me? My dating history has taught me to enjoy the uncertain phase girls usually hate. I enjoy allowing things to unfold naturally without pushing and I relish the build-up, which is just as well because moving too quickly with 'straight' women only pushes them away. Perhaps Grey appreciated that I didn't rush us towards a premature destination. Or was it simply that, with the right person, too much is never enough?

In bed that night, she props herself up on her elbows, pins them either side of my head and looks directly at me, pupils pearly from the streetlights coming through the window.

"I feel you will be my bad karma," she says.

"What do you mean?"

I've been granted the most intimate role in this girls' life before I've had the chance to take her off her pedestal. Weird questions like this remind me that I don't yet know who she is. It's like I've married my celebrity crush and have yet to learn the skeletons in their closet.

"If I'd known I was going to meet you, I would never have treated girls the way I did," she repeats. "You are perfect. I feel you will be my bad karma."

This line penetrates something within me, as if a chord has been struck that I know will be picked up and elaborated upon in the future. The integral lines in a movie you return to once you know how it ends and think, *Ah. That was the clue.*

But at that moment, in Elysium, I hold her close as the night rolls and swells, kiss her deeply, and we fall asleep wrapped in each other.

CHAPTER
30

Y OU MAY THINK you know how the story goes from here. That it was a line. I'll end up heartbroken by Grey's hand because a leopard doesn't change its spots. Or maybe you think I'll break Grey's heart and go back to pining after Red. Neither is true. We dote on one another. We don't set out to hurt each other. We just don't know another way.

No one likes to be bored with the details of a relationship when it is good, particularly in the early stages when every lover believes their relationship to be unique and unprecedented. An overview will suffice. Here is my humble attempt:

She loves when my ears turn red in the cold, because apparently this means I'm aroused. "*Oh baba you so cuuute*" she purrs, kissing their tips. I catch her watching me as I sing around the house, chewing gently on her bottom lip and looking exactly like Adele Exarchopolous, with that permanently pouty face; a judicious squint that mocks me. *Do you know what you have done?* this face threatens, daily. *Loving you has changed my perception of myself. How dare you make me feel strongly towards you. I will stare at you in expectant disbelief until you do something that makes it all crash down, and I can cry, "I knew it! I have been a fool", and go back to my old ways.* Then this very look—which scares and excites me in turn—will evaporate by the time I reach the chorus, at which point she simply says, "Je pourrais te regarder toute la journée. Not like when my sister does it."

Face to face in bed, she whispers, deranged on lust, "I love the scent of the air that comes out of your nose," and when our eyes

lock before mine close, the whole universe falls into alignment, everything turning to white noise. This is th e fee l ing Id imagined as comparable to Sherry placing me number one in her Top 8 when I was younger. On the weekends that Grey works, I wake up early (a feat impossible when compulsory), the winter sunlight streaming through the kitchen windows, bouncing off the cheap linoleum tablecloth and transforming her box kitchen into a brasserie of light. I read the daily love note she leaves for me on the kitchen chalkboard, replace it with my own and set about cleaning the place so she can return to a tidy house. Grey compares being with me to a French poem that describes the feeling of putting your keys in the door after a long day, so I want to make sure that feeling is a positive one. My passions and the dreams that I have for myself perish now she is here (and have barely been mentioned by me at all because women tend to take over my every thought, but for the record, at this time my dream is to become a writer and my passion is hot yoga)—not because I am losing myself, but because this great feat of love was the main plan all along and everything else is a distraction from the emptiness I've nursed, an emptiness I didn't even realise came from not knowing her. Her love makes me s o f t and languorous. I'd felt it coming with the first whispers of infatuation, like a sleeping draught settling over my limbs, turning my blood to custard. Whatever motivation I have for writing and yoga dwindles.

My stories have her undivided attention. She wants sex *all* the time and makes me ten times more confident in my body. A frequent backhanded compliment is that I could not possibly be English, because the English are ugly. I gain weight comfortably, growing accustomed to the French's love of butter. I begin to expect the customary Facebook message from Adri when Grey is on the late shift: *Baba, you sleep here tonight?*, wondering if she should move the sofa to the end of the bed in order to accommodate us all. All four of us sleep in one bed— (in both senses of the word!)—and Grey has to push herself against me, willing us into one thing so as not to wake the other

pair. We are a content foursome, "Poor, but happy," she says with the air of Tiny Tim on Christmas Day as we tuck ourselves under the sheets each night. I set five alarms in the morning at fifteen-minute intervals, all of which I ignore, with the intention of being jolted into a state of semi-consciousness so that I can enjoy a morning cuddle before getting up. This drives Adri nuts. "How many alarms you need, Baba?!" She groans, tugging the duvet over her head. Grey notices the absence of my body warmth once I'm in the shower and sacrifices her own lie in to lovingly prepare us a breakfast of Pan di Stelle, caffe latte, and a hand-rolled cigarette. Her 'latte' is made literally: a steaming mug of milk only slightly browned with the coffee so it looks more like what's l e ft in the bowl after C oco P ops. S he learned this in Sicily. We dip our biscuits into it as I busy myself around the kitchen table. "You are perfect," I repeat between eyeliner, tights, perfume. "I am not perfect," she replies, fastening my bra and giving me a dewy kiss. "You are." I start to feel like I am working in a FTSE 100 company simply because of how my mornings start. My commutes become something I romanticise, grabbing a Starbucks like I imagine Carrie Bradshaw would. Love can change your perception of everything. The whole world has promise now Grey is in it. I thank the universe for the time I've taken to adjust my frequency and draw her soul in.

One morning after this steady routine, three weeks into our relationship, I grab my bag and swing the door closed behind me.
 "Bye! Love you!"
The moment before it shuts, I catch a glimpse of Grey standing motionless—not for any dramatic reason—just caught between two actions, like picking up a sock and throwing it in the laundry bin, her dozy gaze fixed on me.

I freeze on the landing, hunched with embarrassment.
Fuck! I laugh aloud, cringing. I pick up my phone and text her from outside the door.
Sorry, I hope that didn't scare you. It was a Freudian slip.

The reply comes as I am walking down the high street, alive on my mistake, the crisp air and my first morning hit of nicotine pinging round my lungs.

Fuck off. I am not scared of these things. We will talk about this later.

More swearing. I love her command of authority. I know this is confirmation we are about to agree we are in love.

All day I think about the elephant I've let loose in Grey's room, parading around with her on her day off. I dare to assume she feels the same and that for once I am going to find out, instead of basking in the illusion lest the illusion be popped. That's the game I've been playing with Red for four years. The response Grey gives me proves it needn't be that way.

We get into bed early that evening, no Netflix in the kitchen, no Corona and lime, both knowing we have something to say but neither of us wanting to be the first to say it. Between the covers, we lock eyes and refuse to blink, grins teasing the sides of our mouths, kissing each other and raising our eyebrows every so often as if to say, "Go on, you say it." After minutes of this back and forth, when I've drunk in as much of her as I can stand, my love feels so natural and correct that I can't hold it in anymore. I don't care if I am the first to say it. She has asked me to be hers, and now it is my turn.

"I love you."

"Je t'aime." she replies. "How could you not be mine?"

CHAPTER
31

WHEN I WAS fifteen, I went on a month-long camping trip around Europe with my family. We stayed in Germany for a week, where the rain came down like a sharp sheet of manga tears. In the entrance of one of the many galleries we sought shelter in was a grand portrait of an emperor and his family. In the corner of the painting, dressed in royal blue like an emperor himself, was a child of no more than three years old. He looked both adorable and inherently evil, with sleek black hair pulled into a tight doughnut at the top of his head which lifted the ends of his eyebrows severely. I couldn't take my eyes off him. Why did I want to cuddle something that looked so sweet but also like it could kill me? How could someone who looked like Satan's handsome spawn be so *small*? The poor kid was probably lovely, I just don't think his Croydon facelift ponytail helped convey that. The ambiguity of his majesty haunted me.

My point is that this is the feeling I have whenever I look at Grey. I am beguiled by the danger I've tamed in her, how I've diverted her from the path of hedonism and casual flings, as if said path was also one that involved blood sacrifices and devil worship. There's something about the placement of sharp features and angry facial expressions on beautiful characters that make them look like they will swallow you whole because you're the sustenance they cannot live without (hence my crush on Juntao from Rush Hour, whose elegance and sinister glare suggest he could kiss or kill you with equal passion and probability, depending on the coin he tossed that morning). I've finally caught a woman

who is apparently difficult to capture, without necessarily having to work for it. But because of the story she tells me about herself, I still get the kick of 'winning her over' in a way I haven't got from anyone else I've dated. Even better, she shows me over and over how she considers *me* the prize. It is a win-win for my complicated emotional wiring. But as intoxicating as this cocktail is, this is where the problems creep in. Remembering her past behaviour, she begins to treat me like a trophy that can be taken from her at any moment. She is terrified I am going to be her punishment, wants to tighten the reins to stop me from leaving her, the way she left her exes. This happens slowly, and, I believe, not intentionally nor from a place of malice. It comes from past guilt and a fear that she will reap what she has sowed. Grey is paranoid, sometimes even convinced, that I have a golden chain of women at my disposal and will simply unclip her from around my neck if I get bored.

One night in bed, again —where she has many of her existential musings—she lies still on her back after sex, staring at the ceiling. Moonlight illuminates her profile so I can see that beautiful Roman nose, the luminous wet of a hot tear on her cheek. Something is troubling her and it worries me. My Catholic Guilt activates, fearing she has access to the back of my brain and can tell I've spent four years loving Red, despite having put it to bed.

"What's wrong, baba?" I ask.

She shakes her head but says nothing, so I shuffle around her at different angles with varying degrees of success for a number of minutes in an attempt to soften her body, to get her to mould into me until she finally speaks.

"I am not like this. It is not like me to be like this."

"Like what? What's wrong?"

A pause. And then,

"...Is there something I should know?"

"Baba! Like what?"

I sit up. She turns her back to me and curls into herself, so I won't see more tears, coming quicker now.

"If there is something I should know, you should tell me."

When I wake the next morning, she has already left for work and I've received the following WhatsApp messages, sent as I lay sleeping next to her.

01:33: ...

01:33: Fern

01:33: A question

01:34: Why you have pictures with your ex-girlfriend last July/ June?

01:58: Actually she is everywhere. This year—2015—2014—2013

02:00: I hope for you there's an explanation that is enough good for me, if not you can directly go to fuck off.

I've never deleted old photos from social media. Some people do it to help them heal, or because they no longer want to be associated with their exes. But I'm proud of who I've been and loved at every stage of my life. Deleting these would erase my history and proof of my memories unnecessarily. I reply:

07:28: Good morning

07:28 Not a nice way for me to wake up :(

07:28: Show me

07:40: I told you, I haven't seen my ex-girlfriend since we broke up in 2013. Except for when she saw me on the tube.

07:48: So, it's not true.

07:49: And also, can I ask you a favour... when you have something you want to ask me, don't swear at me like this before you know the answer. I've now woken up horribly because the last words from my girlfriend were "fuck off."

07:51 I need you to stop speaking to me like this

08:49: I will happily clarify things for you. Show me.

She sends me a bunch of screenshots from my Instagram. Photos not of me and Pink, as I'd hoped, but of me and Red.

Grey opens her front door in an oversized cream knit sweater and joggers, at once furious yet tender. She has strawberry blotches on her cheeks either from tears or anger. Knowing her, it's probably the latter. *Why is anger always her go-to?* Shame is such second nature to me now, that I forget I've ended things with Red and am riddled with remorse despite having done nothing wrong. Why is it that the lover I've felt the strongest for and behaved the best towards, has taken the news of Red the hardest? I only want to take this beautiful girl, so in love and so changed because of me, and smother her worry until it disappears. Instead, I help her unload her washing machine in the communal landing on the ground floor in silence and carry her laundry up the stairs. She reluctantly gives me a kiss with her tear-blushed lips in the hallway, then sits down at her kitchen table—the table of many future difficult conversations. She pulls her box of tobacco towards her and flippantly gestures at me to sit opposite. I'm five years old again, in trouble with the police. I plead my innocence. Climb onto the lap of my petulant, gorgeous baby.

I tell her the plain truth, this time smart enough to leave out the details. The gist of it: I loved Red once. It's over. After half an hour of reassurance that borders on begging, she's satisfied that Red is in the past and forgives me. She even takes it well when I remind her I've pre-booked a holiday to Canada on Boxing Day to visit the friendship group Red is part of. I invite her along, assure her she'll feel no threat once she meets Red in person, but

she can't because she's scheduled onto the lucrative New Year's Eve shift. I feel better now everything's out in the open, but it still freaks me out that despite Grey being the first person I've decided not to tell about Red, she has somehow cottoned on and deemed it a big enough deal to cry over some old photos. I can't win. Is Red forever going to haunt me, because I told the universe it could do what it wanted with my life as long as I could meet her that night in Paris? Am I cursed?

"I love you, Grey. It is you I have chosen to be with," I tell her. And I mean it.

"I feel it now," she whispers.

"Feel what?"

"I feel you mine."

Nothing has changed. I was already hers. Still, my nervous system is shot for being 'found out'. For having loved someone I'd met long before I knew Grey existed.

I'm listening to the new George Michael documentary with my family and lazily opening an Amazon package, when George speaks from beyond the grave, yanking my eyes to the screen.

Anselmo, he says, is the first and only man he truly loved. They found each other when George stepped off the merry-go-round of fame's pressure. Being in a new relationship myself, it makes me smile to watch old VHS footage of the two young lovers playing together on the beach. I smile down at my lap and pull out a red and black latex dress from the cardboard.

"I was looking at the sky, saying 'don't you dare do this to me!'" George addresses the camera, his tone suddenly grave.

Within six short months, Anselmo was dead. HIV positive, he passed away before George came out as gay. No other soul knew of his private pain. I choke up. *So many of his lyrics make sense now.*

George performed his famous Freddie Mercury tribute just days after his love's own diagnosis. I'd watched it before, but hearing him belt out *Somebody to Love* for his friend Freddie who'd passed away from the same disease, knowing it was closer to home for him than I'd originally realised, makes me well up.

"I was twenty-seven going on twenty-eight, but at that point in time, you think, that's a lifetime of waiting to be loved."

I'm twenty-six. My blood runs cold with the reminder that nothing is guaranteed. The very idea of Grey being taken from me within six months is unthinkable when it has taken me this long to find her.

"I wanted to die inside," George continues, to the respectfully hushed audience of my mum, stepdad and I.

I'm supposed to be staying at home to prepare this year's Halloween costume. I chuck the dress in my room and jump on a tube to see my girl.

She meets me at the station because she always needs something from the off-licence. We grab provisions for the evening: beer, chocolate, chewing gum, and wait for the bus back to hers.

While we're stood at the bus stop, a sneer behind my ear startles me.

"Are you sisters?"

I look down to see a short, drunk man hobbling towards Grey and I, with an overgrown copper beard, his clothes in tatters.

Grey narrows her eyes at me in solidarity and turns to face him.

"No," we bleat in unison. I laugh awkwardly. Surely, he'd just seen us peck each other on the lips.

The man isn't fazed. Cranes his neck forward as his eyes bore into us.

"You won't last longer than three months," he declares, more to the entire bus stop than to us directly, swinging his left arm and letting it guide him into a clockwise spin. His long grey coat billows out behind him like a wizard casting a spell as he turns. The

crowd at the bus stop watches with a mixture of ambivalence and uncomfortable curiosity.

"Is he fucking kidding me?" I whisper to Grey out of the corner of my mouth. After the documentary I've just watched, there's no way I'm letting him leave without elaborating. Grey turns her back to him, her interest in the conversation over. I challenge him.

"What do you mean?"

The man looks right through me. "*You* can't handle it. It will be over in three months."

Oddly, this comforts me a little, as I know I can handle anything when it comes to Grey and I. My love for her is bottomless. With fate now back in my control, I ignore the man and he moves on, a vagabond Mercury, whistling and singing into the night.

We squeeze onto the packed bus, trapped next to the conductor's booth.

"Did you hear what he said? I don't like that."

"Baba, don't be silly. What does he know? He is just a random man."

Grey and I have not discussed fate, manifestation, or anything supernatural or spiritual. All I know is that Nana Jenny once refused to buy lavender from a street vendor who then told her, "You will bleed every day for ten years." Shortly after, Nana Jenny developed severe menorrhagia. The lavender-seller was right. She bled every day.

I forget these man's words soon enough, Grey's company enough to distract me from worry. But the signs keep coming. There are anchors in our story that are not for us to unroot, too many signs blowing in the wind at every crossroad, leading me somewhere I have no control over.

It soon becomes apparent that Grey is contentious and has control issues that don't bode well with my desire for freedom and independence. I've been used to my own company for most of my life and relish being alone. She has a hard time with this. Her personal culture is inherently social and all her pursuits are communal.

"Ba," she says, whenever I tell her I won't be sleeping at hers that night. This response isn't too bad in itself, but summons a great wave in my chest as I know it pre-empts sulking, silent treatment, or worst of all, an argument. I can never just get an "Okay, sure." The anxiety her reaction sparks in me manifests in two ways: a need to justify myself, to assure her that wanting alone time does not mean I love her less; and a brewing fury that I even have to explain myself. Needless confrontation exhausts me, and if she is going to start a conversation about it each time, I'd rather just back down, stay at hers and let the bitterness eat away at me. French anger is not to be messed with. She stays at mine about three times throughout the entirety of our relationship. For the rest of it, I'm at hers. This is not logistically easy for me. Before we met, I liked to go for a run and lift weights in the evening if I wasn't taking a hot yoga class. Since meeting Grey, maintaining this regime has required extra discipline, as all I really want to do after work is melt into bed and dream about her. Sometimes I even prefer dreaming about her to being in her company – as a fantasist, that's just the way I'm built. In order to stick to my routine and still appease her by sleeping at her house, I must rush home from work, exercise, eat, shower and get back on the tube to hers, five nights per week. Some nights, neither Grey nor her flatmates finish their restaurant shifts until midnight. As our relationship is still new, I haven't got a key to her place yet, meaning I often have to wait at home until it's time to meet her at the tube station around 1am. By the time she comes through the barriers, I am sitting cross-legged on the floor with my head resting on my overnight bag, struggling to keep my eyes open. I daren't mention how tired I am because she's only just finished work and I've had

'the whole evening to myself'. This is okay in the beginning; the honeymoon period is a strong painkiller. But it's not sustainable. Grey's solution to this is simple: I should keep my weights at hers. Why would I have the desire to be in my own home, with my own family, ever again? She doesn't say this, of course, and neither do I give her my sarcastic response, but she doesn't consider that I may want to be at home, and eventually I stop hinting because I do not want to offend her. Each time I try to argue for more than two nights to myself per week, my palms sweat as I work myself up, knowing she'll take it the wrong way. I spend sleepless nights stressing about what she'll think of the packed December I'd already planned with my work friends before we got together. It's still only early November, but I print off a calendar template from Google to stick on her bedroom wall with my Christmas plans prepopulated onto it, proposing she should add her own as a thoughtful exercise for both our sakes, when really it's just so that she has at least a month's notice if I want to go out.

Nana Jenny sadly passes away in November, a month into Grey and I's relationship, after a long battle with alcoholism and a shorter one with bowel cancer. Grey kindly sends flowers to my mum, and as the hearse pulls up to St. Agnes' church on the morning of nan's funeral, I spot her alone and beautiful in black, ready to hold me as I cry. It means the world to me, as I still haven't got used to someone loving me not just with words but with actions. My uncle, auntie and cousins have flown over from Hong Kong, and as Cricklewood tradition would have it, our plan is to spend the evening pouring one out for her down the Trades Hall. Grey is polite and charming as I introduce her to everyone. At 4pm, she gets up from our table to leave for her evening shift.

"I'll see you later, at mine?" she asks, putting on her coat and offering me her cheek.

"Oh. I'm staying here tonight baba, my family are over from Hong Kong—I don't get to see them often. And I want to be there for my mum."

"Ba. Ok." I feel myself tense as I follow her to the pub exit. "Well, tomorrow?"

"Tomorrow I'm in Great Yarmouth for my friend's 40TH, remember? It's been in the calendar for months."

She swings open the double doors and the November wind whacks me in the chest. Now we're outside alone, she can afford to change her tone.

"So I don't see you AT ALL this weekend?!"

"Well, sorry Grey, but I didn't plan for my nan to die right before Natasha's birthday." I say.

The glower she gives me when she's mad never fails to fill me with rage and before you know it, I'm releasing a bottled up monologue.

"I thought you were all about family. Every night when I was up at the care home before she passed, you told me family comes first. I'd like to think the death of my nan would be enough to warrant sleeping in my own bed for once! And you know what—sorry nan— but I was actually RELIEVED I'd have an excuse! Could you not just lay off me on today of ALL days?"

I don't mean that about my nan, of course, I'm just furious. She is already walking away in a strop. I don't follow her, instead I remain in the doorway, shaking with anger. Without thinking, I pull out my phone and type 'Lesbian custody rights' into Google. I've been thinking long game with Grey. I want to know whether she'd have the right to take our future child away from me if we ever broke up, and if biology would be factor. It's a dark thought, but her proclivity for unfairness has impacted my feelings about our future. She is extremely family-oriented and I wouldn't put it past her to rip our kid from me out of spite. My boundaries are so shaky that when I do muster some resistance, it escapes from me

like war. I am ashamed of my intuitive Google search. As much as I like the idea of marriage and a family with her, I begin to fear it.

I should have taken heed of that red flag. I should have also taken heed of the red flag when she first blows up over something small. I am at home while she's on her night shift, daydreaming about her and procrastinating packing my overnight bag. Staring at the first and only post I'd uploaded of us on Instagram—a grainy picture of us kissing in the reflection of a tube window—I decide the quality isn't good enough to reflect my feelings for her and I want our social media debut to do her justice, so I delete it. One of the tiny, inoffensive decisions I am so used to making throughout my day. My phone rings less than five minutes later.

"Baba why the fuck you delete that photo?" It's Grey, calling from the stockroom cupboard at work. She doesn't miss a trick.

I am sent a series of expletives over the next hour from inside the pocket of her apron until my spirit is squashed; I was planning to exercise but instead I leave my dumbbells on the floor beside my bed because I no longer have the motivation to make a fist, let alone lift them. I spend the rest of the night under my bedcovers, my stomach in knots. I tell her I am so disappointed in her reaction, and for not believing me, that I will not be staying at hers tonight, and will instead be going straight to sleep. This is not entirely true, but the only way she takes my feelings seriously is if I dramatise them. So, I learn to exaggerate to get my point across and put boundaries in place. When she hears I won't be coming over, she relents.

Do not be sad. I cover you in kisses.

All is then right in the world, until I renege and agree to sleep at her place. And just like that, my mood hinges on her behaviour towards me. Lovebombed until I am dependent.

She doesn't want me going to see my favourite actress and ultimate crush, Natalie Dormer, in a play, so I lie and attend alone. When Christmas rolls around, I end up changing my office party

outfit because she doesn't want me wearing a short dress. I notice *that* red flag but let it down half-mast for an easy life, until she sends me her own selfie from her Christmas party a few days later, in hotpants and a sports bra. When I point this out, out of principle, I am the unreasonable one, because it is fancy dress, she's gone as a boxer and it isn't supposed to be 'sexy'. She doesn't get it. I would have fully supported her costume had she not refused mine. I only bring it up to show her hypocrisy. "I don't want to be with a mirror!" she shouts, one of her favourite phrases whenever I call her out on her own bullshit. I can't win, stumble over my argument, and make such a meal out of explaining myself that everything I say sounds like I'm making a big deal out of nothing. Whether it is the chicken or the egg's fault, my lack of initially asserting limits to the behavior I will accept, and my subsequent fear of re-introducing them, makes me quick to aggravation because I feel whatever agency I have slipping away. Being at Grey's home starts to feel like visiting extended family at Christmas—you can muster polite conversation and stay up past your bedtime for the first few nights, but after that you long for the comfort of your own space.

Intimacy always softens me, though, so all Grey has to do is pull me underneath her and I surrender, second guess myself and make excuses for her. *Perhaps I am the baddie because she only wants to spend time with me, to shower me with love and affection. Our love languages are just different, that's all.* In any case, none of her behaviour has put out the fire she's started in me. I am able to compartmentalise because I'm hypnotised by that red circus mouth, the small beauty spot above her top lip. Sometimes during sex my mind will wander as I try to hold onto these preferable thoughts, and twice she notices, yanking herself off me and locking herself in the toilet because she notices my distant facial expression and can't bear that I may have an independent thought she's not privy to. I have no energy left to cry when this happens, though my whole body is heavy like a cloud full of tears because my thoughts have pure intentions, and aren't I entitled to enjoy

sex, too? So I start to yell, often, until my behaviour becomes alien to me. Several mornings I send her screaming voice notes on my way to work as my fury about the previous night's disagreement rises like the crest of a tsunami and spills out of my mouth as I walk down the high street, not caring who hears me. Her volume isn't always as loud as mine but her tone and use of language is despicable, sometimes downright cruel. I can't work out if she means to sound so aggressive or if it is just a cultural misunderstanding, a French bluntness, but I can't deal with it. I threaten breakups and start to walk out when I can't get through to her. I hope she'll take me seriously enough to change; it seems to me the only feasible way of warning her I can't continue like this. And so I relaunch the habits I'd used on unavailable women on my very available partner—roleplaying leaving before I am left. She justifiably hates this, the threatening of our relationship like it is disposable. Her ex used to walk out during fights and it triggers some abandonment issues she has. But I always back down and am the one to say sorry, because shouting, even if you have reason to shout, automatically puts you in the wrong. There's only one thing for it: to commit to walking on eggshells and use a magic eraser on the boundaries I've hastily attempted to draw, so honoured I am to have the relationship in the first place.

CHAPTER
32

In November, Grey invites me to France to meet her family. Adri is once again shocked ("What the?! Grey is not like this, baba!"). I appreciate that it is a huge step. Her hometown is beautiful: ancient, with cobbled back streets and little old French ladies making pastries from scratch in alcoves that shield them from the dry heat. At night, tealights and lamps adorn tables for alfresco diners outside the local restaurants, and streetlamps illuminate the winding roads like basic night mode on an iPhone 5. The swoosh of the bedtime sea is brown noise against a jet sky.

Her family live in a man-made village up on a cliff, where the neat rows of houses—with their alternating red and green doors—each have rooves shaped like a gnome's hat. I am awestruck by how quaint it is. I can imagine a life where I might bring our children here to see their grandparents each summer - the pride I'd feel that half of their history is here. On the first night, before bed, I lean over the balconette in our bedroom to look at what Grey is pointing to. Ahead and to the right, I can see a restaurant built into a grotto on the cliff's face. It is breath-taking. Hundreds of candles wave to us from pristine white tablecloths, on circular tables that look like twirling ball-gowns from above. The ocean glints below - an onyx dancefloor. When I realise what it is I am looking at, I am lost for words. Another core memory is unlocked, one I haven't thought about since the day it happened. When I was twelve, I had ripped a photo of this exact place out of a magazine and put it in my scrapbook. I take this as proof that Grey and I are meant to be together,

the universe gifting me this Easter Egg to assure me. As a little girl I'd imagined dining there as a glamorous adult, but the reality is better—it's next to the home of my beautiful girlfriend. She wraps her arms around me from behind, sandwiching me between her pelvis and the railings, and kisses the side of my head, promises me she'll take us here one day. "Perhaps for a very special occasion," she hints with a wink.

I smile at this suggestion of marriage, and so my knee-jerk reaction the next night startles me. We're in a bar with her friends, queuing for the toilet. Entering a cubicle together, Grey locks the door behind us and tries to find a place to put my bag other than the floor, which is sticky with littered toilet paper.

"My friends all really like you. Luna even called you "belle soeur préférée", she says with pride.

I squat over the toilet and attempt to pee through my stage fright. She comes close and grabs my jaw affectionately between her thumb and forefinger.

"You never know," she continues, "with things going this well, in six months we could be—"

I shove my finger over her lips to shut her up. I know she's referencing a proposal and it freaks me out.

"Too soon!" I laugh. We're only two months in!

I'm surprised I have the courage to tell her this given how sensitive she is, even more surprised by how well she takes it—with a grin and a shrug—but what I'm most surprised about is that this is my reaction. *Of course* I want to be with her forever, why was my body so quick to freak out? Again my instinct has overridden my emotional response, acting in my better interests before I write a cheque that my butt can't cash. I've been enjoying my time here for the most part—it's made me feel like I am a character in a foreign coming of age film—her friends pulling up on mopeds in the dusty early evenings, sunbleached and too cool to care. Maybe it is because we've stayed out until 4am most nights, drinking in car parks, standing awkwardly around each other's vehicles like teenagers with nowhere to go. It is easy to grow tired of this—I

am three years' older and done with anything resembling student life—especially when everyone is speaking French and unintentionally isolating me until I end up sitting on my own on the kerb playing with Grey's family dog, Mickey, until it's finally time to go home and start another unnecessary busy day of hanging around, doing nothing of note. Perhaps it is because I have no say in any of our plans here. I haven't voiced this, because I know it is her holiday and I am just here for the ride. Waking up early to meet her friends on the other side of town is something Grey has made me aware I can't *possibly* skip, not even once, even though this is also my annual leave. She assumes that everything she does, I'll want to do too. I must stop brushing my teeth and come into the bedroom right now, for example—who cares if toothpaste is running down my chin—because Mickey is doing something cute and it can't wait, "*LOOK*!"

Am I being petty? All I know is I am exhausted.

On our last night in France, we have plans to drive to a famous nightclub three hours away. Pre-drinks at Luna's flat don't start until 11pm, so naturally I am looking forward to my bed before the night begins. I take an upper to sustain me. It kicks in when we arrive at the underground warehouse. Inside are several girls Grey has slept with. I know this because her friends are whispering things like "That's Celestine!" and "There's that bitch, Noémie." Grey nods knowingly, narrowing her eyes as she rolls her tongue piercing between her teeth, completely unphased. She pulls me towards her to dance.

One of Grey's redeeming characteristics is that she vehemently denounces anyone who came before me, apparently has no ties to her past and never tries to make me feel jealous on purpose. It happens anyway, of course, because I can see how these girls fly towards her like moths smacking themselves dead against a window, failing to touch an unreachable light on the other side. As the strobe lights from the DJ booth flash between us, I am presented with a rainbow of Greys: green Grey, purple Grey, lemon Grey, blue Grey, all neon and appearing before me like photos

on a shutter camera, developing an important flashback for my deathbed in years to come, an album chock full of colourful versions of a lover I am so intoxicated with. I am sick with lust for all of these Greys, the butterflies in my stomach overdosing on the drugs I've taken. She bends her knees a little and sticks her face towards me while dancing. My grin expands like the Cheshire Cat's, kaleidoscoping of my face.

We stumble out of the club at 5am and stop at a petrol station with a large, classic French cafe in the middle. The pill is still keeping me warm, and I feel like I'm in a Gaspar Noé film. I force a croissant down my sandpaper throat and soothe it with hot chocolate and marshmallows, digesting the lumpy feelings of obsession with my own girlfriend. This is what it's meant to be like, obsessed with the one you have, not a greener one on the other side.

The road stretches ahead of us like the Sahara on the drive home, the sun already high in the sky. Grey has only had two drinks, and the coffee has sobered her up. I daren't question the drugs. "You want to go to the beach?" she asks. "Or sleep?" I only have to look at her and she understands. All of me is grit, I want nothing but to crawl into cool sheets and rest with her next to me, my ragged heartbeat pounding itself into unconsciousness. I am so hungover that I know the moments between resting my head on my pillow and falling unconscious will be physically painful. She agrees with a silent nod, but there's one more thing we must do first. She swerves violently, pulls over onto the hard shoulder. Yanks the lever to recline my seat so that my body jolts against the headrest. Climbs on top of me. All thirst and heat.

CHAPTER
33

"OPEN YOUR EYES."
It's the last thing Grey says to me before I leave on Christmas night. I'm standing on her box-landing with my suitcase, ready for the airport, when she pulls the door softly closed behind her so that her friends visiting from France—distracted in the kitchen making Snowballs—won't be able to hear, and drives the words into me like a snow plough. "Open your eyes and realise what you have." It's a weird threat; she's nervous about my time in Canada, but she needn't be. Since I first laid eyes on her, I've not even blinked.

The journey to Vancouver is almost ten hours. Nike and Steffi, close friends of Red and I, are waiting for me when I land.

"She's home!" Steffi whoops, throwing her arms into the air and pulling me into a bear hug at arrivals. She wheels my suitcase out into the short stay carpark, and I climb into the backseat of Nike's car after loading my luggage in the boot. When the engine is on and we're ready to go, Steffi passes me a plastic shot glass filled with vodka from the front. I'm spent.

"We're going to The Ovid." Nike announces. "Red and Olive are meeting us there. We gotta celebrate your first night here!" They'd created a WhatsApp group called *The Queen is Coming* to arrange plans while I was on the plane. Best hosts, every time.

I wasn't expecting to party on my first night and am desperate for a shower and some sleep, but I can't deny a night out at our favourite club, plus I'm touched that everyone has cleared their schedules because they're excited to see me. I'll be staying

at Nike's for the week, so we make a pitstop to dump my luggage and freshen up for the night. My phone battery is on 3% and I want my data to last the whole trip, so I think it best to leave it on charge at Nike's while we're out. That way, when we get back in the early hours, it'll be morning in London and I can call Grey on Nike's WiFi. I send her a text to wake up to.

Arrived. Nike came to pick me up at the airport with Steffi. Now we're going to grab something to eat and then head to one of our favourite clubs. I'll leave my phone on charge and text you when I'm in. Love you.

Our night at The Ovid is a better welcome than I could have hoped for. Even the guys in our wider friendship group are here, and one who works behind the bar orders us a round of free tequila shots. I'm relieved that seeing Red in the flesh for the first time since I sent her the voice note isn't awkward and doesn't make me doubt my allegiance to Grey. I can already tell, when smoking outside in between cocktails, that the sky here is coloured differently now, no longer fizzing with the promise of us. She has brought her boyfriend with her, and he seems nice enough. She asks about Grey, says she seems awesome. There is nothing too weird in the air between us, no residual embarrassment about my confession (which neither of us bring up). The only downside is that we can't display the easy affection of friendship with each other the way we can with Nike, Steffi or Olive, because it's loaded now. Our welcome hug is shorter, our eye contact briefer. I'm anxious that if I'm left on my own with her for longer than five minutes, even for a cigarette, I will have done something wrong. It's as if Grey has hooked me up to a secret camera.

When Nike and I get home at 4am, Grey's response to my text is not what I expected.

Bonjour. Maybe it was better if the phone was with you, no? How to win from the first day.

I swallow hard, pricks of sweat forming on the back of my neck. But then I see the message that follows, a selfie of Grey

sticking her middle finger up to the camera. She's smirking, so I know she can't be too mad. To diffuse any tension, I explain my reasoning for leaving my phone behind and swiftly change the subject, spamming her with details about our night out and how everyone says they can't wait to meet her. But for the rest of the holiday I manoeuvre as if a bomb is about to go off at any moment, dreading the times I don't have WiFi or signal, conscious of being away from my phone too long. I keep a steady eye on the time difference, but it doesn't look like Grey does the same, because she gets annoyed if I haven't texted her during the night while I'm asleep.

Any context is lost in translation because of our language barrier. I need to concentrate when we're texting no matter what I'm in the middle of, so as not be distracted by the fun I'm having in case I accidentally ignore something she has said and provoke her. I resent how anti-social this makes me; being out with the girls while glued to my phone because a lack of immediate response warrants questions from Grey. And so I commit to messaging her constantly, which still isn't good enough. One night at a Mexican restaurant, I reject her video call because eight of us are in the middle of eating, instead asking if it can wait until I'm home because I don't want to waste data when I can't give her my full attention. She doesn't believe me, simply texts me the emoji of the disapproving face. I wouldn't mind if it was a sad face or crying emoji, but I hate that she always defaults to anger or disappointment as if I'm at fault. Nothing I do is satisfactory - still, I keep it up the steady flow of communication as best I can because I want to make her happy and I've come to rely on it too. I start to fear something is wrong if I haven't received a message from her for half an hour, and so I perpetuate the constant communication. I do miss her terribly.

It's not all bad. The messages of longing, lust and missing me, almost make the jumpy dynamic worth it. We send photos and videos when in the bath each evening, hundreds of heart emojis. But even in the middle of a good hour, she'll suddenly send the

disapproving emoji again, and although I know it's just because she misses me, it looks so much like the face she makes when she's pissed off that my blood pressure spikes and I go into fight mode, prepared for battle should her mood switch.

The night of the New Year's Eve party rolls around, hosted at Nike's. There are around fifty of us in attendance: Steffi, Olive, Red and her boyfriend included. When the clock strikes midnight (and once Steffi has popped open both of the miniature bottles of champagne cradled in each of Nike's bra cups), I call Grey so that I can begin my new year with her. She picks up between serving guests, so can't talk for long, but Facetimes me at 2pm the next day, on her own New Year's Eve. It's 6am where I am, so this wakes me up, but I'm happy for the disruption because I want to celebrate with her over the phone. She's not in a good mood, and the camera is pixellated.

"I had a such a fucking stressful shift last night", she starts. I notice she is wearing an Adidas jumper of mine, which softens her sharp edges. When she is upset she is always angry, so I try to comfort.

"Oh no! Happy New Year's Eve baba, what's wrong? How can I make you feel better."

"You should already know", she scowls.

This could be classed as coquettish, if it wasn't for her tone and facial expression. Of course, she wants me by her side, something I can't deliver. I don't know how to reply. I'm apprehensive that my new year should begin like this so soon, when the sun hasn't even had its breakfast, so I pause... after a beat, I know there's only one thing I can say.

"I love you."

"I hate you." She responds. I know she just misses me, wants to be mad at something. But this is what I've woken up to. On my New Year's Day. I can feel my buttons being pushed but ignore it and resort to fawning.

"Hey, I'm being nice!"

"You think that's nice?!" She looks at me with disgust, as if I'm chewing with my mouth open. Instant rage crashes over me so I fling my duvet off and exit the bedroom so as not to disturb Nike's sleep. All the straws she has dumped on my back over the past week make my legs buckle. This has to be the final one. It's one of my golden dates. I can't bear how little she respects me, that she is talking to me like dirt when I've just opened my eyes and am trying to be patient.

"Don't ever talk to me like that again. I'm not speaking to you until you apologise." I hang up.

She texts me.

Grey: Good way to start the year Fern.

Me: I agree. You heard what I said. I'm not being spoken to that way. I don't know why you think that's okay.

Grey: You were not there when I needed.

Me: Your tone and words were disgusting. Sarcasm isn't an excuse, it's 6am and I'm exhausted. I don't say things like this to you when I'm stressed. And I swear to God I won't accept it any more. Not one apology. Unbelievable.

Grey: Not one apology from you too. It's always my fault for you. I was exploding inside and I usually do it by myself, with nobody else. I'm sorry because I thought I could actually explode with you when I was feeling empty, but maybe you can't reach my way to be. I was being sarcastic, trying to calm down and you left me like this.

Me: If that's the case, then when I hang up you should message me saying you're sorry. Instead you justify it. You can 'explode with me' all you like, but the second your explosion gets turned ONTO me, I'm out. If you want a girlfriend that stays on the phone while you tell her you hate her, that's not me. I won't do it. I was there for you until you got nasty to me.

Grey: And you put your feelings at the first position also when I'm in that condition. That's the problem. You just care about a fucking SORRY?????????

Me: Yes. Apologies are important in a relationship!

Grey: You don't give a shit about how I felt. You don't give a shit if it's not about your things.

Me: I'm not gonna sit here and accept you having a go at me because you had a hard night. I was asleep but wanted to say good morning to my girlfriend, then suddenly it all goes crazy.

Grey: This is disgusting. If you don't understand French sarcasm then sorry I can't help you.

Me: What you said to me is disgusting. Like I said, until you apologise, I don't want to speak to you. Sorry I can't reach your 'way to be'. Maybe one day I'll be strong enough to stay on the phone while you tell me you hate me. Fingers crossed for next year! Read what you're saying and how it sounds. All it would have taken was "I'm sorry, I love you. I'm upset but not at you" and I would have called you right back and hopefully you would have told me what was actually wrong.

Grey: I'm really sorry for that fucking HATE YOU, it was sarcastic. Nothing more than that. On the other side I think all the things I've said about us have been a big deep delusion for me. And believe me when I say this.

Me: What other things?

Grey: Nothing more, nothing less. I really don't know what to say after this. You act like a child. You act like it's just you in the fucking world. Just your things are important. Just your things deserve value. I'm fucking tired about this shit. You don't know how I felt when I went to sleep. You are sure you didn't do any mistake? Ok. Perfect.

Me: I'm not sure what my mistake was? Hanging up the phone? Not calling you back? I've already told you why. They were a reaction to how you were behaving. If you tell me my other mistakes I'll listen and try to see it from your point of view. I don't mind saying sorry when I'm wrong.

Grey: Do what the fuck you want. You hung up, I said sorry now for the fucking sentence and you are still discussing about this because you just care about underlining what I did wrong also after I apologised. It's never enough. My things never get value. This has been the last time. You just showed me how much you don't give a shit either to let me feel better now, to calm me down. Nothing. Unbelievable I HAVE TO SAY THESE THINGS. WHEN YOU FEEL I'M CHANGED YOU KNOW ALREADY THE ANSWER.

Me: Obviously I'm really sorry you had a bad shift. I'm sorry you went to sleep feeling bad. I could have been there to comfort you this morning but you've made it worse for yourself. If you're gonna change your feelings about me because of this, then you're being dramatic. I'm happy to forget all this and move on. If you're gonna hold a grudge, then enjoy your next few days and I'll see you when I'm back.

Grey: Do you what you feel. You gonna take the consequences. I spoke too much already.

Me: It's you who's taking the consequences right now for how you just spoke to me, and you aren't able to handle it. I'm gonna get up and enjoy my holiday now. Bonnuit.

Grey: I'M GOING TO ENJOY MY HOLIDAY? YOU DIDN'T HAVE TO SAY THIS. YOU SHOULDN'T HAVE DONE IT.

Me: Why not? Why do you always think I mean things I don't mean? I mean I'm going to enjoy it with my friends without

spending my whole time arguing with my girlfriend on the phone.

Grey: ENJOY IT BY YOURSELF BUT DON'T EXPECT TO FIND ME HERE AFTER YOU DESAPPEAR!!!!!!!!!!

Me: What are you talking about?. I'm continuing as I am… in a relationship. I'm not talking about enjoying time with Red! If you do something bad because of what I just said… I don't know what to say. You'll regret it.

Grey: After this I'm done. Don't waste your time arguing at the phone with me. ENJOY!

Me: I'm literally just going to chill with my friends…

Grey: Don't lose your time at the phone with me ;)

Me: It will be interesting to see if you fuck things up with your actions now. I'm obviously going to behave because I'm still in a relationship and I love you? Enjoy x

I want so badly to stand up for myself, to hold her accountable for once, that I end up sounding like a twat for making a big deal out of something so small. If Grey doesn't take my big feelings seriously, I can hardly expect her to start with something tiny. Still, I try to stick to my guns throughout the day so that I can get through to her for once, so that she'll treat me with some respect instead of getting her knickers in a twist about an ex-lover. I don't text her at all and by evening, when I still haven't heard from her, I am miserable and wondering if I should have just conformed and apologised to her instead. Because it is my last night, Nike has booked a karaoke booth for us all. Everyone who was at The Ovid on my first night is there, to say goodbye to me, and I hate that I'm too deflated to enjoy it. My life could so easily be perfect right now—I am in a relationship with the girl I want and should be having the time of my life with some of my best friends. Instead, the two don't mix. I spend most of the night sitting on a

plinth above the pleather sofa in the booth, pretending to enjoy myself by singing a song every now and then and smiling weakly. But for most of the night I am messaging Grey, or rather shouting into the void, because she's still not talking to me and the room is underground so my messages aren't delivering. Holding a grudge is futile when I could potentially lose her over it. I don't believe she'll cheat, but I'm scared of the punishment she'll put me through because of this argument. I open my video camera and pan across the room so I can watch it back later and remember how my friends filled me up at my lowest, because I can't be present right now. I post it to Instagram so the world will think I am enjoying myself, then stick my face right back in my phone, staring at line upon line of singular, grey ticks.

We go to Nike's friend Nancy's house for afters. I don't want to, but I don't have much choice because Nike is my ride home. I sit on a skateboard in her industrial apartment, zipping back and forth across the room as Red and Nike chat to Red's boyfriend in the kitchenette. Steffi and Olive have gone home. I am still checking my phone even though there is no point, I may as well be dead to Grey. As we are leaving, Nike and Red are a few steps ahead and I stand in the doorframe checking my pockets for my wallet. Nancy pulls me to her and as I say goodbye, leans in to kiss me. I've been so distracted that I don't see it coming at all, had no idea she might be interested in me. I pull back and smile politely, as if refusing something as innocent as a sweet. I am too exhausted to be outraged, and it isn't in my nature. I don't want to offend her. "Sorry, I'm in love with my girlfriend," I reply weakly. Nancy shakes her head, gives me a cheeky grin and closes the door. When it shuts, I turn to Nike.

"Nancy just tried to kiss me?"

"Dude, what?" She's had too many beers and is slurring. "Get the hell back there!"

She shoves my shoulder in the direction of Nancy's house, I laugh and shrug it off. This is so out of character for Nike. Morals and loyalty are two of her defining traits. I can tell she is no longer

rooting for me and Grey. She can see that Grey has broken me during my week here, that this relationship has taken such a toll on us all that she doesn't even care if I cheat.

Our final stop is iHop, 3am. The only place this side of town that does 24-hour breakfasts. I don't even notice Red's hands delicately tearing at her bacon pancakes the way I would have before I met Grey. I'm not watching her at all because I'm too busy itching to get back home to my girlfriend. I can barely eat for worry.

When I get back to Nike's, the WiFi sends a whoosh of texts to my phone.

> *Grey: I SAID IF YOU DON'T UNDERSTAND THEN DON'T TEXT ME AGAIN. DON'T WASTE OTHER TIME WITH THESE THINGS. BECAUSE NOW IT'S ALSO WORSE FOR ME AFTER WHAT YOU SAID. YOU ARE JUST ABLE TO POINT YOUR FINGER. ENJOY YOUR LAST DAY FERN AND DON'T EXPECT TO FIND ME HERE.*

and sent half an hour later:

> *Grey: SHE IS IN YOUR FUCKING INSTAGRAM STORY*

> *VA TE FAIRE FOUTRE*

> *Disparaître.*

PART

FOUR

"Life has been trundling along and then, bang, with no warning, it explodes. Something makes your soul cry out, whacks you in the stomach with an iron bar, makes you feel that some outside agency has reached a fist into you, unfurling angry fingers tearing your heart from your body. Life has changed forever; perhaps it has now become unlivable."

Cathy Rentzenbrink—A Manual For Heartache

CHAPTER
34

A ND THEN?
Nothing in my life is the same.

This is my Grenade Moment, a term coined by Cathy Rentzen-brink in her book *A Manual For Heartache*. A Grenade Moment can be described as a loss, a diagnosis, or a major life change that sees you lost and overwhelmed. For many, a break-up, especially after just three months of dating, will seem microscopic in comparison to tangible catastrophes: wars, natural disasters, death. I've told you about multiple endings already, of longer relationships, so what makes this one different? Well this moment—this heartbreak—is the most tangible threat I can imagine. As someone who navigates the world through the lens of loving women, whose priority in life is the receipt of true love; what could possibly be worse? Finally receiving the love of a woman who terrifies, thrills and dotes on me in equal measure, then losing her because I was stupid enough to test it? Nothing. Particularly because the added layer of emotional abuse has caused confusion that's untethered me from myself. Losing Grey is as palpable as the cloying smell of Dove deodorant which has plagued me for years - unlike other brands, the smell does not dissipate and you do not come out the other side. The soapy fumes clog your lungs and the idea that you may never breathe fresh air again becomes plausible.

The most visceral way I can describe depression is a disconnect in the base of my spine. That my torso is hovering a couple of inches above my butt, suspended in synovial fluid. I find out, after curiosity over this symptom leads me to research it, that this

is where our Muladhara—or root chakra—is situated. Our root chakra represents grounding, stability, security, and other basic needs. When aggravated, it can affect the way we cope with life and its challenges. I am struggling with the simplest task of existing. The imaginary gap I feel in my lower back lets in an emotional draft, blowing cold air throughout my body, filling me with nothingness. But I've learned that no matter how well somebody is able to explain depression, no matter how great a writer or raconteur they are, you can never truly understand the way it feels unless you've been there. And that is a blessing. Depression is an exclusive, desperate club whose membership I would not wish upon anyone.

Despite growing up in a society with pressures both unprecedented and inherited, and my awareness of mental health issues increasing exponentially with every news headline, I thought I had some understanding about depression, when truly I had no idea. I've known friends who've suffered from it, watched documentaries about living with chronic emotional pain, have read books on its debilitating effects. I've debated with the older generation who do not believe it is a real disease. I've defended it, I've even thought I had a minor bout of it aged eighteen after Miss White died, although its sequel is enough to render that first round obsolete. I am educated and empathetic. But there's something about depression that a mentally healthy person who has not ventured there before will never have access to. Regardless of their well-meaning intentions, they will always see it from the viewpoint of an outsider, even as their hearts break while enduring their own, separate (but equally devastating) battle if they are unfortunate enough to watch a loved one suffer. And we have to be thankful for that.

As I write this having come out the other side, I no longer have the same access to depression that I once did. I write from muscle memory—a sharp, bitter flashback, but I cannot go back there. Not really. Even if I had the energy to write this entire book during the depths of my illness, I doubt it'd have made a difference to

my ability to tell it, as no matter how adept the writer is at leading their reader to the binoculars, the field of vision will always be subjective.

I've not always been so open-minded about depression. Until I left secondary school, I considered it a dirty word. It was not spoken about amongst millennials the same way Gen Z now discuss it. On the rare occasions I heard it muttered in the nineties and noughties, it was still relatively taboo, and my mind conjured an impermissible black hole I had no business being near. With a shudder I would quickly turn my attention elsewhere. Those who had it were terminal, dangerous, condemned to a half-life. They had malfunctioned at birth. I pictured pale, goth girls teetering on the brink of this void, burdened with heavy eyeliner and jet-black Wednesday Addams plaits, somehow still alive despite a flatlined trace. Doctors lingered behind them, holding up straitjackets with tentative resignation, lest they fall into the chasm themselves. There were rumours that someone in my year group was visited by the black dog in Year 7 and I didn't let myself think about it for longer than a few seconds. Then I got older and it became a buzzword—a cultural phenomenon. Thank goodness. I wised up.

The minor bout of depression I had as a teenager was the milder, more common type, fused with the anxiety that is often experienced by kids who've just been released from institutional education and into the wild world of responsibility, employment, and all the other colourful shocks of reality. The pressure to be perfect is oftentimes a functioning kind, particularly in the age of social media. It can be subconscious and sometimes even galvanising, so I barely recognised it, even though I did sign myself up for cognitive behavioural therapy and used my wages from the dance studio to drive myself to a private therapist in Hampstead for a one-off £40 session when I became impatient with the waitlist at age nineteen. The session did me so much good that the relief gave me a nosebleed as soon as I got in my car after-

wards. I hadn't realised that I was mentally unwell until a professional gave me permission to talk candidly. It's odd how our minds can trick us into denial, can convince us destruction is not imminent, even when our body is visibly on the journey towards it - the way mine had manifested as weight gain, then weight loss, and an eventual eating disorder, destroying my thighs with purple stretch marks (that had to be laser-removed) in the process. Our wonderful NHS are under so underfunded and under resourced that I recovered through the sheer forward-movement of living, and my referral letter landed on my doormat a whole seven years later (then went straight in the bin). Around this time, a close friend admitted that she too was suffering from the disease and was on medication. I was horrified to hear she was taking antidepressants—my education on tablets having not surpassed the Black Hole imagery of my teenage years—but was still deeply concerned for her wellbeing, recognising the reality of the illness despite having no real grasp of its potential severity.

I was the happiest girl in the world before Grey. Anyone will tell you. Even when I was sad and bereaved, my baseline was still happiness. Joy was my default state. Depression was not yet in my personal vocabulary. I was carefree to the point of being careless, didn't worry about things I was told I should worry about: money, my career prospects, my physical health. But if there's one thing that has always had the ability to push my buttons and cause me to malfunction, it's affairs of the heart. I care deeply about love. Too much, perhaps. If love goes wrong for me, I am fucked. Well and truly, out for the count, can't move a muscle, fucked. So if my Big Love goes wrong, and moreover I believe I am the *cause* - that I pushed her away - then what the hell am I doing with my life? Everything I know about myself must be a lie.

As soon I receive Grey's text about Red being in my Instagram story, I call her. She is rabid, spitting, yelling. I match her energy because my holiday has been ruined and I am enraged at the state she's worked herself up into over nothing: her ungrounded suspicions that I'm seeing Red behind her back and her anger at my insistence on an apology. And so I break up with her—just like that, over the phone. It's January 1st, after all and—I won't realise this until years later, but—exactly 3 months since we got together, affirming the old man's prophecy at the bus stop. The boldness of my decision buoys me on the night, and I fall asleep soundly in self-righteousness next to Nike. But on the plane back home the following evening, alone with my thoughts and with no connection to life back on the ground. I panic, realise what I've done. I blow up her phone from the cabin.

> *22:22: Can you call me when I land please? I have something to say and I don't want to text.*

> *My flight lands in 2 hours. If you could call me then I would really appreciate it.*

> *I have read over our conversation to try and understand your point of view better. I can see your side. Mine exists too, but I can also see yours better now. If you won't fight, I will. But not over text. You are my happiness and without you, I don't have my joy to come home to. I have to learn you.*

("I need you to learn me" was a phrase Grey often used whenever she thought I didn't understand where she was coming from. I was hoping that by mirroring her broken English, I could salvage a closeness that seemed to be fading.)

> *00:08: And I completely understand why you were upset.*

When I land, there is nothing. Radio silence.
Where the hell is she?

12:23: I've landed to no reply even though you've been online. You can't understand the pain I feel to come home to this. I'll fight for you Grey but you also need to fight. There are two people in this relationship. I am breaking.

12:35: GREY. CAN YOU CALL ME PLEASE.

12:55: I AM HEARTBROKEN.

I hate all this dramatic talk of 'fighting' for each other, but it's another term she uses often, and I'm ready to be fully immersed in her language and hopefully her way of thinking, desperate for her to respond to me.

Eventually, after a sending a dozen more texts, Grey calls me back. She sounds pestered, like she's wondering what the hell I could possibly want, as if there had been a small emergency she wasn't privy to while she was at work, and we hadn't had a theatrical breakup the night before. Or is it worse – that she is treating me like a cold caller? She reluctantly agrees to meet me the next day, "to discuss things, nothing more."

We repeat the familiar motions of the night I atoned for ever having loved Red. The same hard-set face when she opens her front door, the same silence as I follow her up the stairs, the same beckoning to join her at the kitchen table, the same brand of tobacco. Only this time, I do not offer to help her with her laundry, we don't kiss, and the strawberry blotches on her cheeks are lacking. She has not been crying today. We sit opposite each other, total strangers in this new year somehow, until she gestures at a skinny black box between us on the table. I look at her, wondering what she wants me to do with it.

"I bought it for you when you were away. It's so you can stop smoking."

Inside the box is a metallic rainbow vape pen and two miniature bottles of bubblegum and raspberry ripple flavour juice. It's a beautiful device, and this act of kindness is so wholesome my chest cracks. Guilt and love overwhelm me as I acknowledge this

is probably the final selfless gesture I will receive from her. I regret breaking up with her more than I've ever regretted anything. In gratitude, I climb onto her lap again, knowing this physical act of intimacy worked last time. Although she isn't forthcoming, she allows me to cuddle her. With my head on her shoulder, I spot a Nike logo beneath the collar of her jumper and notice she is wearing my t-shirt. Another pinprick on my heart. I move to kiss her, to thank her for still wanting to wear my clothes, and as I do I smell something unfamiliar on her neck. I sit up, cock my jaw to the side to assess her face. Something isn't right.

"You smell different" I say matter-of-factly, knowing I have no right to accuse her of anything, seeing that I broke up with her over the phone from another continent.

She shrugs, her usual downturned face.

"A different shower gel". She says, pulling my t-shirt away from her neck as if to catch the scent and remember the flavour. "Tropical fruits?"

I do not press, and as she agrees to let me stay and 'see how things go', I try my hardest to repress the *Fatal Attraction* level of crazy I am feeling. I lie in her bed like a stone, too afraid to touch her because she has not initiated cuddling, and because of this I cannot sleep. Eventually my curiosity gets the better of me so I check her Facebook profile on my phone under the covers and sort them by 'date added'. She became Facebook friends with a girl I don't recognise the night before I broke up with her, when we first started arguing. I click on the girl's name, to see she was checked into She Bar the following night. I know Grey frequents She Bar with her friends, and that they'd been on nights out while I was away. If she'd been with this girl that night, it would explain why she hadn't replied to my texts on the plane. My blood soars, particularly as their friendship request came before we broke up. How do they know each other? Had she cheated? I send a message to the girl.

"Hey, I'm sorry to message you randomly! Listen, me and my girlfriend Grey broke up right at the end of last year and we're working things out—she's told me she met you on a night out after our break and that you may have kissed—can I ask if anything else happened? She says she was so drunk she doesn't remember but I want to make sure we're on a clean slate if we try again and I'm sure you'd understand I want to know if there's anything I'm not being told. I know it's not your fault, at all, so I don't mean it to come across in a strange way! Just want to be sure and would appreciate your honesty. Thanks ☺ "

The reply comes the next day when my skin is crawling with the anticipation for her response.

"Hey girl! I'm totally not ignoring you, just super busy at work! I'm not mad at all that you reached out to me, you seem really cool. And I'm sorry for the situation. I didn't know Grey was involved with anyone."

Hmmm. No outright answer. My instinct was right. I'm terrified to find out if Grey cheated, or slept with someone else the night we broke up. I'm not sure that one is more preferable than the other.

"No problem at all! It's no one's fault—we're just trying to fix things and I appreciate her telling me in the first place but just for my own peace of mind I need to know exactly what went down. Thanks for the reply ☺ if you could let me know you finish work I'd really appreciate it."

By evening, I've heard nothing.

"Have you finished work? Sorry to keep messaging but I can't sleep and I don't wanna start tomorrow with it still playing on my mind."

"Hey, no I totally get it. I just feel like I'm in a tough position here. We did have drinks at Soho the other night and hit it off. But it's obviously nothing!"

"Okay thanks for letting me know. Did you kiss? That's all I wanna know! Then I'll leave it."

"Not it's totally okay. I actually really feel for you. I'm sorry you've been put in this position. Yes we did."

"Thank you for letting me know"

"Thanks for being so understanding. I'm sorry if I did something to hurt you. Obviously not my intention."

"Not at all! I appreciate your honesty."

"I'm really sorry to bother you again and feel free to block me after this! But did you guys meet in the club and that's the only time you hung out? Did you sleep together? Please let me know."

"Hey, I feel a little stuck and I really think these are questions you should be asking Grey not me..."

My whole world caves from underneath me when I read this. As far as I'm concerned, it's confirmation, and I don't know what to do with my hands. The time is 23:39. Knowing I will be unable to sit still in this bed, let alone sleep within it, I book an Uber to Grey's, all rational thought gone.

I let myself in with my key (one of my Christmas presents). As the front door swings open and I appear in the doorway, Grey and Raph stare at me from that cursed kitchen table like they're watching a car crash; burgers poised at their lips. They are seated opposite each other, watching Netflix on the iPad she'd bought me for Christmas which is propped up against the windowsill and

eating fast food out of polystyrene containers. I can't believe they are able to cosplay regular people on a regular evening, like my life isn't spiralling out of my grasp.

I don't waste time looking at them, but barge into Grey's bedroom to collect some inconsequential belongs I've left behind, not because I need them, but to show her that I know what she's done, and that there will be no 'seeing how things go'. As I scramble to grab random items, I yell into the kitchen.

"HOW DARE YOU MAKE YOURSELF A VICTIM JUST BECAUSE I'M ON HOLIDAY AND YOU ARE PARANOID ABOUT ANOTHER GIRL, WHEN YOU ARE THE ONE WHO SLEPT WITH SOMEBODY BEHIND MY BACK!"

They are still frozen in the same position when I leave and the front door slams behind me. They don't say a word. She doesn't even call me when I leave.

CHAPTER
35

I'VE FELT HEARTBREAK before, many times. When my last fling before Grey ended, I cried to Black on the phone and she promptly drove to my house in her dressing gown, already prepped for sleep. We chewed the fat in her car for an hour, hugged goodbye, then I took a pink cocktail Sobranie from the packet I kept for special occasions, smoked it in my garden and set about the grim business of getting over it. There was no future in that affair, despite the hurt, so I could see the other side even if I couldn't be bothered to take the journey that would enable me to reach it. But I'd taken emotional steps with Grey that I hadn't with anyone else. My relationship with her was my whole life. I really believed that. Now that I realise it isn't, it seems trite to admit it. We always think our most recent heartbreak is the worst one, but the truth is it just gets harder and harder every time, until you finally say "enough is enough" and accept that you simply will not put up another unhealthy relationship. Grey is this moment for me. Part of me truly dies with her. Our breakup is the equator of my life—each half a tectonic plate on North and South Poles. Anything after her is my Anno Domini. In the words of Nayyirah Waheed, 'she stained my shoulders. My whole life smelled like her. This would take time, undoing her from my blood'[7]. If that was ever possible.

Considering I am socially and culturally aware, armed with knowledge and perhaps even a little experience under my belt,

7. Salt, 2013.

you would think that to be suddenly plunged into depression, even if only circumstantial, I would at least be a little prepared for it.

It is with great regret that I tell you it is so much worse than I imagine.

It starts off as hysteria.

"PROMISE ME YOU WILL NEVER LET ME FALL IN LOVE AGAIN!" I beg my mother at the top of my lungs when I arrive home, my voice a howl of anguish, unrecognisable in my own throat and only comparable to a human noise if said human had just had their newborn torn from their chest. My poor mum, harshly woken from her sleep, stands in my bedroom doorway with her heart likely breaking too, watching her firstborn falling apart in the darkness, inconsolable. This is not the first time she's seen me devastated, but it's the first and only time she sees me *manic*.

Then comes the numbness, intermingled with denial. I punish myself for breaking up with my only two girlfriends, yet having the nerve to be upset when they'd immediately slept with some-one else the night we ended. That they didn't have the foresight to think we could resolve it.

I continue going to work each day (although I can't be sure whether I'm awake or asleep when doing so), but the pride I take in my appearance dwindles. First to go is my hair, which is always wet when I sleep because I can't be bothered to dry it. Next, my characteristic winged eyeliner disappears. I paint less foundation onto my face, merely a thin veil separating my sensitive skin from the harshness of the world as I become increasingly vulnerable but give less of a damn what people think of me. The only opinion I care about is Grey's.

Poor Sara, whose work ethic has always been on point, starts pick-ing up the slack for me at work while I sit watching YouTube tarot card readings on repeat all day with my earphones in, barely try-ing to hide the fact my workload remains untouched.

"You alright mate?" she asks me cautiously every hour, appeased temporarily each time I take an ear out to assure her I am. I haven't told anyone that Grey and I have broken up.

I'm a good actress when it comes to masking my darker emotions. Even those closest to me rarely know I'm going through something until I've processed it and come out the other side. But this time there's no hiding how I feel. My face is slack and I can't lift it into a smile. *The truth is, Sara, I'm eardrum deep into every Cancer/Gemini YouTube tarot card reading I can get my hands on, desperately awaiting an oracle card that hints that Grey and I might get back together. If anything suggests otherwise, I'm skipping to the next video.* I'm not fully depressed yet—the adrenaline is far too potent at this stage—but my unhealthy tunnel vision certainly puts me on the slope, and when work is done I go home, eat dinner, fall into bed to watch more tarot and start the cycle all over again, each aspect of personal grooming gradually falling away to make more time for my obsession with these false portrayals of hope.

I self-analyse, frenetically searching for all the blame I can label as mine. I'm desperate to be in the wrong; that way I'll have the autonomy to fix it. I want to pick apart all the times I've looked for love in the wrong places and harmed others' relationships, so I can be sure that this was in fact *my* karma. That way there's a sense of fairness and logic to my pain; I can turn it into action and make sure it never happens again. I almost wish she'd cheated on me, so that this could be black and white. But if it was on the night we broke up, it's a grey area. For now, all I can do is fall deeper into the rabbit hole of tarot. I become very sick.

When I have reached a particularly desperate low (my tarot reader of choice that morning has pulled the Tower card repeatedly), I can't bear the thought of going home that evening to repeat another negative cycle, so I decide I need to take it up a notch and bring matters into my own hands.

"Sara," I whisper. "I need to take an early lunch. It's urgent. I'll probably be gone for longer too. Hope that's alright."

Sara nods, asks if I'm okay once more, and assuring her that I am, I leave the office and jump on the tube to Oxford Circus. I've remembered a place just off Carnaby Street called *The Astrology Shop* which I'd seen on shopping trips with my mum as a teenager. It looked magical, the royal blue exterior with gold lettering suggesting a Diagon Alley boutique (and with any luck, a hidden doorway through which I will be whisked away to a magical school so I can forget all about Grey). I wonder if the folk behind the desk are the spiritual kind that can sense the energy of their visitors upon entrance, the way my boss at the dance studio would light a Nag Champa whenever a difficult customer left the building. I also wonder—with a particular strain of narcissism reserved only for the depressed—if they can tell by my bedraggled appearance and crushed spirit that I am dying, that this is my final shot at life, if not a pitstop to palliative care. Purchasing a smudge stick of sage and an original Rider Waite deck, I head back to the office with a slight spring in my step. Action is what I need, and this is enough to boost my mood for now – even if only superficially.

At home that night, I tip my purchases onto the bed, light the sage and smudge its shrub around my room. I open the deck and shuffle the cards with haste until one springs out of its own accord. *The Ten of Swords.* I know that this is considered the most powerful image. *Betrayal. Ultimate Ruination. Deep wounds. Loss. Crisis.* On the card is a man draped in a crimson cloak, lying on the ground with ten swords in his back, facing a body of water. Beyond him are purple mountains on the horizon and above, in a blinding yellow sky, black clouds threaten.

The Ten of Swords marks a painful yet inevitable ending that's come out of the blue and rocked your world. You wonder if you'll ever love or trust again as you've been the victim of another person's betrayal and deceit. It runs deep because you know it marks the end of your relationship as you know it. You can't change the actions of another person but you can change how you

respond, so you have a choice to pick yourself up and move forward, rather than falling down in a heap. There must be a change to facilitate renewal, and you must accept it, not fight it. The good news is that the Ten of Swords marks the final ordeal—no more pain will come to you from that source. The hour is darkest before dawn, and you must experience the full impact before you can start over. Pick yourself up and reflect on what you can learn about why this happened. Then the hurt will fade and you'll realise why it was needed for you to evolve into your full potential. It's not without purpose. Draw wisdom from defeat.[8]

My heart fractures a little at the line 'you know deep down that this marks the end of your relationship as you know it'. I choose to cling to the 'as you know it' part. Perhaps this is a trick message. It *could* mean that I can fix my relationship with Grey and turn it into something better than it ever was before. *Couldn't it?*

Isn't that scary? How can we delude ourselves to such an extent? Every time I pull The Star (hope) or The Lovers (self-explanatory), it's like I've plugged myself into the mains and become briefly recharged; motivated for at least five minutes—long enough to make myself a cup of tea. But whenever I pull a negative card, such as Death or any with a large number of Swords, I simply want to collapse. I don't have the energy nor patience for *wisdom*. I've stitched myself up after so many endings that I don't have it in me anymore. 'No more pain from the same source' is not something I interpret as a silver lining. It would be great if it meant that Grey would never hurt me again, but not if that's only because she's no longer in my life. We've been texting a bit this past week but only when I initiate, and her responses take days. She probably doesn't respect that I still want to contact her after what she did, even though she hasn't admit-

8. https://www.biddytarot.com/tarot-card-meanings/minor-arcana/
suit-of-swords/ten-of-swords/

ted it. I used to hear from her constantly and now with every hour that passes, I feel she is falling further and further away. To be honest, I can't imagine Grey never hurting me again and it's crazy how I've ceased to care. I'll take pain over her absence. I have pain anyway. What I don't have is the positive power to turn anything into anything.

Next card. The Tower.

Please God no. Not again. I'm terrified of this card. In part because it exposes my situation with such accuracy that I feel autopsied. The Tower represents sudden, unforeseen change. *Accident or damage. Catastrophe. Destruction. Renovation.* A lightning bolt strikes the turret of a tower and causes it to topple, flinging two figures out of the window. One victim is facing skywards on their descent, having unwittingly fallen; the other forwards with their arms out in the brace position, suggesting they've jumped. I can't tell which is me and which is Grey. The dynamics of our breakup are constantly shifting, bringing back memories of my first breakup with Pink, where I couldn't make up my mind which of us to feel sorry for. Surely, Grey betrayed *me* by sleeping with someone the night I called quits on our relationship (or potentially even before), knowing I'd been hurt when my ex did the same thing. Or had I betrayed her? I knew she hated being walked out on, yet I'd threatened to walk away repeatedly until she finally shut the door. I broke up with her at the worst moment, on a special occasion, when she was already fearful and suspicious of where I was. I didn't do it to hurt her, only to protect myself. Perhaps that's how she also feels. Maybe we were just dealing with our own pain, refusing to learn Saturn's lessons, not paying attention to the fact we'd crossed each other's lines.

Expect the unexpected—massive change, upheaval, destruction and chaos, affecting you spiritually, mentally and physically. There's no escaping it; you have no choice but to surrender. Change is here to destroy everything in its path (but trust me, it's for your Highest Good). Just when you're comfortable, it

throws you for a loop. A lightning bolt of clarity cuts through the lies you have been telling yourself. Your world may come crashing down in ways you could never have imagined as the truth comes to light and you realise you've been building your life on unstable foundations. Core belief systems are challenged as you question what's real and what isn't. Over time, you'll see your original beliefs were built on false understanding and your new ones represent reality. Change on this deep level is hard but you need to trust that life is happening FOR you, not TO you. Develop a new perspective on life you didn't know existed. Truth and honesty will bring about a positive change and allow soul growth, even if it brings pain and anxiety.

I want to be sick. I wish I'd drawn the Tower card before I'd gone to Canada so I could heed its warning, think twice about threatening to leave. I need to pull another card to soften the blow of this one.

Four of Swords.

Fuck. This. Shit. How is it that I've pulled the worst three cards? A golden casket, with a statue of the man inside inlaid above it with his hands clasped in prayer. One sword is buried with him. Three more are levitating above, ready to drop onto his chest.

Rest before you take on your next challenge. You've reached an important first milestone and must recharge your energy before the next phase begins so you are refreshed and ready to go. Even if you are highly productive and driven, restore your energy, heal your body and mind. Constant stress and tension will break even the hardest and most resilient of people unless they heed this. Take a day off work. Travel to a new destination. Clear your mind of stress and mental clutter to connect with your Higher Self. You need seclusion to navigate your situation. Solitude, although often difficult to bear, is necessary. This is an excellent time to reassess your priorities for success in the future.

I settle into my rearranged bed. Since the breakup, I've taken to sitting along the width of it, with my back against the wall and my duvet over my head. I want to alter every experience and build new neural pathways. Can't lie on my usual side of the bed because that's what I did when I was with Grey. It hurts to wake up in my same room, to brush my teeth in my same sink.

I switch my laptop on and the lights from *American Crime Story: The Assassination of Gianni Versace* turn my fort into a grotto. This show has become my staple lately, something I can look forward to in the daytime and lose myself in at night, once I've thumbed my cards dry. It hits the sweet spot, both comforting me and making me feel worse in equal measure. A brief period where the pain I'm in is almost exquisite, like the pain of easier breakups I've had, where you kind of want to bite down into it. And because I'm losing my mind, I'm able to draw parallels from the weakest of links. Like, when watching Penelope Cruz play Donatella Versace—defiantly defending her brother's empire after his death—I picture Grey decades from now. She's not Italian, nor blonde, nor does she have a brother. But their fiery nature, seductive European accents and mafia-like loyalty are similar. When she sits next to Gianni's private tomb and sobs over his gilded remains—like those of the man in the Four of Swords—I imagine Grey doing the same over my corpse, falling apart with regret. I can't even bear to watch that Dolmio advert with the stupid puppets, because the set has stucco buildings like those in her village back home.

'Take a day off work, travel to a new destination', the card had said. A thought races through my mind at lightning speed and just like that, my mind is made up. I'm dealing with extremes at the moment, so of course, instead of just taking a day off work, I realise I must quit my job. Move to Canada. (I repeat, I have become very sick). The only thing that's given my life joy in equal measure to Grey, is Red. Now is the time to grasp at the golden

thread she left me. Not even because I *want* to any more, but because I can feel my thoughts heading to dangerous places if I don't do something, and she is my only hope.

I've tried searching for crumbs of joy and found myself wanting. For the first time in my life, everything is redundant and means nothing, except the brief comfort of a hug from my family. I know for sure that I won't be able to pull myself out of this unless I swallow every gram of serotonin I can find, and from what I can remember in the deep recesses of my brain, Red gave me kilos. I can feel myself going crazy—am probably only weeks away from needing a lobotomy—so it's my last chance at salvaging happiness. Plus, moving to Canada for Red will piss Grey off, which is a bonus. The hit of dopamine this instant decision releases inside me is enough to relieve the pressure weighing down on my body for a moment, allowing me to carry on watching TV without spiralling. With this newfound lightness of being, I even find the strength to get a glass of water from the kitchen, give mum a kiss and shout, "I love you" to my sister in the other room. I wouldn't have been able to five minutes before, so I'm convinced that leaving my job and migrating continents is the salve and dramatic shift of attention I need. This is my exit strategy.

CHAPTER
36

I WAKE UP and my body tenses, pre-empting the pain I've grown accustomed to. Then I remember my plan to emigrate, and the pain doesn't come. Nothing matters now I'm leaving my job. At work, I can sit in front of a blank screen all day (poor Sara, who will have to start picking up my work soon) and come home to my vicarious Versace life on screen. I've done less than an hour's work all week and can't believe I've got away with it, but by a stroke of luck we are having a rare quiet period; the employee relations cases are low and Ula is spending a lot of time in external meetings. When she's back I'll have a lot to answer for. But honestly, I don't have it in me anymore. I've stopped caring.

Ula has emailed me a calendar invite for my annual appraisal the next day. I print the attached form that I'm supposed to fill out with all my successes and failures over the past year and an outline of plans for the next, knowing that instead, I'll use this meeting to hand in my resignation.

At the allotted time, I head up to the room we used to yell in. Ula is sitting at the end of a long table with her white blazer sleeves rolled up and her hands clasped expectantly, silver bracelets jangling on her tanned wrists. I place my blank booklet face down on the table before sitting down opposite her. I'm shaking. She isn't empathetic at the best of times, let alone when someone who hasn't completed any of their objectives dares to show emotion, which I surely will during this meeting. It crosses my mind that she hasn't asked me to send her a copy of my completed form, so that she can structure the meeting around my answers

the way she usually does. Neither does she look twice at my blank booklet. She leans forward in her chair, veins snaking up her forearms like blue vines. I'm worried these weeks of silence were a test, that she knows full well what's been happening behind my screen protector but has been seeing how long I can keep it up so that she has more evidence against me. But her face looks gentler than usual. Almost resigned. Almost, *concerned*.

"How are you?" She asks.

I shrug.

"I don't know, to be honest, I haven't filled ou—"

She cuts me off with her palm, lays it on my booklet and slides it away from us. I meet her eyes cautiously, to find they are wet. Her lips are pursed.

Are those *tears*?

"Fern, forget about the appraisal. You are not right. You're not in a fit state, there's no point. Talk to me as a friend. I'm worried about you. What's going on?"

This kind of sympathy is unexpected from the Queen of Darkness. It's too much to bear. My eyes reflect hers; I start to cry.

"I think I need to leave." I wince at her impending reaction, but she doesn't flinch.

"I can see that."

"Really?"

"Yes. I mean, come on Fern, you've barely done anything for a *mooonth*." She elongates the word, allowing her usual exasperated emphasis to seep through. "It can't go on! But don't worry about that now—do you have any idea what you want to do? Where will you go?"

"I want to train as a yoga teacher and move to Canada," I say, pulling the former part of this plan out of thin air, where it had been tucked away since its birth in my imagination a few years ago. I enjoy hot yoga so much that in recent years I've had a vague dream of being an instructor one day, with no finite plans to move towards it (kind of like how I imagined my marriage to Red would happen) and had been saving the money slowly with mum's

help. Well, we were saving either for that or for a new car—whatever I was most ready for by the time my target was hit. Who knew that the answer hinged on this moment. Hot yoga wins the toss-up.

I am ashamed to admit this to Ula. Not only is she risk-averse, process driven, and not inherently creative, but appraisals condition you to stick to your expected career trajectory. I've gone so off-kilter with my answer that I feel fraudulent to be in this job in the first place; forgetting, in my shame, that the role was handed over specifically to me, by these kind, caring women I'd manifested fortuitously when I was miserable in accounts. My time in this team has given me some of the greatest memories of my life so far. I was doing well in HR until recently, but have never had much drive to progress, always shuddering at the thought of doing my CIPD out of hours when I already worked overtime most days. Plus, they'd seen me publish two poetry collections and write a short dance film during my time here. I'm not fooling anyone that this is where I see myself long-term.

"Do you have enough money to support yourself through this?"

"I don't know," I lie. The answer is no. "I don't know what I'm doing."

I'm on the bottom rung of Maslow's Hierarchy of Needs. My focus is on survival only, and the only way I know I can do that is by lying in bed watching Ryan Murphy series' back-to-back while chain-smoking.

"Let me speak to Claire. We can't let you leave with nothing."

The milk of human kindness in these words, particularly from the mouth of the person I'd least expect them from, catches in my chest and almost makes me second guess my decision to leave. Why am I abandoning more of the people I love the most, when that's what's got me into this state in the first place? My doubt only lasts for a split second though, because I can't bear the thought of doubling back on decision when the relief it's brought with it is the only thing giving me the ability to put one foot

in front of the other. I must relinquish control and let myself be cared for. It's all I have energy for.

In the greatest act of generosity I've experienced since Josh sent me money to go to Paris, I'm allowed to leave the company with a bit of cash and to take my one month notice period as sick leave. My friends are aware I'm absent due to my mental health, but with the exception of Sara, no one knows I'll be leaving. It's sad that it has come to this, sliding out the back door. I've lost such a drastic amount of weight in a short time, rumours are spread by those I'm less close to that I've gone away because I've developed a drug problem. *If only that was the truth,* I think. Anything's better than this.

CHAPTER
37

I T'S ONLY WHEN my sick leave expires and I officially leave the company that the gravity of what I have done hits me. I've left behind my main channel of support aside from my family, and it is now that—left to my own devices while my parents are at work and my sister is at school—I fall into a full, deep depression. The grief stage. Of course I'm not going to bloody Canada.

For the next three months, I lie in as long as my body will allow me, and when I wake it is often to a text from Kim, willing me to remember who I am. She knows how low I am, and her commitment to being there for me is admirable. She is consistent as a pastor.

Tell me three positive things about today!

Every time you see yourself in the mirror I want you to say out loud, or to yourself "I'm a beautiful person inside and out. I love with my whole heart. I deserve to be loved and I love me."

Thinking of you! You're beautiful and strong and have the world ahead of you!

Saw this on someone's jumper [insert photo of a jumper with a slogan that reads: EVERYTHING IS GOING TO BE FINE.]

I leave my bed only to walk to my local Costa at midday in tracksuit bottoms and a jacket pulled over my pyjama top. Without fail, I buy a soy iced mocha and drink it in the outdoor seating area while staring into traffic. It's March, and the cold weather

is a refreshing reprieve from feeling nothing but anguish. If I'm up to it, I make the trip twice daily, sometimes stopping off at the McDonalds at the top of my road to buy a chicken BLC, which is the only thing I can stomach except a few mouthfuls of my mum's dinners in the evening. My self-esteem deems itself only worthy of McDonalds, Marlboro Lights, coffee and a variety of energy drinks.

I soon become so underweight—having lost three and a half stone, that I have to bunch the waistband of my tracksuit bottoms in my fists as I walk. Every step I take feels as if someone has sprinkled dirt into my blood. I fight to stay awake; it's so easy and tempting to succumb to knocking out filthily in public, head tilted back, throat locked, mouth open. I pass some of my old punters from the Irish pub who can't hide their shock at my weight loss when they stop to talk to me on the street—and not in a good way. It would seem that I illicit concern every time I look someone in the face. I want to be anyone but myself.

When you're depressed you're not in the world, you're sucked below it, and those who are going about their normal business and interacting with each other feel like simulations you've forgotten how to emulate. How can they be bothered to act as if any of this matters? There's no point of reference with depression—it's like amnesia—wiping away any memory of worth. And so these small journeys to Costa are the highlight of my day; nicotine and caffeine the only things able to hit my pleasure centres. I watch people on the tables next to me, listening for clues in their conversations, any nugget that might remind me how to live again, how to latch onto something worth caring about. Their son's grades. Their evening dinner plans. The new iPhone. I listen to their loose, throwaway sentences, read into their facial expressions to figure out how they are functioning, how they can walk through the world as if it isn't burning. I want to be any one of them. I would trade my life in a split second with any person in this tired branch of Costa in Colindale, just to be rid of the disgusting soreness permeating my core.

It's when I return to my bedroom with my little plastic cup in hand that things get even more bleak, the closer I get to the chocolate at the bottom. I usually take a nap and dream about Grey in vivid, horrific flashes, splayed over someone else's legs. Her lover changes each time, and sometimes it's a man. Her whole aura glints with seduction. She appears to me like a siren – silver, red, purple - and I have flashbacks of her in the French nightclub, convincing me I'm on my deathbed decades before my time. I wake up with the insane certainty only nightmares can provide - that she is pure evil. These images confuse, gut, and fillet me, almost turn me on. I writhe in my sheets, light candles that I brought from spiritual shops—pink for love, black for black magic, sketch symbols onto them. Google spells. *How to make someone fall back in love with you.* I buy a diary and write daily letters to our future child, detailing how this trying time only made their parents stronger and trying my hardest to believe it. I force myself to turn our story into something positive, to manifest any pathetic weed out of our tragic story. I masturbate furiously to fantasies of us on a balcony in Vienna, her in a sheer peach robe a with fur trim, proposing to me the way she wanted to.

I know I am sick. I know that all of these actions are of an unwell person, but I can't stop myself. I am willing to sell my soul to the devil to get her back. I am Christina Yang after the shooting in *Grey's Anatomy,* when she quits her job as a surgeon to work at Joe's Bar because the trauma of performing heart surgery on her best friend's boyfriend with a gun to her head is too much for her. Christina, usually self-restrained and prudent, dances like a Bacchic woman on the bar, willingly losing the plot. *And with me, it's all because of a breakup!*

I'm not proud of any of this. I know it is pathetic, but I don't self-flagellate because I have accepted this way of existence. I turn over in my head how she lied, repeatedly, in the days after I confronted her about sleeping with someone else. How that poor random girl had finally given in to my harassment and confessed to me. How because of the time difference, I couldn't work out if it

was the night we broke up, or the night before, and I never found out because I didn't want to pester her anymore. How I was so desperate for Grey's love that I took her back for a week and tried, failingly, to act as if it never happened. How, when she wouldn't admit it - even when I had proof – and told her I forgave her, that she didn't even have to own up or apologise - *we could just carry on as things were* - she still didn't own up. How I chipped away at my own self-respect until I was a husk. Then finally, how I blew up, changed my mind and stormed out of her kitchen for that final time—this time, her decision. Her final text to me "You need to stop messaging me now. I've met someone else."

These mortifying memories send me spiralling in my bed, sweat soaked through to the mattress. I'm constantly on high alert. Imagine seeing the name of someone you're suspicious of flash up on your partner's phone: the hot glob of blood that gushes from your heart mechanically, the slick of sweat between your shoulder blades, the sheer panic that washes over you. Imagine being suspended there every day.

I can't accept that I had her and lost her, this mythic creature—she was mine, her evil hidden yet bottomless, but her goodness given only to me until I crossed her. *Why did I have to cross her?* It isn't her actions that hurt the most, but the malignant energy I sense behind the intention, her cruelty in repeatedly denying it, as if her soul is made of soot. I begin hallucinating that I am in hell, ticketed at the gates, led down the infernal staircase. But then I speak to Black, who still lives in the real world, and says, "Stop imagining her as some sexy demon Fern. In reality, she's just a dick."

Sometimes I remember that she loved me, that she's not evil at all. It's like she is two different people—the human embodiment of Gemini—me meeting my shadow twin. I can't reconcile the conundrum of her two halves. Grey looked after me, was overprotective, showered me with affection, wanted me all to herself. I would cut a limb off to have that back now. I'd stay at hers every night! I miss the way she would shake her head and frown quizzi-

cally when she couldn't hear what I'd said. My heart and stomach still plummet when I think of those transparent smudges of cuteness framing her skull as if a devil and an angel had kissed her on each side at birth. If she slept with the girl the night we broke up, then her energy didn't turn until I ended it. It was my actions that caused the change in her behaviour. This is what tears my heart to shreds. Because most of the memories I have of her now are somehow good. I hurt her too.

I hurt her too.

CHAPTER
38

M Y FINGERS TREMBLE as I remove the first sheet from its box. I stare at the chalky bricks in their silver igloos, hesitant to crack one open because if I commit there's no 'undo' button: I will be someone who has taken antidepressants.

After walking to my local doctors' surgery three times in the past week and bottling it, I'd finally decided to go in and tell my GP about my depression. She'd prescribed me sertraline when I marked myself as 11/10 on a scale of emotional pain and assured her I was not exaggerating. But they've been sitting in my bag untouched for days, because I'd been hoping that simply telling someone about what I'm going through would be enough to cure me. It isn't. I finally decide to take them because I have no choice. My thoughts have been entirely taken over by my perceived loss of life, and I'm frightened I will solidify this belief with tragic action. My first night on the pills, I sweat through my sheets until it wakes me up, though I am not lucid—I am hallucinating: cinematic visions of hell and death and decay, neon Greys taunting me again. In order to find something tangible in the darkness that will orient me to reality, I reach for my phone to check the time. It's 5.45am. In an hour, mum and Pete will be up for work. If I'm quick, I can sneak out of the front door, walk the ten-minute journey to the tube station and climb onto the tracks without anyone noticing. If I do it right now before my brain has a chance to wake up, it will be easier for me to commit suicide as I won't have a chance to think about what I'm doing.

A distant voice inside me commands me to listen. *You don't want to die, for fucks sake. You've just forgotten how to live.*

But what can save me from this? I've had such a wonderful life, why can't I invoke a single happy memory? I can recount thousands of times I've felt true joy, but my amygdala has been hijacked and my hippocampus may as well have been cauterised, because I can't translate the knowledge of these times into any positive feeling the way I used to be able to.

Then the voice asks, *What about Red?*

Red is the strongest link to pure joy I've ever felt.

What is the happiest moment I have in relation to Red?

Listening to the drum solo on her song *Take Advantage* on the way to Paris for the first time.

If tapping into this memory doesn't summon some glimmer of happiness, doesn't assure me I'm still capable of generating positive emotion, then I will get out of bed and head to the train station. I'm damned if the greatest moment of my life can't wake up something inside of me.

My fingers are still sticky and trembling with sweat as I plug my earphones into my phone and play the song. With my head back on the pillow, I push the buds as far into my ears as I can and hold them there, so the sound can permeate me, drown out my suicidal thoughts. Music therapy, that I'm sure looks more like a self-induced version of the Ludovico Technique in *A Clockwork Orange*: my eyes wide and my skin dripping wet. I remain still in cold perspiration for the entire three minutes and when it stops, the iron gate starts coming down again, crushing my lungs. I press repeat. I say with no hint of histrionics: listening to this song is the only thing keeping me alive.

After half an hour of my *Take Advantage* sound bath, I do get out of bed. I walk to the front door, climb the stairs and enter my parents' bedroom, where I squeeze into bed between Pete and my mum. I cling onto her, clammy and cold. A blood and flesh reminder that will force me to remember there is still something to live for without my earphones in.

CHAPTER
39

I THOUGHT THE antidepressants would make me better. Instead, I am on The Samaritans high-risk list, and they are calling my mother every half an hour. She phoned them on my behalf when she woke to find me flatpacked and congealed beside her the next morning.

"It takes about three days for our bodies to metabolise SSRIs. Her symptoms will get worse before they get better but her mood should stabilise within three days."

"I have no room to get any worse," I mouth to my mum as I hear this over loudspeaker. "I'm already on the floor". I have been watching documentaries on catatonic psychosis all morning because I haven't moved, even to eat, for the past two days and I'm genuinely scared I might forget how to. The Samaritan tells my mum to monitor me on every trip out of the house in case I do something stupid. I don't resent this—I need it; I'm scared I will too. Unfortunately, this episode has come at a time when I've told my stepsister I will cat sit for her while she's on holiday, and my wider family aren't aware I am ill.

After three days, I come off the tablets abruptly. I have no choice—they are actively making me want to kill myself. They've also make me unable to come, my clitoris now cauterised as well as my hippocampus, when masturbation had been my only remaining access to some semblance of feeling. Now I am Sisyphus, eternally at the brink. The silver lining from all of this, is that where I had told my mum I couldn't get lower, the sertraline has showed me that in fact I can—there is always another rung to descend on

the ladder. This realisation is my light at the end of the tunnel. The situation I had been in before taking the tablets might have felt hopeless, but now I am even worse—showing me I'd been wrong—I hadn't been at rock bottom the way I thought. Getting back to the state of pre-sertraline depression now seems like something to aspire to, something I can live with. If I can even get back to that place, it will be a relief.

The day I resolve to come off the tablets, I have the energy to get out of bed. And just as well, because it's the day of my cousin Carly's wedding. I make myself as presentable as I can because family gatherings are a good way to evoke fond memories, which will be amplified if I'm proud of my appearance and can pretend to my distant relatives that I'm doing well for myself. I put on a grey wiggle dress to match my colourless skin, and even though I'd washed and blow dried my hair the night before, it lays lank and flat over my head, another side-effect of the antidepressants. I try not to let this bother me. It's a big day for another reason, too: my parents have bought a new house and we are driving to visit it on the way to the ceremony. I'm the only one in our household who hasn't seen it yet. I'd been spiralling backwards in my bedroom while mum, Taylor and Pete made plans to move onto better things. I'd assumed I'd be living with Grey by the time moving day came, but I'm no closer to renting my own place, particularly given my mental state. This will likely be my new home.

Once I've made the best of my meagre appearance, I head into the garden. It's a crisp spring day, the air smells sharp and the grass has frosted tips like a nineties heartthrob. I have a slight headache, something which could be helped with hydration, but having developed a recent aversion to water where so much as a sip makes me heave, I allow my tongue to lay curled and heavy inside my mouth like a fat slug. I need the cold air as a consolation, the sounds of birds chirping—a sound that, for some reason, always reminds me of waiting to be called in from the playground on primary school mornings—and the gentle peal of the wind-chime hanging off the bird feeder on our terrace. These noises

ground me to reality, a sensory preparation for a day outside of my four walls. Had I been able to think, I might have had the idea to meditate, because the ability with which I can empty my mind at the moment is unprecedented for me. There is only thick static between my ears, microbytes of thousands of thoughts that haven't yet materialised but still hold the weight of their final form.

I came out here to smoke, but I can't be bothered to pull the pack of cigarettes from my pocket. It's a sorry situation, when not even my greatest vice seems worth it. Mum comes outside to join me for one of her own and sits on the chair beside me. Understanding me without words—the way she has always been able to—she knows I don't want to talk. Instead, she looks at me for a moment while I stare unblinkingly ahead, squeezes my knee, then turns her head forward as she takes a drag. All the muscles on my face are slack, and that's when a singular thought finally comes—how ill I must look to my mother, like molten grey wax poured over a skull and left to dry.

As we sit there in silence, her hand on my knee, a lone sparrow lands on the grass in front of us. I turn my face to meet my mum's and squint my eyes to lift my cheekbones, an attempt at a small smile that she returns. Birds in our garden—albeit usually robins—have always signified to us the presence of family members who have passed. It seems fitting on a date where all living members will come together. As we acknowledge this silently, a sudden volley of squawks fills the air, accompanied by a whir of batting wings. Tens, and then hundreds of sparrows descend into our garden at once, until they've covering every inch of the icicled grass in an arrow formation. More crowd onto the birdfeeder and the roof of our garden shed. I have never seen so many birds in my life, nor do I know the reason they've chosen to alight here. We have no food in the feeder, but there must be at least three hundred of them. It takes my breath away, but I can't do anything except raise my eyebrows. Mum's mouth hangs open. A tear rolls down my cheek. I don't know what it means but if it's a sign, I'm

taking it. Mum squeezes my knee again and her face is red, eyes squinting back tears. She is superstitious and spiritual; I think she needed a message from her parents that her daughter would be okay. We head inside.

To say our new house is impressive is an understatement. I'm proud of how far mum and Pete have come; the size of it could rival a property in Wisconsin. It's the first house on a cul de sac in Hertfordshire, set back on a huge, hilled driveway. Inside is a run-down labyrinth, twists and turns and random staircases leading to nowhere in places that don't make sense. There are dead ends, secret rooms that connect to each other, and I'm not sure how many floors there are, because in this building it's not clear how many stairs constitute a flight. There are staircases of ten steps, five steps, two steps. The interior looks like one of those computer-generated images designed to confuse you because each object looks like something familiar, but when you step back you realise the bigger picture makes no sense. I love it.

As we walk through the bare rooms with their naked windows letting in huge blocks of buttercup light, I can imagine my kids visiting in the future. Even the thought of having kids doesn't sting in this house. It seems possible, as if I'll love again. As if Dante has given me a reprieve from hell for a while, for a tour of the better living conditions I could have, should I be granted parole. I separate from my family in order to harvest this long-lost feeing, and as I peek into the upstairs bathroom, one of the gleaming shafts of sunlight welcomes me. I step into it and something remarkable happens: the depression physically lifts. For the first time in months, I feel only the burden of being human. I remember happiness. It's so sudden I am shocked, as if I've been carrying this around with me for so long that I have nothing to compare its absence to anymore. I step out of the shaft of light—scared—braced for it to come back. But it doesn't. I walk silently, almost on tiptoe so it doesn't find me again, into the liv-

ing room where my mum and stepdad are admiring the garden through the sliding doors. I grasp my mum's hand.

"It's lifted, mum," I whisper, so as not to wake it.

She doesn't have to ask what I'm talking about.

"Good," she replies discreetly, stroking my back without looking at me, focusing on what Pete is telling her about knocking down the alcove separating the living and dining rooms.

It's about forty seconds before Dante handcuffs me again, my day release up. I'm back in that dark place by the time we stop for tea and cake in a farm shop en route to the wedding venue. But this is a huge breakthrough. A reminder that I am not forever changed. I will feel like myself again, one day, maybe even someday soon. It'll be like riding a bike.

CHAPTER
40

THE WEDDING IS a struggle for me. I hold back tears as my cousin walks down the aisle to meet her husband-to-be and try hard to forget myself, to fully immerse myself in their union and soak up some of their love through observation. She looks so pretty, so in love, and I'm overcome with affection. Unfortunately, my aforementioned empty mind—primed for meditation - decides to regress at the worst moment, and I fight not to run out of the church and vomit all over the pebble dash. This is not how today was supposed to go. I am meant to be enjoying my cousin's special day. A few months ago, I had everything. I should be standing in the pews with Grey right now, both of us appreciating the wonderful couple - double the love to pour upon them. "You look well!" My distant family would maybe even say. "How are you doing? Where are you working now?" I'd be able to answer these questions positively. Instead, I am single, unemployed and only recently released from suicide watch. I can't help but feel selfish at the thought that I'll never have my own wedding. In fact, I know for sure that I won't, because I won't ever love anyone the way I've loved Grey. I reproach myself for allowing my thoughts to drift from my lovely cousin.

At the reception, I stand alone on the hotel veranda, overlooking its boundless green grounds with their *Sound of Music* hills. The pastoral surroundings are once again a farce, reminding me only of how unworthy I am of them. I repeat a very specific phrase to myself as I smoke—one I wholly believe to be true: *You've relinquished your last chance at love.* I wish I could say I was repeating

it in my head, but instead I whisper it aloud to myself. It's pretentious language, navel–gazey and a little insane. When I'm down to the butt, I fix a smile on my face and, knowing these gatherings don't come around often, head back to my extended family. I dread the questions they'll ask me because I'm not sure how I can stick a bow on the fact I've backpedalled in life. But still, I grab a feather boa and a giant pair of sunglasses from the rented fancy dress box and take some photographs with my aunt Denise. My auntie Val – the bride's mother - looks on and smiles at me from her wheelchair in the corner of the dancefloor, where she is hooked up to an oxygen tank. I'm aware that logically, my problems are inconsequential compared to hers, yet still she is smiling. *Why am I such a selfish prick? I am surrounded by love and only know how to sabotage it.* To counteract my indulgent behaviour, I run over to her, and the smile I've plastered on my face turns from fake to genuine. I pray to God she doesn't ever feel half as bad as I do, in her heart, no matter how much her body lets her down. "I love you!" I yell to her over the music with prosecco on my breath, leaning my hands on each arm of her wheelchair and planting a kiss on both her cheeks, lined like a beautiful wisdom tree.

Over her shoulder, I spot my stepdad in the foyer of the venue. He has removed his suit jacket and is standing in his shirt and bow-tie behind the receptionist's desk, frowning with concentration at the computer screen whilst holding the hotel's phone receiver upside down. The effort to do whatever he's trying to do is visible in his expression and he is clearly inebriated, trying to book a hotel room for us so that he doesn't have to drive home. The front of house staff have disappeared. My mum and sister are sitting on the sofas chatting with my uncle. "There aren't any available, dad!" Taylor says, nudging us to convince him of the same, because we have nothing with us and don't fancy sleeping in our wedding outfits with our makeup on.

"Ahhhthasssalrigh. I'll drive home!" he slurs, beaming his staple cheeky grin at us.

"Don't be STUPID Pete," my mum spits through a grimace

that she's hoping looks like a polite smile. She doesn't want to draw attention to him.

"What! It'll be fine honey, I'm fine," he laughs, putting his arms around her waist and attempting a very poor waltz.

"Dad WHAT are you on about?" Taylor says. "We're getting a cab. There's no way you can drive home like that."

"You're drunk, Pete!" I interject, laughing. "I'm not letting you drive yourself and everyone home like that."

Then I have a brainwave. If he doesn't let up, I have a solution that will be win-win for everyone.

Pete releases my mum and goes back behind the reception desk. In his three-piece suit, he looks like he works there. I pull mum to the side. "Mum, I'll drive the car home. I'm sober. You lot get a cab. He'll feel bad in the morning and pay you back for it."

I have my licence, but I haven't driven in ten years. I know I'll never be able to commit suicide, but I am tired of the pain of living. By offering to drive the car home, I can leave it up to fate. If I crash, I might die without actively trying to. I can serve a purpose here—ensure my family get home safe and if the car doesn't make it, then I won't mind being the casualty. It makes sense to me. My mum stares at me like I've just told her I want to marry a family member.

"PLEASE let me drive the car home." I beg all the way to the vehicle, desperate for euthanasia.

The novelty of driving us home wears off for my stepdad on the walk to the car, when the fresh air hits his face and he realises how drunk he is. Plus, three women nagging him is enough to sober any man up. He calls a cab. We get in with him. Pick the car up the next day.

CHAPTER
41

I SEE VANGELIS' six foot shadow skulking up the drive before I hear the doorbell. When I let him in, he sing-songs his usual "HI-iii" and walks right past me into the hallway, not batting an eyelid that I'm still undressed and in my robe despite the fact it's 12pm. It's a Thursday, but I'm still jobless and Vangelis is a backing singer for Culture Club after making it through to the semi-finals of *The Voice* in 2016 under the tutelage of Boy George, so he doesn't work normal hours. "Good one" he simply says, taking in my attire once he's finally kicked off his shoes. "Shall we go get some Sniceters?"

"Sniceters" is a compound word for "snacks" and "nice things"—a term coined by his mother to mean treats from the off-licence. As usual, Vangelis takes everything about me on the chin, so my depression to him is as unalarming as mild tummyache. I do not mean that he is unsympathetic, on the contrary, he always listens and gives advice when I need it. It's just that when I'm in his company I'm allowed to forget I have it. I throw on a tracksuit without doing my makeup and we head out to the new Asian food hall round the corner from my house, as it's meant to be the largest in Europe and has great reviews. The sertraline is out of my system now, so I can belly laugh with him as we eat purple ube cake with sprinkles and custard, in a way I haven't been able to in months. I realise I'd needed him earlier. If I'd not been so insular and agreed to meet him all the times he'd asked over the past three months, then I wouldn't have fallen so far within myself. The simplicity of Vangelis' company is what makes me love him most of

all. He takes me as I am and never judges me. He is a natural radiator, obliterating everything else with his warmth, only interested in talking about singing and showing me back-to-back vocal videos - the good (Celine Dion, of course) and the bad (Girls' Aloud's bum notes). I haven't lost everything. I still have him.

I have dinner scheduled with my old work lot in the evening, and Vangelis is the perfect pre-game. He leaves me warm and quietly buzzed, happy to stay out of my feral pit a while longer. I'm meeting my friends in King's Cross, a short walk from my old office, so I get off the tube a stop early and walk the remainder of my old commute for nostalgia. Now I can feel beyond my immediate pain once more, the sentimentality is dense as I walk, bruising my skin with every bounding pulse. The bathos is no longer for Grey, who I never want to see again. Now it's for the other things I've left behind. Euston Station holds the majority of my romantic and platonic memories, like a shrine to my personal history of love. It's not only where I rushed to and from work each day, where I grabbed lunch, but where I met and kissed and dreamt about many of my past lovers. The memories arrive sharp as I walk, and I'm suddenly awash with grief for all the shorter romances I hadn't properly processed in the wake of Grey. I realise it's not just the station, but the surrounding areas that evoke tenderness in me. This is unsurprising considering I started work here at the age of sixteen, then again for much of my early twenties, when all that teenage longing came to fruition. Golden hour in the city always transports me back to those crazy, tired, beautiful days where I felt I had everything to live for. I turn right on Eversholt Street and head towards King's Cross. It's the same here as when I'm in Bank, or Liverpool Street, or any area in the city where a gang of suits are drinking pints outside the pub and clouding the air with their cologne and cigarette smoke. The sight of them always zaps me with energy and ambition—not just for a career, but for romance—the exciting prospect of flirtation with office eye candy, getting drunk together in a safe space. *Why did I leave my job?* They say you don't know what you have until it's

gone, and I know for sure that working there was the best time of my life. No matter how many jobs I will go on to have or how many companies employ me, everything will always feel like a consolation to that place. I joined long before my frontal lobe finished forming, when the opportunities of my life were still an endless cluster of ivy sprawling up a castle wall, leading anywhere I wanted. Even if my dream to be a full-time writer is fulfilled, I don't ever expect to be as wholesomely, naively happy as I was there. And that's okay. Sometimes, what was meant to be a transient phase ends up being the crutch of your life. The sixteen-year-old Fern who had just finished h er A L evels a n d w as frustrated with her mum for cutting her Summer short by making her work, is now eternally grateful.

I pass a spot outside the British Library—suspended in resin—where a girl named Amber and I had first kissed. I look into a window of a bar I'd drank in with a taken woman called Green, remembering her cat-like grin, her stupid cheeky face with its upturned nose and lips. That n i g h t, I' d s at in s i l e n c e a s we drank, and fiddled w i t h t h e l e o pard p r i nt c u ff on on e of her leather gloves as it dawned on me that I was falling for her. The kiss we'd had outside was, she'd told me "the best of her life". My cheeks colour at the memory. Right next to it is the hotel she'd stayed in on another trip to the office. I'd snuck in later that night. "Do I smell of smoke?" I'd asked when I entered. "No, you did when you walked in but not now", she'd answered, before asking me to join her under the covers. Amongst the drama of these affairs, it's odd how the most trivial memories have stuck, washing the broader experience away. All these moments of romance mingled with pain and sadness, I realise, gave me adrenaline and purpose, and I miss them now they are gone. I was with many women I shouldn't have been, and I thrived off i t. I u sed t o l ove how every few years my life burned down. And yet I understand that although these experiences are still in my immediate past, they feel decades old. I am no longer that person. All of that finished with Grey. I don't want a life of spite anymore, waiting to be cho-

sen, often at the expense of another. Most of all, I know for sure that I truly no longer want to be with anyone who doesn't want me fully. Being single with intention will mean I'll have to face myself and all of my mistakes. It's scary, but freeing, and something I know I must do. It takes a lot of energy to upend a life. I say that both to myself – who has hurt men she's never met - and to the women that shouldn't have been with me either, injuring my young heart and my ego in the process. As much as it was fun, I know that to continue would no longer be worth it.

A month before I met Grey, Alicia was visiting from France, where she now lives with her boyfriend on a plot of land, running herbalism workshops. We'd caught up over kir royales and steak frites at one of my company's restaurants. I'd told her about Green, the taken woman I'd just stopped seeing, fleshing out details like we were back at school. Alicia had smiled, her eyes wild to reflect my crazy back at me as she plucked an escargot from its shell.

"Fern," she says with an almost deranged smile. "You're setting yourself up for a world of pain."

"What do you mean?

"You keep trying to steal your mum back from your stepdad, over and over again?"

I swallow a mouthful of Chambord and look at her. It sounds so clear, but I've never thought about it that way before. "Oh my God." My glass pauses on its way back to the table as I try to process what she's just told me. "You're right."

"Have you NEVER realised that!? I've thought it all this time! I just always thought you knew! It's so obvious!"

Within a month I was with the available and lesbian Grey, so I'd considered that lesson learned. But now that's over, I can fully digest the truth of what she'd told me. I don't think it had been palatable the FIrst time. Alison Light says in her memoir, *A Radical Romance*, "Freud thought that children cope with love being taken away by re-enacting its absence compulsively on their own terms", and I'd heard from Dolly Alderton that the

coping mechanisms you use to recover from your first trauma are
the ones you continue with your whole life, unless you commit
to growth and healing. We're all compelled to reenact our first
injury so that we can exert control over the healing process.
Infatuation always felt bigger than me. I'd followed my
appetite to its limit each and every time. But going with the
whims of the universe is still a choice. The younger we are,
the wider we generally believe our breadth of possibilities to
be, therefore the lower our resistance to opportunity and the
less we care about the consequences of our selfishness. It's been
no more than six months since that conversation with Alicia,
but I feel old now. Grey has robbed me of my childish
mindset. We were so passionate, both so sure we were meant
for each other that we neglected the toxic behaviours we had yet
to release. If you believe in karmic soulmates, you will have
heard they are given to you for emotional growth—yet the
strength of the initial union can disillusion you into thinking
there is no more growing to be done. That was our failure.
And now everything holding me together externally has been
stripped from me, I am forced to analyse the glistening meat of
myself, the substance of the bones. I realise what I have taken for
granted and the people who have helped me through my
depression, who I'm still blessed to have in my life. At a time
when I'm wobbling on my legs, I've lost all trust and interest in
meeting someone new. My perspective has gone through a
dramatic shift on these Bloomsbury streets. If I am to be
intimate with anyone, I care only for it to be someone who
already knows me and whom I am comfortable fully being
myself around without threat. I want security only, the intimacy
of comfort. I want to be with a friend.

My walk ends in Granary Square, with the unpredictable neon
sprays from its public water fountain. I see the familiar group of
people I have grown to love so much, standing together and
waving at me on the other side of the water, looking as
welcoming as they always have. Being with them is the only
time my cares can completely melt away, admittedly even more
so than when I'm with Vangelis. Conor (the stag) is there too -

he left the company sixth months earlier – and as he tells an anecdote over our meal, he says "Ah, but that was the me that worked with you guys! The best, most fun version", as a way to excuse his mischievous behaviour. So, it isn't just me who feels this way. There was a concentrated magic in those years we worked together, something that went accidentally right - like God had launched a holy missile of angels in the wrong direction, aiming for a wedding ceremony, or a church, or a school, and instead had hit us by mistake. The love we all felt was some seismic event, like that science experiment asking everyone to jump at the same time to see if the earth moves. We all jumped, and it did.

We play charades after dessert. It's Duncan's turn to make us guess a TV show. He gestures frantically at our group, repeatedly. Looking around at each other, we shout "FAMILY!" in unison. He shakes his head, frustrated, and Megan signals that the time is up. We've got it wrong. The answer is *Friends*. "AWWW!" is our collective response. How much we mean to each other is evident in our error.

A few of the group hand me belated leaving presents before we pay the bill. I open Ula's, and a ceramic star falls out of her gift bag and onto the tiled floor, smashing in two. She picks up one half and hands me the other. "Keep this part, and one day we might come back together again." I can't see myself ever going back to work for Ula, to be completely honest, but it's the second nicest thing she's ever said to me.

I'm still very much a part of them all.
In Bluets, Maggie Nelson shares something her therapist told her. "If he hadn't lied to you, he would be a different person than he is."[9] There is no alternate reality where Grey wouldn't have spoken to me the way she did, where she wouldn't have slept with someone else the night we broke up. No parallel life where we would have grown old together in marriage with

9. Bluets, page 44.

kids. Where I wouldn't leave her. Where she wouldn't sleep with someone the night we ended, when she knew my ex had done the same. Because I did leave her. And she did jump right into bed with a stranger. If we could have made it, we simply would have.

I am done with what ifs.

It was hitting rock bottom that made me stop playing the game altogether.

But at least I stopped. That's what counts.

CHAPTER
42

I PROPEL MYSELF by the steel bannister, climbing the stairs two at a time. When I open the double doors to the building, I'm hit with the smell of first aid kit, lemon cake, and sweat. I've taken countless Bikram classes here over the past decade but have only just learnt from the introductory teacher training pamphlet that this was the first hot yoga studio to open in Europe, back in the nineties. I will be learning directly from the founder, one of Bikram's students and the woman who created the sequence we'll be studying. I breathe a sigh of relief that this morning has finally come, instinct telling me that the next month is what will save me.

I kick my shoes off at the entrance, dump my bag in the locker room and enter the main studio for registration. Cross-legged at the front of the room, their backs to the mirrored wall like a panel of yogic X Factor judges, sit three beautiful middle-aged women with tanned, glowing skin and calm, stable energies. They appear like Aphrodite, Hera, and Athena at the Judgement of Paris, waiting to find out whom we'll crown the Fairest; to which of them we'll grant the gift of the golden apple. The gleam from their uber white teeth is so strong it's difficult to look at them. It will be hard to judge.

My energy is drawn to the one on the left, wearing blue linen overalls with long honey hair dripping down her back. She reminds me of a teenage art student in an older—albeit radiant—vessel. Her periwinkle eyes peer over a pair of round, tortoiseshell glasses which she intermittently pushes back up the bridge of her nose with all four fingers of one hand. Her name

is Emma. I know this because she signed my referral form, so I deem her personally responsible for my salvation. I'd taken her class only once before, so that she could judge my alignment, my ability to take instruction, and then hopefully give her approval for me to train as a teacher. Right before I asked for her signature, I almost bopped her on the head with my water bottle to say hello because I felt like I'd known her before. We had a brief conversation where we introduced ourselves; I told her I write poetry and she told me she does too. When I got home, I Googled her name to find out that she's also an actress. I watched every film of hers that I could find that weekend—my motivation always catalysed when focused on a woman—and now I have a soft spot.

I join the rest of the students and sit down in the broken circle they've made, ready for the universally dreaded but inevitable Creeping Jesus where we have to say our names, something about ourselves and the reason we want to be a hot yoga teacher.

"I'm taking this course because my husband divorced me."

"The endorphins I get from the hot room help me with the self-esteem issues I've had since my abusive father died when I was a child."

"Yoga cured my depression and I want to help others."

I'm surprised by how many of us are here due to some sort of breakdown. As my peers take turns, I start to feel settled. The confessional biographies may be vague and sweeping, but I can tell there are layers of trauma underneath by the way they are shrugged off conversationally by the speaker. I too discuss my most painful memories nonchalantly, or with removed and self-deprecating dramatics. The nonplussed reaction my peers and the judging panel give each story is its own personal nod of acceptance, so I feel safe enough to tell my own in a way I haven't yet felt able to, with even my closest friends. My situation is entirely applicable yet irrelevant here.

The founder, her posture straight as an anatomical skeleton, thanks us all for sharing and begins an introduction to her personal yoga system. I let my eyes slip around the room. Between one wide-eyed lady scribbling furiously on a notebook and a cute, strawberry of a girl giving her undivided attention to our leader, I spot a set of silver curls, below which is a face I recognise. It's Caroline, my art teacher from secondary school who gave me a lift to the crematorium after Nadine's funeral. I lean to the right so that my movement can catch her eye, and when she looks at me I drop my jaw to convey my surprise at this coincidence. She does the same. It's surreal to me that this woman who put me in detention umpteen times will now be studying opposite me as my equal. Her presence here feels like a sign from Nadine, letting me know I'm in the right place.

We're a small group: twelve girls and one boy whom we affectionately nickname 'Number 13'. The panel brief us with an overview of our schedule for the next four weeks:

- Two hot yoga classes per day (minimum three hours total)
- Posture Clinic, where each asana is broken down and demonstrated for us in a hands-on seminar
- Anatomy
- Philosophy
- Sanskrit
- Camera classes, where watching ourselves back will help to build confidence and identify our subconscious public speaking ticks
- Voice coaching

I dive straight in with enthusiasm.

Classes begin at 7am, which means I wake at dawn, full of excitement. By the end of that first week, I've done more exercise than in the rest of my life put together. I complete so many wash cycles that I run out of yoga gear by the third day, sports bras and cycling shorts threadbare from profuse sweating. I must resort to

wearing a dusty pair of men's shorts from lost property when I start my period unexpectedly during class. They have an obvious space for my non-existent balls, much to the amusement of my new friends.

To get a feel of what the physical element of teacher training entails, it's important to state what first attracted me to hot yoga. I'm an all or nothing kind of person; swinging more towards the 'nothing' when it comes to exercise - unless it's an activity I enjoy, where my focus is wholly on the experience and the results are secondary. Dance, of course, is an example of this. With running, the gym, or anything else which is a means to an end, my mind is allowed to wander and after a minute, screams, "I'M BORED! I WANT THIS STOP!" (particularly if there are no immediate signs of abs or a peachier bum). When I first watched an introductory video to hot yoga on the company website, I was drawn in by the sheer amount of sweat on bodies that seemed to be doing... well, not much. At least not when you compare it to CrossFit or interval training. I (correctly) believed that if I was immersed in an environment conducive to a sauna (hot rooms are 42 degrees), I would be so removed from the outside world that I might forget it exists for the duration of the workout, and therefore be much less likely to lose focus and float back into the real world. On top of that, I (correctly) believed the heat would trick my brain into (correctly) believing the exercise was working, because I'd be sweating from the get-go. Instant results, or at least the illusion of instant results, cement my commitment.

In my first ever hot class, back when I was twenty and trying to unburden myself of my post-grief weight-gain, I was enamoured by the studio's blonde-wood floors, floor to ceiling mirrors and diamond chandeliers hanging from the ceiling, as well as how the humid air engulfed me the moment I walked in. Whilst I was holding positions that I'd assumed were easy, such as half-moon—where you clasp your hands above your head with locked arms and lean over to the side—I soon realised they weren't, not when you have to remain in them for thirty seconds with correct

alignment: chin up, length in the waist, right lung forward, breathing through the nose. Breathing through the nose is compulsory in Bikram—which is the hot yoga I was doing back then—both for inhales and exhales. Forget to do this, and you are in danger of passing out, particularly if you're not used to the heat. If you do feel faint, staying in the room is integral because it's dangerous to move rapidly from one temperature to another. In my second class, I fell asleep during savasana because I'd pulled an all-nighter and stupidly assumed I'd be fine. In my third class, a student passed out from the heat and started seizing. I was alarmed to see the instructor pick her up and continue to instruct us while holding her until she came round, not wanting to remove her from the room. Fear of fainting notwithstanding, I enjoyed seeing my muscles flex underneath my skin with my mind completely still, for it had no time to shout, "I'M BORED", when every fibre of my concentration was taken up by trying to stay conscious. Practising hot yoga has always made me feel like a knife through butter—not a room temperature block that succumbs like a willing lover, but a new pack fresh from the fridge. I don't simply glide through the asanas with ease, but there is a satisfying resistance which pushes back against me yet slowly gives away as the knife—my body—generates its own heat from the exertion. By the end of the hour and a half class, I look like I've been swimming. I have the head of a fluffy newborn chick as opposed to the sleek bun I started with, my face is red and blotchy, I have been wrung out like a flannel.[10]

By the end of the first week, I'm addicted to the heat and have bagsied the mat directly next to the radiator. I look imploringly at the founder when she asks how we're coping with the temperature during water breaks, hoping she'll turn it up (students are not to speak during class, it interrupts the peace).

10. A Bikram metaphor.

"No, Bambi! If you're not hot enough, you're not working hard enough!" she scolds affectionately.

The founder calls me Bambi because she says I have a clumsy grace, and I surprise her with how my body can do certain things so well, whereas others not at all, when the former should predict the latter. I have loose hips but a 'man back', meaning I find it difficult to sit forward of my hip bones, and so I cannot easily lock my legs in a seated position without rounding backwards.

Traditional hot yoga sequences are the only form of exercise which allow our bodies to experience their full range of motion in a single class. The diagonal muscles across our backs are stretched. The toes are stretched. The space between our eyebrows is stretched. The only thing that isn't stretched are the ears, which is why I like to give them a hard squish in the final savasana for good measure. Fresh, oxygenated blood is flushed to every part of our body, including those long forgotten in our daily movements, meaning in time our chakras are unblocked and our channels are cleared for energy to flow freely through the body so that emotional baggage can escape. It's remarkable the number of things this can heal. Hot yoga can improve mood, overall health, sleeping patterns, appetite, libido, the ways in which we communicate. It's quite literally the resetting of the body which can ease the symptoms of depression. Couple this with the extreme focus on one task and presence of mind, and I soon realise I have not thought about anything else other than my breathing for the class. The thoughts I receive are now real thoughts, guidance from within, not premeditated, fearful thoughts, sought out by anxiety.

No matter how many months, years, or decades they have been practising, some peoples' full expression of a posture may not reach the 'ideal' maximum, seen on glossy posters. Newbies with natural flexibility may have not exercised a day in their life but are able to lift their leg as high as a ballerina, yet have poor core strength which can cause hyperextension and injury. Not everyone can squat with their feet no wider than hip width apart and their heels fully on the floor, due to the placement of their ankle

bones. Similarly, I have yet to master the splits but can do arm balances all day long. Learning this is humbling and freeing for me, as I realise no one should ever be ashamed to come to class. No one can tell how 'well' you are practising through appearance alone, except your teacher, and even then, only if they have been witnessing your practice consistently.

This extends to life. No one knows where anyone is at internally, so shouldn't judge. I find this a lovely metaphor for my current state, and my embarrassment over my backwards sliding career, love life, and emotional wellbeing. My strength is quite literally my strength. I am not so flexible. I consider the humour in this, that my lack of flexibility means I did not cope too well when my life changed, but my core strength is getting me through it. You do not need to have your life figured out to get on the mat. The mat is where it all happens.

My love of Classics and History means I'm most intrigued by our Philosophy classes. One of our key textbooks is *The Upanishads*, the late vedic Sanskrit texts of religious teachings still revered in Hinduism. In our first lesson, I sit in lotus with my coursemates as we chant one of the Sanskrit mantras aloud to start our morning off right, when my eyes jump ahead and scan a passage that makes me double take. *"Often it is the anguish of parting—the death of a loved one, the breaking apart of a relationship, even the growing up of our children—that propels us into the search for a reality that will never let us down."* And then, *"[it is] the state of seriousness, of being shocked into alertness, that makes one ready to absorb spiritual insight."*

That makes sense, I think. In the turmoil of my relationship breakdown, I made shocking, unpredictable choices. If I hadn't hit rock bottom, who knows for how long I would have stayed where I was. I certainly wouldn't be sitting in this room, making reality out of a vague dream about becoming a yoga teacher which I'd previously only taken out of my pocket on rainy days. Perhaps I would have stayed comfortable in my admin job and my toxic relationship forever. The breaking apart of this relationship,

which certainly felt like the death of a loved one, is why I've been searching for a higher meaning in the first place. And the reason we are all in *this* room at *this* time, is because we are meant to be here. Had it been any other term, I wouldn't be studying with Caroline.

Similarly, interrogating my inner being throughout this course wouldn't have been as poignant for me a few years ago, but now everything our tutors tell me, everything I'm reading in these ancient, historical texts, rings clear as a bell because I need it. It's clear from the testimonies of my coursemates during the Creeping Jesus that I'm not alone in feeling something different when practising hot yoga. Something not gained from running, boxing, or even dancing. It's the silencing of the mind while simultaneously working the body, in conditions of heat that allow you to sink deeper into yourself with minimum movement and to sweat out all that is unnecessary, that helps you to come into deeper communion with yourself. This is what makes it so powerful. This is why it's working.

I look around at my new friends, sipping their coffees, smiling contentedly, some unable to resist the immature urge to giggle at the ruder sounding Sanskrit words. A wave of appreciation for them washes over me, and I cling to it. There is a reason I'd 'ruined' my life. It was to make it ten times better, which is what I am going to do—am already doing right now. Next to me, my friend Nicole (the strawberry girl) squeezes my knee and silently offers me a cashew from her packet.

Whereas on the first day we are shy—facing the wall while washing to hide our modesty— we have now grown very close, having been thrust into this transformative experience together. We are openly naked together in the changing rooms, feeding each other dehydrated apricots in the communal showers. We laugh at each other's poor teaching sans offence, get Thai food and iced coffee together at breaks, cry with each other before exams. Inhibitions fall away because what we need to get us through this is pure connection. Teaching is not a solitary act; the teacher

needs their student and vice versa, so we take it in turns to be the 'body'—a student symbol, so our friends won't feel like they're shouting into a void when it's their turn to practice teaching. A few times I'm paired with Caroline, and we share memories of Nadine in between postures. It's a full circle moment, aiding her in her learning, triggering my psyche to recognise I am now an adult, giving me closure from my teenage years.

I get home at midnight most nights, by which point, I'm famished. Before dropping my things off, I run straight to Sara's room for a debrief of our days at 100mph before throwing something quick together for dinner. We live together now, and her constant company is my safety and makes me feel like I've not left my job at all. I then start on the evening's homework while supine, falling asleep with my textbook on my chest only to wake again at a new dawn, the September sun a ball of persimmon spilling onto my bedsheets. I've no time to think of anything except the yoga I'm immersed in, which for me is key. I had worn myself into an amoebic nub from overthinking after the breakup, but the manual exertion and pure focus this course requires is a meditative antidote to that, not to mention the actual meditation in class. Any spare time is spent nose deep in my teaching manual, or a Tupperware lunchbox, or the washing machine. I have no idea how my coursemates with kids or even partners are managing this when it's a twenty-four-hour commitment, six days per week for a month (I'm dividing my month over two terms, as I cannot take more than a fortnight off my current part-time job as a waitress).

I am spending most of my mental energy on myself, but of course I wouldn't be me without the idolatry of a woman to motivate me. Emma has a warmth to her that is lapped up by all of us, and subtly different to the other two who bear assigned distance. We flock to her like she's our personal guru, and I'm always at the front, shepherding the flock. She reminds me of Nadine in both size and nature, the juxtaposition of distracted busyness and warmth—although she is a lot more whimsical and eccentric than Nadine, who was direct and matter of fact. We bond about writ-

ing, and if we are in the mood to pick up an extra class, she gives Nicole and I last minute lifts to and from the various London studios, our dried sweat and wet hair encased in hoodies and tracksuit bottoms that dampen the seats of her car because there is no time for a shower beforehand.

On Sundays, our only days off, I binge more of Emma's films that she's sent to me via email. She is balm for my spirit. When she talks, she leaves her sentences open for interpretation. If she asks us a question in class it's usually open-ended, yet she still answers most of them herself with a "maybe... maybe not". She reminds me of a more lucid Emma Thomson playing Professor Trelawney in Harry Potter, mixed with the beauty of Kate Winslet. She has a mystic energy, as if she knows the secrets of the universe, turning her aura into a sort of golden halo. But her mystery isn't superior enough that she is averse to a hug when she sees me, asking kindly, "Have you had a dodgy day?" predicting it correctly the way Nadine used to. She has an old-fashioned English rose quality about her and is utterly numinous. She is grandmother's cake, a good BBC drama after a bath. I hang onto her every word and feel such a strong connection to her that sometimes when it's cold in our evening church hall classes, I have to stop myself reaching for the crumpled hoodie that lies discarded by her knees, as if it were natural that I should borrow her warmth.

By the end of the course, we are as close as Nadine and I were, and she allows me to babysit her son despite insisting she doesn't let just anyone into her home. I imagine her house to be cosy and full of magic in unknown corners, with knitted shawls and homemade cakes, and I am not wrong.

Her classes are everyone's favourite, and there's no denying it. We whisper it amongst herself in the changing rooms, or if we don't, we've already silently made a pact about it through eye contact. Emma's acting background means she is gifted at learning scripts and after over two decades of teaching practice, she wears the words she is teaching rather than speaks them. They are part of her, and she needs only to open her mouth to let them out, easy

as water. It's the difference between the clothes wearing the model and the model wearing the clothes. She notices each individual's slightest move, how to tweak it gently in order to better it, sometimes with only the gentle nudge of two fingers, often just with her voice. Her body translates her knowledge into instant speech, like Abraham through Jerry & Esther Hicks. Her dulcet tones are nurturing and maternal - she summons and coaxes until our resistance is released. Emma prefers her night-time classes to be performed in darkness, setting tealights around the studio so the lights can guide us to her—a yogic Florence Nightingale—then back to ourselves. She shows me a new life I want to aim for. One with purpose. A life where I am filled to the top with her wisdom and blessed to pass it onto others.

I struggle with pigeon pose, an intense hip opener. If I sit in it for longer than thirty seconds my breath turns shallow, my fingers grasp the floor, twitching with apprehension to get out of it. I feel my blood pressure rise as if something is waiting for me at the bottom, an emotion I am not ready to meet. It feels like stubbing your toe when you are falling asleep, and being told you have to breathe through it. *Through the nose!* "We hold our childhood emotions in our hips" Emma says, as she treads lightly between our bodies, "as they tense to protect our reproductive organs. And as we hold ourselves there, we are working into scar tissue". I breathe deeper, release a sigh. "Always be at the edge of your maximum, not quite there, let your body know there is space it can move into when it is ready, and not before. Find the space and breathe into it." I exhale a little more, extend my left leg farther backwards, drop my head. Even though I already know this, about the breathing, it is daunting and difficult to get to grips with during hip openers. It's natural to breathe heavily through our mouths during physical exertion because fight or flight mode has evolutionarily conditioned us to believe we need to take in as much air in as possible from our external environment to survive. "Breathing through the nose keeps the inside of your body calm and tricks it into thinking it's not under pressure, so that it

doesn't go into panic mode. Our inhales and exhales are meant to be for the same amount of time each to balance out our emotions, because the inhale is feminine (to receive) and the exhale is masculine (to give). This is why when we are upset we find it hard to breathe properly, taking deep breaths because we're looking to receive some consolation from the outside world, when really we have everything needed to regulate us, inside us already".

I already have everything I need. I do not need validation from Grey. She is fucking CO_2. I breathe out, sink deeper.

Emma's most special class, which she keeps a secret up until the day before—meaning we have no idea why we've been asked to bring in ten magazines each—is to make a Dream Box, which is essentially a 3D vision board. She scatters a few dozen cardboard boxes in front of us in different shapes: circles, stars, hearts, and asks us to pick one. We are asked to fill and cover our boxes in cuttings from the magazines that represent how we want our dream life to look. She puts on *Drinking in LA* by Van Bran 3000 and tells us not to talk to each other. "You'll be surprised how quick things manifest when you're focused on yourself. Imagine how you'd feel if you got what you wanted," she says. We set to work in silence, snipping bits of paper like toddlers at nursery, as she tells us a story about two trainees from the previous year who wanted marriage, one of them believing her box wasn't big enough to hold all her dreams. "Then get a bigger box!" Emma had said, with the perfect clarity of a child, and the girl rushed out to the stationary store across the road. The two students ended up marrying each other.

I put my list of everything I want in a woman in my box, plus pictures of books, publishing, and poetry.

"HAS ANYONE GOT A MILLION DOLLARS?" "HAS ANYONE GOT A MANSION?" my coursemates call out, and if we see something in our magazines that represents that, we cut it out and hand it over.

"I'm looking for Love," I say to no one in particular, rifling through some tossed articles at the front of the room. "I'll find

you your love," Emma says, and a few minutes later kneels beside me, placing love, in small pink italics, on top of my heart shaped box.

One week into the course, a friend from secondary school (number 5), who is also called Emma, texts me out of the blue. We'd lost touch since she left after GCSEs and I stayed on for sixth form, but we were so close in key stage 3, in a sisterly way that had such a lack of shame it was almost disgusting. So there is no room for pretence with each other and even after all these years, she doesn't mince her words, telling me she's getting in touch because she's been feeling depressed lately and wants to know how I keep my shit together, because apparently, that looks like what I'm doing (the power and delusion of social media knows no bounds). Little does she know she's come to the right person. Little Emma's mental health sounds dark, still in the suicidal stage, exactly like mine a few months ago, so I bring her along to some of our classes to see if she gets the same sense of healing and belonging from them that I do.

During a difficult patch in her late teens, Little Emma considered joining the military, so I know discipline and commitment may be what she needs to help her channel any dangerous thoughts. If anyone needs to drink the Kool Aid as much as me, it's her. She starts coming to our open classes in the evening and vicariously becomes a teacher training student herself, via the voice notes I send her after every lesson. She falls in love with the idea of Big Emma simply from what I've told her, and when they meet, she loves her with just as much gumption as me. Soon she joins me in voice-noting every detail about Emma's classes. Sometimes Little Emma's depression is so bad I have to guide her onto the train during a meltdown, or squeeze her foot tight during the

journey to ground her as she closes her eyes and clamps her jaw shut. But in the hot room, she is given a reprieve.

Before teacher training, I reaped the physical benefits of hot yoga and generally felt less anxious, with more endorphins and better sleep. But during teacher training I realise I am getting closer and closer to my inner self and towards the end I feel... happy. At first it is on a superficial level: I have abs, have grown an inch and a half taller from the improvement in my posture, and I have someone new to love in Big Emma. But this time I am grown enough to know she is a mirror, helping me to love myself. *When the student is ready, the teacher appears.* But there is a child-like miraculousness in the discovery that I can feel that again, for a more substantial and sustainable period of time than standing in a patch of light in my parent's new bathroom. It also helps that I am doing something brand new that has no ties to Grey and so allows me to build new brain maps.

At the end of the first week, I am buying an iced coffee from a local health shop near my house at 11.30pm before going home when it suddenly occurs to me that I am acting like myself. In fact, I'm not even acting. I am me before Grey. Vital, like I'm back in my carefree days at school, or at the job I loved so much, with everyone working towards a desired goal. I am exactly where I need to be, as Eckhart Tolle spent so long trying to convince me, and I am finally starting to see it. Hot yoga squeezes all the negative energy out of me through sweat, until I am reborn. Every day starts to feel like a fresh start and I remember how to get excited about small things, like what I'm going to wear on the weekend. A big part of this is sharing my pain with Little Emma and passing on my support to her so that she can heal with me.

So long as the drop remains separate from the ocean, it is small and weak; but when it is one with the ocean, then it has all the strength of the ocean. Similarly, so long as man believes himself to be separate from the Whole, he is helpless; but when he

identifies himself with It, then he transcends all weakness.
—The Upanishads

Little Emma knows me just as well as she always has. After the first class, during which she became hooked, and promptly signed herself up to the next wave of teacher trainees, she texts me a succinct and articulate hypothesis:

You love the feeling of belonging to a group of people that you decided (after careful observation and meticulous introspection) are difficult to get approval from and worth their every drop of hard-earned validation.

So yes, I use the love of another woman to drag me over the final hurdle. And this is why I know this affliction is a part of me I would never choose to be without it. Sometimes it ruins me. This time it saves me.

In everyone's life, at some time, our inner fire goes out. It is then burst into flame by an encounter with another human being. We should all be thankful for those people who rekindle the inner spirit.

—Albert Schweitzer

One day towards the end of the course, I am particularly in the zone. Maybe I am having my own breakthrough, or, as I laugh with my coursemates, *closer to reaching "Brahman"*—the state of pure enlightenment we seek and often only reach in death, but which we frequently joke as having found after something as trivial as a particularly good lunch. Either way, I feel myself go deeper in postures that day than any other, and by 7pm, I am caffeinated

and still wanting more. I jump in the car with Emma, dusting a smatter of leaves off her passenger seat. She is on her way to teach two public classes at the other end of London. The group cries, "Six hours of yoga in one day?!" and "You're crazy!" But I know it's rare for my body to be on form like this and I need to take advantage of it. There is something hidden in today's practice that I have to chase.

As usual, the class is packed. I descend into the crypt; our largest studio with a blue alpine horizon painted on the back wall, to help Emma weave fairy lights in front of the mirror and drop tealights between the mats.

The class is like nothing I've ever experienced. I'm already warm and supple from the full day of practice so I feel like I don't have any bones left. My mind is buzzing gently after four hours of movement meditation. My focus is highly acute. Sounds are more vivid and I feel powerful.

Emma says "I saw that!" over the mic when I beat my personal best in the super slow push up, my strongest posture. This time, I feel able enough to take in every single one of her instructions (a tough feat usually, you can't listen to everything) and for the first time ever, in paschi, my legs are straight and I'm grabbing on my big toes with my torso on my shins.

"Good, Fern, beautiful."

You rarely get a personal mention in class, let alone two. A spark of electricity zaps through my heart—pride. Something I haven't felt in a long time.

During the second class, my energy starts to dip. Feeling like Johnny Depp as Jack the Ripper in *In Hell* when he's in the opium den, I pour the remaining contents of my water bottle over my head during the first ten minutes to cool my rising body temperature, but it's indistinguishable from the sweat pouring from me, turning my mat into a paddling pool. For once, I'm careful to imagine how my practice looks in each asana, when usually we're told only to focus on how it feels. But Nicole and Little Emma are observing, and I know if there was ever a day I'll look impres-

sive or flexible, it'll be today. I imagine myself as an athlete, even though this second class feels like doing *Ghost Dance* with a faint, having to catch myself from passing out twice in standing bow. Even still, I keep thinking, *this feels amazing.*

During pigeon, I bend my knee at a right angle and gently lower my buttocks to the floor using my fingertips, remembering Big Emma's words. Breathing through my nose I tune into the tightness in my hips, but instead of wincing, I exhale slowly and lay down over my bent knee, extending my arms out into Sleeping Swan. I let my forehead rest on the floor and stay, breathing through all the pain of my past few years. My body starts to shake—huge guttural, heaving sobs, and that's the only way I can tell I'm crying, because my tears are lost in all the sweat. I'm grateful no one can see me in the darkness. Suddenly, Big Emma is over me, a medicinal palm on my back, stroking my hair. She sits with me as I let go of my past. "Sssh". She whispers gently, in between continued instructions to the class. "Sssh. It's okay honey."

The dam bursts. I sob for Grey. I sob because of my depression. I know I wouldn't have recovered from Grey had I stayed the same person I was. The old me, with all my selfishness, was meant to be killed by the strength of that pain. And I was supposed to do it myself. Grey doesn't get to take credit for what she put me through. I had to fashion a brand-new person in order to be worthy of more. So I sob for the loss of my life and finally, I sob because I realise I've got it back. Nothing is temporary, everything I have is already in me. I sob because I've let it go.

It's gone.

"All this is full. All that is full.
From fullness, fullness comes.
When fullness is taken from fullness,
Fullness still remains."
OM shanti shanti shanti

(Brihadaranyaka Chapter IV)

I exit the sanctum and into the bright light of the studio reception. Little Emma runs over to me as I struggle to put one foot in front of the other. I am red, blotchy and shaking from loss of sodium. She pushes a bottle of pale pink liquid in front of me, electrolyte tablet fizzing at the bottom like a Refresher.

"FERN." She says, breathless and wild-eyed. "You were insane in that class. I was watching you and I know you got further in your postures than you ever had before. I could tell you were so in the zone!"

My vision is blurry, I can barely speak in full sentences. But every muscle and cell in my body is buzzing.

How could I not want to live?

As a caterpillar, having come to the end of one blade of grass,
draws itself together and reaches out for the next, so the Self,
having come to the end of one life and dispelled all ignorance,
gathers in his faculties and reaches out from the old body to new."
The Brihadaranyaka Upanishad [IV. 4. 3]

EPILOGUE
MAY 2019

I LEFT THE corporate world to join the creative one. The plan was to make money teaching hot yoga and to write in my spare time until I'd made enough money to do the latter for a living. Once I made the leap, I found this life lonely. I missed the social aspect of work. Sara and I eventually moved into a new house with MK, which helped. But I was excited when I got a call from one of my ex-colleagues, asking if I was interested in a HR Office Manager role for a company that deals with film acquisition, distribution and arthouse cinemas. I'd be surrounded by writers and directors as colleagues, she said; there's even an employee incentive to have your own feature film made and distributed. It sounded like the perfect balance of stability and creative freedom. I took it.

"You should meet my friend Christina; she dresses just like you. In fact, she has that exact top. I think you'd have a lot in common." My teammate mentions to me one morning, noticing my outfit.

I meet this Christina person for the first time the following week, when three cinema-based employees loudly enter head office for a HR meeting, disrupting our cliquey HQ bubble with their chat and unaware that their volume is not the norm here. The smallest of the three catches my attention. I can't tell her age – she dresses young, all pinks and blacks with mod undertones. *Quadrophenia* meets kawaii. She is short with a birdlike frame, but carries herself with the assured demeanour that usually comes with age. I watch her as she heads to the kitchen with

her entourage, shouting high-pitched hellos to the people she knows and laughing with her head thrown back as if she owns the world. I feel a little intimidated by her confidence as I watch her from behind my laptop, and try not to let her catch me staring as she places a mug beneath the coffee machine and waits for it to fill. I take in her raven-black buzzcut, the tattoos stamped on the inside of her forearms, the top that's exactly like the one I was wearing when I was told we'd get on: a limited edition pink Fred Perry polo with black sleeves. I'd found it on Vinted and hadn't seen anyone else with it before. Christina fascinates me straight away; simultaneously the magpie and the shiny thing.

"Is that her?" I say to my teammate. "Yep", he says. "General Manager of our flagship." Christina is mentioned a lot in our head office meetings as an example of what all General Managers should be aiming towards. She has a great reputation. Of course, making this connection heightens my respect for her. I watch her closer now, observe how skinny her wrists are, how the ink adorning them is a kind of violence on delicacy. How she uses her hips as a table by leaning back onto them. Striking.

She adds milk to her coffee and we head into the glass boardroom for the meeting.

"Hey! Are you Christina?" I ask her. "I've been told I'll get on with you – apparently we have the same fashion sense. I have that top!"

She looks at me as if no one's ever spoken to her before. "Yeah, oh! Hi! Okay."

Although not unfriendly, this is not the enthusiastic response I was hoping for. Throughout the meeting we catch eyes a few times and look away. My boss challenges the managers on HR matters.

"You need to be doing quarterly reviews with all your employees." she says.

"I've already done all of mine" Christina calls out, the class know-it-all.

"I know Christina, but you're not the only manager. I'm not just talking to you."

The following week, I'm carrying out HR audits on all the cinemas. Christina's flagship is my fifth visit of the week, and when I enter her office I'm struck by how well-organised it is. Rows and rows of black and white box files, neatly labelled against a cherry red wall. And so she rises in my estimations a little more. Inside I find her struggling with the knots on a string of rainbow flags.

"Ugh, for God's sake—this is so annoying! I hate the gays!" she yells as I enter, unable to untangle them. Her assistant manager is helping her decorate for Pride.

"Christina!" he scolds her. "Fern's a lesbian!" and to me, "Fern, she's joking, she loves the gays."

Christina seems unphased and doesn't look up from her mess. "Obviously I'm joking, YOU'RE gay. As if I'd say that in front of you."

I laugh, even though she isn't speaking to me. "Ha, don't worry – " I say. "It takes a lot to offend me."

Within the month, Christina is promoted to Regional Manager at Head Office. I'm the one who draws up her contract and issues it to her via email. The next time I see her, I've been tasked with ushering everyone across London from our summer conference to the after-party venue via the London Underground, because my boss is convinced people will trail off and be late if they make their own way. I don't care much to enforce this rule as we're grown adults, and the only people hanging about—seemingly waiting for my instruction—are Christina and a member of her team who I haven't yet met.

"I can't be bothered to make them all come this way", I say, vaguely waving my arm around at the rapidly diminishing crowd.

"I'll get the tube with you," Christina says. "I'm not interested in getting on the wrong side of your boss". On the journey we discover we have lots in common. Both studied creative writing at university. Both love pink. Fred Perry. Japan.

"How long have you guys known each other?" her colleague asks. "Are you joking?! She laughs her silver laugh. "We've only just met!"

I understand why he asked, though, because conversation is easy between us. It continues once we've reached the second venue. For the rest of the night we use each other as a base, dumping our bags and coats in one spot and returning to one another between going to the bar, the toilet, the food trucks. I learn she has a boyfriend, but she mentions this only briefly. A small group of us leave at midnight and head to the bar at the BFI on Southbank. When I mention I have to rush to Euston to catch my last train, she realises that she does too, so we grab an Uber together. On our run from the taxi to the station, a stranger just as drunk as us shoves a handful of twenty pound notes into our hands. When I wake the next morning with the money strewn across my bed-sheets, I find I'm in a particularly good mood. Even when I burst out laughing upon realising that—of course—the scores are fake (and twice the size).

I message Christina on Instagram to warn her we're not as rich as we'd hoped. By the afternoon we've swapped numbers and our conversation has moved to Whatsapp. By the end of the night we know each other's top ten favourite films, three of which we share. She says she'll lend me the DVDs of those I haven't seen. It's a passing offer I won't hold her to, knowing we're in the hungover phase of a drunken new friendship that will probably be cured by Monday morning.

I'm not sure why I check her work calendar on my Outlook app the following week. Or why I make sure I'm outside having a cigarette break around the time I know she's due in HQ for a meeting, so I can 'conveniently' catch her as she arrives. But as she rounds the corner, my heart does a little flip. She's carrying a paper bag full of DVDs. I am touched that she kept her promise. Soon we are texting all the time about movies. When I remember her boyfriend, I wonder how she gets away with talking to me all evening, every evening—won't he wonder who she's messaging this often? And yet she never mentions him again. Our chat is totally innocent. At lunch with my team, the colleague who knew we'd get on, sees her name pop up on my phone.

"You've been texting Christina?" he asks, the surprise in his voice apparent.

"Yeah, love her! We get on so well."

"Be careful Fern, she's been with her partner for fifteen years".

A jolt of defensiveness makes me flush.

"I know?! So? I don't like her like that."

What's more, *he* doesn't know me like that, to make such a comment. But my defensiveness sparks something familiar in me. My stomach sinks because I know this feeling, and it means that I like her. Later that day, the office receptionist notices Christina and I smiling in greeting across the room. "Aw, you two are so cute!" she says, clocking a chemistry I'd assumed was invisible. Alone in the lift down to the lobby at home time, Christina and I share how odd we'd found her reaction; both of us confused to learn there is a laser connecting us which others keep tripping over, prompting them to notice something about us that we'd not yet noticed ourselves.

"Anyway," I ask, "Have you seen *Vita & Virginia*? We should watch it tonight at the same time and text about it."

Christina stares at me for a beat, lets out a little laugh through her nose, then says "Okay? You're so weird."

Instantly I am thirteen, rejected. I pout to counteract my embarrassment.

"No it's not! I do that with all my mates!"

"Don't get upset! I'm only joking" she comforts, still laughing, but in that small space something undeniably awkward passes between us. I go home nursing my wounded ego and watch the film alone to spite her. Halfway through, when I'm almost asleep in bed, my phone pings.

"Ready to start watching V&V?"

"I thought that was weird? I'm already watching it ☺ "

"I was only joking!"

I ignore her message to preserve my pride. Ten minutes later she sends me a screenshot of a Virigina Woolf quote she's fond of:

I always have such need to
merely talk to you.
Even when I have nothing to talk
about—with you I just seem to go
right ahead and sort of invent it.
I invent it for you.
Because I never seem to run out
of tenderness for you and because
I need to feel you near.
Excuse the bad writing and excuse
the emotional overflow. What I mean
to say, perhaps, is that, in a way,
I am never empty of you; not
for a moment, an instant,
a single second.

The potential I could read between these lines makes me throw my phone down on my bed. I like this woman, but she has a boyfriend. I won't encourage forbidden feelings any more.

Good morning and goodnight texts are now standard between us. On my lunch breaks, I walk to the cinema flagship under the pretence of passing by and 'using the toilet'. The truth is, I want to see Christina—even if only for a moment—and I know she still works from there sometimes. When I enter, she looks up briefly from her seat and waves, then turns her attention back to Zoom. I know she takes her work seriously, so I pretend to pee and leave. Those few seconds of eye contact are enough of a boost to get me through many tedious afternoons.

The stomach pangs Christina gives me would have once driven me forward. But now they are unwelcome. Since Grey, romantic anxiety of any kind makes me uncomfortable. I wonder if she can tell I like her, if she too finds it bizarre that we haven't acknowledged *why* we text constantly when we've only known each other a few weeks. My confusion is compounded when I take the day

off work for a blood test and get hit with the same brazenness I had when I texted Nadine that I loved her.

Me: I was off work today—I missed you!

Christina: Aw! Why were y o u of?"

Me: Blood test.

Christina: Oh no, you ok? You should have said. I would have gone with you.

Weird. *Why* would she go with me? That's not normal. We've only met four times. I let myself dare to think that she might like me too. She's not even a hugger, so it's hard to gauge. Annoying, too, as I really want to hold her body to mine. The closest I'd got was when we'd said goodbye as I'd got off the tube one evening. I'd panicked and grab her pinky with my own before stepping onto the platform. We'd not discussed that bizarre exchange, but I'm pretty sure she was surprised by it. Even I was surprised.

We're in the royal box, watching the new Bruce Springsteen movie. Christina got a spare pair of tickets through work and asked if I'd like to go with her. The film is awful. The bench we're sharing is long, and we have it to ourselves, yet we're sitting abnormally far away from each other. I keep looking at her to make jokes about it, but she remains facing determinedly forward. I've mastered the art of vaping without letting the air out of my nose, so I'm dragging on my pen and hiding the blue light with the heel of my palm. It falls to the Floor and as I bend down to catch it, our elbows touch. A jolt of electricity runs up my arm. I'm care-ful not to move, as this is the closest we've been to each other all evening and the next best thing to a hug. Christina doesn't move hers either. *Interesting.*

"That film was the WORST." I say as we exit the cinema and meander back to Green Park Station.

"I know. We should have cancelled and gone for dinner instead. I'm hungry now, actually. Fancy going to Burger & Lobster? Or we could go to Soho?"

It's 10pm. If I'd gone to the cinema with any of my other mates, we'd head straight home afterwards unless a meal was pre-planned. Continuing the night spontaneously is something I only do on a date. Most of my daily activities are mere hoops I have to jump through before I'm reunited with my bed. But I never tire of this woman's company and I don't want to go home just yet.

Walking under the red paper lanterns of Chinatown, we chat about everything from Moomins to New York while peering into the windows of various restaurants. A man taps Christina on the shoulder.

"Excuse me ladies. How much would you charge to let me take photos of your feet?"

We ignore him and I use the opportunity to wrap my arm around her shoulder to steer her away. She pulls back from me.

"Actually, I think I'm gonna go home. I'm not even that hungry. And I'm getting a bit of a headache."

"Oh okay. Are you sure?"

"Yeah, that man weirded me out."

"No problem."

I'm disappointed by this, even a little hurt, although I know it's not personal. I wouldn't normally care if a friend cancelled dinner plans. My feelings for Christina are getting stronger, and I need to stop them before I revert to my old ways. By proxy, my respect for her extends to my respect for her relationship, so I won't make a move the way I would have a few years ago. I'm a changed woman. But I can't lie about my feelings. Our friendship feels safe enough to know I can confide in her with no judgment.

Back at Euston station after saying goodbye, I begin to draft my *Dear John* letter. As I'm writing it, I see a flurry of messages from little Emma appear at the top of my screen.

23:15: Did anything happen to you just now?
I just saw a huge flock of blackbirds fly across a field
Random but I wondered if it had anything to do with you?

I'm too focused on the message I'm writing to Christina to respond. When I'm finally at home and in the bath, I'm brave enough to press send.

23:45: I've been feeling a bit odd lately and I don't like it. I think I'm going to have to stop talking to you as much as I have been. In the interest of honesty I've realised I like you as more than a friend, and because you're in a relationship I don't think it's healthy for me to spend so much time messaging you. I'm ignoring girls on dating apps because I'd rather be talking to you and that's not good for me. Don't get me wrong, I love talking to you. I hope you take this for the compliment it is.

She responds as soon as she's read it.

23:46: This upsets me. I love talking to you too. You are one of the best people I know.

23:55: I won't say anything inappropriate but just so you know, I'm sleeping downstairs tonight.

The next day she calls me to tell me she has ended her relationship. She'd felt the same way about me all this time. The reason she'd cancelled on dinner was because our elbows touched in the cinema screen and it was too much for her. She didn't feel comfortable being alone with me. Understanding that the feeling was mutual prompted her to take action. Life, she says, is too short.

The first time we kiss, I say "I love you" before our lips can part. I don't mean to, but it's true, and the words just fall out. I watch her fix her hair in my bedroom mirror, and clear as water, hear my

own voice inside my head say *"I've hung my boots up."* This is it for me now. I know it is. I've arrived home. I walk over to kiss her again, and when I look down at her five foot two frame, for the first time in years I am actually looking straight ahead.

Being with Christina is new to me in every sense of the word. The boldness with which she chose me—without testing the milk or doing anything shady—starts us off on such a strong foundation of trust, that coupled with the closeness of our friendship, I feel a security I've not felt since childhood. Yet she still chose me over a man, so I get the little kick of having 'won', which is much appreciated by my inner child (I might have changed my behaviours, but I never professed to be perfect). By letting go of my immature need to be chosen and instead prioritising the right thing, I *was* chosen, and received what I'd always wanted. For once I don't have to choose between excitement and stability. Christina is aloof before you get to know her but with me she's warm, *hot*, affectionate. I have butterflies *and* peace. And not only does she love me, but she loves in the exact way I need to be loved. I can't underestimate the difference that makes. That woman loves me like it's her job. My favourite example being that she's the biggest clean freak I've ever met, yet the second I accidentally dropped my vape in a public bin, she had her arm all up in that shit like she was saving a drowning child from a swimming pool. That's the moment I knew she'd do anything for me. I move into her pink and mint home during lockdown, with its Day of the Dead portraits adorning the walls (like her, always toeing the line between dark and sugary), and together we're fortunate enough to spend a year-long honeymoon on furlough: writing, riding bikes, wine-tasting, watching the entire back catalogue of *Grey's Anatomy* and baking cakes at 2am. When I tell her that iced mochas are my favourite drink, she learns to make them better than Costa. Each morning I wake to a mason jar of cold chocolate coffee and a bubble bath because she knows that lying down in hot water is the only thing that will tempt me out of bed. I check the manifestation list I made before I met Grey, because I don't

remember any of those bonus points being on there. But she's the first person who ticks all of the boxes.

This is the only relationship I've had that hasn't started with some form of resentment. With Grey, the seeds of bitterness were sown as soon as my freedom was threatened. With Blue, we weren't officially together and I had an issue with her negative feelings towards Red, despite them being totally reasonable. With Pink, Purple, and all the other lovers that weren't mine to take, I was jealous before they even began—in fact the jealousy fuelled my interest. There's no splinter of spite in my heart with Christina. She teaches me that a healthy relationship doesn't make you compromise on things integral to your lifestyle and character. That when the bond is stable, you don't want to hurt your loved one just to get a reaction. She doesn't deny me my memories of past loves and experiences. Her attachment style is secure, not avoidant. I want to be better to be worthy of her.

It's been a year and a half since my depression. Thankfully, I've made a full recovery. My personal circumstances have vastly improved. My third poetry collection is published by an award winning independent press. Previously, I'd been submitting to an American publishing house for years without realising they don't publish non-US writers. I'd taken that rejection time and again until my manuscript got picked up by my UK publisher. But when the American company posts an Instagram story announcing they're opening a Canadian branch, I respond via direct message, asking "PLEASE open a branch in the UK? I'll run it for you!" because I haven't let go of my dream to be published by them one day. I'm joking of course, but the founder, a guy named Derrick, gets in touch. He takes me up on my threat and offers to coach me through the startup even though I have no experience. Within the year I've founded the UK branch of Write Bloody and am running it single-handedly part time, as well as teaching hot yoga on the weekends. Another example of how sometimes the things you want don't happen, because something bigger is planned for you.

When you're on the right path, you just know it. There's nothing dramatic like the answer in blood on your palm. You just follow the best, lightest feeling in each moment, and it will eventually lead you to the love of your life—whether that's a person or a passion. It's like the way turning left in a maze will always get you out. Christina was not my saviour, not even the original ending of this book. But unlearning my toxic habits cleared the path that led me to her. By practicing the Law of Attraction and taking little steps to change my thought pattern so that I could convince myself everything that had happened to me was for my highest good, eventually that became the truth. We only experience contrast within the range of what we've been practicing, and I had to do things differently. It is not until you go back to the beginning, tug at the root of your actions and unearth the *why*, that you can start to feel the sunroof opening on your life and expectations, as long as you keep your eyes open for the signposts that call to you. Walking out of Grey's kitchen for the last time was, I now realise, the best thing that ever happened to me. *Because I made sure that it was.* I healed myself before I could find Christina, but without a doubt she is the base from which everything in my life has flourished tenfold. No longer preoccupied with finding and keeping love, I am better able to nourish other areas of my life.

When we first got together, I was constantly gushing. People kept saying "That will go away!" But it hasn't. I love the way her skin always smells like a newborn's. Her forehead has a niche scent of baby lotion, talc, candyfloss and—weirdly—elderflower lemonade. She is most intoxicating when she's toasty first thing in the morning, or when she's just come through the door from work, doused in fresh air. She isn't one of my Saturnian rings—she's the whole planet. When life is as perfect as mine has been since I've met her, it's almost like you need a witness to the movie that's become your life.

Several times throughout writing this book I've been reminded how visceral the insecurity of my twenties felt. The longing and grasping to be further along in my life than I was. I

automatically hold my breath, bracing myself against an old anxiety. It's a relief to know I don't ever need to feel like that again. I do *not* miss waiting for a text back. There is no more agonising over my worth. I am thirty in a few months, and can feel the past decade rolling off my shoulders like a melting clock.

It's really quite terrifying that I had so much emotion for someone whom I now feel nothing for at all. That I razed my whole life to the ground for Grey, and was even willing to exit it. I received a text from her a year after we broke up: *How are you? I dreamed about you last night.* Feeling nothing when I read it was the final step in my recovery. Looking back, those three months were just a blip, a coma, one melodramatic *Marcella*-style blackout. It didn't make up even one percent of my life. I agree that it's important to remember the general impact of depression—how dangerous a place it is—in order to protect your mental health so that you do not end up back there. But in my opinion, you *must* drop what it feels like to be able to move forward. That's how heavy it is. It's why many of my friends don't know the extent of what I was going through when I broke up with Grey. I didn't want every experience with them to be tainted by my mental illness, rather I needed them to remind me who I was before it. Instead of talking, I write these moments down so that I do not lose them, and perhaps another can get something from them. This way, I am less lonely and never deprived after a loss. To anyone else suffering from situational depression, anyone who is deeply unhappy due to their current circumstance—be they mental, emotional, financial, familial—I'd like to quote from a poem by Bryony Littlefair, called *Giraffe*.

When you feel better from this—and you will—it will feel quiet and unremarkable, like walking into the next room.

The written word has always comforted me. I hope mine do the same for you. My highs and lows were tumultuous, and now

I am ready for peace.

(Well, as much as someone like me can be. I don't want to be *bored*.)

"The hardship, with Saturn, can turn into a kind of earthly paradise, if you listen to him right." *Surviving Saturn's Return: Overcoming the Most Tumultuous Time of Your Life—Sherene Schostak and Stefanie Iris Weiss*

ACKNOWLEDGEMENTS

I T HAS TAKEN five years and all of my emotional reserves to write this book. Thank you to the government for furlough in 2020, without which it still wouldn't be finished.

Thank you to Megan Falley, for your encouragement and solidarity while writing your own memoir and for recommending your editor Hannah Beresford. I knew that by handing over my manuscript to someone you trusted, I'd be able to relax somewhat. I was right. Thank you to the talented Hannah, for cutting and shaping my memoir into something that is relatively cohesive (I hope). I apologise for not taking *all* of your notes—alas I am still a servant to exposition! Thank you to Cathy Rentzenbrink, whose advice on the Curtis Brown memoir writing course provided a motivational jumping off point for this book. Thank you to Caggie Dunlop, Cecilia Knapp and Charlie Brogan for being open to receive an ARC, and to Coco Mellors and Dolly Alderton for the tweets, messages and in-person pep talks.

Thank you to the late author Shane Kang. We never met, but when you told me you had a line of my poetry pinned on the wall above your desk and that I must write a book one day, I was enormously flattered and it spurred me on. You were cool in the true sense of the word. I'm sorry we didn't get to meet. Thank you to Kristy Duru, who tweeted "I'm ready for your book now", over fifteen years ago. Here it is.

To my friends, whose support pushed me to continue both writing and living when I found it hardest. For the cards and plants sent to my home during those horrific six months. Specifically to Megha Menon and Shauna Young for providing feedback on several of these chapters in their early phases, and to Sara

Lozano-Bernabeu, for allowing me to share a home with you when I most needed it.

Thank you to Nadine, who inspired me to dance, and then to write. To the late Sohrab Mehta, Write Bloody UK's angel donor. And to Kim, for remaining in my life – that's fourteen years and counting now! I had only *just* been alive that long when I met your sister. I love you entirely in your own right, and I hope you know that.

Thanks to my family; to Taylor for always being on hand with your creative expertise, and of course my mum who has never stopped believing in me or my work. You are my biggest champion. To my late auntie Val, who – on the evening I had a death wish and ran over to kiss her – told my mum I have a way of making everyone feel loved. Mum told me this once I'd recovered; how it made her cry because she knew how broken I was at the time. Hearing this made me realise that no matter how low you are, you are always able to offer value to another. Thank you for this. I miss you.

Biggest thanks of all to my fiancée Christina, for my happy ending both on the page and in real life. It takes one hell of a woman to read a book about all of your fiancée's exes and say only how much you are enjoying the story. Thank you for encouraging my creative freedom and for your confidence in my feelings for you. I love you.

Milton Keynes UK
Ingram Content Group UK Ltd.
UKHW042332290324
440240UK00004B/11/J